A LIFETIME OF MOVIE GLAMOUR, ART AND HIGH FASHION

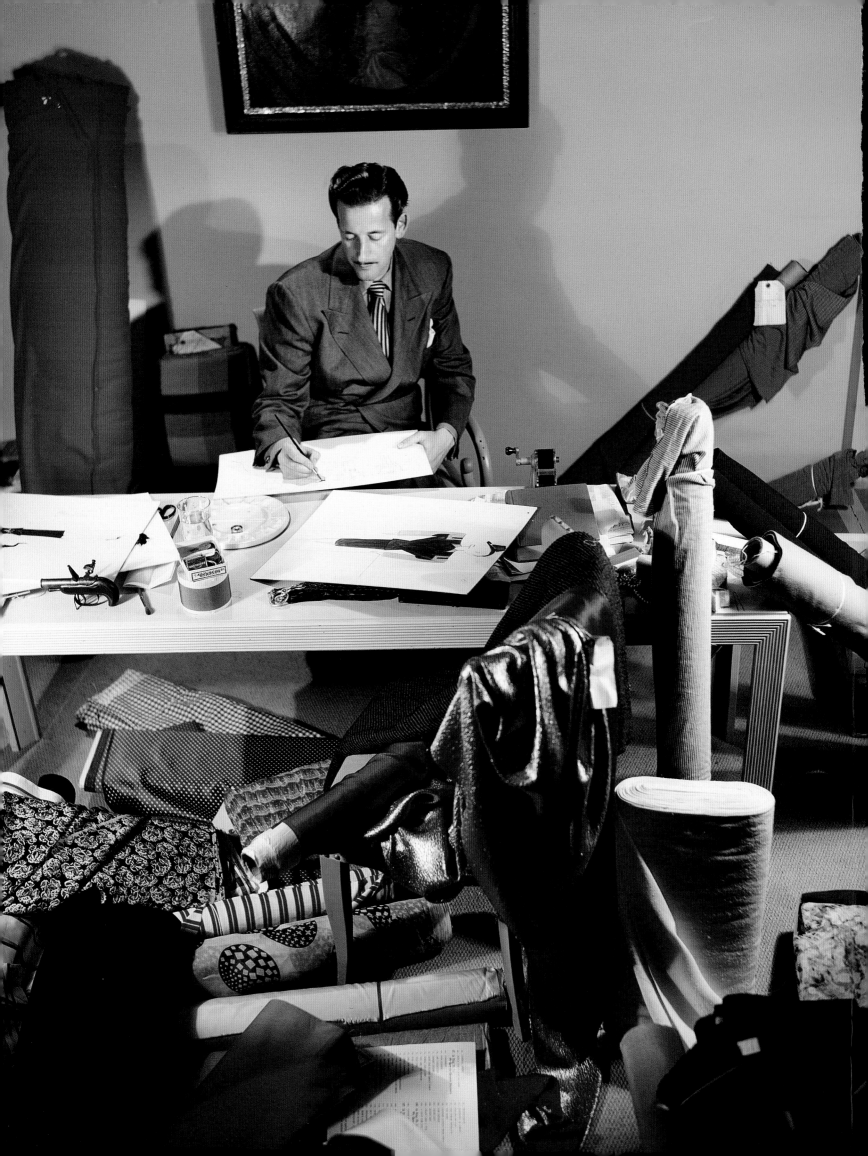

Adrian

A LIFETIME OF MOVIE GLAMOUR, ART AND HIGH FASHION

LEONARD STANLEY

TEXT BY MARK A. VIEIRA

RIZZOLI
NEW YORK

New York · Paris · London · Milan

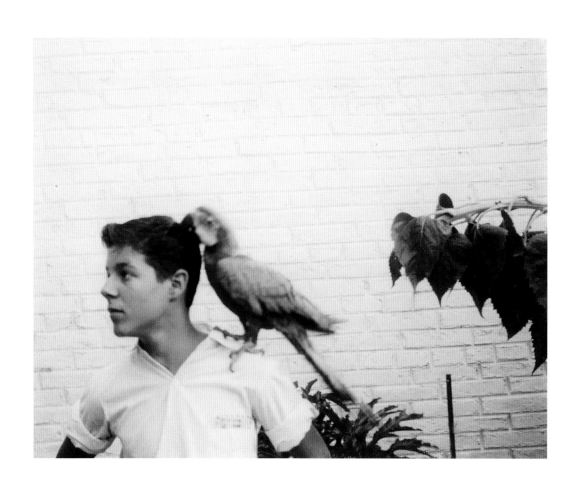

FOR ROBIN

"Talent is habitual facility of execution. Inspiration is the continuation of the divine effort that built man."

—RALPH WALDO EMERSON

CONTENTS

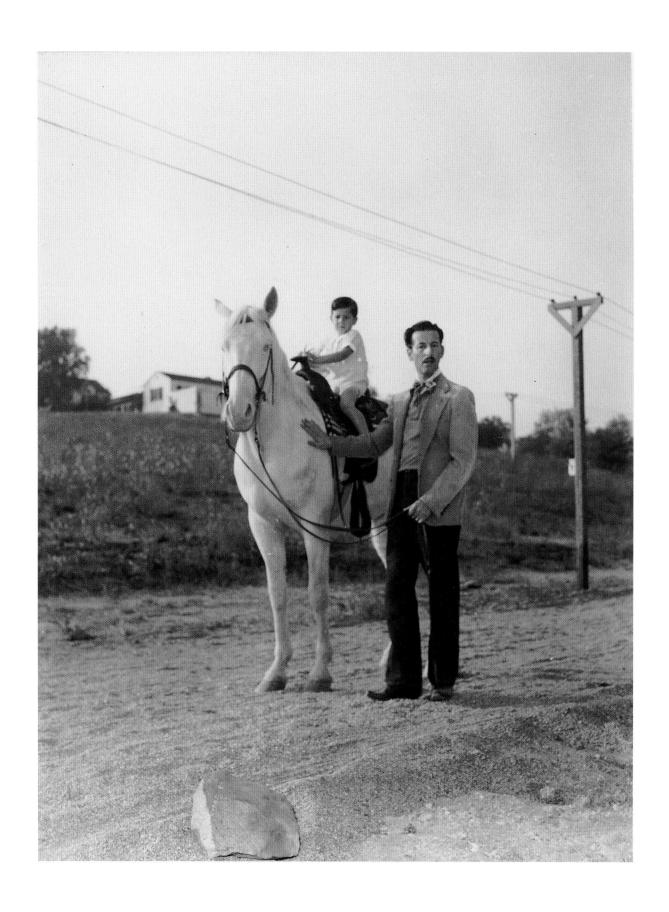

MY FATHER

BY ROBIN ADRIAN

My father, Adrian, was best known for his designs of women's clothes—both during his years at Metro-Goldwyn-Mayer and afterward for his collections at his Beverly Hills salon.

What most people don't know about are the many other interests he had outside of the world of fashion.

He was always fascinated by animals and began sketching them as a young boy whenever the circus came to town. This developed into a lifelong interest that resulted in many oil paintings of Africa. He painted an entire collection for an exhibition at M. Knoedler Gallery in New York before his trip to Africa in 1949.

My parents were people who never lived in the past, even though both had noteworthy careers. They always lived in the present or looked forward to a future endeavor. Though both received numerous awards, they were never on display in the house. My father was far more interested in an antique or a new piece of art than trophies of any kind. He read a great deal about various religions and philosophies, as he was always open to new ideas. He also liked to surround himself with interesting people who stimulated his imagination.

My father and my mother went to a film festival in Brazil because it sounded like it would be a new adventure. It turned into a real adventure. They ended up buying a coffee fazenda in the interior of the country and spent six months of the year there.

All in all, Adrian was a Renaissance man.

Adrian teaching Robin to ride at Pepper Hill Farm, their ten-acre property in Northridge, California, 1944.

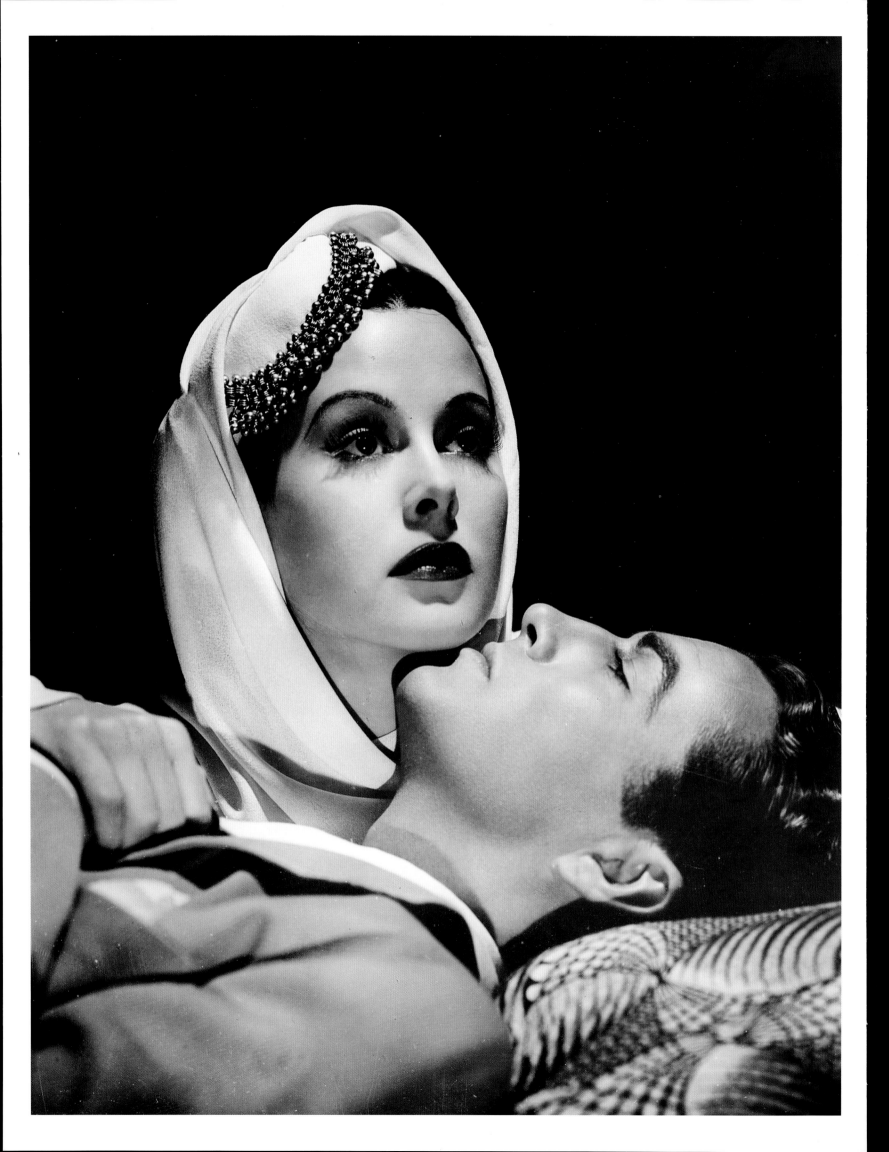

INTRODUCTION

BY LEONARD STANLEY

L ady of the Tropics, starring Hedy Lamarr in 1939, started it all. I was nine years old and that is when I began collecting on Metro-Goldwyn-Mayer's chief costume designer, Adrian.

My father knew someone in the motion picture business, and I had access to black and white "stills" from the movie. After that, there was no going back. Seventy-nine years later, I am still collecting on Adrian, and 95 percent of the images in this book are from my collection. Collecting is in my DNA.

June 6, 1951: the day that my life really began. I was twenty years old, having grown up in Honolulu, Hawaii, but 1951 was my first year in Los Angeles, where, mentally and spiritually, I felt really alive.

I had been attracted to Hollywood, film, and glamour all my life and, now, it all started for me. My first job was assistant to Tony Duquette, who had a studio near Vermont Avenue and Sunset Boulevard. He also had a shop in the Beverly Hills Hotel, which was chock-full of the most imaginative and original pieces of furniture, screens, paintings, and other extraordinary objets d'art. Half of the time I was working at the studio and the other half I was at the shop.

One slow Friday afternoon, I decided to close the shop at 4:30 rather than 5:00, and I went to have tea with Madame Lisa des Renaud, who lived in the hotel. Suddenly, there was a knock on the door, and who walked in but Adrian and his wife, Janet Gaynor!

I had been so influenced by Adrian my whole life, and there he was right in front of me. They said that they had come to the hotel to look at Tony Duquette's shop but found it closed, so they thought they would visit their old friend, Madame des Renaud. I felt terribly

M-G-M publicity photograph of Hedy Lamarr and Robert Taylor from *Lady of the Tropics*, 1939.

guilty about closing the shop early, and I offered to reopen it for them, but they declined, so the four of us had tea together and I was in complete heaven.

That was the first time I met Adrian. The second time was Christmas Eve 1952. Tony Duquette had designed a fabulous Christmas present for Janet and Adrian consisting of a large tortoise with a candelabra on its back, all jeweled and encrusted with Venetian glass-beaded flowers.

Tony told me to deliver the gift to Adrian's new house in Bel-Air. My instructions were to hand it to Adrian himself and to light the candelabra just before presenting the gift.

When I arrived, the butler answered the door and told me that he would take it. I said, "Oh no. I have to give this personally to Mr. Adrian." The butler said that Mr. Adrian was dressing for a black-tie dinner party and could not be disturbed. I told him that I would wait—which I did— but not for long.

When Adrian arrived, I lit the candelabra and he was enchanted. He quickly removed the centerpiece from his dining room table and put Tony's tortoise in its place. Adrian was absolutely over the moon!

Another time that I saw Adrian was at a black-tie dinner party at Tony and Beegle Duquette's studio on Robertson Boulevard.

After dinner, all of the guests were talking in the upstairs sitting room. I went downstairs to my room (I was living in the studio at the time), and I gathered up my tons of clippings and photographs of Adrian's work that I had collected all my life. I took them upstairs and dropped them in Adrian's lap, and said, "I am your biggest fan!"

THE EARLY YEARS

CONNECTICUT, 1903

Fashion and fashionable clothes were not part of my plan for a career," wrote Adrian. "I wanted to be an animal painter, from the time that I was nine years old, when I saw a painting by Rosa Bonheur, *The Horse Fair*." Bonheur had executed the painting in 1853, disguising herself as a man to sneak into the Paris horse market to make preliminary sketches for the work she would later call her "Parthenon frieze." The painting spoke to the impressionable boy, with its composition, the robust beauty of its white horses, and the contrast of its dark, dramatic background.

Adrian Adolph Greenburg was born on March 3, 1903, in Naugatuck, Connecticut. His father was Gilbert Greenburg, who owned a millinery store. His mother was Helena (née Pollak) Greenburg. She met Gilbert in 1894 when they were both working in New York: he as a furrier at C. G. Gunther & Sons, and she as a seamstress for the Lichtenstein import company. The Naugatuck store had been a Pollak family business, but Gilbert and Helena took it over in 1896. Their business acumen, design skills, and lively personalities made Gilbert Greenburg a going concern on Barnum Block in Naugatuck. Both parents were adept at art, and Adrian was encouraged to draw. One of his early achievements was a panorama on a kindergarten chalkboard. His images of a circus parade—especially the beasts—were so well rendered that his teacher let them occupy the important space for four days.

In elementary school, Adrian's interests pulled him to exotic worlds, and his talents pushed him to interpret them. "I liked to draw

Early family photograph of Adrian, circa 1906.

animals from the start," recalled Adrian. "There wasn't an animal book in the Naugatuck Library that I hadn't read. And as for medieval and ancient history, I lived it. I had gorgeous, embroidered dreams, and I tried to get them down on paper."

Adrian had no formal art training during his childhood years, but his mother showed him how to mix colors and a housekeeper taught him to sew. Adrian was also encouraged by his uncle, Max Greenburg, a scenic artist who created backdrops and designs for theaters in nearby New Haven. Mostly, though, Adrian drew pictures on whatever blank surface was available, be it the flyleaf of a book or a paper bag.

The Greenburgs recognized their son's gifts and, in September 1920, when he was seventeen, they sent him to the New York School of Fine and Applied Arts located in Manhattan (now Parsons) which was the cultural capital of the country. Art, artists, and galleries were proliferating in the postwar boom. And there were numerous schools, including the Beaux-Arts Institute of Design and Pratt Institute. Adrian rented a room in a brownstone apartment about a mile from the school. He found the environment stimulating but not the curriculum; it involved an inordinate amount of copying. "I was to study art and costume design," wrote Adrian, "but with the aggressiveness of youth, I felt the school was not allowing me to go fast enough. I would finish the simple problems my teachers gave me and, when they told me to do them over, I would spend nights in my room making illustrations from Edgar Allan Poe or Lord Dunsany. Once I brought in drawings of weird characters titled 'Diseases.' An unearthly figure dripping green was 'Pneumonia,' and an image trailing folds of skin full of holes was 'Leprosy.'"

Adrian's shocked teachers directed him to the Museum of Natural History to look at Peruvian textiles, but he gravitated to the Zoological Park. "I could sketch animals," wrote Adrian. "Their bodies seemed more graceful than the ladies who took uninspired poses on the platforms at school." His penchant for the glamorous and exotic soon found an outlet. Faculty at the school had submitted student designs to the Broadway producer George White, who was preparing a follow-up to his recent review, *Scandals*. The 1921 version would

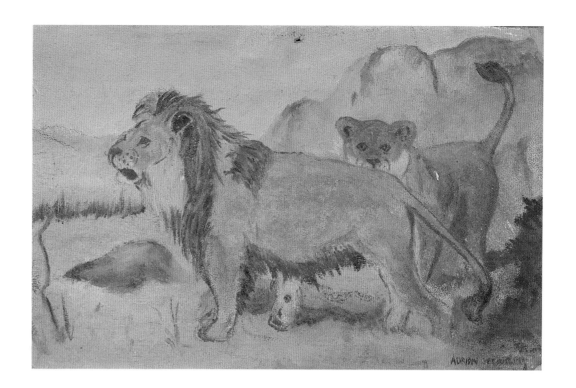

Top: Early childhood painting of a lion and a cub by Adrian.

Bottom: Childhood drawing of a Chinese man in costume.

also feature songs by twenty-two-year-old George Gershwin. The producers commissioned two costumes from Adrian for a Don Juan musical number. When the show became a hit, he had a moment of celebrity.

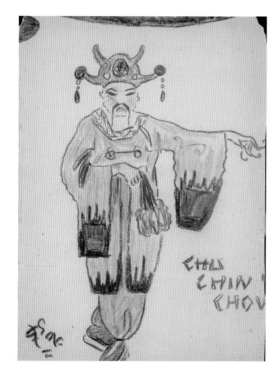

Adrian's brush with the theater had made him impatient with school. "Frank Alvah Parsons, the founder, was a remarkable man, full of high spirits and sarcasm," recalled Adrian. "But his comments on banal taste, Victorian weakness, and ugliness stung like wasp bites."

In fall 1921, Parsons sent his colleague William M. Odom to open a Paris branch in a leased house in the Place des Vosges. Adrian had been earning consistently good marks and was to be included in the group of students going to Paris, yet he had the temerity to ask Parsons if the curriculum would be better than his current one. "Mr. Parsons had a peculiar habit of slapping himself on his bald head to accent a point," wrote Adrian. "I can still hear the sound of the slap as he flew into a rage at my impertinence." Parsons was so angry that he wrote Gilbert and Helena Greenburg: "Your son has practically driven his teachers to

distraction. He evidently believes himself to be a genius. If he continues with this attitude, I am afraid we cannot allow him to go to Paris." Gilbert hastened to New York and assured Parsons of his son's intentions. "I meekly returned to my studies," wrote Adrian.

These studies included a guest lecture by Robert Kalloch, who had also attended The New York School of Fine and Applied Arts and, thereafter, had gone on to work for Lucile, Ltd. This was the international design firm owned by the elegant Lady Duff-Gordon, a *Titanic* survivor and the sister of novelist Elinor Glyn. Kalloch was obviously in a position to help Adrian. The designer liked the student's work and recommended that he spend a few months at Florence Cunningham's Gloucester Theatre School in Massachusetts.

An unexpected development occurred at the school. Florence Cunningham advised Adrian to change his name. The celebrated Léon Bakst of the Ballets Russes had, after all, changed his name from Leyb Rosenberg. Adrian had already been signing his work with both his father's name and his own, as Gilbert Adrian. After this, he would use the single name, Adrian.

Fantasy figure costume sketch by Adrian.

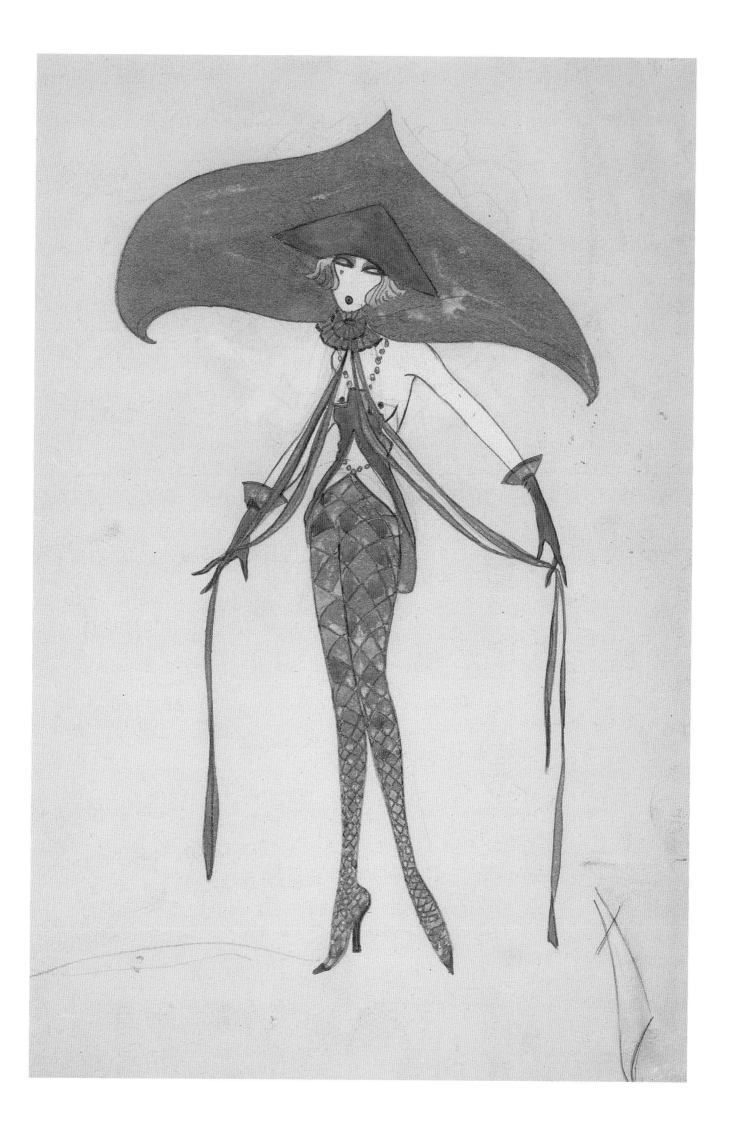

I n February 1922, shortly before his nineteenth birthday, Adrian boarded the Cunard liner *Mauretania*, bound for Paris. The *Mauretania* docked in Cherbourg, France, and the students took a train to Paris.

Adrian adapted to his new surroundings. His hotel was on the Left Bank, adjacent to the famous Cafe de Deux Magots, a half-hour walk from his school. This *pension* was a change from his New York brownstone. As he recalled: "It had one bathroom, horrible wallpaper, and a cranky concierge whom we had to awaken by ringing a bell if we came in after eleven o'clock at night. Yet I was enchanted." He began his first semester on March 15, and he soon made more friends, taking field trips with them to museums. He was unaccustomed to the damp, piercing cold of a Paris winter and was grateful when spring arrived with its warmth and cheer.

France was recovering from the Great War and struggling with a national deficit, but the City of Lights was still the world's capital of literature, art, and fashion. For aspiring artists Paris was more than a destination. It was Mecca. In the early 1920s there were already Americans living in the city.

A classmate introduced Adrian to an older man who lived with his brother in a moss-covered home near Napoleon's tomb. "Mr. Charles Holman Black had lived in Paris most of his life," wrote Adrian. "Like a great many expatriates, he had thrown himself into the life of Paris. The old families had opened their homes to him, and through his friendship I was allowed the privilege of entering a world that I would not have otherwise known."

When Adrian was not meeting the elite of Paris, he was seeing the cabarets of Montmartre. "The city captured me as it does every other student," recalled Adrian. "The Folies Bergère was a shabby temple devoted to the human desire for beauty—and shock. Statuesque beauties paraded, sometimes unsteadily, down staircases, ostrich feathers curled around their pink-tipped breasts. Their bodies

An imaginative costume sketch for the theatre signed and dated, "Adrian Paris '22."

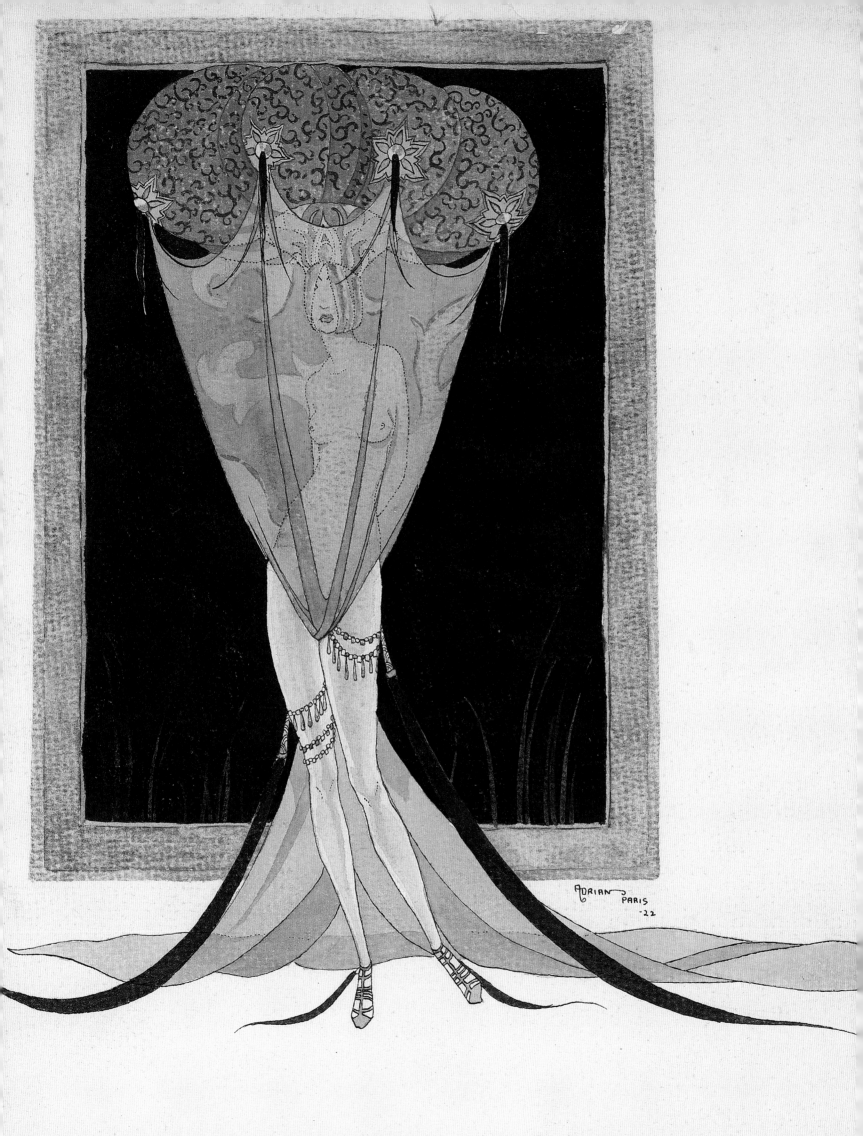

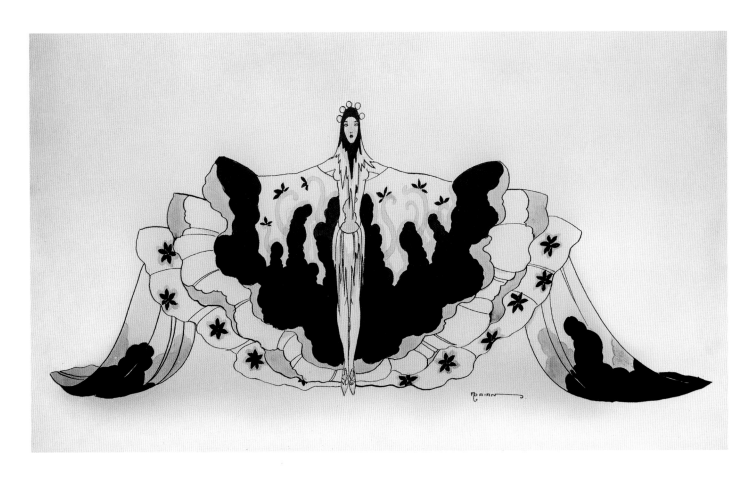

were freshly powdered, pink under the lights, luminous, their eyes enlarged with mascara, and their lips glistening in red spotlights."

The nightclub inspired Adrian to hurry back to his room and create his own version of the revue. "My freshly powdered ladies peered out of eyes shadowed beyond recognition," he wrote. "Costumes exploded in fanciful tumult, and not a breast was covered." When he wrote to his parents about the nightlife he had seen, he recalled "it must have made them wonder whether they had been wise to send me out into the world so young." Talented as Adrian was, he was not precocious; he was innocent. As he saw more of Parisian life, he began to understand things: "I became aware of the meaning behind the painted eyes and lips of the girls who promenaded with such friendliness between the acts in the Folies forecourt."

Every young person in Paris was trying to comprehend such things. When they congregated and socialized, they learned.

"My life in Paris was full of wonders which this worldly-wise city allows visitors to discover. After years of New England hypocrisy, the

Above: Showgirl costume sketch by Adrian.

Opposite: A highly unusual and creative stage set designed by Adrian.

sudden exposure to centuries of experience offered a shortcut to the emotions, breaking through the self-imposed boundaries of youth."

As Adrian continued to visit Charles Black, his mentor had a suggestion. There was an event called the Bal du Grand Prix, held yearly at the Opéra de Paris to mark the end of the racing season. The house was redressed for the gala, the stage with black velvet and the opera boxes with gold swags. "Society women vied with each other to wear the most elaborate gown at the event" wrote Adrian, "and fortunes were spent for this one evening. Mr. Black felt that I should make every effort to attend."

One of Adrian's classmates was a twenty-year-old woman from New York named Honor Leeming. A striking beauty, she would be an ideal model for the costume Adrian had in mind, a princess from the popular book titled *The Arabian Nights' Entertainment*. He summoned up equal amounts of invention and ingenuity and went to work. The Bal du Grand Prix was scheduled for Saturday, June 24, 1922. As the date approached, Adrian hurried to complete the costume, hoping to set Honor above the beauties of Paris, and to showcase his talent.

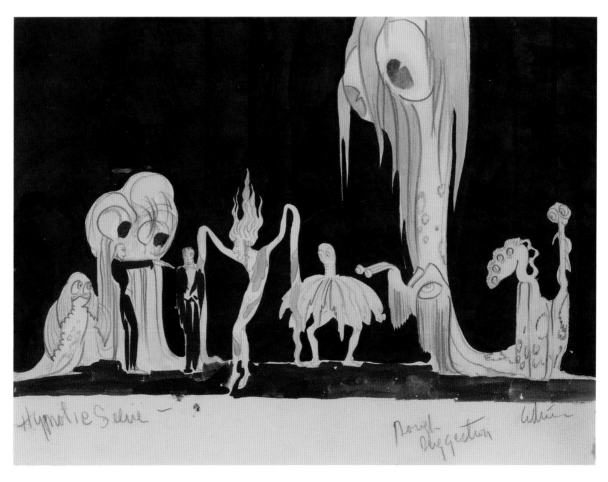

Frances's deficit did nothing to diminish the sparkle of the Bal du Grand Prix. "We climbed the great marble staircase of the opera house," recalled Adrian, "and stood wide-eyed watching the guests arrive. Before long, we were a little in awe—and quite self-conscious. We had not expected such grandeur." Every arrival introduced a costume that was more imaginative, more splendid than the one before it, but one entrance was especially exciting for the design students present.

Paul Poiret was famed as Paris's foremost couturier, and rightly so. In twenty years, he had innovated numerous traditions: fabric draping as a design element, harem pants, and a perfume line. He promoted all of his lines with elaborate receptions reflecting Far-Eastern themes. Poiret's entrance to the ball was theatrical, to say the least. He "arrived with a group of Parisiennes who were straight out of Baghdad. Poiret was the potentate and the Parisiennes, his court. Peacocks walked beside them on gold chains, and Poiret led a cheetah that had jewel-encrusted claws."

Pearl White was the international star of Saturday-afternoon serials. Dressed by designer Charles Frederick Worth, she made her entrance as an incandescent light bulb. Adrian was agog.

Another partygoer was dressed as an East Indian goddess, her body painted gold and bejeweled with gems. Her embroidered chair was carried on the shoulders of ten semi-nude men who were painted blue. "The spectacle seemed unending," Adrian recalled. "This was Paris—Paris bursting at the seams of its own imagination. Honor and I began to wonder if we dared compete with this display of extravagance."

Honor recalled, "The costume Adrian created for me had a design of palm fronds, which he stitched in bright-green thread. It shimmered under the lights."

This shimmer caught the eye of a short man with shiny dark hair who was standing nearby. Adrian could not help but notice the man's

Composer Irving Berlin
photographed by Cecil Beaton.

fixed gaze. "Honor, that man has been watching you constantly. Do you know him?"

"I don't know him, but I think I know who he is. He looks like Irving Berlin." This clicked with Adrian. Irving Berlin had created a 1911 dance craze with "Alexander's Ragtime Band," and more recently composed "A Pretty Girl Is Like a Melody" for the Ziegfeld Follies. He was an international star, reportedly in Paris to sign talent for his own Broadway show, the *Music Box Revue of 1922–23*. Honor knew about Adrian's showgirl sketches and asked, "Why don't you go over and speak to him?"

Adrian was naturally reserved, but this was an opportunity. When Adrian approached the man, it was the man who acted self-conscious, probably because he thought Adrian was going to tell him to stop staring at Honor. Adrian asked him if he was Irving Berlin. Yes. He was. Adrian said that Mr. Berlin appeared to be admiring Miss Leeming.

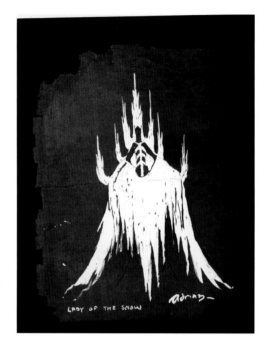

"Yes, I am," said Berlin after an embarrassed pause. "I have been looking at your partner's costume. I think it is one of the most interesting here."

Adrian had not expected this. He was thrilled. Still, he retained his poise. "That's fine—because I designed it. And I have many more that I would like to show you."

"I would like to see them," said Berlin. "I'm staying at the Crillon. Bring your sketches there tomorrow morning."

The Hôtel de Crillon was a half-hour walk from Adrian's hotel. When he arrived, he was welcomed to Berlin's suite by Hassard Short, the well-known British actor who had switched to directing for Berlin's hit show of the previous year, *The Music Box Revue of 1921*. Berlin was present. After looking at Adrian's sketches, he deferred to Short. "We are working on an idea for a musical number," said Short. "An auction scene in which

Two detailed Adrian costume sketches.

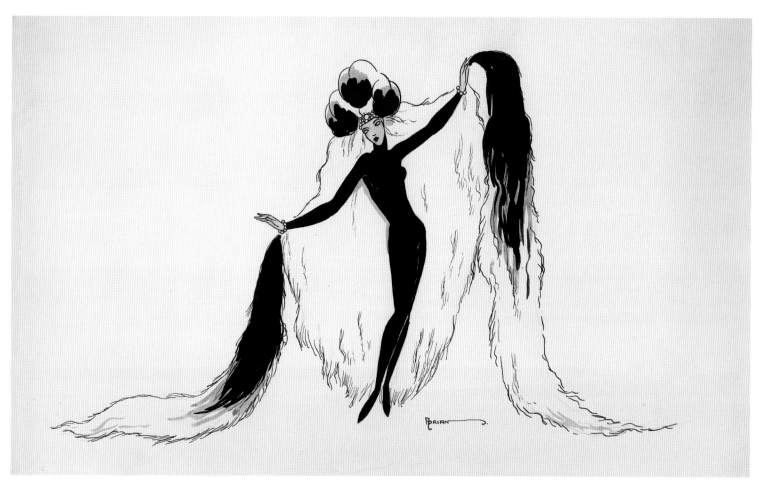

An early 1920s showgirl costume sketch by Adrian.

various bits of art are sold, such as porcelains and paintings. After they are sold, they come to life. Work on it, Gilbert. See what you can do with it. Then bring your conceptions to us in a week."

A week? Adrian hastened to his hotel. He looked at the material Short had given him. Adrian thought of Jean-Baptiste Pillement (1728–1808), the eighteenth-century artist who specialized in Chinoiserie. He pulled out the research he had done on this painter and applied the style to the ballet, designing both settings and costumes of Chinese porcelain figures in the manner of Pillement. For two days Adrian worked without stopping. Then he called Berlin. When he presented his work to Berlin and Short, they were delighted.

"Before I knew it," recalled Adrian, "Messrs. Berlin and Short had signed me to a contract to design the costumes and one setting for the *Music Box Revue of 1922–23*. My teachers were pleased but slightly hesitant. They thought I should continue with my studies. Nothing could dissuade me. I couldn't wait to get on a boat for New York. I cabled my family that I was returning." Both Adrian's parents and

The Fans –

BRIAN

teachers prevailed upon him to complete his first term, which would end on July 10, 1922. After an approval from Berlin and Short, Adrian completed his projects and papers and took his exams. On July 22, Adrian sailed for New York on the RMS *Homeric*.

"My first exposure to the musty magic of backstage life took place on West Forty-Fifth Street," wrote Adrian. "I found Hassard Short and Irving Berlin seated down front in the empty Music Box, watching tall, languid showgirls parade in front of them. They welcomed me warmly and invited me to sit with them as they scrutinized the beauties who were to eventually decorate the stage. It was like being in on a great secret."

The Music Box Theatre had been built only two years earlier, to accommodate Irving Berlin's popularity. Producer Sam Harris reasoned that Berlin should be writing hits for his own shows, not for Ziegfeld's. The first *Music Box Revue* had been a success; Adrian would be a part of the second *Revue*. He was contracted to design

Fantasy costume sketch for the theater.

Above: Three costume drawings for Irving Berlin's *Music Box Revue*.

Following pages: Extravagant 1920s showgirl costume sketch by Adrian.

two numbers: the Little Red Lacquer Cage and the Porcelain House. Adrian worked in one area creating designs, went to a different hall for costume fittings of the chorus girls and showgirls, and then went to the Schneider-Anderson Company to have the costumes made. "Veronica was in charge at Schneider-Anderson," recalled Adrian. "She had dealt with producers for so long that the idiosyncrasies of a Florenz Ziegfeld or a Charles Dillingham were no longer formidable. She had a way of making her prices sound less when she quoted them. She took me under her wing and gave me sound advice—where to cut corners on the chorus and where to splurge on the showgirls. She did a great deal to help me in my early career."

Music Box Revue of 1922–23 opened on October 23, 1922. "The reality was even more spectacular than the dream," wrote Adrian. "I had designed glittering black poplar trees which turned about, split open, and became jeweled macaws with great wings outstretched. Then, up from the floor, on an invisible elevator, came the bird of paradise, with a train of golden feathers that stretched across the stage. The audience burst into spontaneous applause, as they did at my porcelain figures. I knew these were my designs, yet when I saw them realized and presented with Mr. Berlin's music, I was hypnotized by the magic of the theatre."

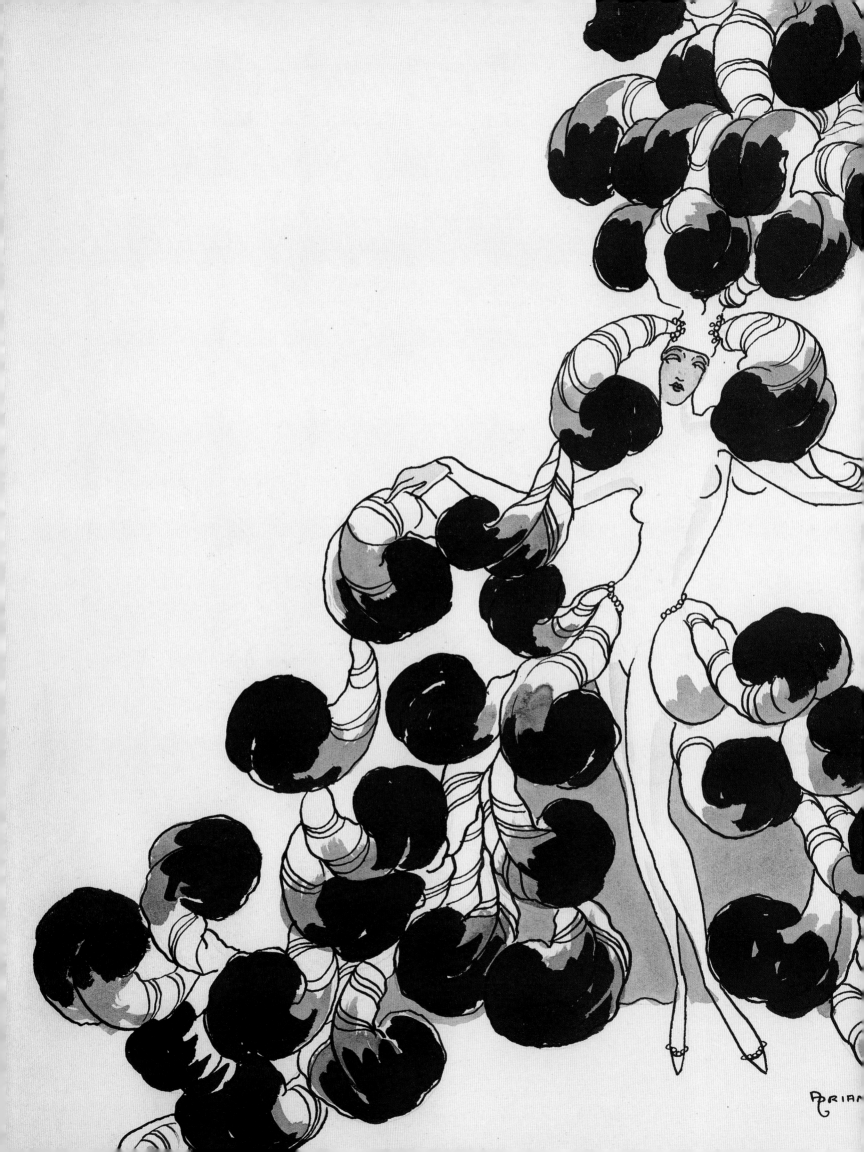

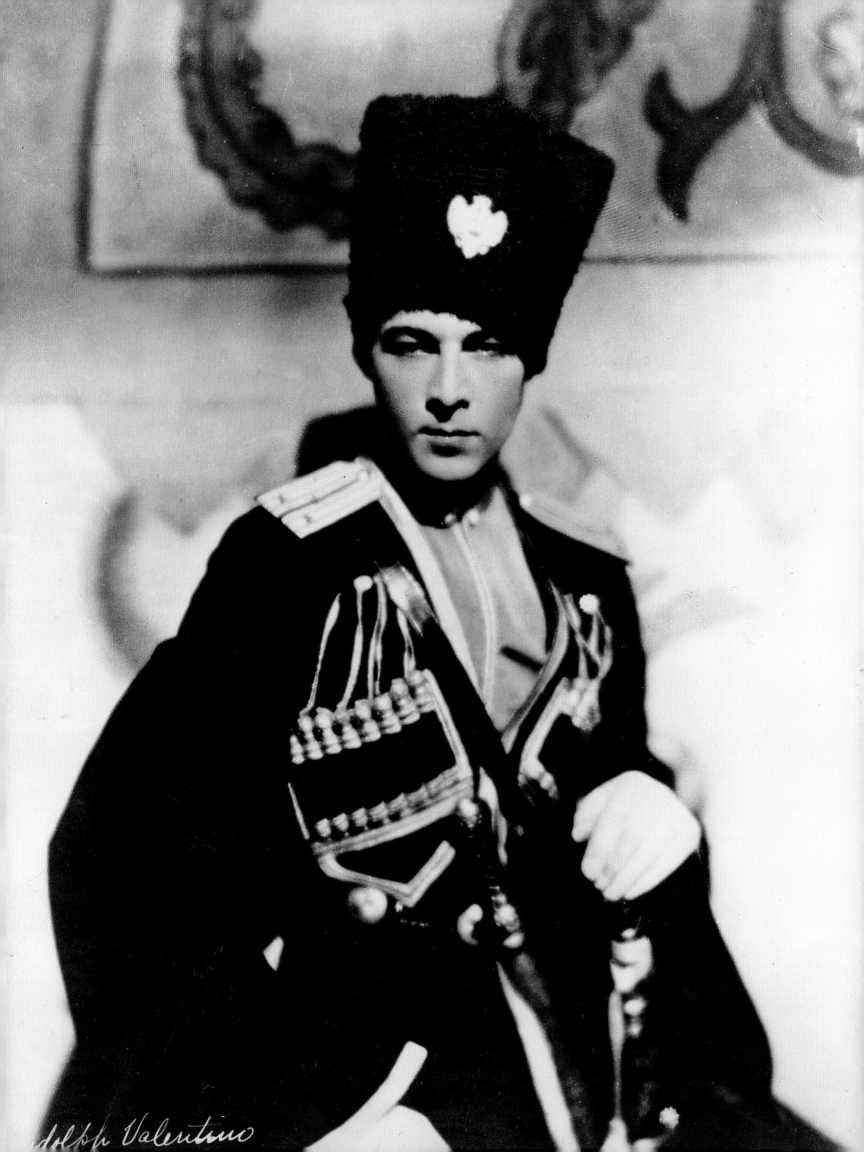

Rudolph Valentino

HOLLYWOOD

Adrian's success on his first Broadway production was not beginner's luck. Even at nineteen, he had the vision of a genius and the skill to express it. Hassard Short assigned him to the next *Music Box Revue* and, before 1922 was over, he was also designing for Distinctive Pictures, a New York company. His first assignment was a film called *Backbone*. It starred Alfred Lunt, who was newly married to the British actress, Lynn Fontanne. "*Backbone* gave me one of my happiest experiences," wrote Adrian, "the friendship of Alfred Lunt and Lynn Fontanne." Adrian had seemingly come out of nowhere, yet he was already moving in exclusive circles.

For the next two years Adrian commuted between local film companies, theaters, and costume houses. Working on Short's *Ritz Revue* and Charles Dillingham's *Nifties of 1923*, Adrian made frequent stops at Schneider-Anderson. On one of these hurried visits, he left some sketches in the reception area, and they were noticed by another client. Natacha Rambova was intrigued by the work she saw lying on a table.

In an era when "Hollywood" meant exotic, self-invented, and alluring, Rambova led the pack. She had come to films through the Russian dance teacher Theodore Kosloff, first as his protégée and dancing partner and then as a designer for Cecil B. DeMille. After working on several DeMille films, Rambova designed both costumes and sets for Alla Nazimova's dreamlike productions of *Camille* and *Salomé*.

Rambova's work was original and very creative. "I am perfectly willing to admit that my drawings are morbid," she told *Photoplay*.

Previous page: Photograph of Rudolph Valentino for the film *The Eagle*, 1925.

Above: Portrait drawing of Valentino's wife, Natacha Rambova.

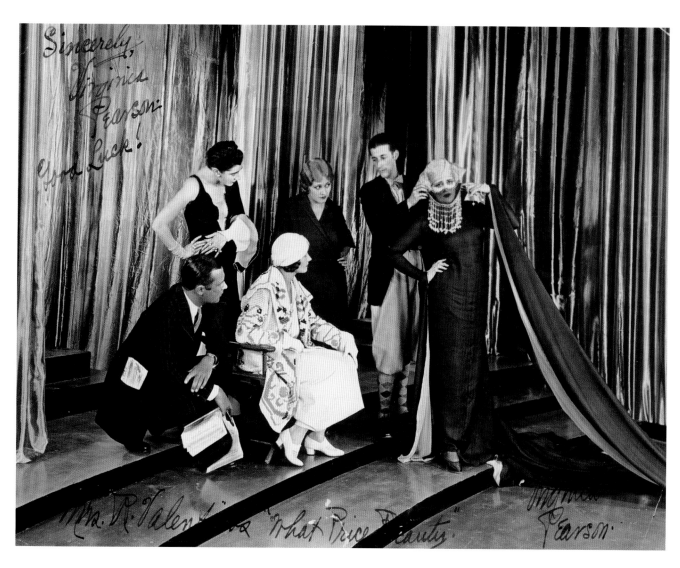

Photograph of Natacha Rambova (seated in the white dress) with Adrian on the set of *What Price Beauty?*, 1925. The film was released in 1928.

"The exotic quality in my sketches is part of me." She projected an aura of mystery, but she had been born Winifred Shaughnessy in Salt Lake City. She became Winifred Hudnut when her mother married the cosmetics magnate Richard Hudnut. Kosloff dubbed her Rambova for his Imperial Russian Ballet Company.

While working on *Camille*, Rambova was asked to arrange the hair of the young man playing Armand. She had seen the actor on various sets but only got to know him as he was enjoying his first taste of stardom. Rudolph Valentino had been led to stardom in *The Four Horsemen of the Apocalypse* by writer June Mathis and director Rex Ingram in 1921. After playing an Arab in *The Sheik* the same year, the one-time Italian immigrant became a superstar. Valentino was twenty-six; Rambova was twenty-four. Within months they were married, and it became obvious that Rambova intended to control Valentino, both

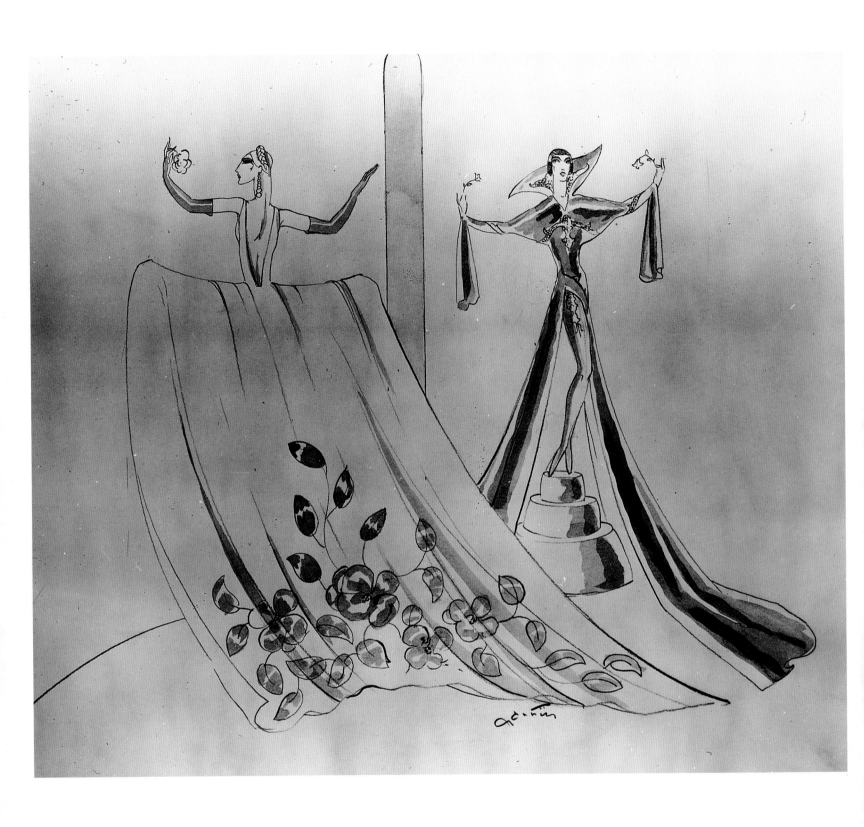

A costume sketch from *What Price Beauty?* and, opposite, the finished costume.

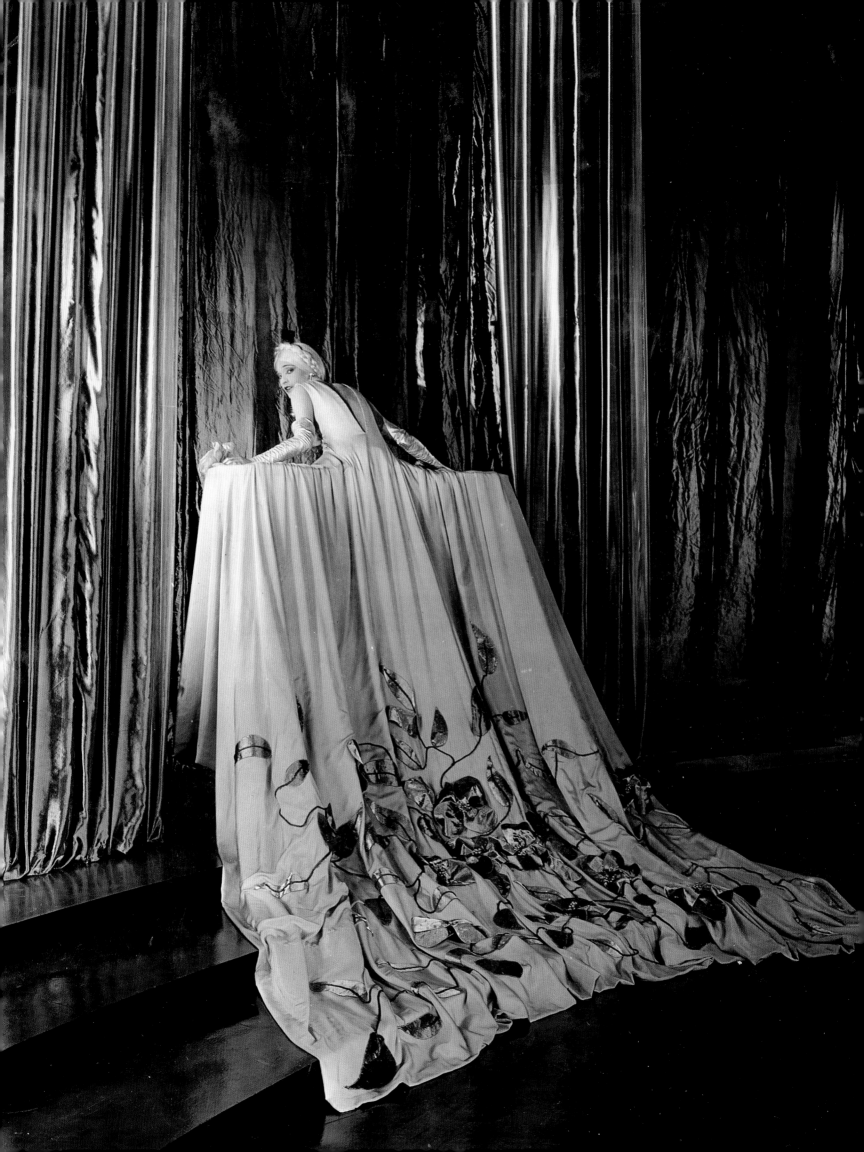

personally and professionally. By the fall of 1924, she had pulled him away from Paramount, which was underpaying him. Once the dust (and lawsuits) cleared, she began to choose Valentino's vehicles and design them. Still, she wanted to meet Adrian, so he brought his portfolio to the Ritz-Carlton Hotel.

"Natacha greeted me with her most enchanting smile," wrote Adrian. "She wore an Oriental robe, a turban, and curious jewels. I watched her move about the room. She was the essence of glamour, with a grace and worldly assurance that captured me. As I showed her drawing after drawing, we talked. She had a whip-like intelligence and gave me the feeling that she could almost look into my dreams. For the first time in my life, I felt that someone understood me."

Rambova asked Adrian if he could leave his theater work and come to California; she was producing a complicated project and wanted someone to take over her design work. Adrian was more than eager, but Rambova told him that she needed the approval of both her husband and an associate named Dorian Tree. Valentino soon arrived, accompanied by his manager George Ullman and a quiet, dark-haired woman. "This is Dorian," said Natacha. "We want you to sit with us after dinner, Gilbert, to see how Black Feather likes you."

Adrian had been curious to meet the celebrated Valentino. "He was shorter than I had expected, stockier, yet flashing his world-famous smile. Although he emanated some of the magnetic quality he showed on the screen, I saw that much of it derived from the costumes, accoutrements, and guidance that Natacha gave him." As Adrian pondered the illusion, he became so absorbed that he forgot to ask who Black Feather might be.

Dinner was served, and then Adrian was invited to sit in a circle with his hosts and the other guests. "Dorian receives messages and does automatic writing," explained Rambova. "She has been under the control of various people, including Oscar Wilde, Virginia Mathis, and an American Indian named Black Feather. We want to see what they think of you."

There was little that Adrian could say. "My heart sank," he

admitted. "Virginia Mathis, the mother of June, had been dead for two years, not to mention Wilde. I was prepared to let my work speak for itself, but, when I thought of my future being decided by people who were not in the room, I had a mental panic." As Tree took pencils and notepads out of a satchel and began writing, Adrian had no choice but to sit and watch. He absentmindedly ran his fingers through the plume-like tail of a nearby Pekingese. "I could hardly believe what I was doing," he recalled. "It seemed utter madness to be waiting to hear from spirits."

Finally Tree stopped writing. "Virginia has come through," she murmured. "She says you will go to California." Deadly serious, Rambova believed what she was hearing. Adrian was in.

Only later did Adrian realize that "Dorian" was the designer Dora McGeachy and had worked on the same Music Box show as he had. This could have signaled intrigue, but as Adrian seemed to lead a charmed life, it was just an amusing coincidence. Not so amusing were the reactions from Hassard Short, John Murray Anderson, and the other Broadway producers whom Adrian was leaving in the lurch; he somehow managed to finish his assignments and wriggle out of his contracts.

On November 24, 1924, Adrian stepped onto the platform at the Santa Fe station in Los Angeles. He was wearing a white linen suit, white spats, and an Oxford military cape. No one looked at him. How could they? The scene was chaotic. Rudy and Natacha were arriving. Two thousand fans were waiting along the tracks, crazed for a look at their idol, and he was something to behold. "Valentino was resplendent in a pale grey suit with silver bracelets clanking on his wrists," recalled Adrian. "Natacha wore a Persian jacket and turban, and their Pekingese were dropping to the ground like furry butterflies." As if to drive his fans even crazier, Valentino was sporting a goatee.

"It was November," wrote Adrian, "and here was the balmy sunshine. We had left the cold of the East. From the moment I stood under my first palm tree, I loved California. Mr. William Cameron Menzies, the new art director for the Valentinos, whisked us through

the streets of Los Angeles, past a conglomeration of good and bad architecture—Gothic houses, Turkish houses, and Roman villas. Finally I was left at the Hotel Christie. As I walked up Hollywood Boulevard that first night, the atmosphere was unlike any I had known. The air was warm and fragrant. People were lighthearted and friendly, almost flirtatious. I felt as though anything could happen. From my window I could see the roof of Grauman's Egyptian Theatre next door. An actor dressed as an Arab was slowly walking back and forth on it, carrying a rifle. This was Hollywood."

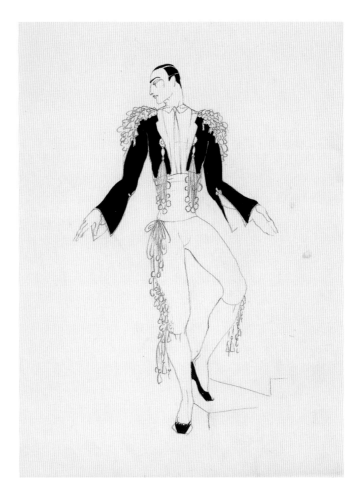

A costume drawing of Rudolph Valentino by Adrian, 1925.

The Valentino project was a version of the El Cid legend with the working title of *The Hooded Falcon*. After Rambova and Valentino shot tests of Adrian's designs for *The Hooded Falcon*, pre-production came to a halt. June Mathis had not completed the script; a project called *Cobra* would be done first. Whatever the project, Adrian was consumed with ideas. He was renting a house on Franklin Place, ten minutes from the Valentinos' home in Whitley Heights. "I would work into the night," wrote Adrian. "Then, in my eagerness and excitement, I would knock on the Valentinos' door—at two in the morning! Natacha would come to the door sleepy-eyed, but she would ask me in, and we would sit on the floor looking at drawings of Spaniards and Moors while her Pekingese dogs waddled over them, making asthmatic sounds."

In February 1925, while *Cobra* was shooting at the United Studios on Melrose Avenue, Adrian continued working on *The Hooded Falcon*, as Rambova cast the film and chose its crew, keying every element to its star. "Valentino was an extraordinary personage," wrote Adrian. "In costume and makeup, he was the Valentino of the screen.

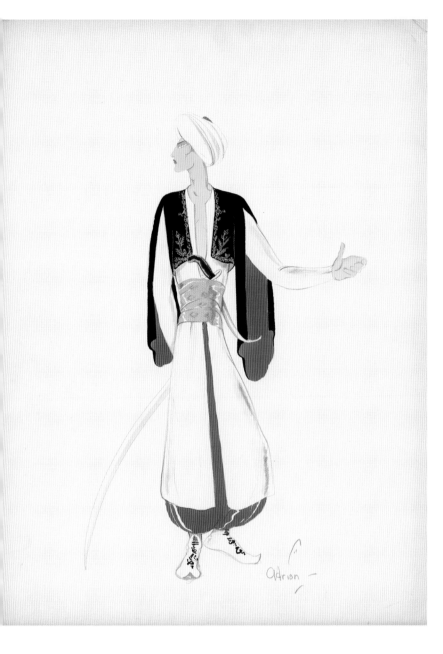

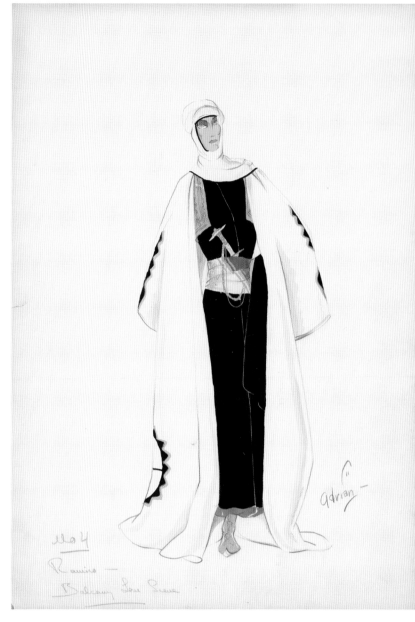

Two Adrian original costume sketches for *The Hooded Falcon.* Unfortunately, the film was never made.

He needed the props, the artifice, the make-believe. Without them, he was just a good-looking actor trying to live up to his reputation; he could be insecure, self-conscious, and just a bit pompous. Natacha was sensitive to this insecurity and kept him away from the curious, mocking world."

Working with the Valentinos for four months, Adrian learned a good deal about marriage and creative collaboration. "Rudy's devotion to Natacha was doglike, but she was kind to him. He would bring a suggestion for a scene. She would see its weakness and treat it with humor, as though he was teasing her with it and knew it wasn't very wise. Time and time again, I watched her play him out of the water like

a trout and then laughingly ease him away." When dealing with studio executives and business partners, Rambova was not so gentle. "She had a one-track mind," wrote Adrian, "but the only train on that track was Rudy. She pulled no punches in the conference room. She was a woman of definite opinions, a little too ruthless for those film bosses."

When the executive could not get around Rambova, they went after Valentino, using the whispering chorus. There were articles in the fan magazines and gossip at parties. "Rudy began hearing talk: 'Who is running you? Are you tied to your wife's apron strings? Who wears the pants?' His masculinity was being questioned." Then, in early March, the bottom dropped out.

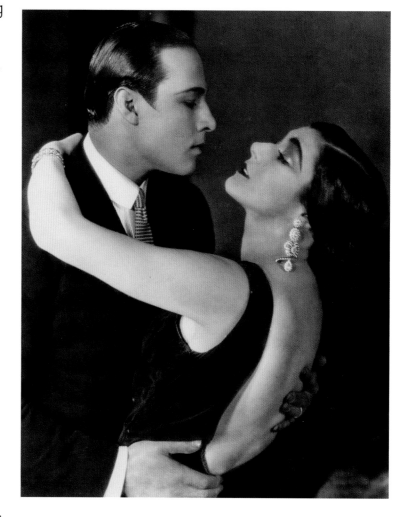

"We came to the studio one morning and found the doors locked," recalled Adrian. "There had been some trouble in the financing. Suddenly, very mysteriously, everything stopped." More than $100,000 had been spent on props from Europe, fantastic costumes, and a cast and crew who were idling while Rambova tried to get a script written. Not a foot of film had been shot, so J. D. Williams pulled the plug. "Mrs. Valentino Cause of Breakup with Williams," was the headline in *Variety*. "Wife's Interference Resented." As the couple tried to salvage their venture, Adrian saw their marriage crumble. "Rudy began to argue with Natacha about her judgment. He began to tell her off. He reminded her that he was master! The arguments grew worse. I saw bits of their happiness break off each day, until there was nothing left."

Valentino was still a hot property. In a week, Ullman came through with a promising new plan: United Artists could offer

Above: Rudolph Valentino and Nita Naldi from the film *Cobra*, 1925.

Opposite: Nita Naldi wearing Adrian's costume from the film *Cobra*, 1925.

Following pages: Design for a veiled headdress (left) and an original costume drawing for an exotic sheer veil and gown, both by Adrian for Nita Naldi.

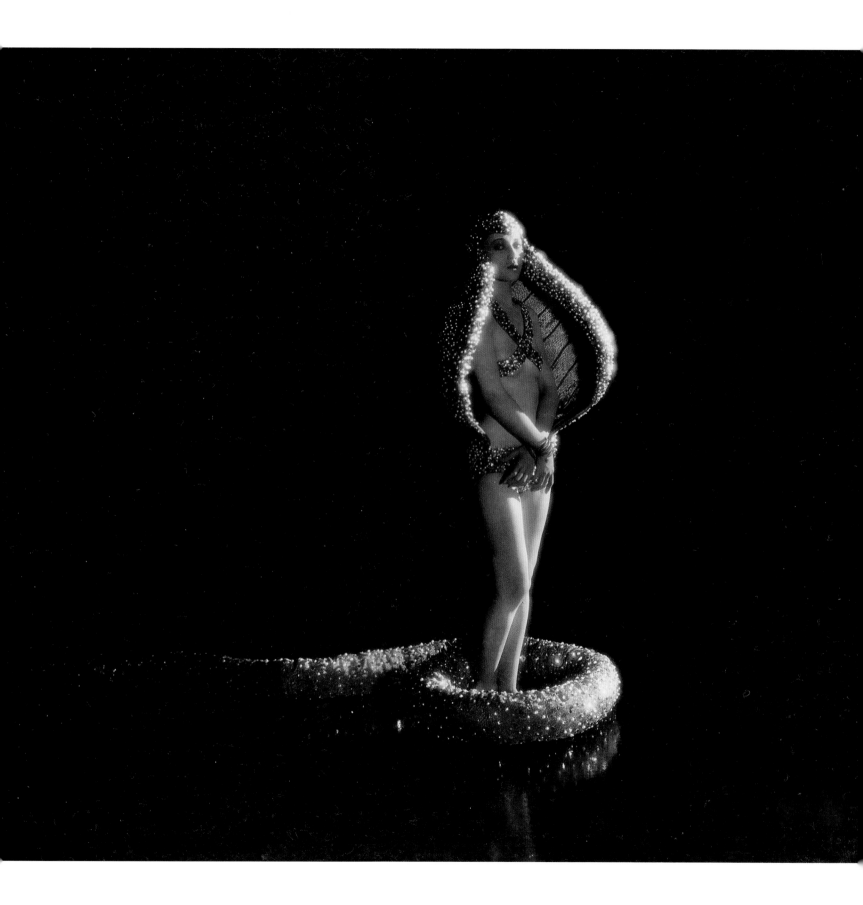

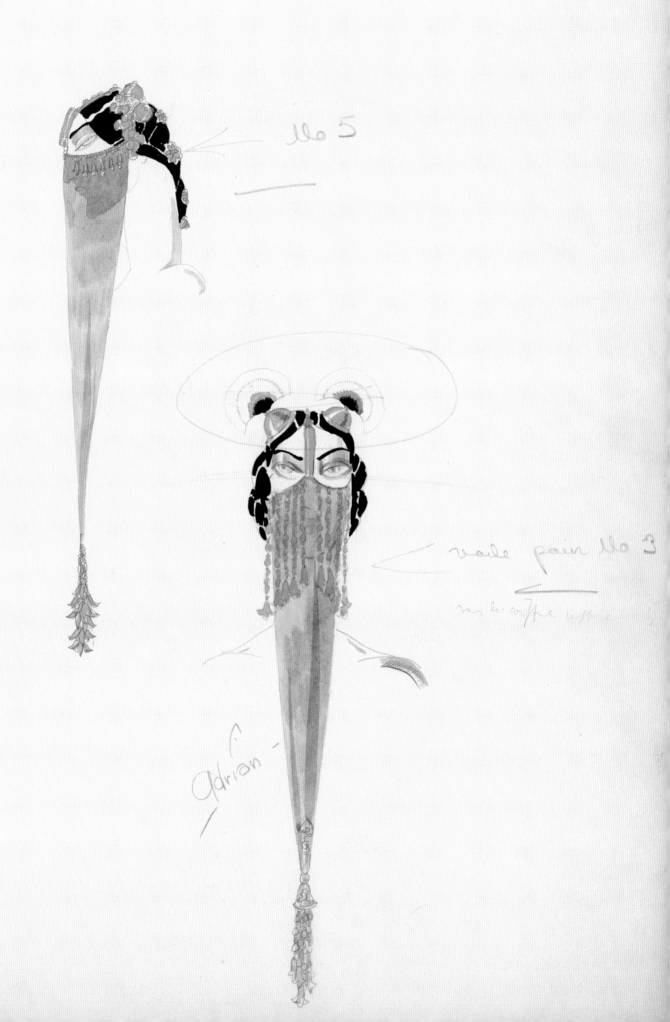

No 5

voile pain No 3

Adrian

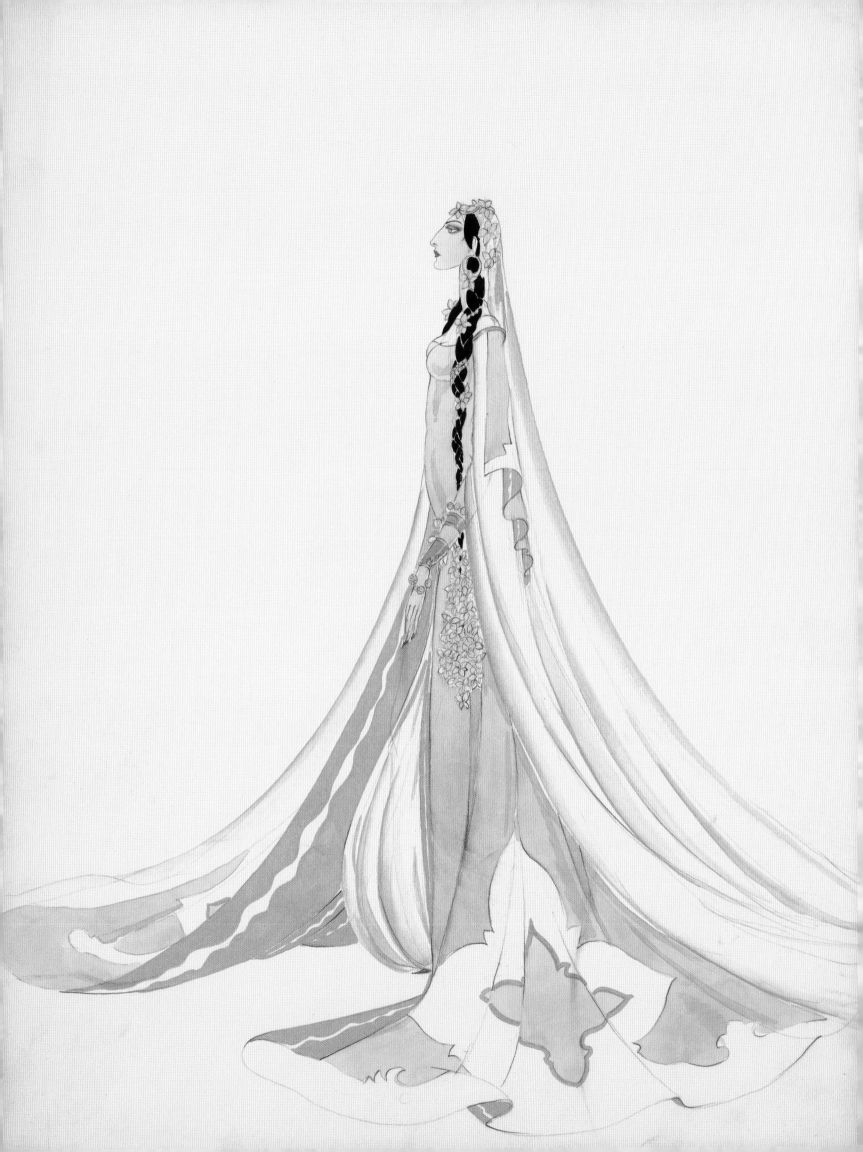

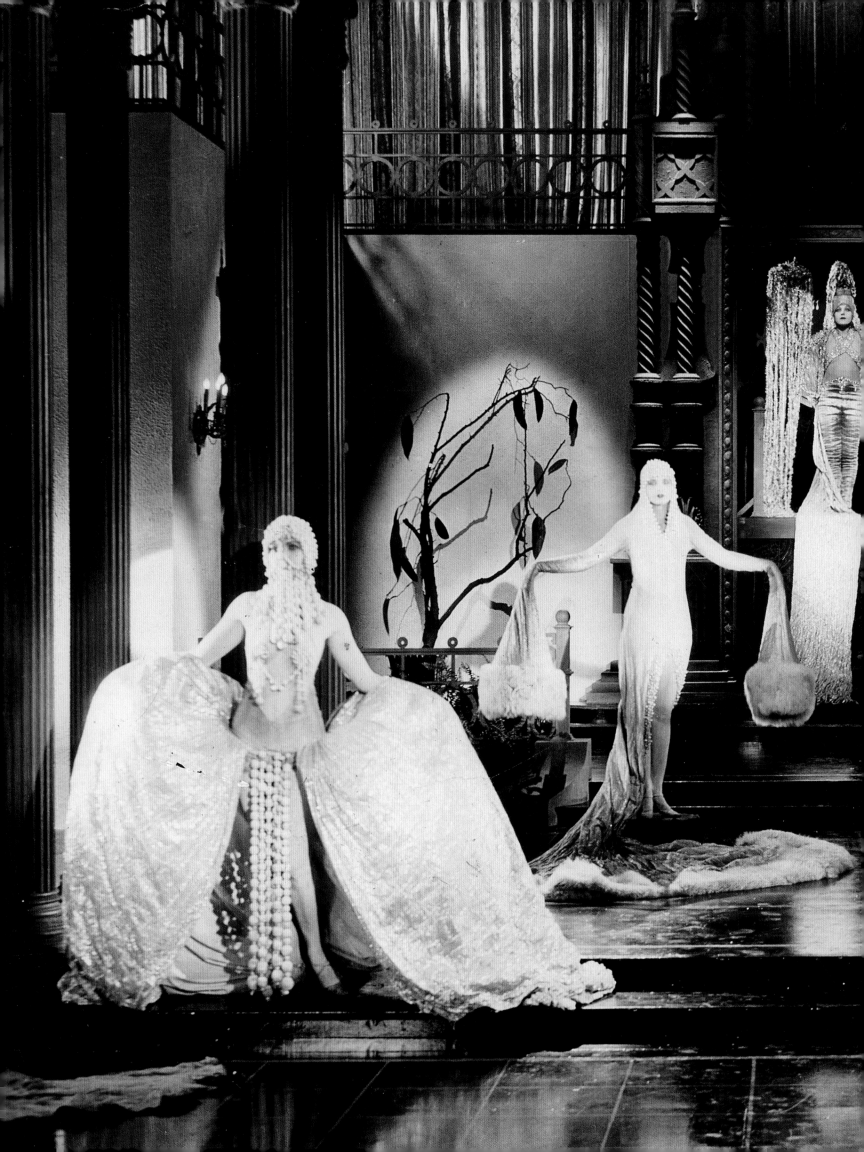

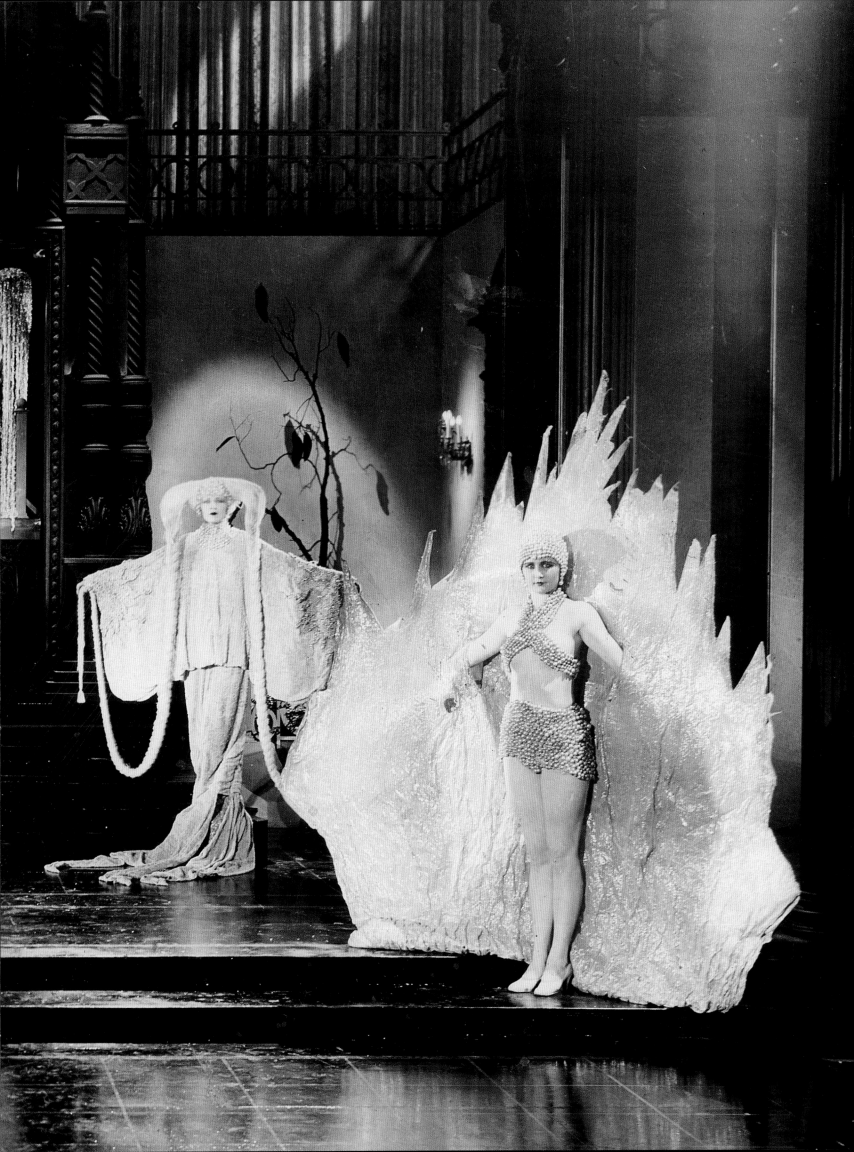

Valentino a fine contract, and an advance to pay off his debts to Williams. The only sticking point was "Mrs. Valentino." She would not be allowed to participate in any aspect of the production. Valentino was strapped for cash; he signed.

Where did this leave Adrian, whose dream job in Hollywood had ended so abruptly?

Ullman offered Rambova a contract to make her own film for Pathé, a satire on Hollywood called *What Price Beauty?* It was imperative that Adrian be the designer. Meanwhile, his services were required at United Artists, where Valentino was making a story of old Russia. And Adrian was also asked to design a Constance Talmadge vehicle called *Her Sister from Paris*.

In the midst of this activity, Adrian was approached by yet another celebrity. Sid Grauman was renowned for the prologues he staged at his theaters, the downtown Million-Dollar and the Hollywood Egyptian. He had secured the coveted world premiere of Charlie Chaplin's *The Gold Rush*, and he wanted to stage a prologue worthy of it. "Sid asked me to conceive costumes of ice and snow representing the 'Spirit of the North.'"

On June 26, 1925, Adrian sat in the same Egyptian Theatre where seven months earlier he had watched the Arab walk back and forth on the roof with his musket. The distinguished audience included stars such as Harold Lloyd, Gloria Swanson, Lillian Gish, John Barrymore, Douglas Fairbanks, and Mary Pickford. It also included directors John Ford and Raoul Walsh of the Fox Film Corporation; Cecil B. DeMille of Cinema Releasing Corporation; and Irving Thalberg of Metro-Goldwyn-Mayer, who was on his first date with a new star, Norma Shearer. "I sat watching the curtain rise on my work," wrote Adrian, "as showgirls in costumes of silver and diamonds filled the stage with a glittering snow fantasy. The next morning, I received offers from three companies: Fox, DeMille, and Metro."

Previous pages: Adrian designed this prologue for Sid Grauman's Egyptian Theatre premiere of Charlie Chaplin's *The Gold Rush*, 1925. The snow and ice costumes depicted the "Spirit of the North."

That June, Adrian considered several offers. They looked good. They offered the security the Valentinos could not. Adrian passed over Samuel Goldwyn, First National, Paramount, and William Fox. M-G-M was only a year old, and gaining on the other studios, but the designer Erte had been installed a month earlier as head of wardrobe, and Adrian had no desire to work with the temperamental Frenchman.

Cecil B. DeMille had started his own company in March, after his partners at Paramount had pushed him out. In 1914, DeMille, Goldwyn, and Jesse Lasky brought the feature-film industry to Hollywood. Then they helped Adolph Zukor make a major success of Paramount. But DeMille's grandness rankled Zukor. DeMille was starting over.

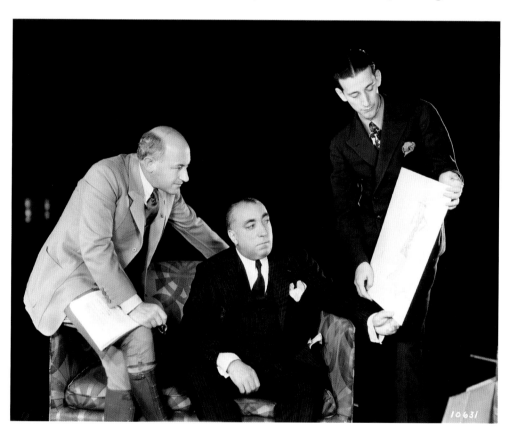

Photograph of Cecil B. DeMille, Paul Poiret, and Adrian discussing one of his costume sketches.

"I chose DeMille," wrote Adrian, "because he was famous for his pictorial extravagance." More than any filmmaker in America, DeMille favored texture, color, scope, and drama. Adrian wanted to translate flights of fancy into fabric. DeMille would allow him to do this. In mid-July Adrian signed with him. The timing was propitious. A month later, Natacha Rambova left Rudolph Valentino.

Adrian's new workplace in Culver City had some history. The studio was built on Washington Boulevard by Thomas Ince in 1919 and was used as his second studio. Ince used its colonial façade as a setting for his 1924 production *Barbara Frietchie*, and then, a month

after the film was released, he died. "The ten-acre lot was a small enclosure," wrote Adrian, "when compared to the M-G-M lot down the road, which was something like thirty acres. What distinguished DeMille's studio was the aura that permeated it, from the front offices, sitting primly in Mount Vernon splendor, to the little rundown cottage used for the research department. Everywhere I looked, people were digging up historical facts, erecting sets, or creating the trappings of the next DeMille feature." DeMille's business plan was to make two big films a year.

To say that the DeMille employees observed special protocol would be an understatement. His studio was an environment unlike any other in Hollywood. Working for the Valentinos had been like working for a mom-and-pop establishment in which Pop was a panther and Mom was the trainer. Working for DeMille was like entering the court of an oriental potentate. Cecil B. DeMille lived like one—and worked like one. As Adrian wrote:

> Each DeMille production commenced in his office with a formal reading of the script. As his cast and technicians sat waiting for him to arrive, it was rather like being in church. There was a tall stained-glass window behind his massive desk. When at last he entered, he sat down, cleared his throat, and looked at us as a professor regards a class. He would not start until there was absolute silence. Then he began to describe the characters and to read the story. He could make a moment of pure corn sound like the most brilliant bit of literature. Situations so outrageous that one could barely believe one's ears were deftly understated. Finally, with his vital, forceful personality, he built toward a series of climaxes.

Thus prepared, DeMille's artists returned to their workrooms, making their respective contributions to DeMille's grand design.

Adrian would occasionally bring his costumes to DeMille, often on the star herself. DeMille's executive assistant, Gladys Rosson, would

see if he could be interrupted and then usher Adrian and the actress into the office. Adrian would have the actress walk and turn in front of DeMille's desk as he leaned back in his chair. "Do you think you can manage that train as you hurl yourself before the door in the last scene?" DeMille asked the actress. After she demonstrated the move, DeMille would turn to Adrian and hum, "Lovely, very lovely."

On one occasion, DeMille reviewed costumes on the set where they were to be worn. *The Volga Boatman* included a sequence with Russian women attending a court ball. "Mr. DeMille sat in the center of the ballroom," recalled Adrian. "He showed the eagerness of a young boy awaiting the elephants at his first circus. One by one, the ladies paraded before him. One woman wore a great bouffant skirt of leopard skin, and another had a train of colobus monkey fur. These costumes, outrageously imagined, having no relation to fashion, delighted him. He loved materials of exotic texture. Nothing was too extravagant to put on a beautiful woman."

DeMille's regard for luxury was not limited to the creation of a film. Adrian was sent to New York with $5,000, which was twice the average citizen's yearly income in 1925. He was instructed to purchase fabrics, jewels, and curios, not only for use in films but also for DeMille's treasure chest. "In this chest," wrote Adrian, "were extravagances that had come to him from every land. Fans, jewelry, trinkets. Rare perfumes. A Persian dagger. An East Indian scarf of pure gold. The workmanship of the metal discs on a shawl, slipping through his fingers like snakeskin, gave him sensuous pleasure. His was a world of antiquity, one from which he rarely emerged. He believed in this world, and his dedication to it.

There was also DeMille's personality, his presence. To work for him was to acknowledge his superiority and to become a channel for his creativity. "Mr. DeMille had a power, almost superhuman, of instilling strength," recalled Adrian. "He was the father of positive thinking. He had a way of making everything he said sound important. We became his worker bees. Nothing could keep us from creating a magnificent DeMille picture. Settings were created as if God himself had

commanded them. Costumes came into being, torn from the imagination. Yes, 'C.B.' could be a slave-driver, but he got a picture that was stamped with his personality and dazzling with showmanship."

This showmanship was not limited to films; DeMille's personal life was conducted with a flair, too. Set in a box canyon in Tujunga, California, about thirty miles from Hollywood, was DeMille's private ranch, which he called Paradise. His entertainments there were as carefully planned and executed as his films. Mitchell Leisen, DeMille's art director, spent weeks preparing the festivities. Adrian attended a number of them.

On Christmas Eve, twelve or fifteen people sat down to dinner at an Arabian Nights table. The men wore vermilion Russian blouses and evening trousers especially made for the night. (These had been given to them upon their arrival at the ranch.) The women wore evening gowns. The table was spread with exquisite china and crystal, rich foods flown from distant parts of the world, with pheasants in full feather, and caviar in three-foot wells of ice lit by hidden electric lights. There was a finale; in the suddenly darkened room appeared a great ice sculpture of birds glowing with indirect light.

After dinner, a table was wheeled in. On it lay Christmas gifts, not wrapped, but draped. There were fur pieces, silk scarves, perfume, jewels, gold embroidered shoes from India, cufflinks, and watches. Foot-high black satin dice were brought in. Each lady would roll the dice, and the highest number would choose from the table first. Then came delighted gasps as they gazed upon their winnings. Next the men would toss the dice.

DeMille enjoyed the pleasure of his guests. He smiled with the benign expression of a rajah humoring a harem. I had never seen such opulence. To me it was history being relived. I was beginning to see that the stories about Hollywood were true.

Back at the studio, Adrian cut loose with exotic designs for *The Volga Boatman* and *The King of Kings*. Then came an assignment that flummoxed him: costumes for a lower-middle-class family. Adrian

had never designed workaday garments. His experience had been in the showy and exotic. The mundane was foreign to him; or at least invisible. On hearing this assignment, he stared in disbelief at the wardrobe mistress. "But, Mrs. Duncan," said Adrian, "I can't do these clothes. I've never noticed what women wear when they cook."

"Now, Gilbert," said Mrs. Duncan, "You have more talent than anyone I've ever known. You sit down and design these dresses. You can't turn tail over this. You've got a head on your shoulders. Make it work."

Adrian had sufficient self-knowledge to admit the truth. "I had lived in a world of fantasy," he recalled. "To control my imagination, to come down to earth and design housedresses seemed a waste of my talent. Never was anything more boring or difficult. I did not realize that meeting this challenge would be the foundation of a new career. I would learn to design modern clothes and ultimately have a career in fashion."

Adrian met this challenge. He met the challenge of working for a taskmaster. There were no appreciable incidents as the young artist designed costumes for two dozen DeMille films. A year turned into two years.

Adrian's third year at DeMille's studio saw Hollywood shudder and then adjust to its own challenge: talking pictures. DeMille made *The Godless Girl* as a silent. The film flopped, a rarity for the master. DeMille faced another trial. "I did not have enough 'picture money,'" he wrote, "to be completely independent, to make only the pictures I wanted to make. My directing was suffering, both from restrictive outside control and from my being head of a studio." DeMille decided to take his chances as an independent producer at Metro-Goldwyn-Mayer. He would take Adrian with him. Adrian hoped it would be a friendly place.

Top: Adrian and Kay Johnson holding his sketch for the dramatic and daring costume that she wore in *Madam Satan*, 1930.

Bottom: Two photographs from *Madam Satan* showing the cape and dress worn by Kay Johnson. The ensemble became one of Adrian's most memorable designs, which became part of Cecil B. DeMille's personal collection.

Opposite: Adrian's costume sketch for Kay Johnson in *Madam Satan*, 1930.

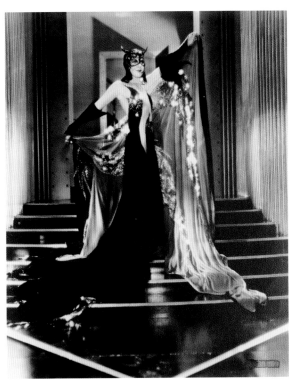

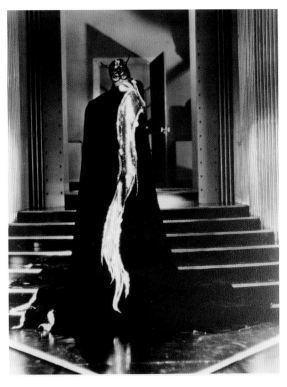

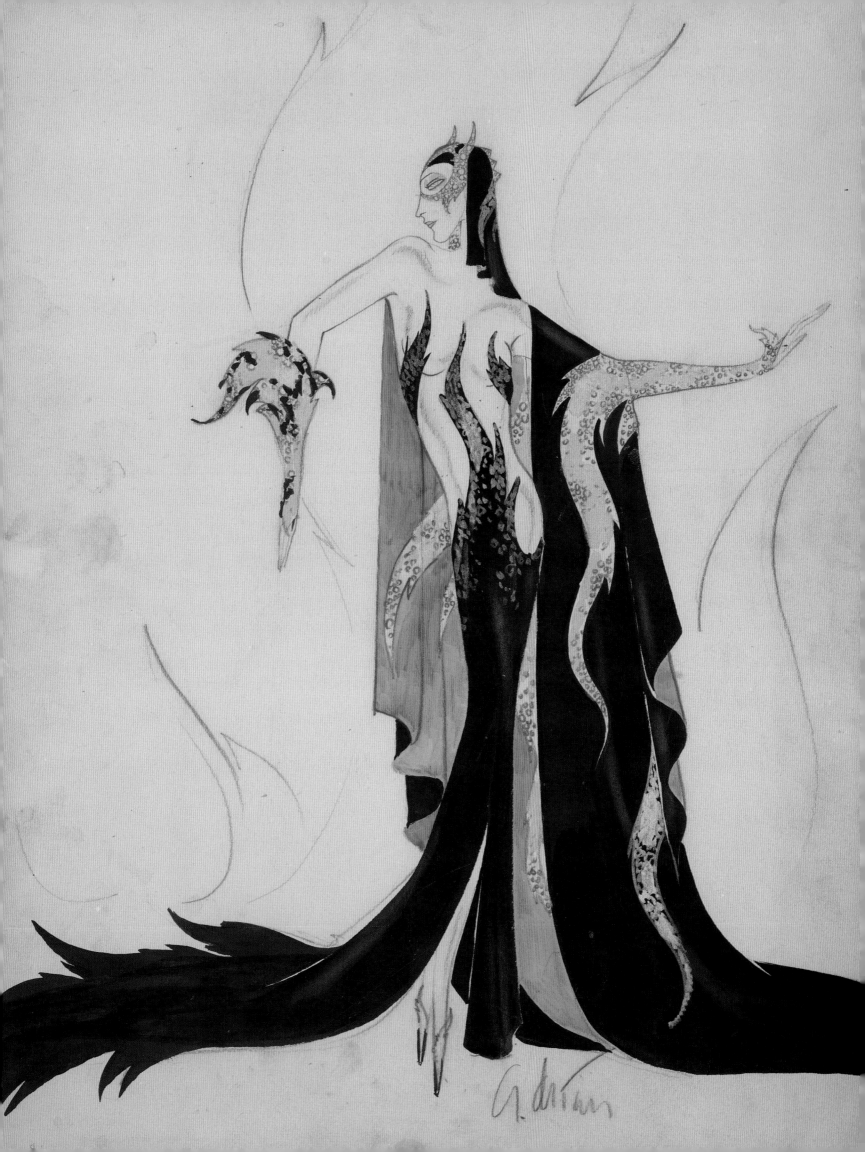

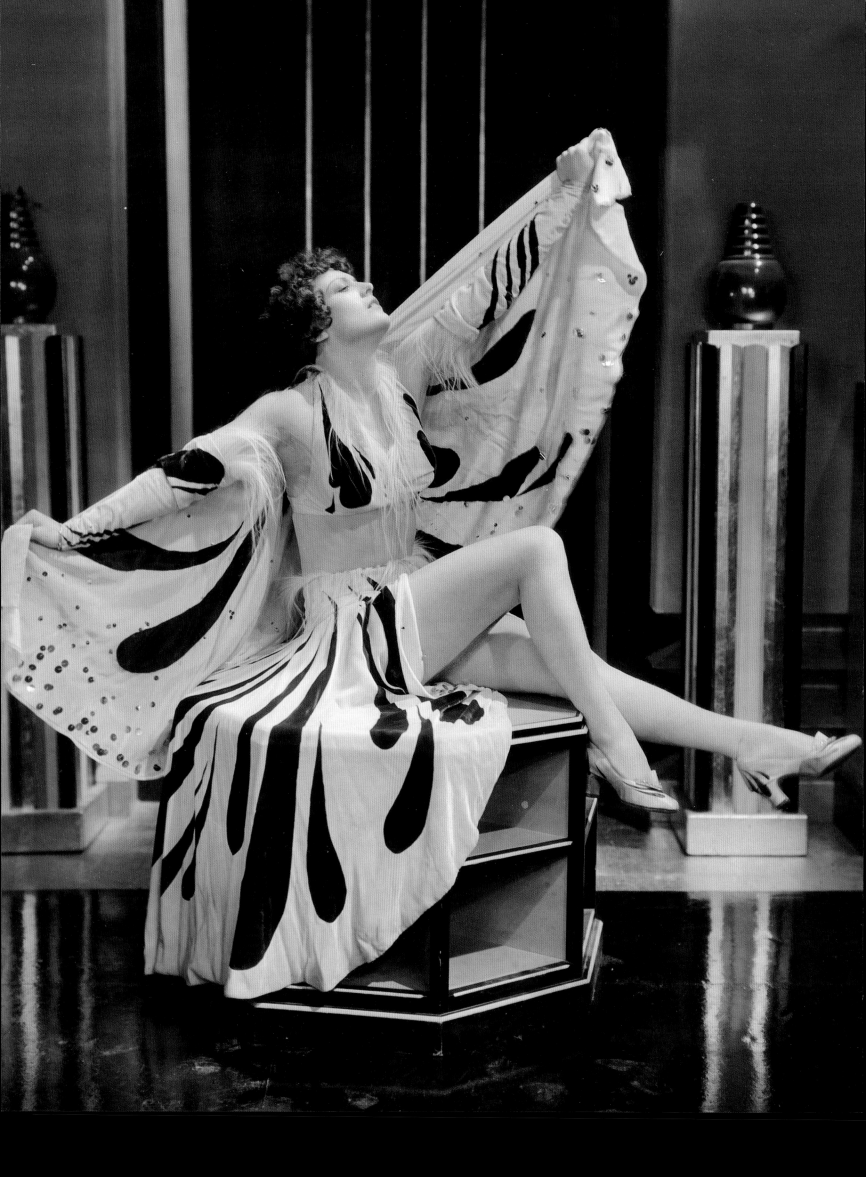

METRO-GOLDWYN-MAYER

Adrian had the good fortune to be working at Metro-Goldwyn-Mayer when it was eminently successful. He had started when the Great Depression caused some studios to go into receivership. M-G-M was showing a profit, and Adrian could spend as much money as he thought necessary. "I worked with people who did not hold tightly to the purse strings," wrote Adrian. "I never had to make pennies count. This was unusual, even in Hollywood. I had complete creative freedom. I went after perfection, especially in detail, since I had to satisfy the discerning eye of the camera, which magnifies everything eight times."

As Adrian was aware, stardom also magnified personalities. This was another element he had to consider. "During my first years at Metro," he wrote, "I found that meeting with a star was like conducting a session in psychoanalysis. In order to create my designs for an actress, I had to see the direction of her drive. I studied her, deciding how I would fire her imagination, and knowing that I could only do it from the plateau of her own comprehension. To watch the unfurling of each woman's emotions was part of my job."

M-G-M had incorporated in 1924. They immediately began grooming stars, which were the currency of Hollywood. Within a few years, Norma Shearer, Greta Garbo, and Joan Crawford were the studio's major actresses. With his keen eye and vivid imagination, Adrian created the iconic screen images of these three stars.

When the script for a Shearer film was delivered to Adrian's studio in the wardrobe building, it was a momentous occasion. Shearer was a major star, usually in the Top Ten Box Office poll each year, the most versatile of the studio's actresses. She was also married to the vice president in charge of production. "As Mrs. Irving Thalberg, Norma was the reigning queen of the studio," recalled Adrian, "although she tried not to show it. She used her position with assurance and usually with grace. I found Norma attractive as a person. Her face had a classic beauty."

Previous page: Joan Crawford studio portrait by Ruth Harriet Louise. Dress by Adrian for *Our Modern Maidens*, 1929.

Opposite: Adrian presents his "Butterfly Gown" to two studio executives for actress Aileen Pringle, for the film *A Single Man*, 1929. At the time, the dress was the most expensive ever created at the studio. Aileen Pringle later purchased the dress for her personal wardrobe.

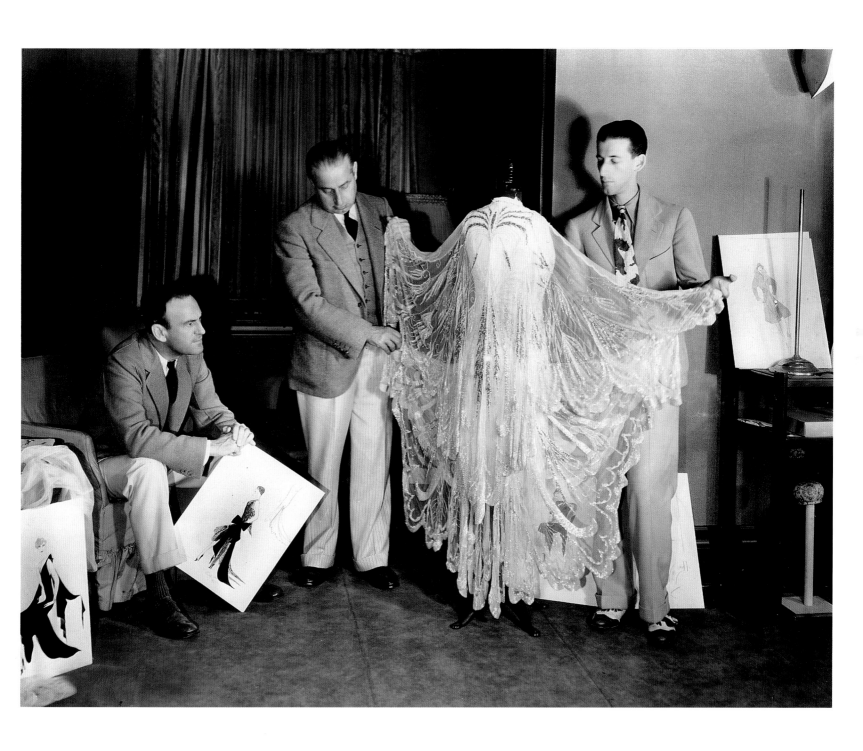

61

Adrian would usually be sent a second script, the "costume script," in which the scenario was broken down into costume changes, with descriptions of action and other aspects that would influence the design. After digesting the material, he made pencil sketches of ideas. "This was only a silhouette, the 'body line,'" said Adrian. "Then I drew the details—neckline, sleeves, trimmings—adapting them to the costume as a whole. Once I did several sketches for each costume, it was time for a costume conference."

Adrian's studio was designed for maximum efficiency. The conferences took place in an office area, where the large sketch boards could be comfortably reviewed. Some stars, including Crawford, would sit on the rug and spread out the sketches. After hearing the star's ideas, Adrian would have each gown made up in plain, unbleached muslin, complete in every detail. Then it was time for the first fitting.

"My studio was designed in light tones of beige and brown so as not to overshadow the costume," wrote Adrian. "The windows were shuttered in white, with beige glazed chintz curtains, to create a neutral background. A studio lamp flooded the figure with a directional light, and as the star moved in front of full-length mirrors that lined one wall, we could see the effect of light and shadow that the camera would capture." The pattern was then fitted and adjusted, implementing changes to a neckline, a sleeve, or even a train.

Once these changes were approved by the star, the original was cut in the fabric and color that was planned for the screen. At a certain point, to save time and energy, the wardrobe department constructed dummy figures of each star. "These were padded to exact measurements," recalled Adrian. "Of course, those dimensions were changed to correspond to any deviation of inches in the star's body. Sometimes they would change as often as once a month. If the star was unavailable, the later fittings were done on these models." These fittings would include accessories so that the full effect could be judged. Sometimes the star would come to the studio for these sessions. The most important fitting, though, was the first.

Opposite: Three early M-G-M costume sketches by Adrian.

Following pages, left to right: Photograph of Myrna Loy in costume for the film *The Mask of Fu Manchu*, 1932. Photograph of Jean Harlow from *Dinner at Eight*. The film was made in 1933 and released in January 1934.

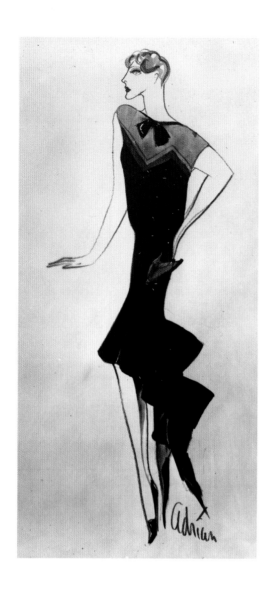

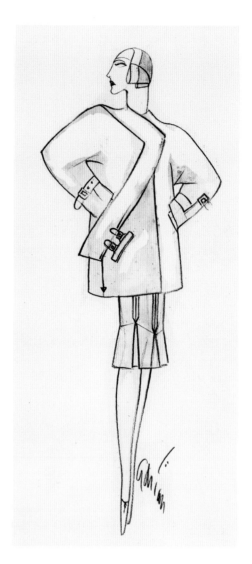

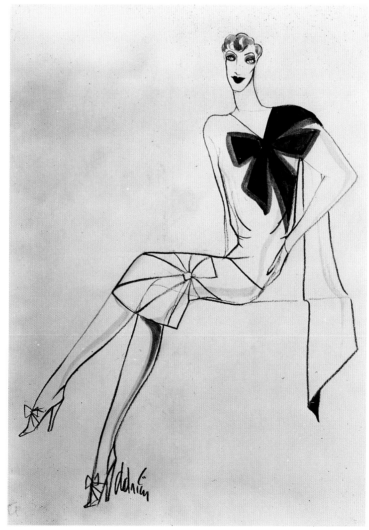

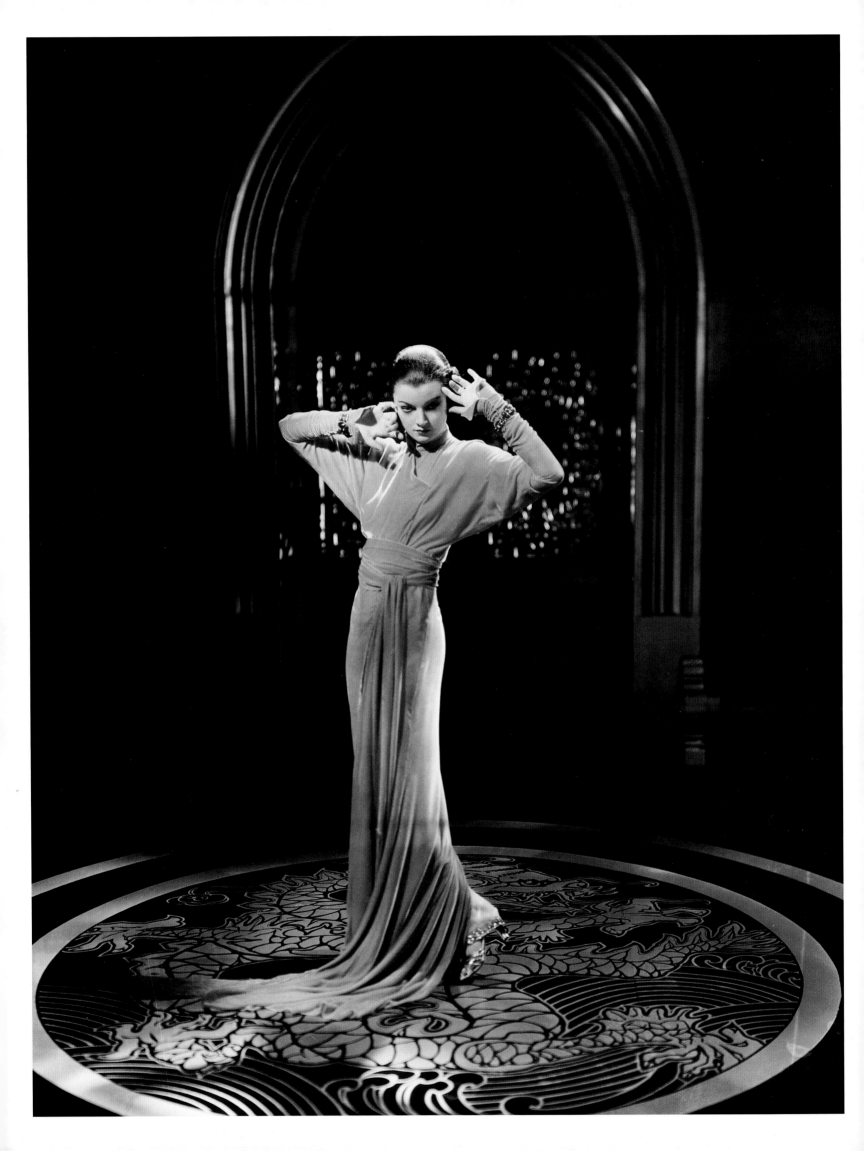

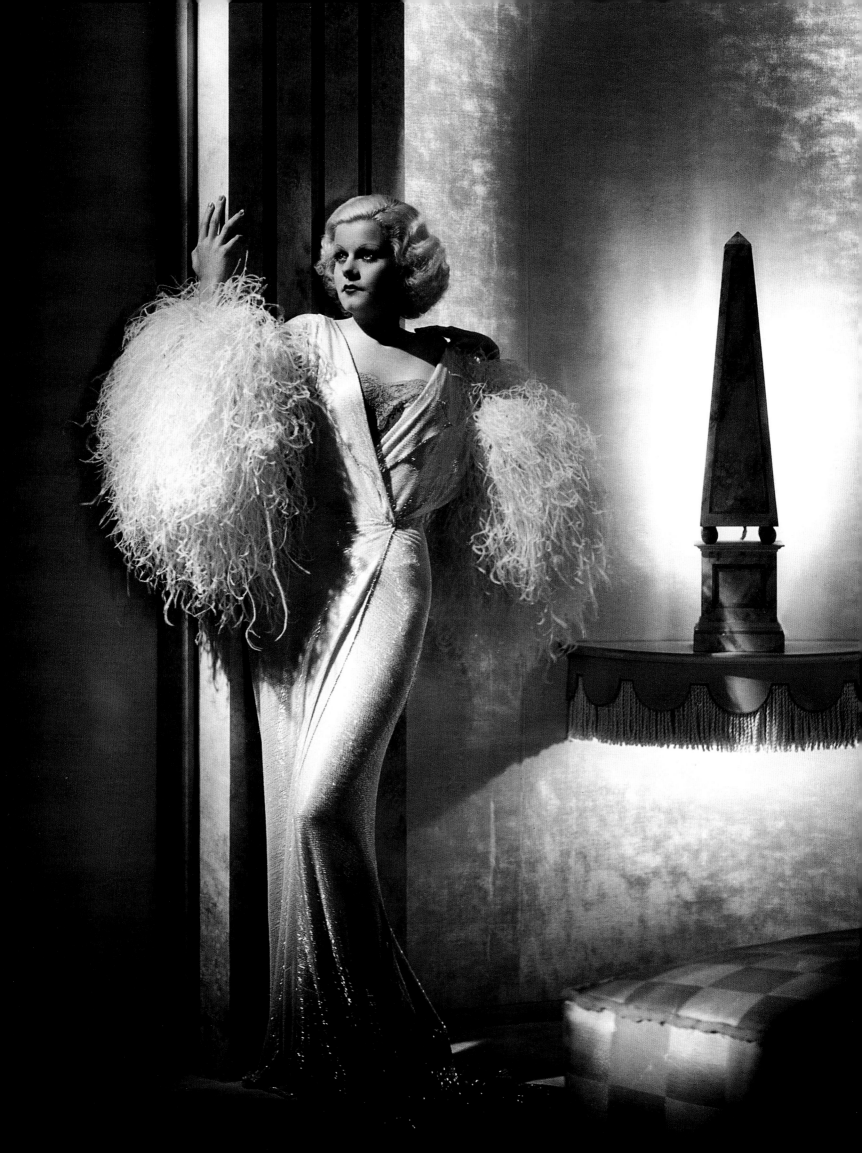

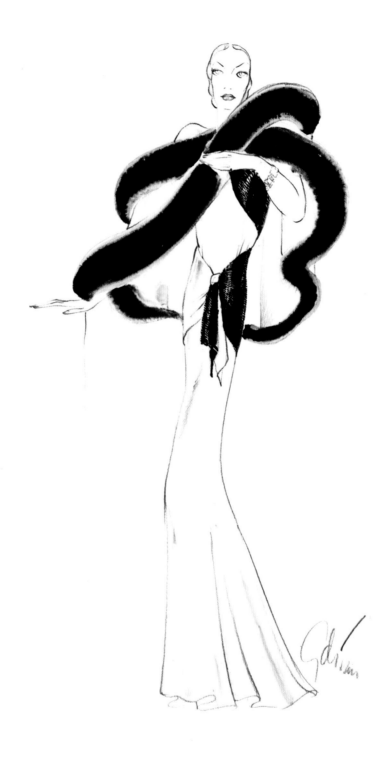

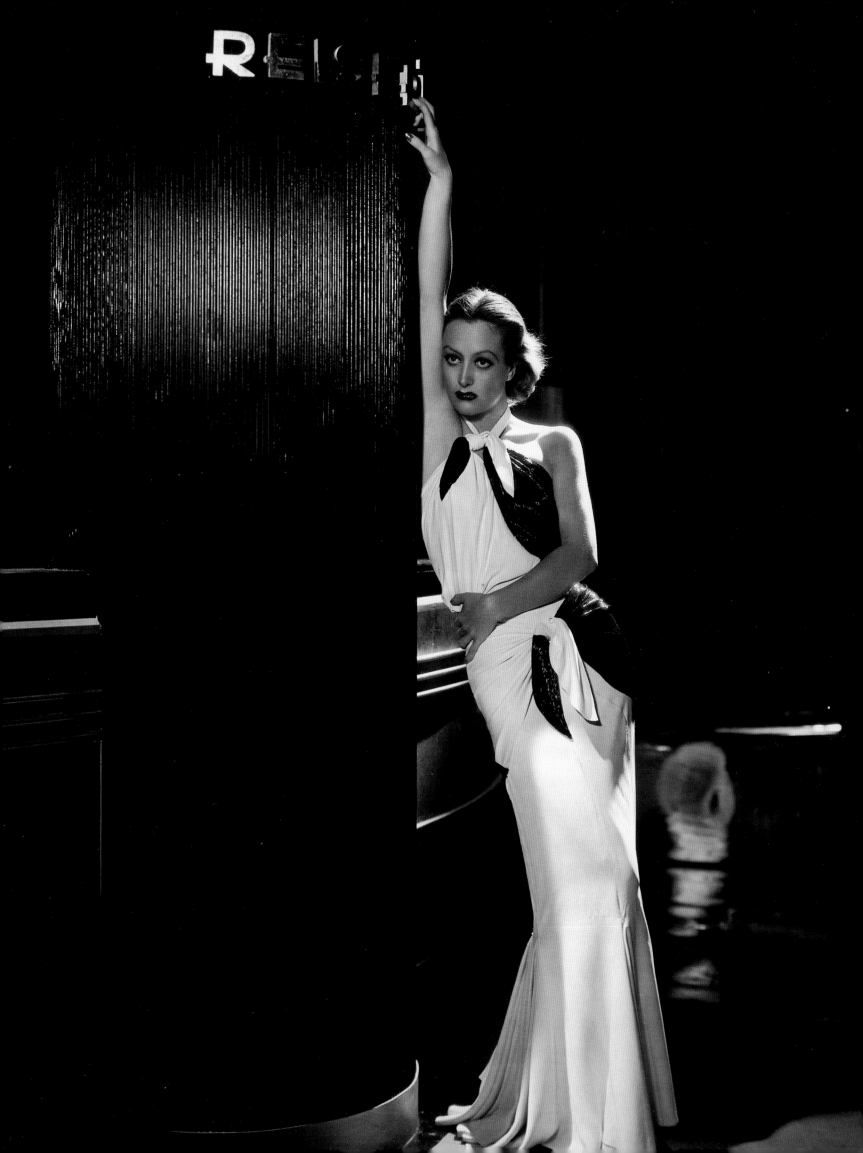

"First fittings were always experimental," wrote Adrian. "This was my serious work time, and I found it difficult to concentrate if visitors were present." There was also the issue that his designs for stars like Joan Crawford were highly anticipated. "Joan Crawford was an enormous fashion influence. She carried the banner of American fashion throughout the world. I did not design subtle fashions for her. Because her beauty had a poster-like quality, bold and clean-cut, I painted her image with a contrasting brush. I enjoyed creating her clothes and was vitally interested in them."

Adrian's designs for Joan Crawford's 1932 film *Letty Lynton* created a sensation in the fashion world. The white organdy gown that Crawford wore in a Christmas party scene on board an ocean liner was not merely talked about for its startlingly large sleeves and flared skirt, but also for its extraordinary popularity: the gown was copied by the Macy's Cinema Shop, where it sold tens of thousands of units. Adrian received wide critical acclaim for his brilliant design, and the gown would later become known as one of the most famous gowns ever designed for the silver screen.

I did not ever feel close to Joan Crawford, even during those confidential moments at fittings when women allow their thoughts to flow freely. I felt the fitting should be private. I would ask her not to bring friends. She invariably arrived at these first fittings with a producer, a hairdresser, a fan magazine writer, and a dear friend, singly or in a group. It was like doing a fashion fitting in Grand Central Station.

The first thing Joan would do would be to whirl her arms about like windmills, ripping seams and bursting armholes until the poor tailor would look at his ruined work in despair. "Can't move!" she would say, her mouth squared with determination. Just why she needed so much room only she knew. Her gyrations were suitable for a gymnasium.

Previous pages: Adrian's sketch of Joan Crawford's evening dress and black fox fur wrap for *Letty Lynton*, 1932. Photograph of Joan Crawford wearing Adrian's dramatic white silk crepe evening gown with black bugle-beaded accents.

Following pages: Joan Crawford in the iconic *Letty Lynton* organdy evening dress. A glamorous studio photograph of Joan Crawford swathed in furs for the same film.

The collaboration between Adrian and Crawford may not have been painless, but it yielded extraordinary costumes.

Norma Shearer's films gave Adrian the opportunity to create fantastical costumes that were verified by history. In 1936 Thalberg mounted an immense, painstakingly researched production of *Romeo and Juliet*. "The conventional sort of stories came along regularly," wrote Adrian. "Only occasionally did the challenging and really serious opportunity come, a project which would call upon one's fullest creative ability. This picture was one of those rare opportunities. I regarded it as an enriching experience and one of the few that could bring forth inspiration." Adrian's costumes were indeed inspired, helping to make Thalberg's *Romeo and Juliet* one of the most exquisitely designed black-and-white films in Hollywood history.

Marie Antoinette went into pre-production in June 1937, as Adrian sailed for Europe. He visited Schönbrunn Palace and perused original letters written by the young queen to her mother, Empress Maria Theresa. Then Adrian went to Paris where, among other things, he studied the portraits of Marie Antoinette painted by Élisabeth Vigée Le Brun.

> I wished to absorb as much of the atmosphere of Marie Antoinette as possible, and to saturate myself with her century. For me, it is important to assimilate a period to such a degree that I can imagine myself creating in that period. After absorbing the manners, the eccentricities, and even the thinking of the time, I let myself go, and I begin my sketches.
>
> When I designed the court costumes for *Marie Antoinette*, I had no assistant designers. I created every detail of embroidery, shoe, and wig. In this process, I came to feel so completely a part of the court of Versailles that all I needed was a powdered wig for myself.
>
> During the making of *Marie Antoinette*, I found Norma agreeable and extremely conscientious, but her fittings were endless. She would arrive full of sweetness and charm, carrying

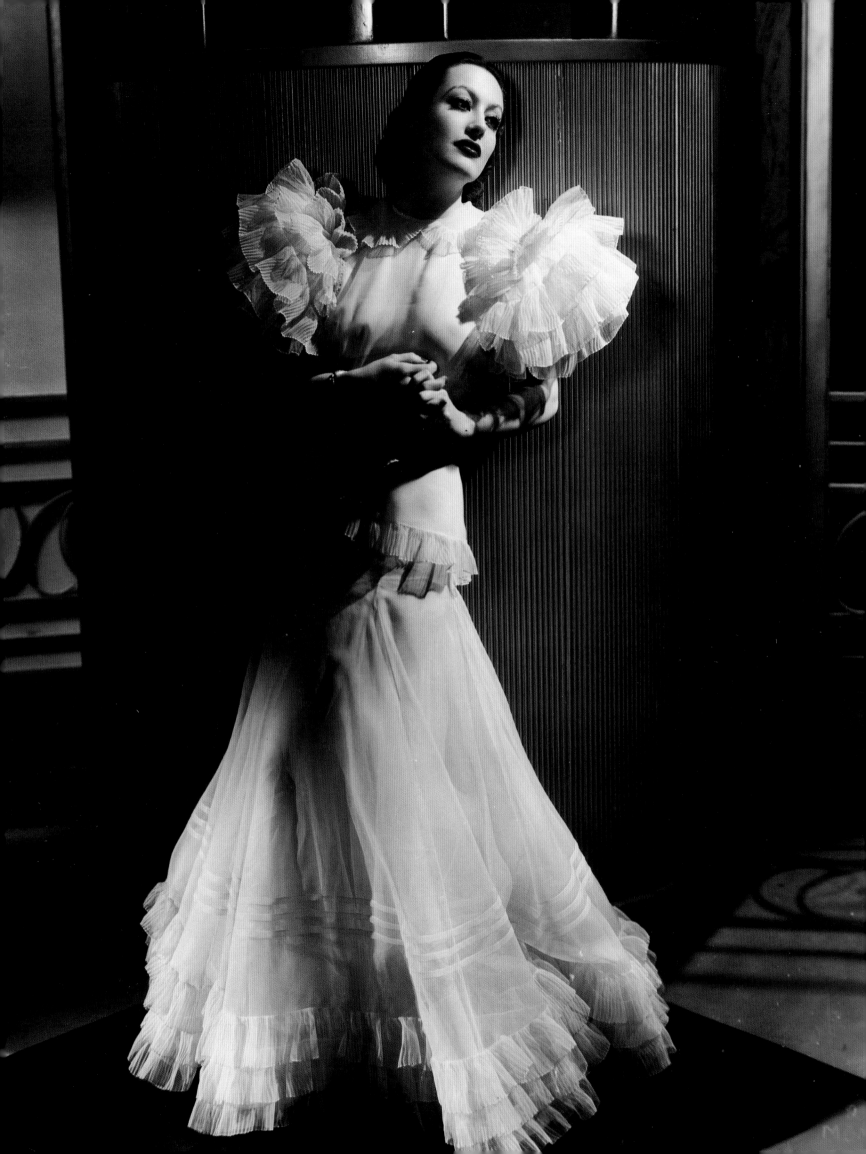

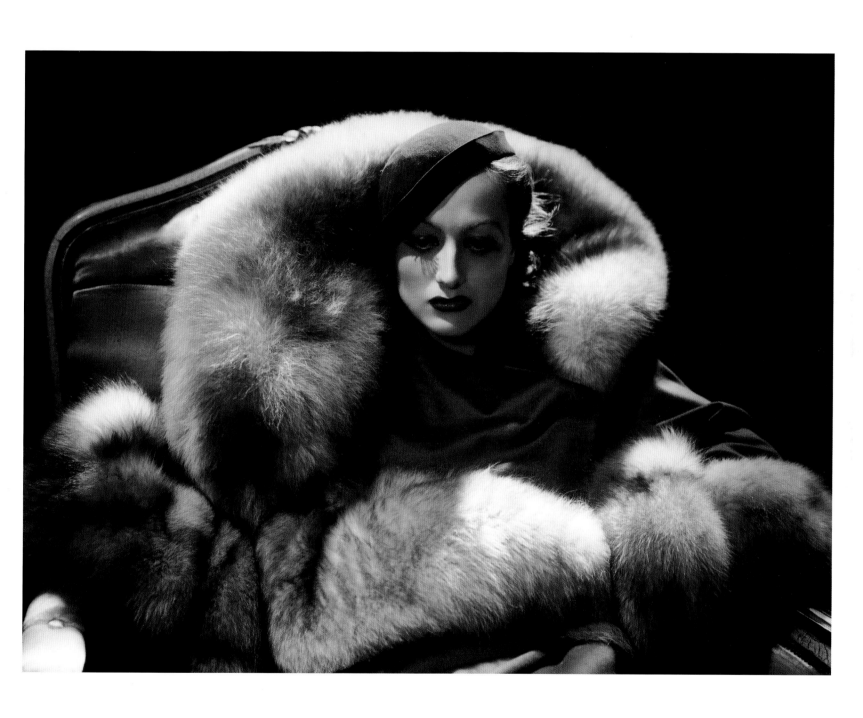

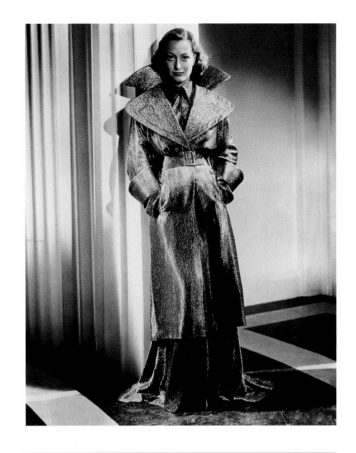

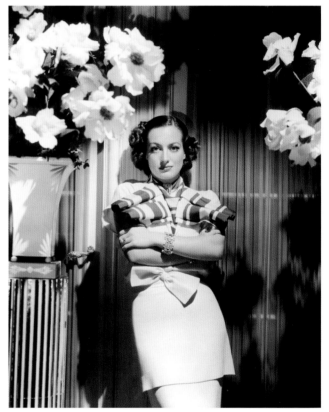

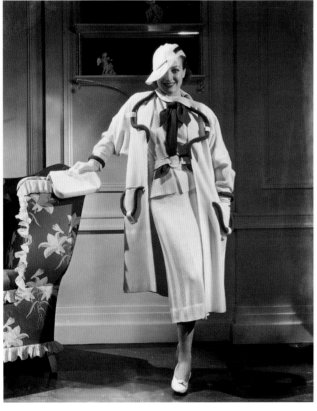

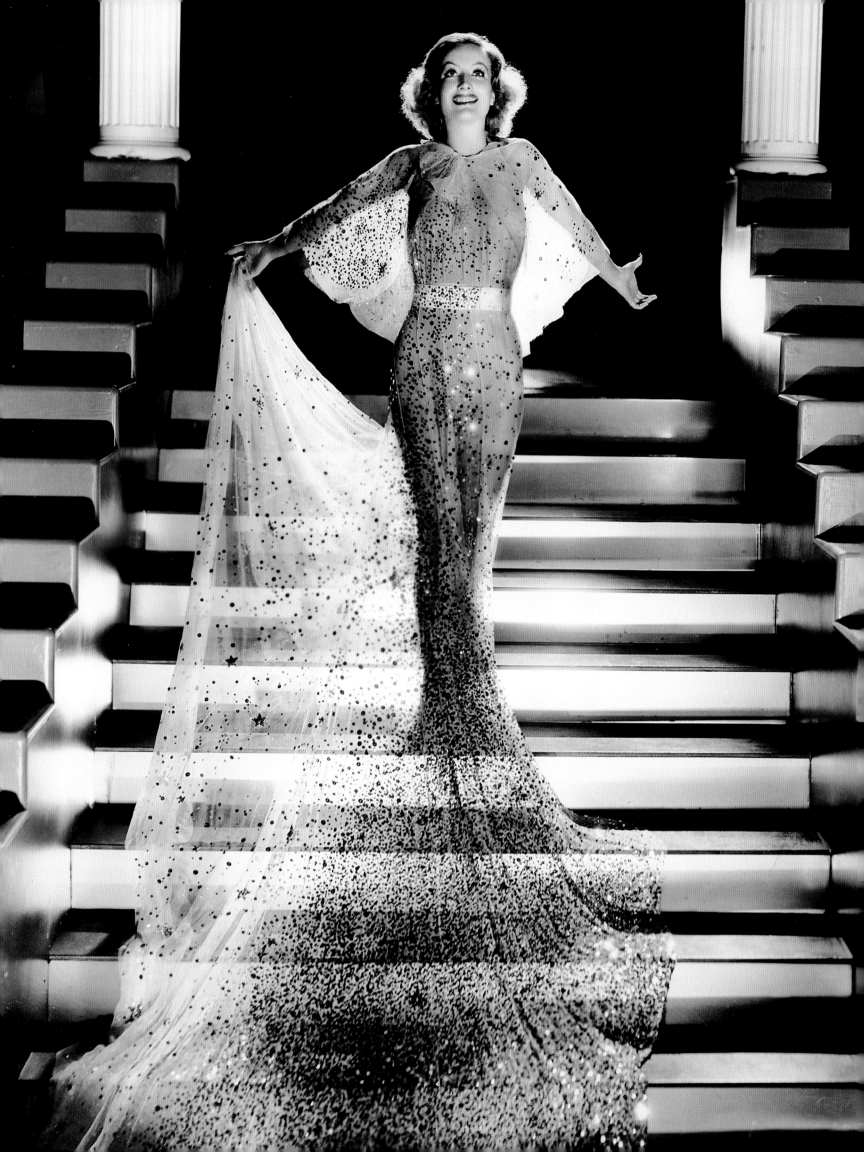

a package of yeast; this she enjoyed taking for her health. Hours would pass. The fitter would be wilting. And Norma would slowly be pulling out one pin after the other, deliberately, patiently, and with great interest, saying quietly, "Let's put the sleeve in again." Working those long hours with her was like watching a mechanical figure that slowly, surely marches on—and no one can find the button to turn it off! Norma looked ravishing in the picture, and our patience paid off.

Adrian's monumental achievement in designing the thirty-four magnificent gowns he created for Shearer to wear in her portrayal of Marie Antoinette would become a milestone in film history, but it would only be recognized by future generations.

Adrian took great pride in the work he did on *Marie Antoinette*. He felt that at least some of the costumes should be preserved, but even before he left M-G-M in 1941, the meticulously created garments were being used in films of lesser importance. "I saw the exquisitely crafted gowns being worn by extras who were trailing them all over the studio lots for fancy dress scenes in other movies. Before long, my gowns would be returned to the wardrobe department as tattered memories of their former grandeur." But, just as the film would one day be honored, many of the costumes did survive haphazard treatment and storage, finding refuge in museums and fashion collections.

Previous pages, left to right: Three M-G-M fashion shots of Joan Crawford. The actress on a staircase from the film *Dancing Lady*, 1933, wearing a sheer gown and train adorned in an array of shimmering sequins.

Opposite: In 1933, Mary Pickford asked Louis B. Mayer, as a favor, to have Adrian design her costumes for her last movie, *Secrets*. The dress was made of the palest blue silk tulle and lace, and was one of her favorites.

Following pages: Five images of showgirls from the film *The Great Ziegfeld*, 1936.

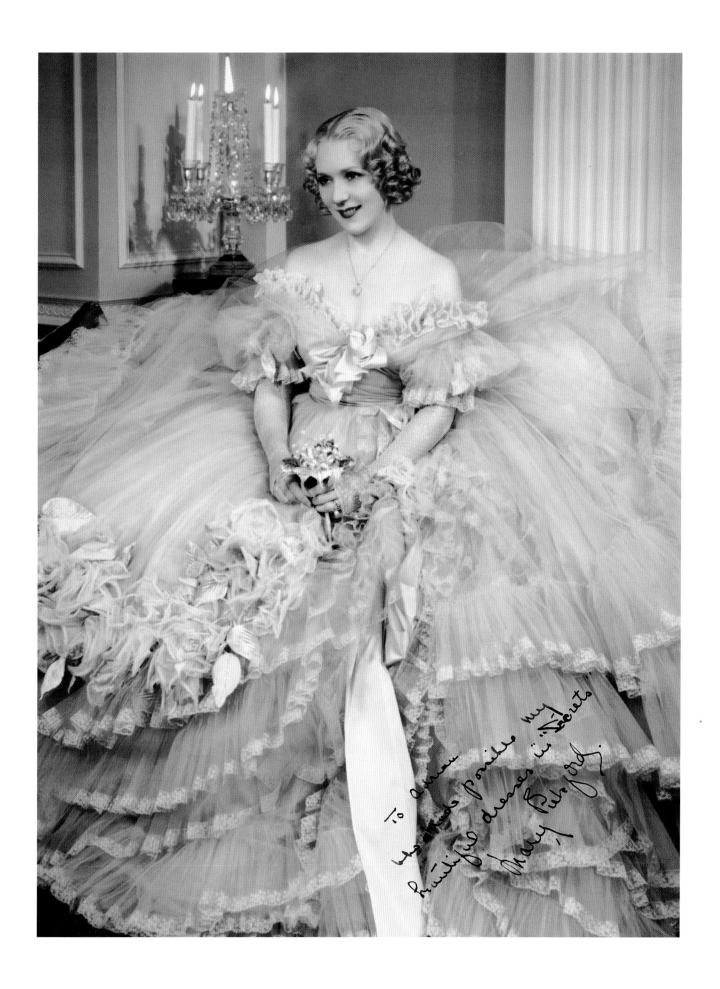

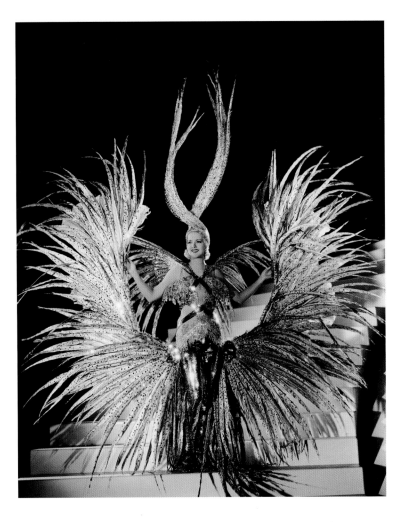

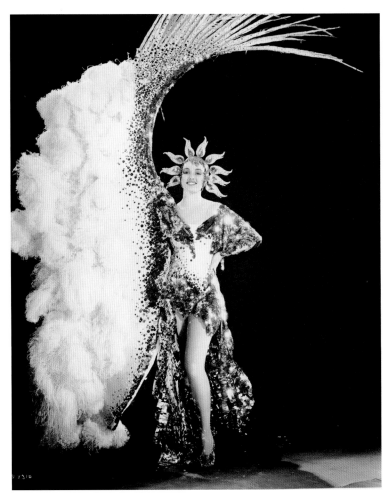

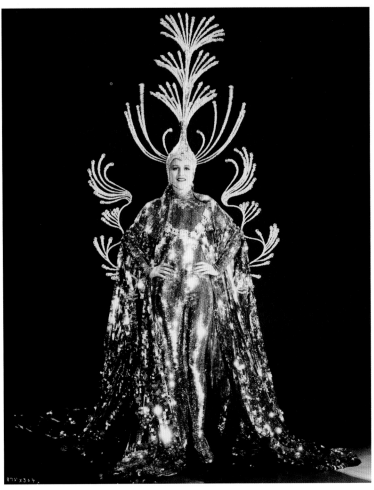

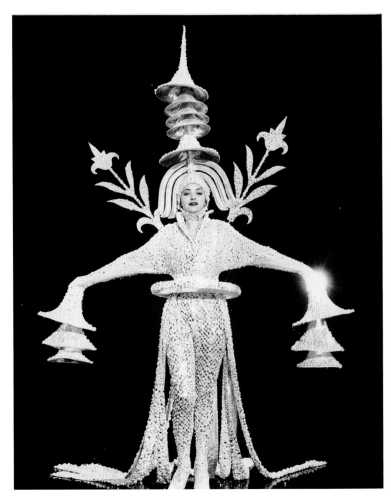

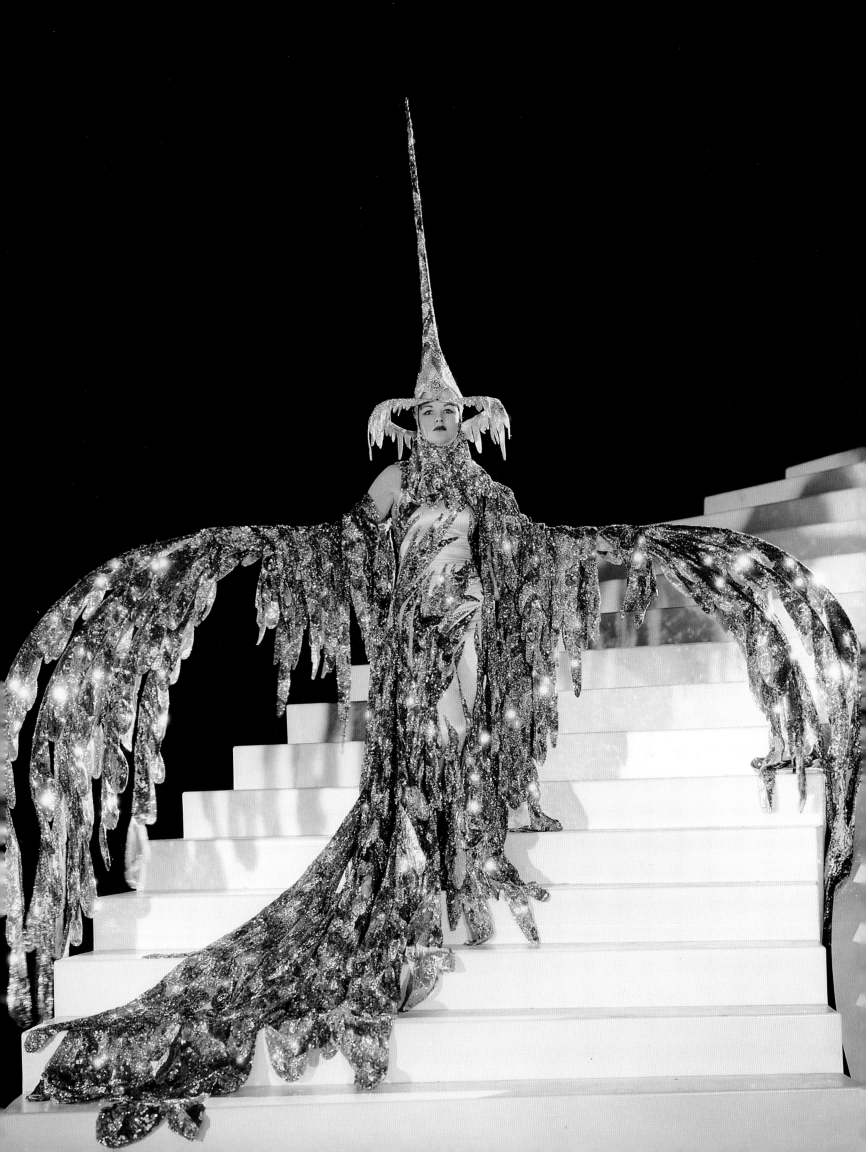

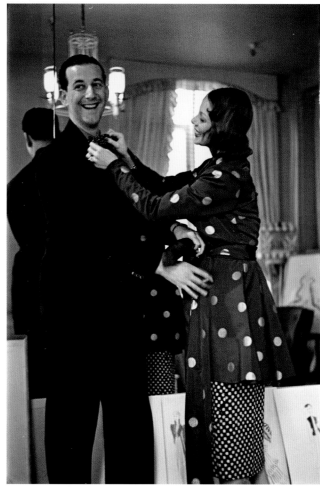

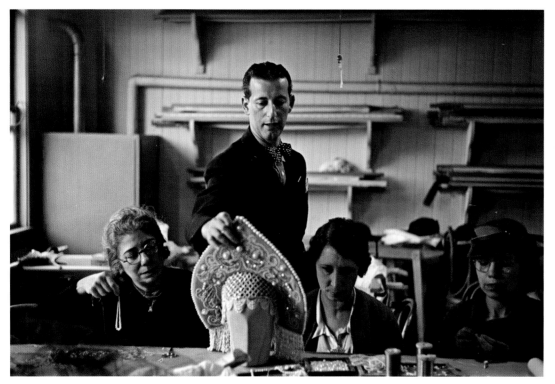

Clockwise from top left: Adrian with Jeanette MacDonald on the set of *Bitter Sweet*, 1940. An M-G-M actress playfully adjusts the designer's bow tie. Photograph by Rex Hardy. Adrian in the M-G-M wardrobe department critiquing a headdress for Jeanette MacDonald. Photograph by Rex Hardy.

Opposite: Adrian surrounded by his sketches for *Romeo and Juliet*, 1936. Photograph by George Hurrell.

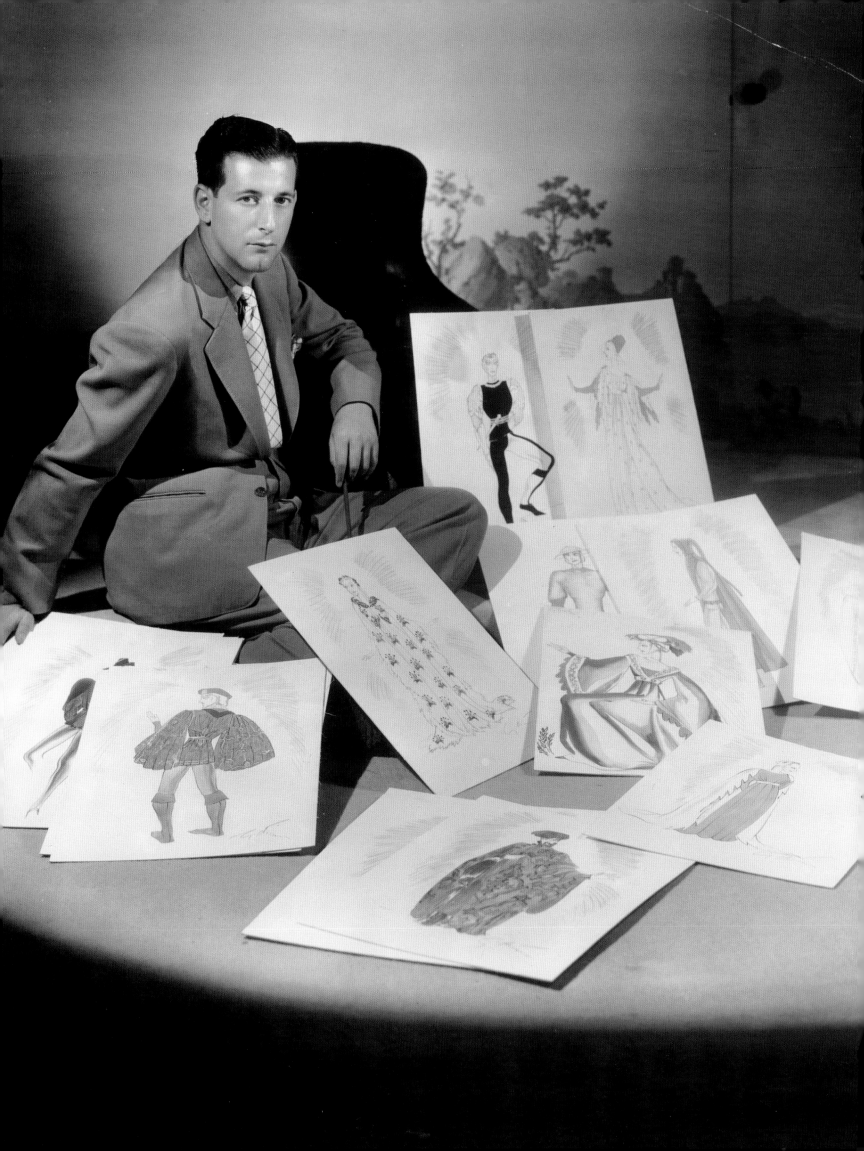

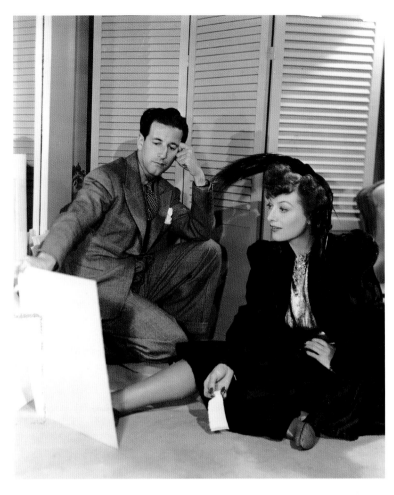

This page, from top: Adrian and Joan Crawford discussing Adrian's sketches for *The Women*, 1939, and again in conversation on the set of *The Last of Mrs. Cheyney*, 1937.

Opposite: Joan Crawford holding Adrian's sketch of her ruby-red, bugle-beaded gown in *The Bride Wore Red*, 1937.

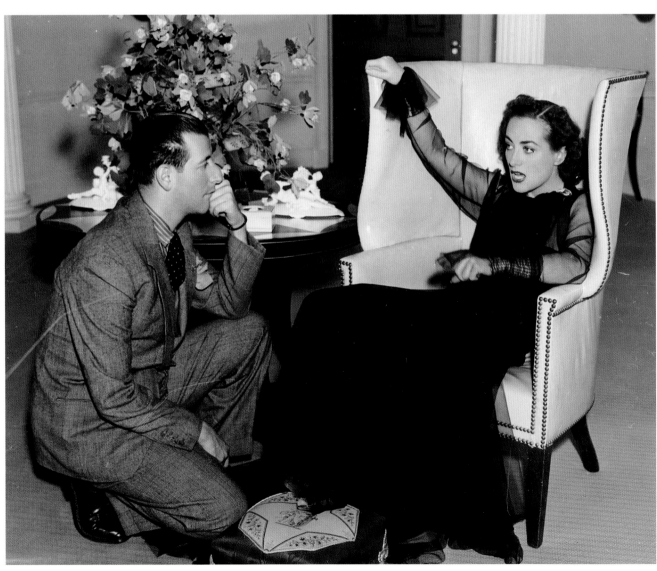

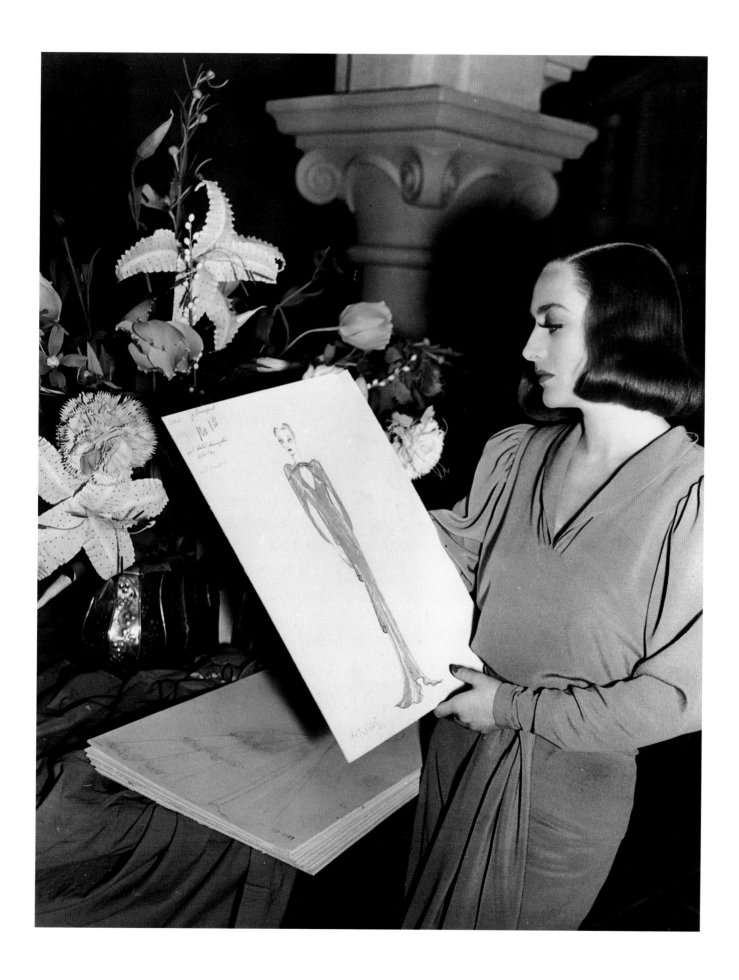

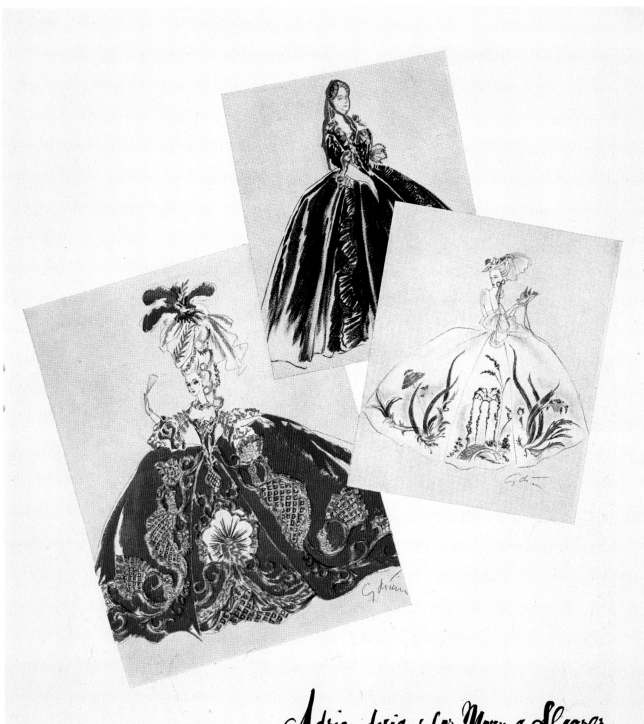

Adrian designs for Norma Shearer

These are just three of the twelve hundred costumes in "Marie Antoinette." (Norma Shearer wears the vermilion gown, left, with its elegant cockades, to the ball at Versailles; the one at the right to a game of blind man's buff. The black, above, is for Marie's mother, Maria Theresa.) Miss Shearer makes a Hollywood record for costume changes with thirty-four gowns and eighteen wigs. It's her first picture since "Romeo and Juliet," and this time she's fortified by Tyrone Power, John Barrymore, and Robert Morley, who looks more like Charles Laughton than Laughton himself

Above: An article about Adrian's costumes for *Marie Antoinette* from a 1930s *Vogue* magazine.

Opposite: Norma Shearer in costume as Marie Antoinette. Photograph by Laszlo Willinger.

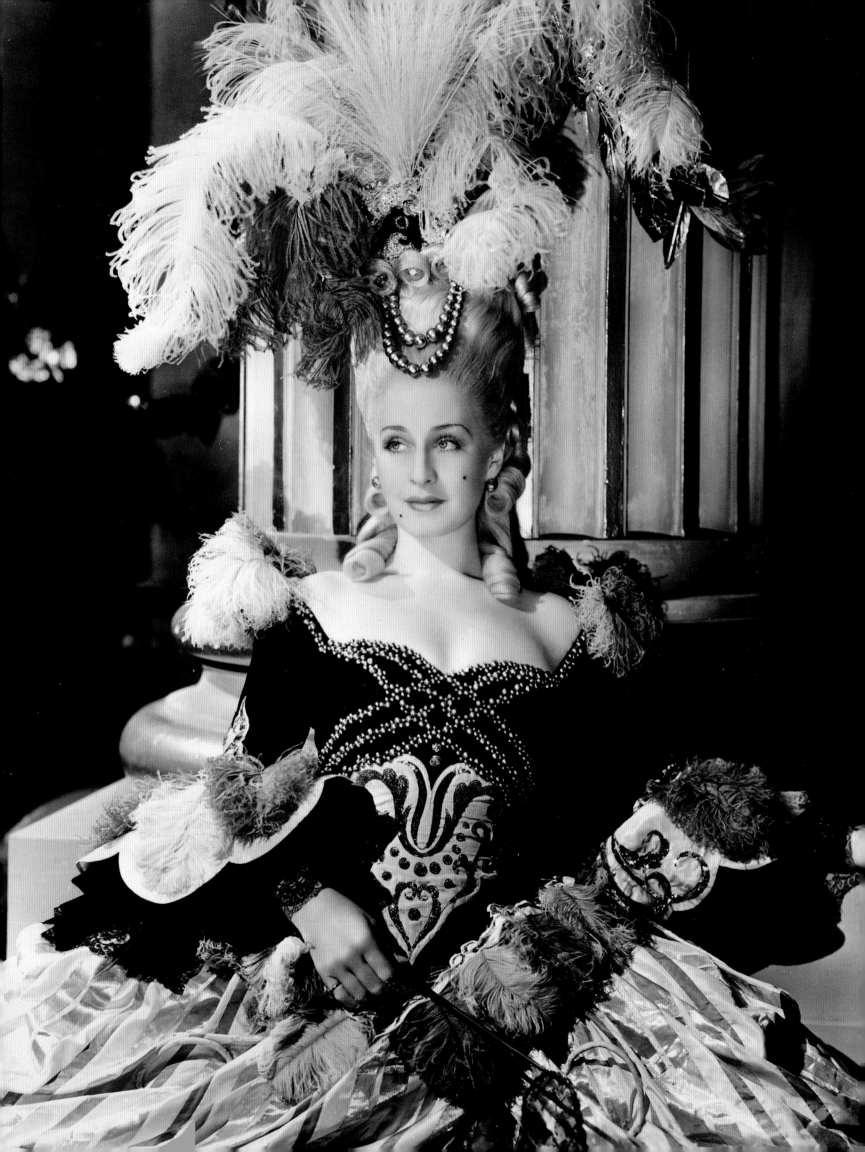

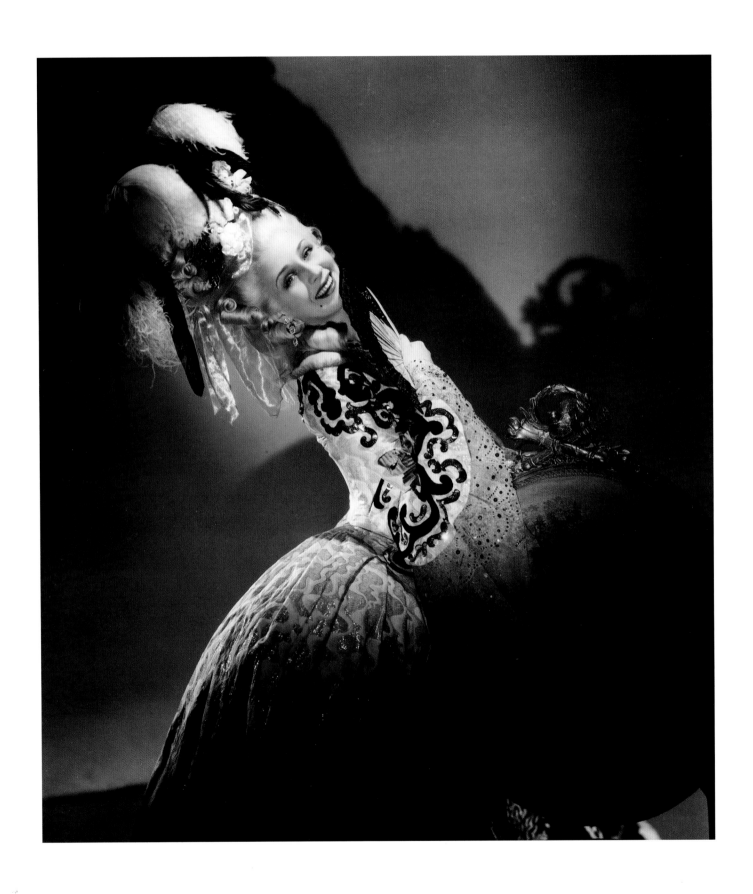

Above and opposite: Two photographs of Norma Shearer as Marie Antoinette. Photographs by Laszlo Willinger.

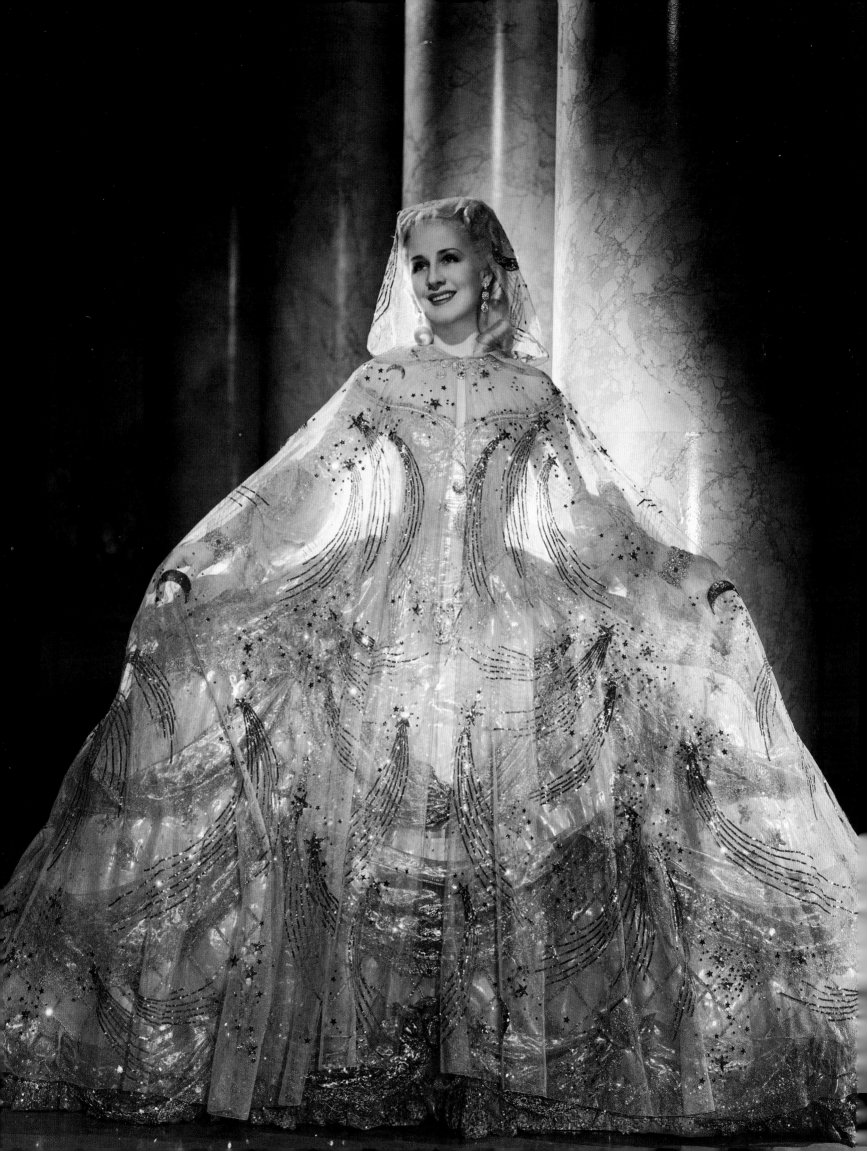

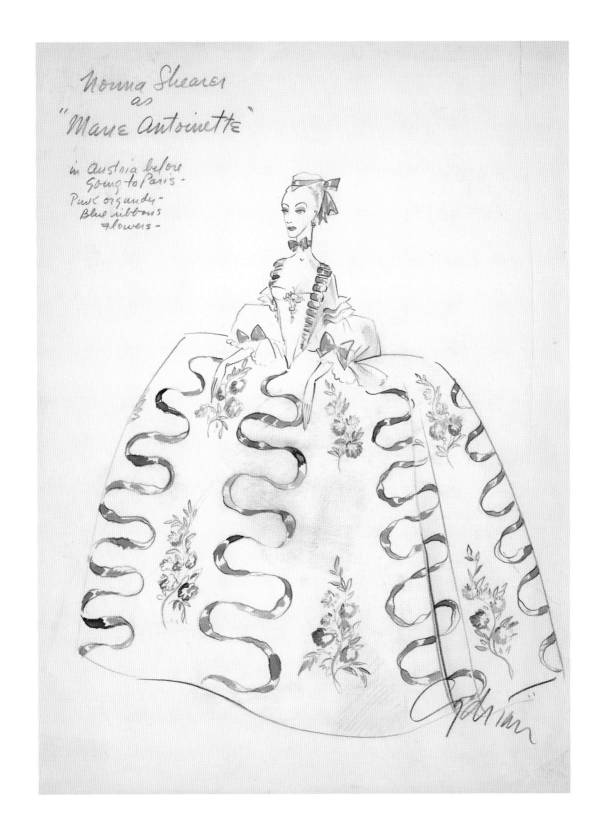

Norma Shearer
as
"Marie Antoinette"

in Austria before
going to Paris —
Pink organdy —
Blue ribbons
+ flowers —

Above: Adrian's original sketch
for Norma Shearer as *Marie
Antoinette*.

Opposite: Norma Shearer wearing
the finished gown, which was
made of pink organdy trimmed
with pale-blue ribbons and flowers.
Photograph by Laszlo Willinger.

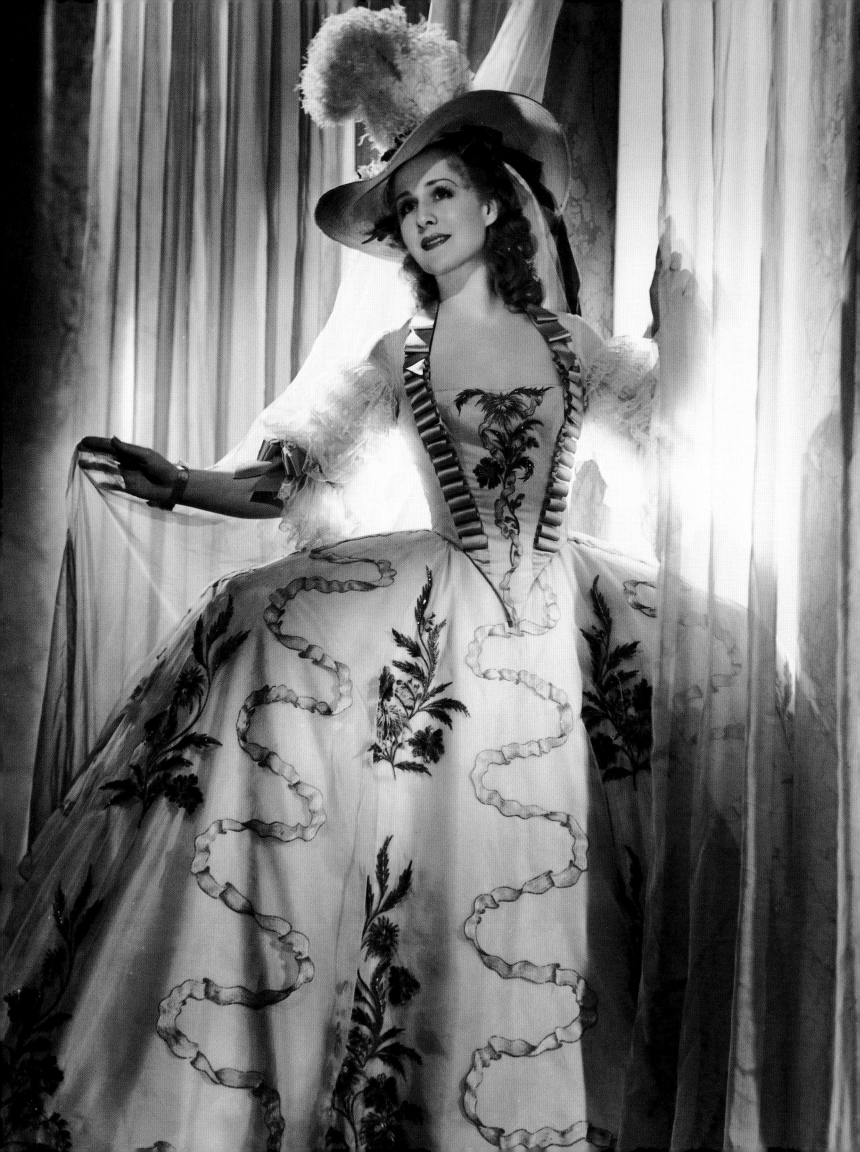

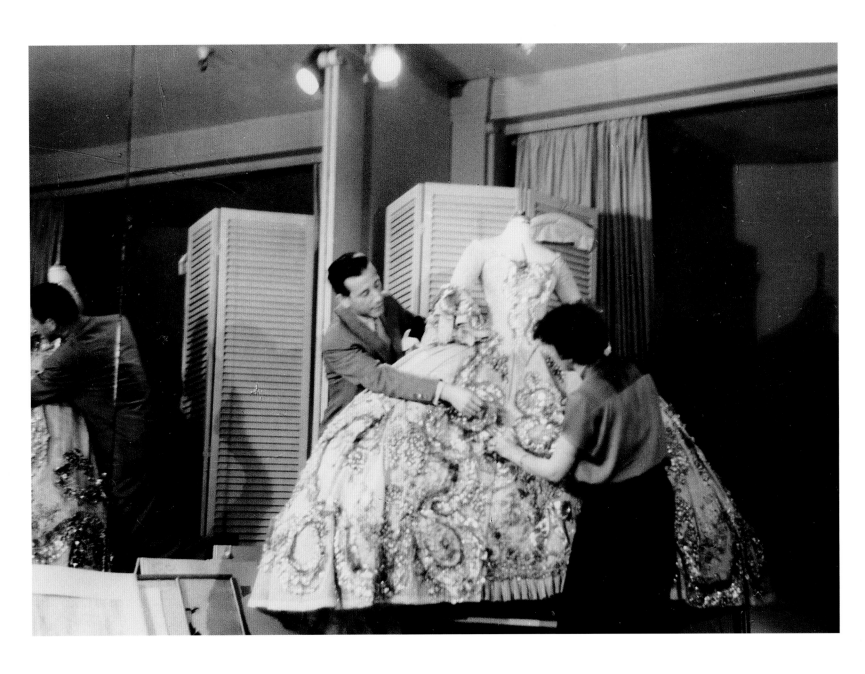

Above: Adrian in his design studio putting the finishing touches on an elaborately embroidered gown for Norma Shearer.

Opposite: Norma Shearer wearing the gown. Photograph by Laszlo Willinger.

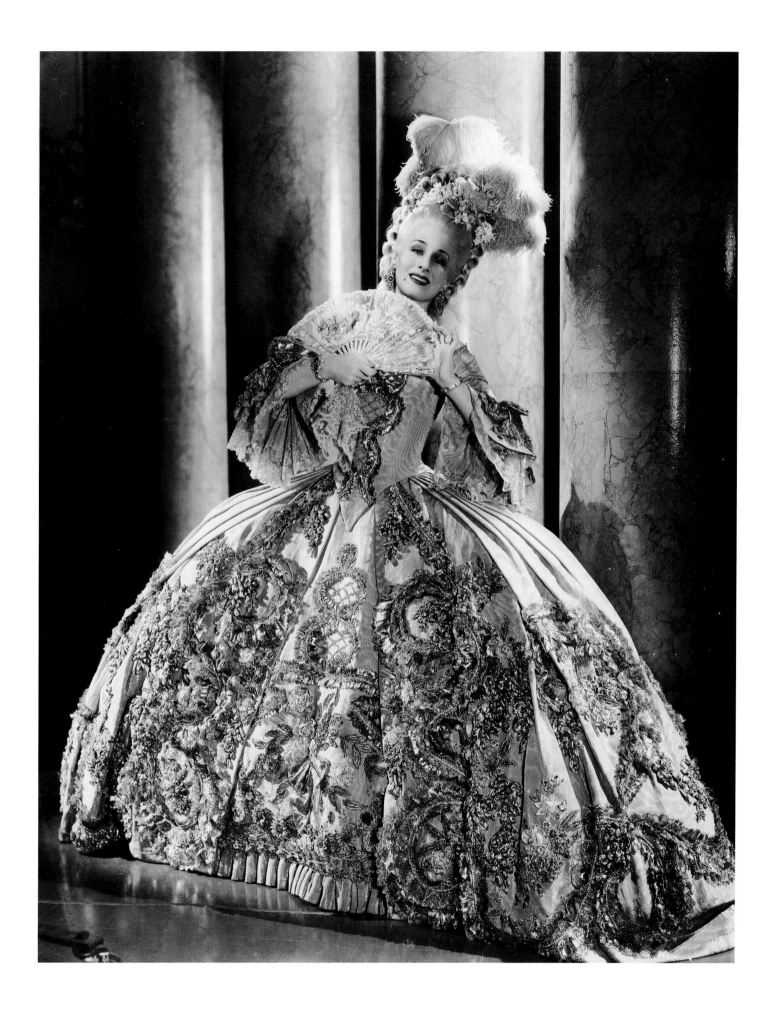

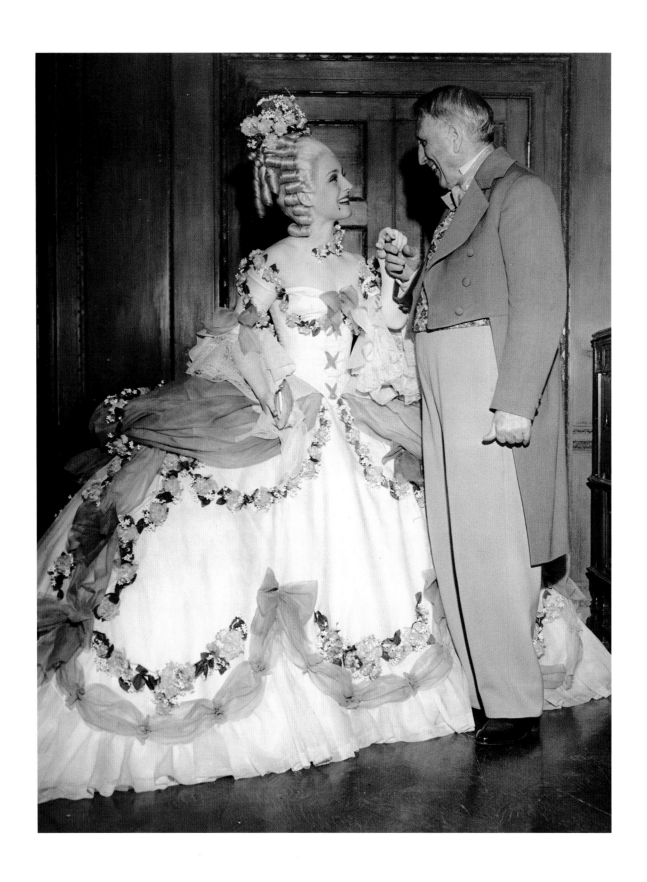

Above: Norma Shearer with
William Randolph Hearst wearing
one of her *Marie Antoinette*
costumes to a private party at
Ocean House, in Santa Monica,
California, the beach house
of Marion Davies and William
Randolph Hearst.

Opposite: Norma Shearer wearing
the same *Marie Antoinette*
costume on the set of the film.
Photograph by Laszlo Willinger.

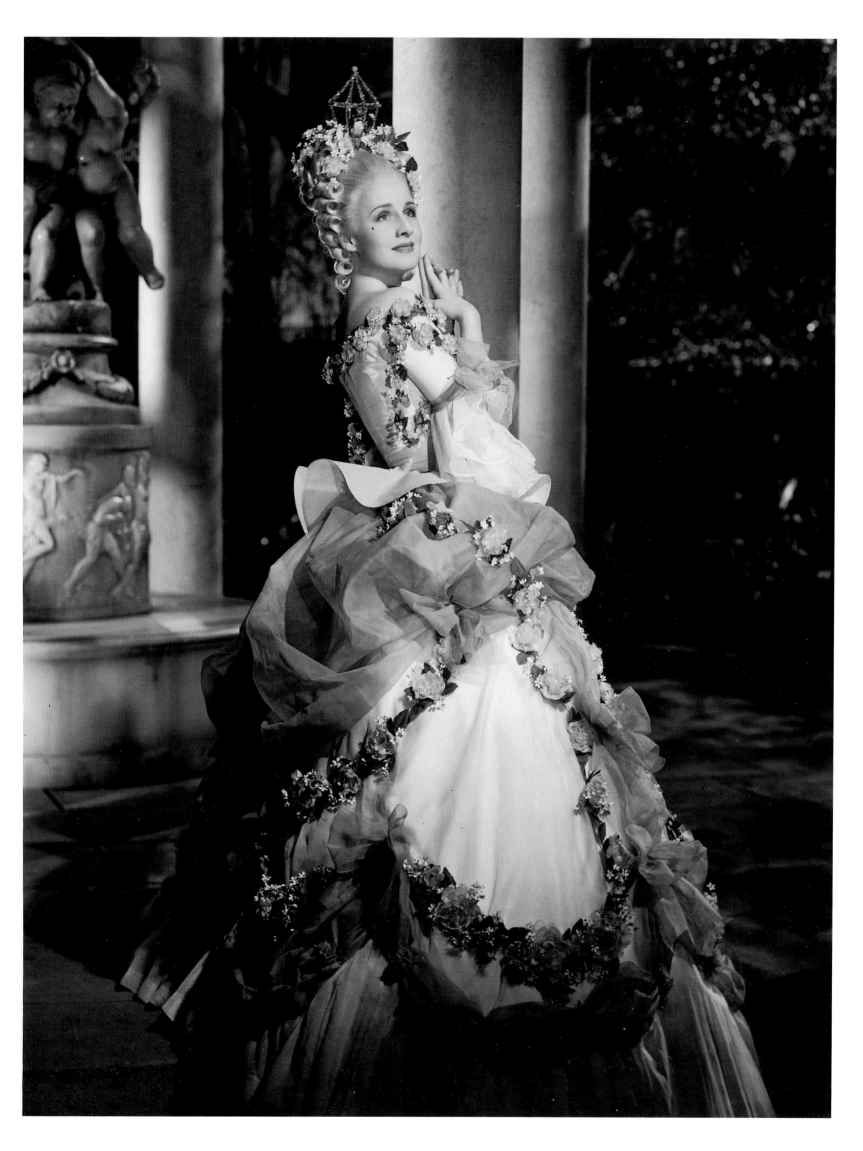

Above: Adrian's sketch of
Norma Shearer in a black velvet
embroidered gown from *Marie
Antoinette* and, opposite, the
actress in the completed costume
in a photograph by Laszlo
Willinger.

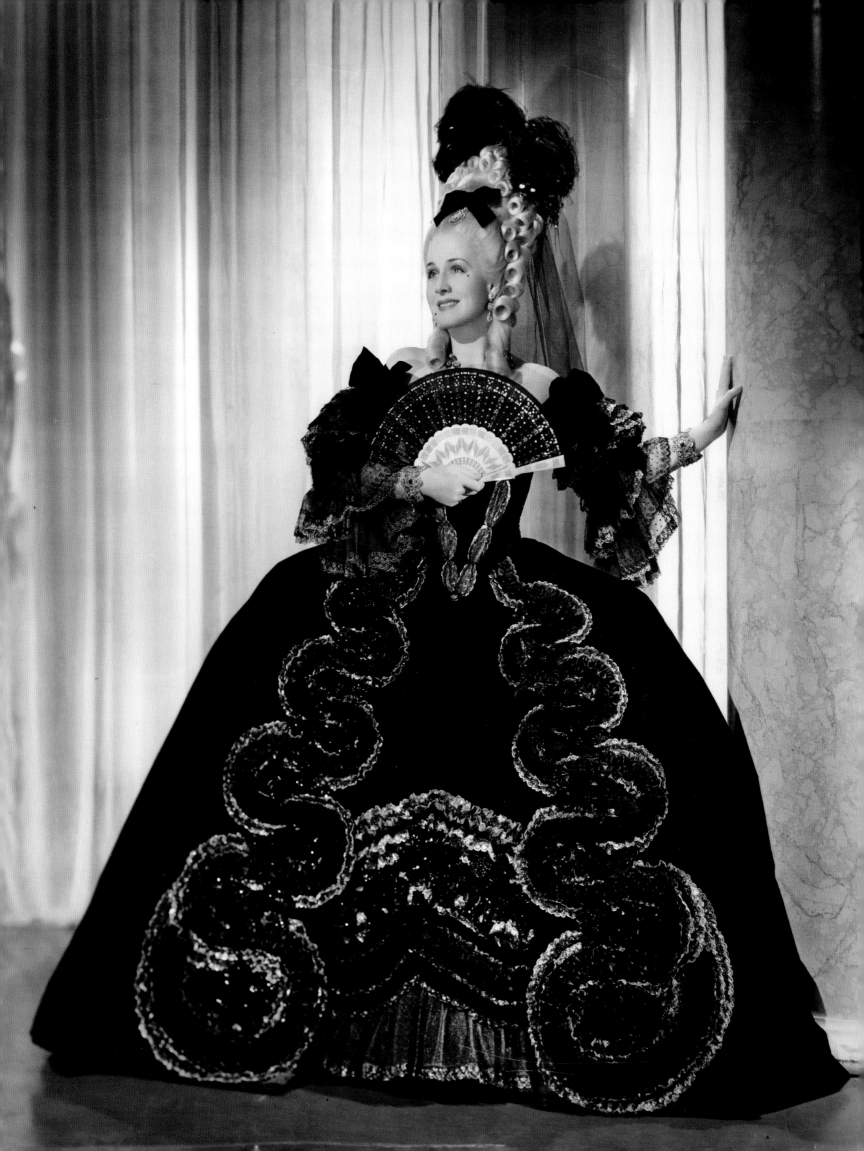

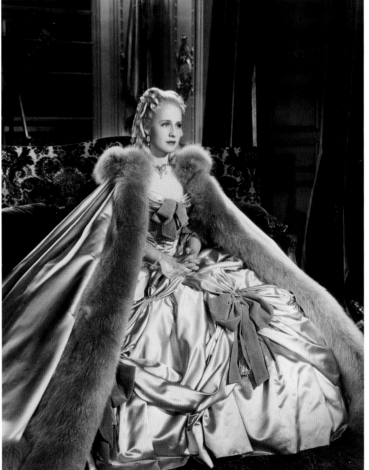

This page: Adrian's sketch of Norma Shearer's pale-blue satin gown and, below, the actress wearing the gown.

Opposite: Norma Shearer wearing the pale-blue satin gown with a fox-fur-trimmed cape. Photograph by Laszlo Willinger.

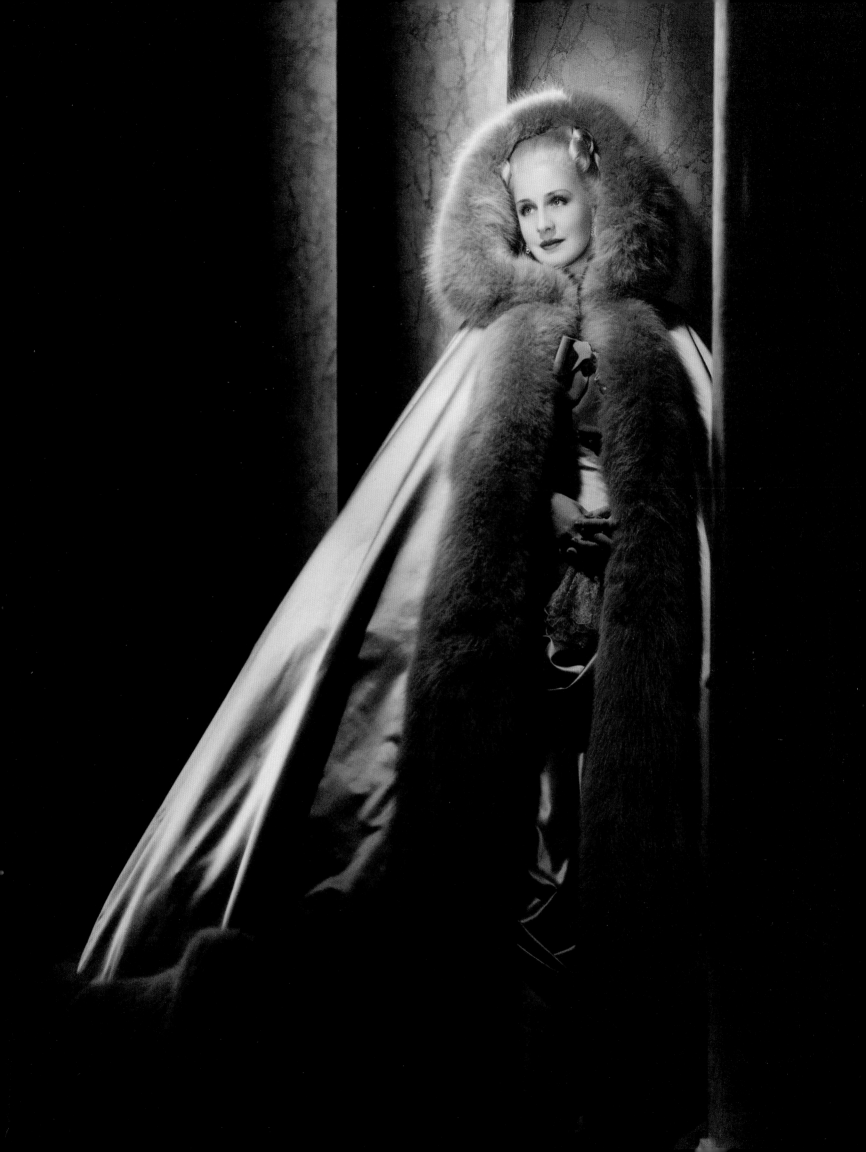

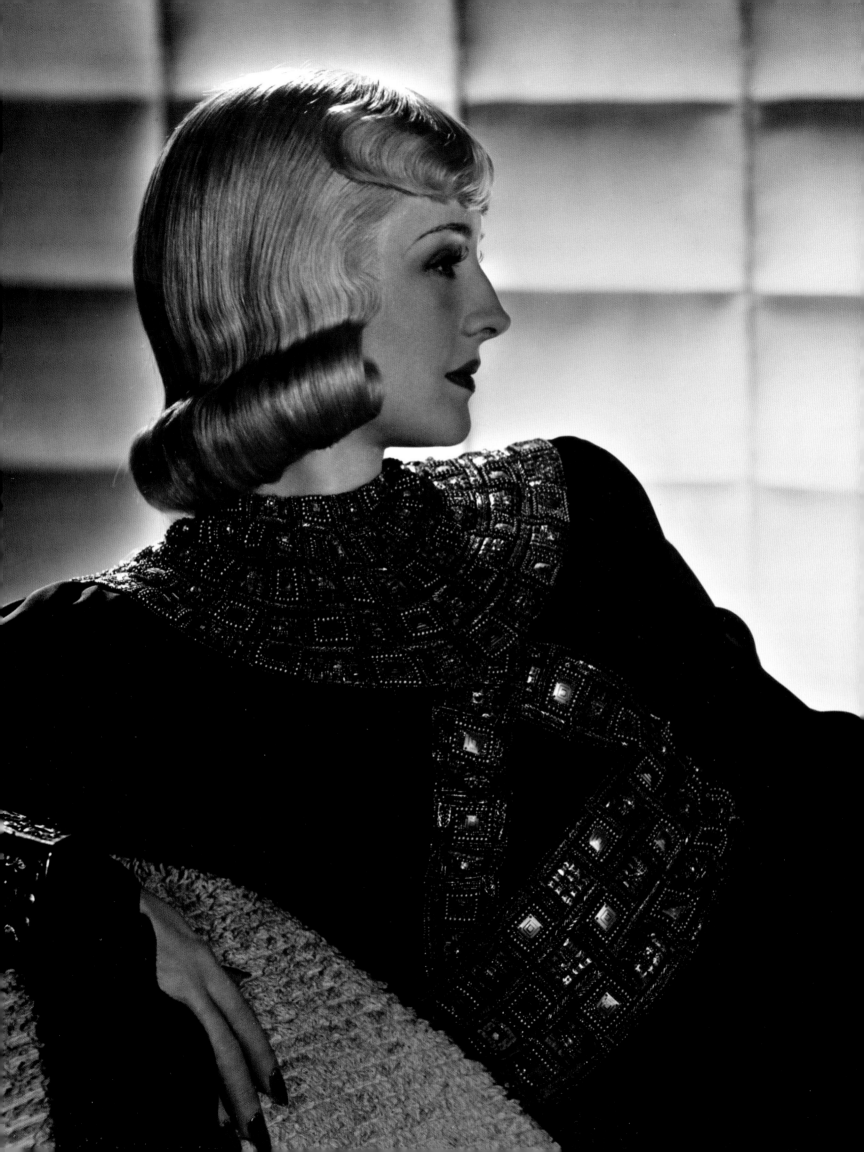

Norma Shearer in an elaborately trimmed gown for *Idiot's Delight*, 1939. Photograph by Laszlo Willinger.

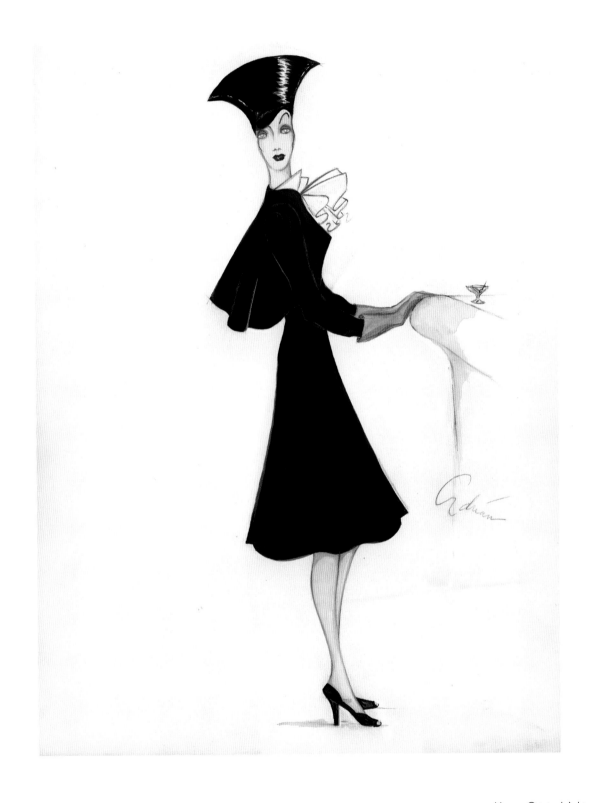

Above: Original Adrian costume
sketch for *The Women*, 1939.

Opposite: A publicity photograph
of the three stars from *The Women*:
Norma Shearer, Joan Crawford,
and Rosalind Russell.

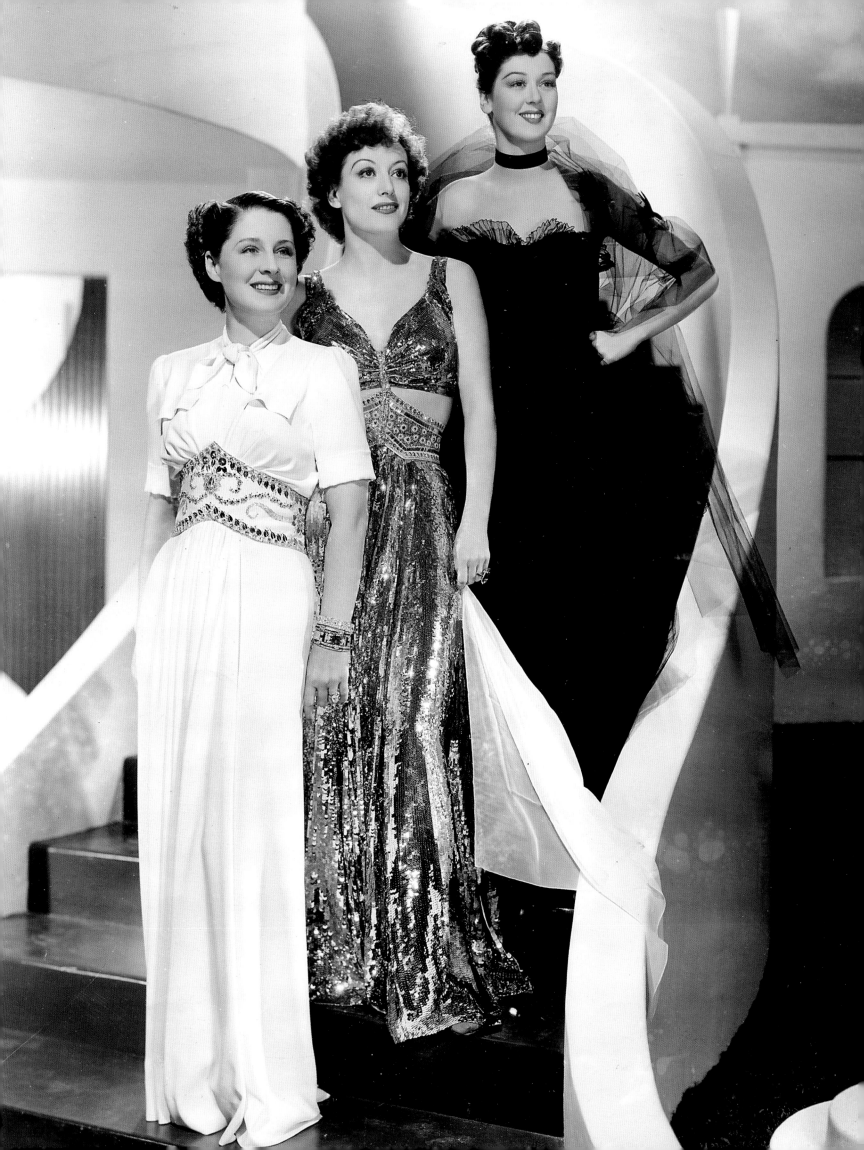

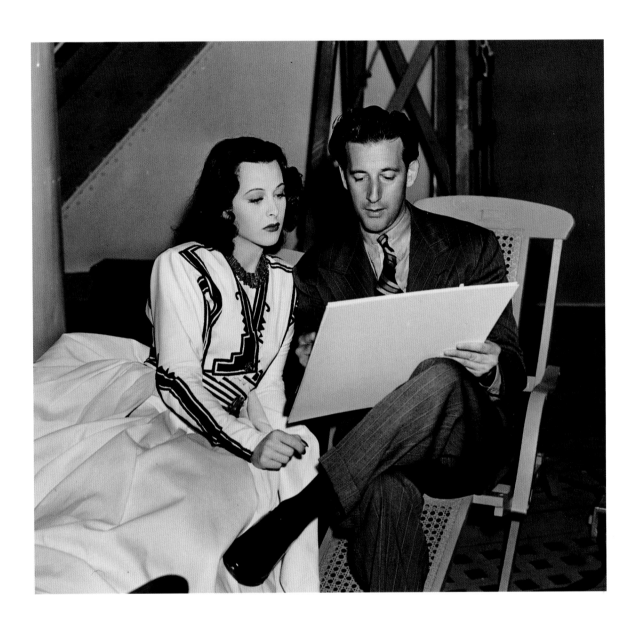

Above: Hedy Lamarr with Adrian on the set of *Lady of the Tropics*, 1939, discussing costume sketches.

Opposite: Hedy Lamarr wearing an exotic East Indian temple dancer's costume from *Lady of the Tropics*, 1939. Photograph by Laszlo Willinger.

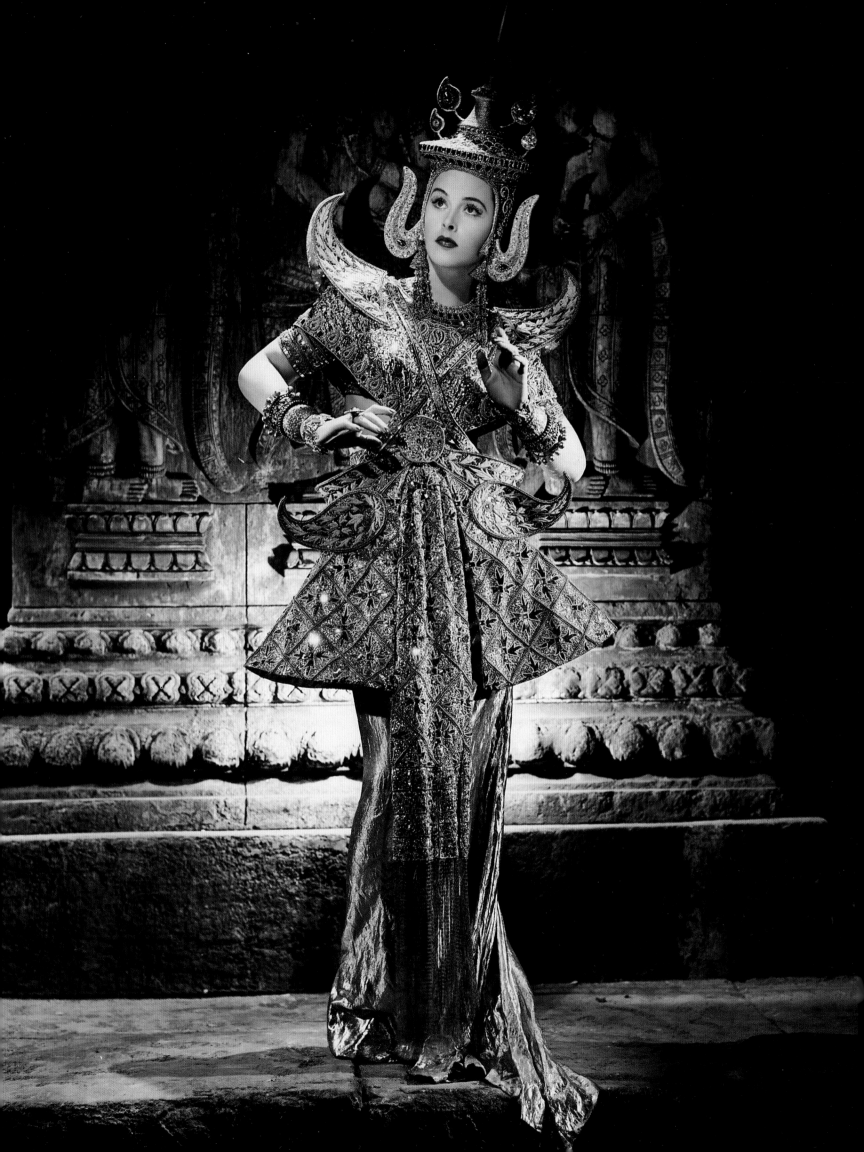

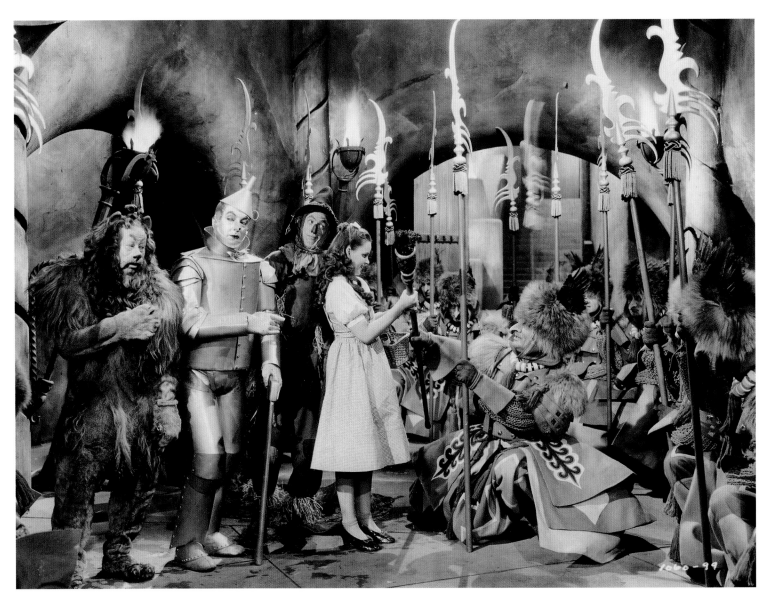

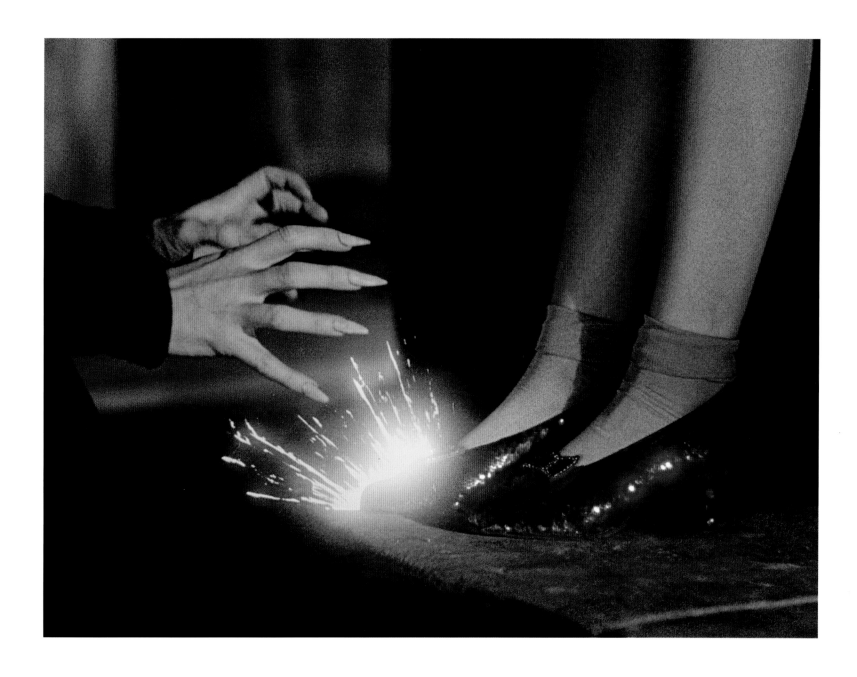

Opposite: Judy Garland with Ray
Bolger (The Scarecrow), Jack
Haley (The Tin Man), and Bert
Lahr (The Cowardly Lion) on the
set of *The Wizard of Oz,* 1939.

Above: The clawlike hands of the
Wicked Witch of the West reach
out for the ruby-red slippers worn
by Judy Garland's Dorothy in
The Wizard of Oz, 1939.

Following pages: Six original Adrian
costume sketches of the famous
munchkins from *The Wizard of Oz.*

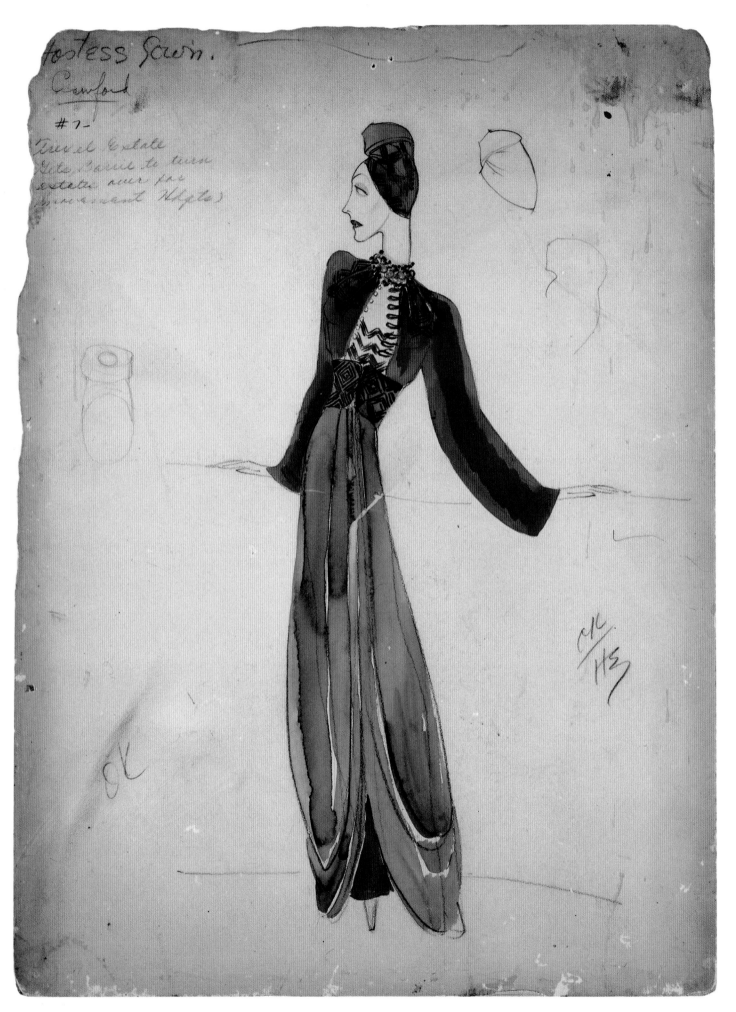

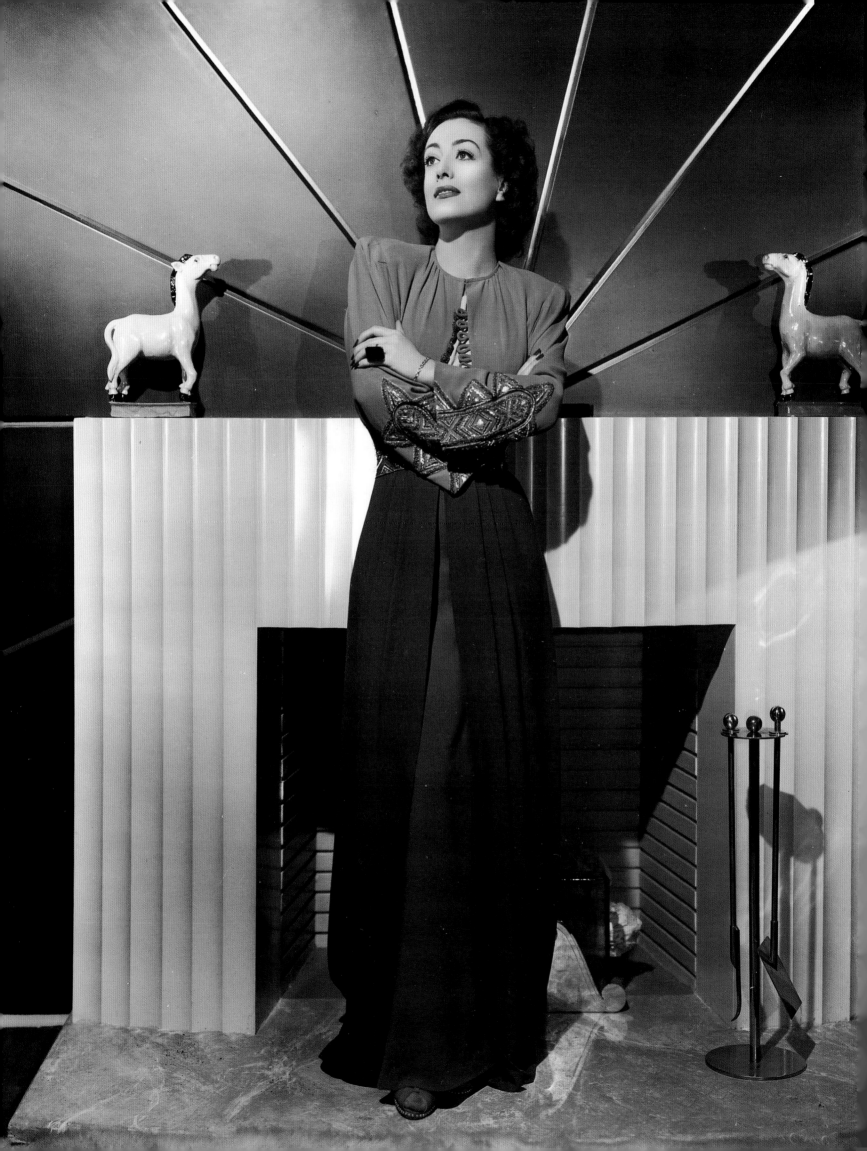

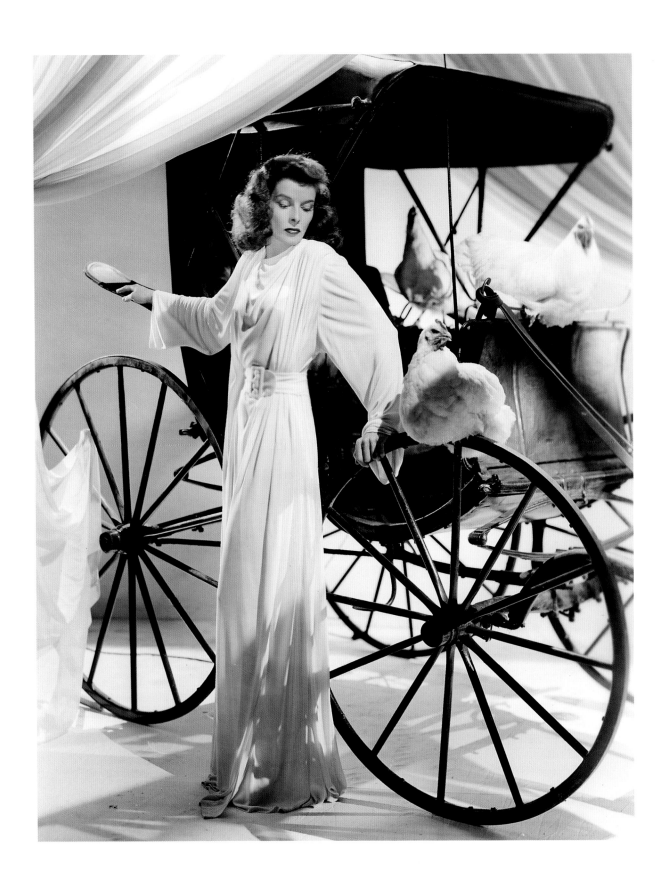

Previous pages, from left: Adrian's original sketch of Joan Crawford's hostess gown from *Susan and God*, 1940, and the actress in the finished dress.

Above and opposite: Katharine Hepburn wearing Adrian's long white jersey wrapped robe from *The Philadelphia Story*, 1940, and the actress in a white, gold-trim-embellished evening dress from the same film.

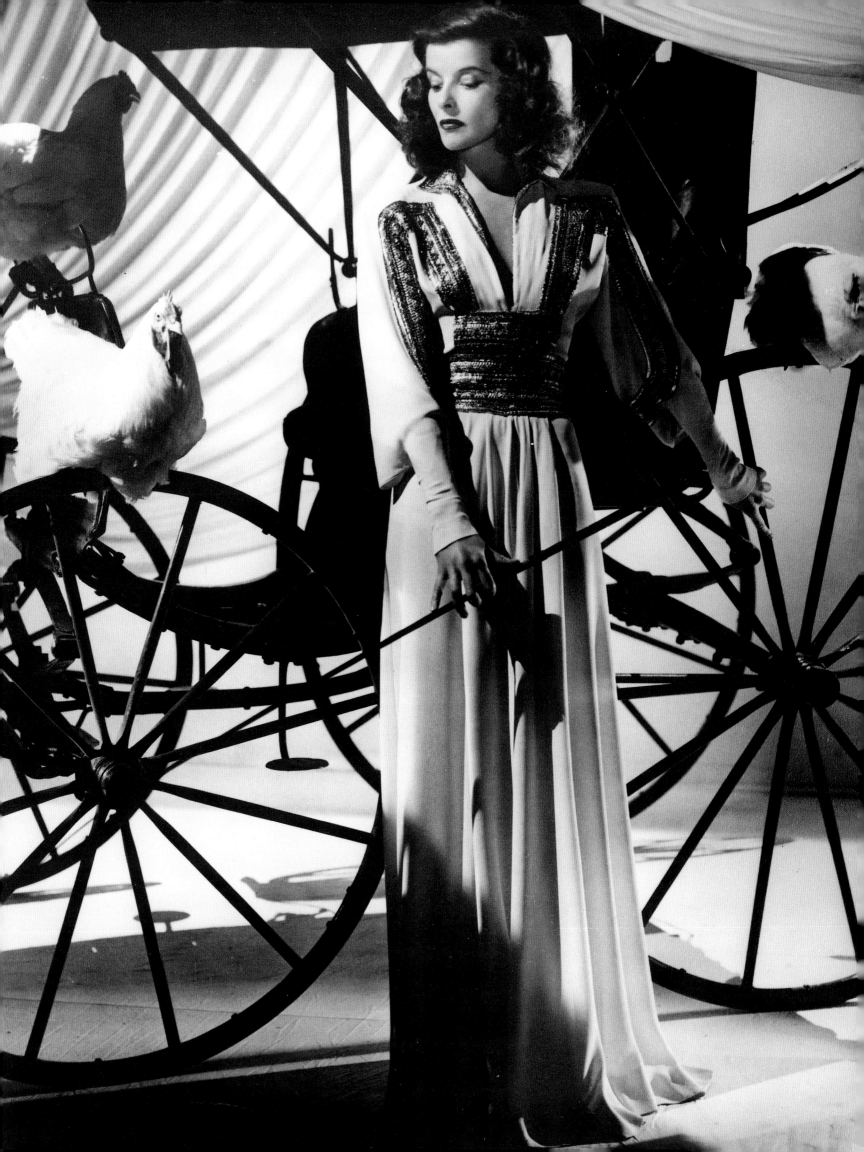

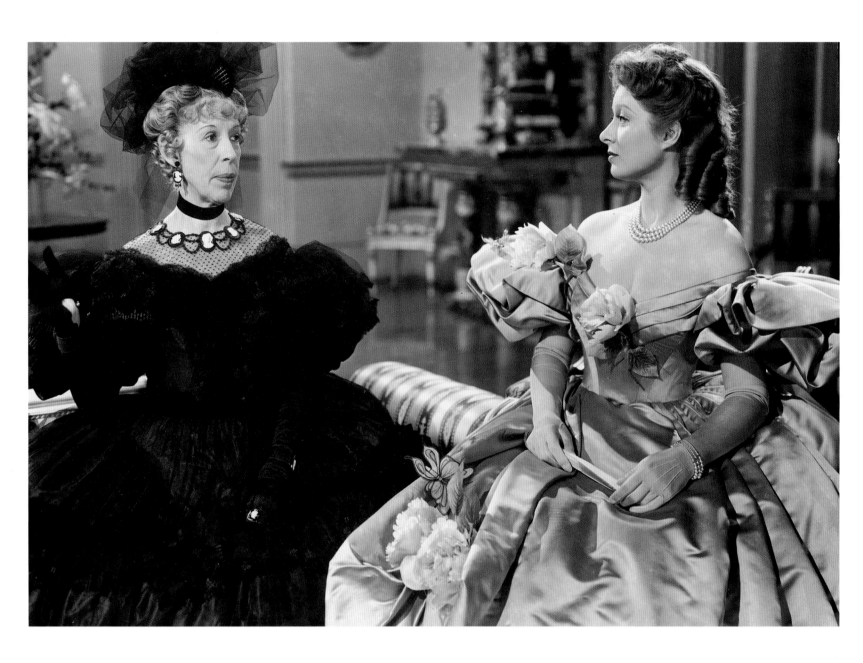

Above: Edna May Oliver wearing a black tulle gown with Greer Garson in an apricot silk satin ball gown on the set of *Pride and Prejudice*, 1940.

Opposite: Greer Garson in a white organdy afternoon party dress for *Pride and Prejudice*.

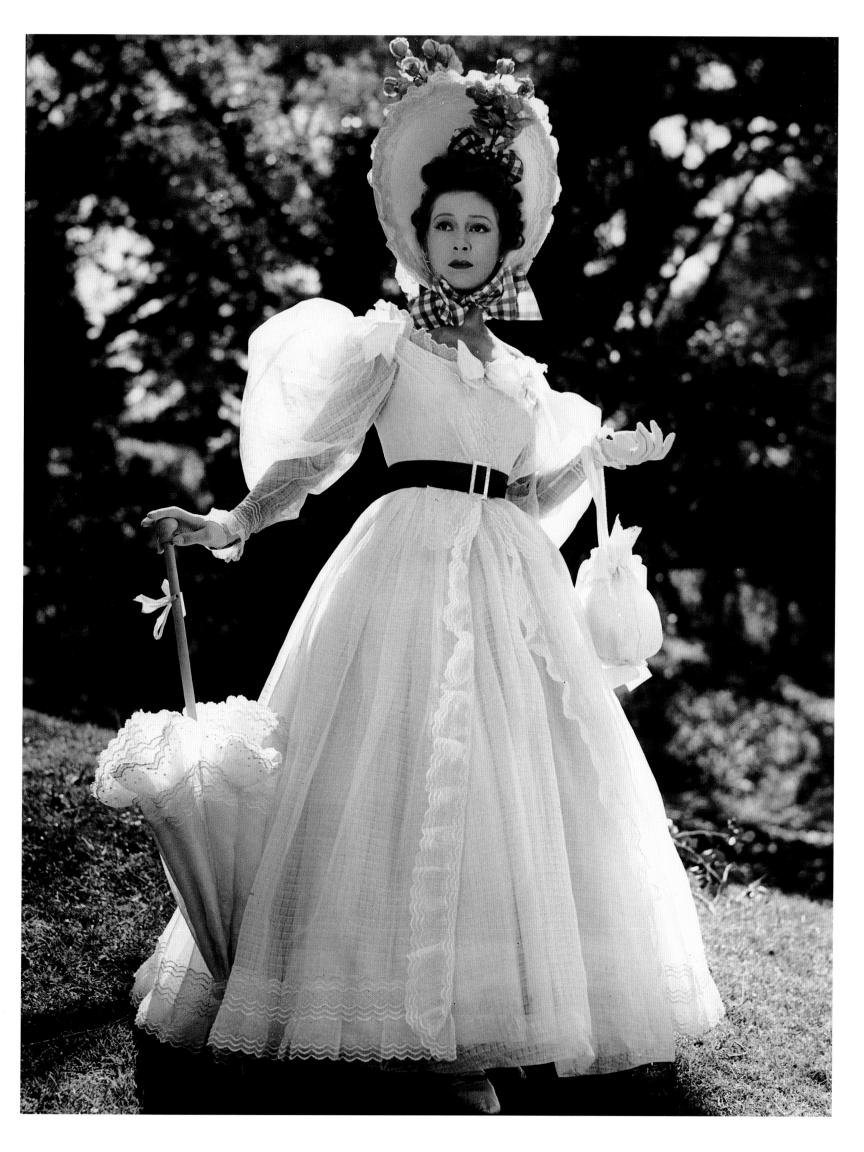

Vivien Leigh in a white silk tulle
ballerina costume from *Waterloo
Bridge*, 1940. Photograph by Laszlo
Willinger.

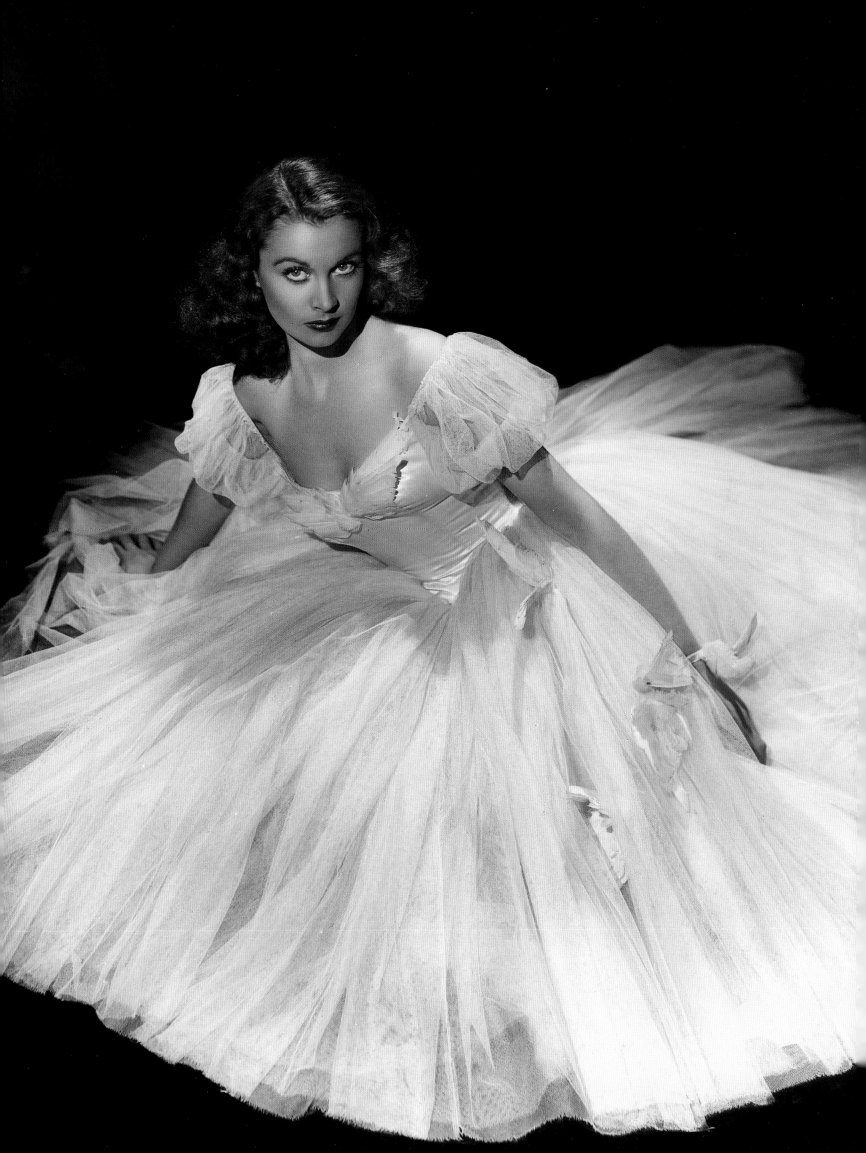

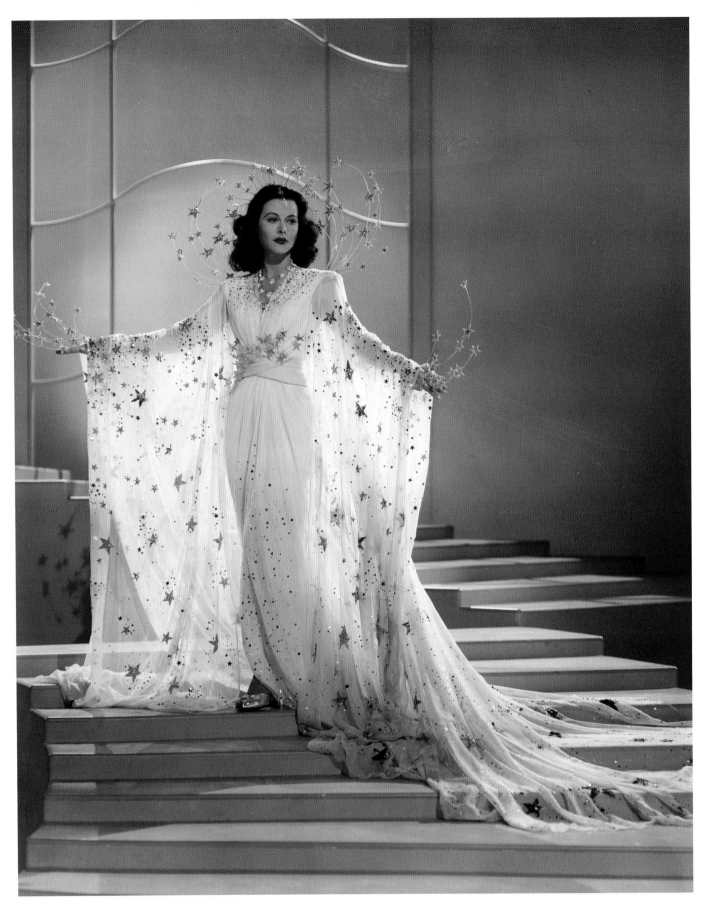

Above: Hedy Lamarr wearing a sheer, embroidered star-strewn costume from *Ziegfeld Girl*, 1941.

Opposite: Lana Turner wearing an ivory-toned, silver-star-embellished tulle costume for the elaborate production number "You Stepped Out of a Dream" from *Ziegfeld Girl*, 1941.

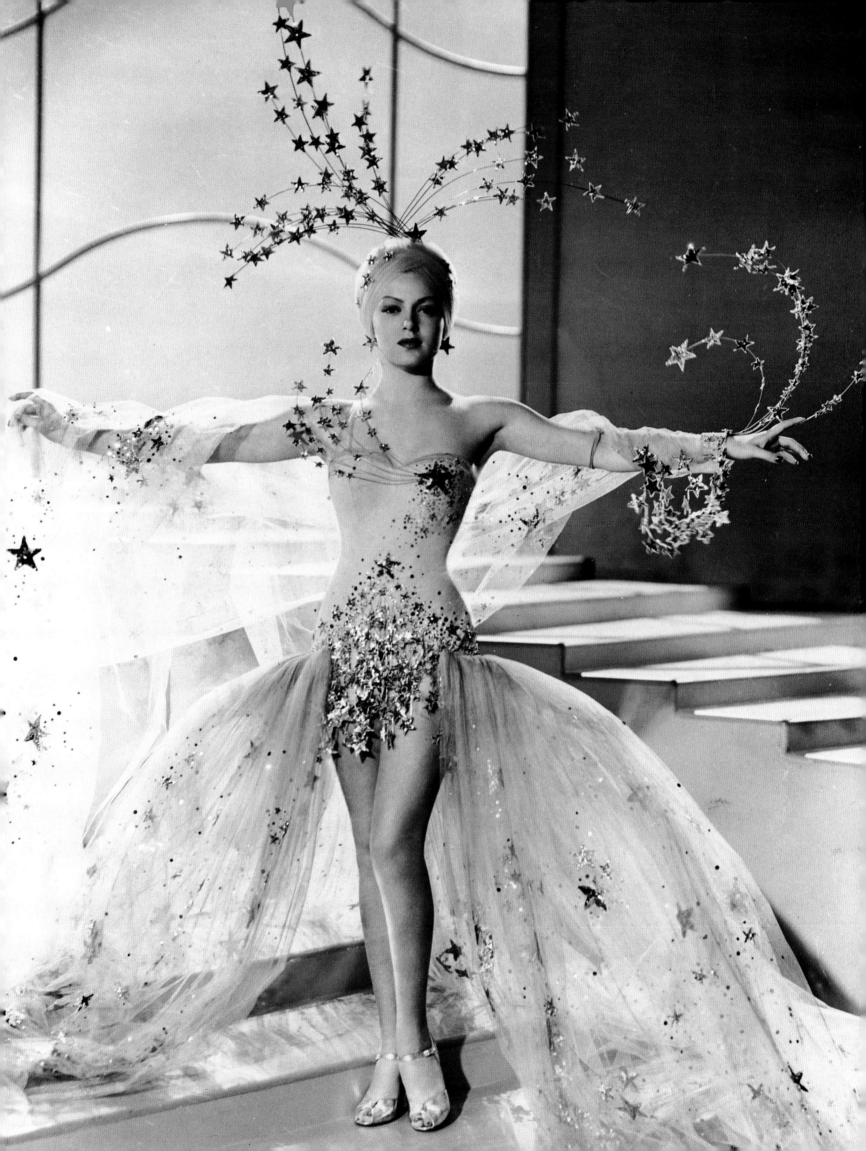

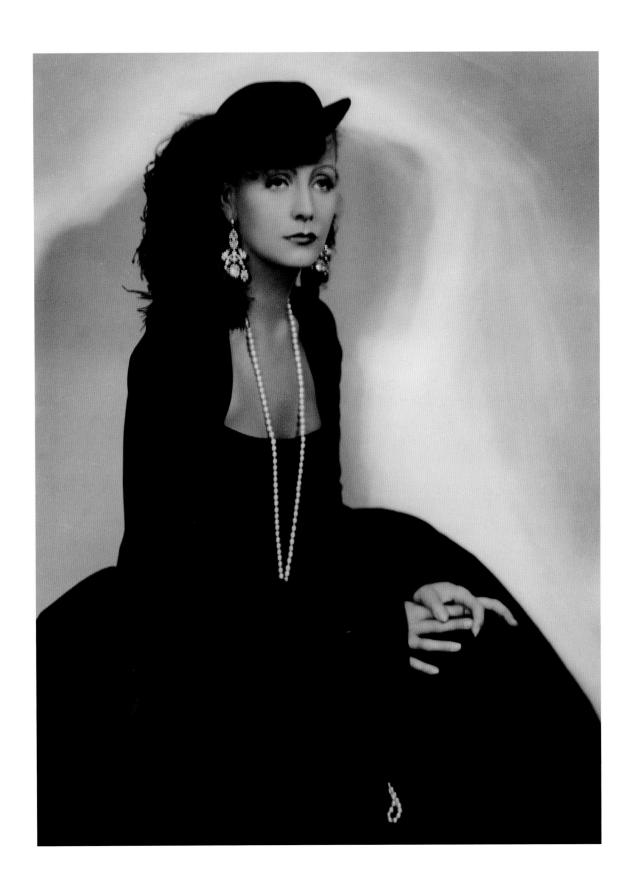

GRETA GARBO

Adrian met Garbo shortly after he arrived at M-G-M. She was finishing a spy film called *The Mysterious Lady*. Partway through the production she had refused to wear a gown designed by Gilbert Clark because she judged it too revealing. She had locked herself in her dressing room. Clark had resigned. After five hit films, Garbo obviously had the upper hand. Would she like Adrian? Having seen her films, he was predisposed to like her. "The image that they created of her was fascinating," he wrote. "She preferred to play the enigmatic woman, and she could, for her beauty was exciting, and she had a talent for cloaking herself in mystery. When I encountered her, she looked as ephemeral and remote as I had imagined. Her beautiful eyes and languid manner were elements of the image that M-G-M sold to the world, but I saw that they were real. After meeting her, I was not disappointed. To the contrary, I was fired by her personality more than by any I had known."

Adrian analyzed Garbo's face and figure and posture before embarking on a sketch marathon. To him, her celebrated countenance was simply symmetrical. "Miss Garbo's face is shaped like an egg," said Adrian. "It forms a perfect oval, which is ideally suited to the new lines in millinery. Simplicity is the keynote to her smartness. Her natural aloofness and poise put meaning into simple clothes, and make it possible for her to handle formal wear without being clothes-conscious."

Known for his charmingly formal manners, Adrian could also be droll or silly with friends, using character voices over the telephone or mounting practical jokes. His natural reserve made these capers more effective. With Garbo, he was cautious. "Garbo invited me to her

Greta Garbo in the film *Romance*, 1930, wearing the famous Empress Eugenie ostrich-feather hat, which was widely copied by the fashion industry.

dressing room," he wrote. "It was dreary, because she kept it dark. As I look back upon my first contact with her, I can see the Garbo formula at work. She acted as though life was a great burden. No one could ever come up to her expectations. People were constantly falling short of her dreams. Still, we became friends at once."

The wardrobe that Adrian designed for Garbo's seventh M-G-M film was a breakthrough. *A Woman of Affairs* was the first film in which modish costumes did not call attention to themselves; instead, they underscored the intent of each sequence. "In the renunciation scene," wrote *Photoplay*'s Leonard Hall, "Garbo wore a slouchy old tweed suit and a squashy felt hat. She never looked more mysterious, more alluring, and she never acted with greater authority or arrogant power."

Thus began a collaboration that spanned thirteen years and eighteen films. "Each picture I designed for her involved extraordinary precision," wrote Adrian. "My imagination was never quiet when I approached her pictures."

Ideas poured into my head with a liquid ease. I soared, because I knew she would be equal to anything I could conceive and that she would more than do it justice. This she did. No one on the screen has worn regal costumes with more authority or evening gowns with more ease. To put her into the costumes with the madness of my *Mata Hari*, the grandness of *Queen Christina*, or the elegance of *Camille* was a stimulating experience. She had a knack for wearing the most astonishing things with a total lack of self-consciousness. She turned the unconventional into a part of herself. A hat of pure fantasy could become a reality on her. Nothing surprised you if she appeared in it. It was simply Garbo, because she had become more and more of a legend with each picture.

When designing for Garbo, I worked from no mold, no formula. No existing fashion was of interest to me. Garbo was unlike anyone else; she should be dressed unlike anyone else. Thus I went about my task with no sense of limitation and with an almost religious fervor. The studio gave me creative freedom.

As a result, these designs were not only effective on the screen
but also influential in the world of fashion.

For example, Garbo did not like the décolleté evening
gowns that were popular in the late twenties and early thirties.
She wanted her upper chest covered, perhaps because she
thought it bony. To put her at ease, I created high-necked eve-
ning gowns. In time these caught on, and they became univer-
sally fashionable. She had broad shoulders, and I did not disguise
these. I emphasized them. This was also true of my designs for
Joan Crawford. Consequently the broad-shouldered suit grew
fashionable.

However, there were a few bumps in the road along the way.

In 1934, for Richard Boleslawski's *The Painted Veil*, Adrian
designed a white daytime ensemble topped with a hat like nothing
seen before. "When the so-called 'Garbo pillbox,' with a square-cut
emerald perched on top, was first seen at a sneak preview, the audi-
ence murmured at the sudden shock." Louella Parsons wrote:

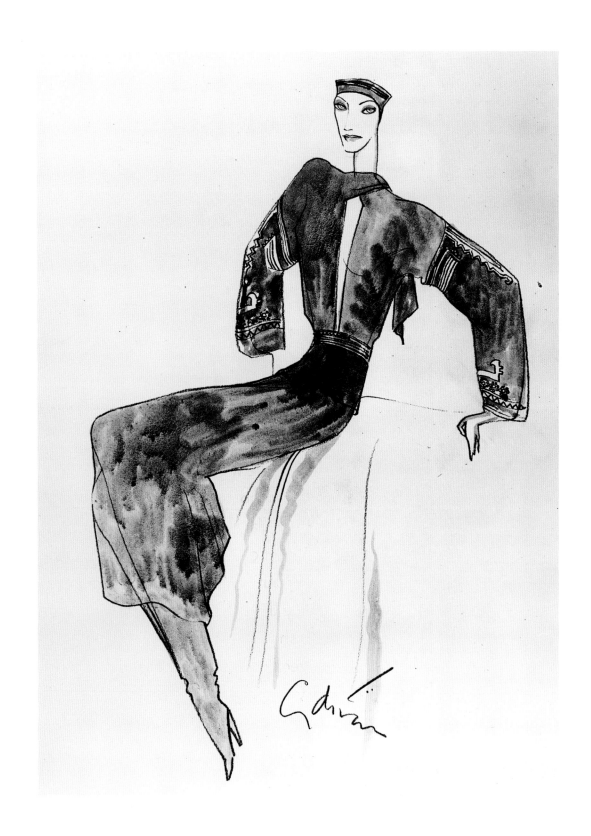

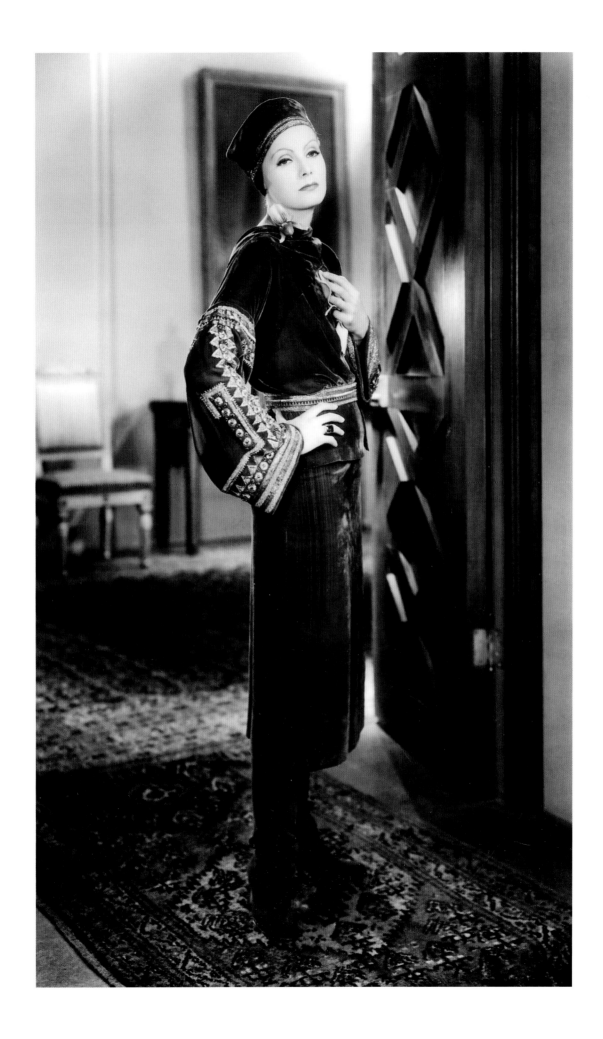

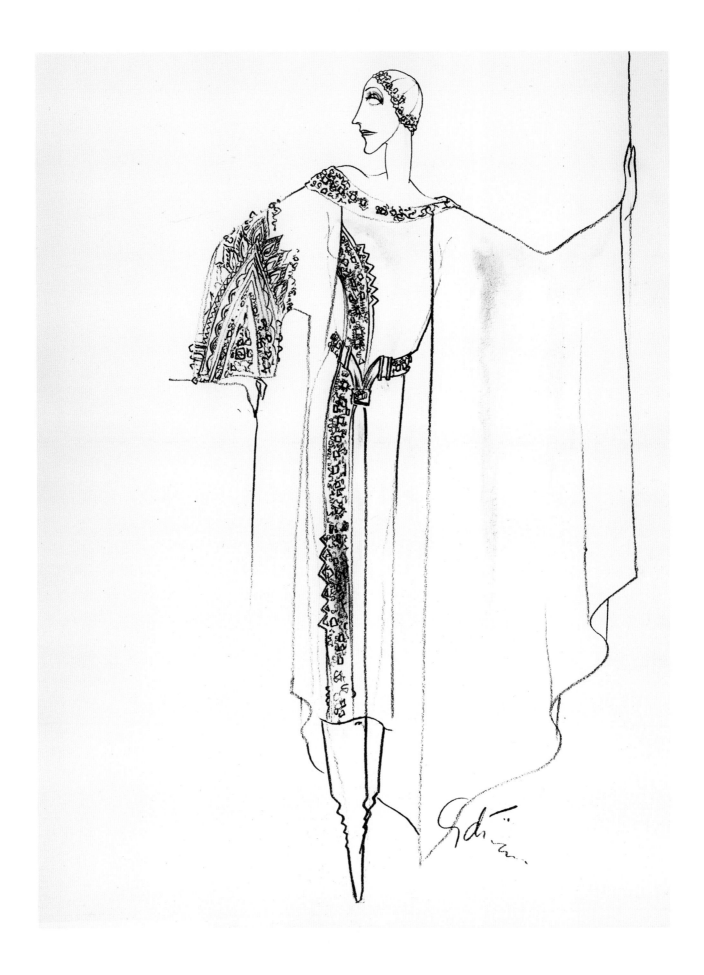

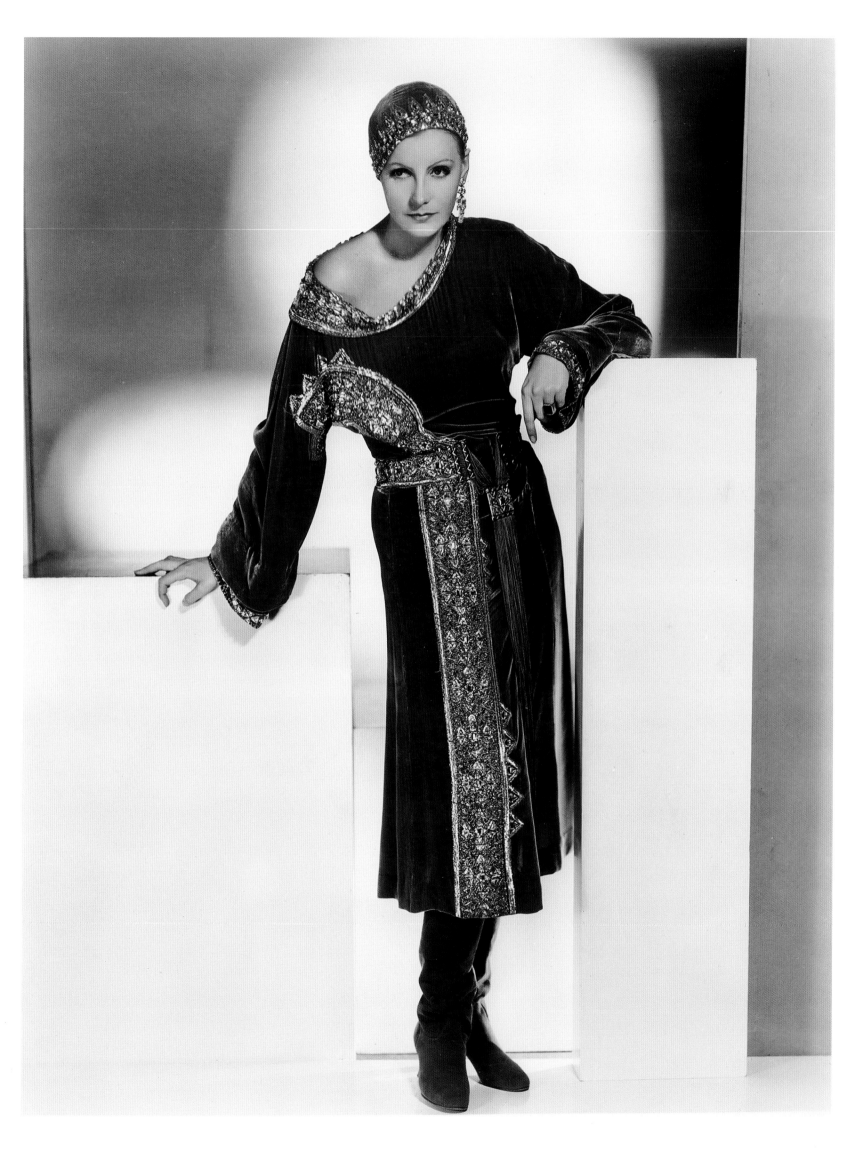

"No star, not even a Garbo, can afford to be laughed at." Adrian received a call from Louis B. Mayer. Once in his office, Adrian looked innocently at the highest-paid man in America. "Mr. Mayer liked me, and I liked him, so he hesitated before he asked me, 'Adrian, what are you trying to do to Garbo? Last night at the preview, her hat caused a disturbance. This is not good for the picture.' I tried to explain that the ripple was one of slight shock but certainly not detrimental to the picture. He was not sure of this and said he only hoped it would not detract from the story. Later, all the fashionable shops in New York featured the 'Garbo pillbox from *The Painted Veil.*'"

Garbo usually supported Adrian's experimental designs, ignoring directors, producers, and anyone who stared at her when she arrived on the set looking like a fantasy character. She was reportedly displeased about the preview incident. She also had an aversion to ostentatious jewelry and refused to wear the necklaces created by Eugene Joseff for George Cukor's *Camille*. "When I was in Sweden," she told Adrian, "women did not wear such jewels. A lady would wear a small chain, with a small diamond." Adrian tried to make her understand that the character Marguerite Gautier was not a lady in that sense. "I told Greta that Marguerite's heart was of pure gold," recalled Adrian, "but her taste in diamonds ran to quantity and extravagance. The impasse ended as it usually did. Garbo wore what I thought she should. We did have our little battles, she and I. Still, my studio was my fortress, and I fought to win. This time the ultimate victory was hers. When she carried the necklace, she made it beautiful beyond comparison."

These were images to be marveled at, and Adrian's brilliance was applauded. Few in Hollywood knew the difficulties he had in getting them onto the screen. Garbo's fitting-room decorum was unlike that of other stars. In the first place, she showed up when she felt like it. Most stars were intolerant of tardiness. "If another star infringed on their time," said Adrian, "there was a note of impatience. However, if Garbo came in early or fitted late, the other stars were willing to adjust their schedules. For some reason, they accepted her peculiar form of selfishness. Perhaps like members of the worldwide Garbo cult, the

Previous pages: Adrian's original sketch for a gown and cape made of silk velvet with elaborate embroidered details. A photograph of the finished costume for *Mata Hari*, 1931.

Following pages: Adrian's sketch of the iconic Greta Garbo wearing a dramatic costume of fully beaded pants and a long overshirt for the film *Mata Hari*, 1931, and a photograph of Garbo wearing the costume.

'Garbomaniacs,' these actresses thought Garbo belonged to her own special tribe."

When Garbo arrived at Adrian's studio, it amused her to enter quietly and then call out "Hopsack!" Then, as he stood there, she would jump into the air and land with her arms around his neck and her legs around his waist. "Carry me! Carry me!" she would say. "If her mood was a merry one," wrote Adrian, "I was a pushover for her charm and would carry her around the studio with pleasure. There were times, particularly if she'd come in late, that I felt like letting her fall on her fanny—charm, glamour, and all." There was also the matter of her appearance. "Garbo dared to be unconventional," wrote Adrian. "She disliked dressing up. She usually showed up in a gray sweater and slacks. Sometimes the sweater was long overdue at the cleaners. I always had the fitter put a muslin pattern on her first, to see how the costume would look and how it would move. She did nothing to lend allure to the image. She usually wore white sneakers, and they stuck out from under the skirts like duckbills."

When Garbo came to Adrian's studio in June 1936 to be fitted for *Camille*, he wrote highlights of her visit in a journal.

Today, arriving at my studio, I find Greta waving frantically at me from her car, "Why, of all days in the world, did these hundreds of people have to arrive and sit practically on your doorstep?" At least two hundred extras are hovering around the entrance to my studio. Greta pulls her coat high about her neck, adjusts her green Isinglass sunshade, and we push our way through to my door. Hardly anyone notices her. She is delighted. She hurries to the quiet of my rooms.

Now Hannah, Mildred, and Sara arrive, loaded with patterns, dresses, and hats for the fitting. I close my eyes and Sara turns her back while Hannah slips one of the designs on Greta. Her hair is very uncombed and hanging in a shaggy mess. It's most dreadful for judging hats. She doesn't seem to care. "Have you seen anything more awful?" she laughs. I never have. We must

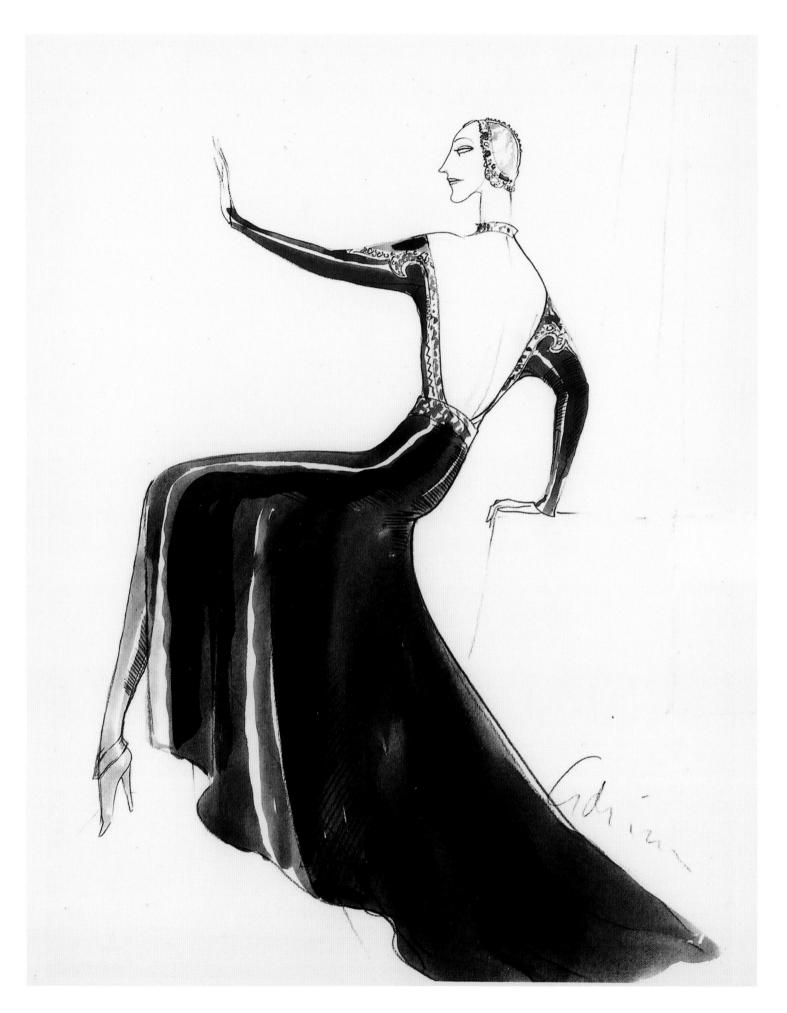

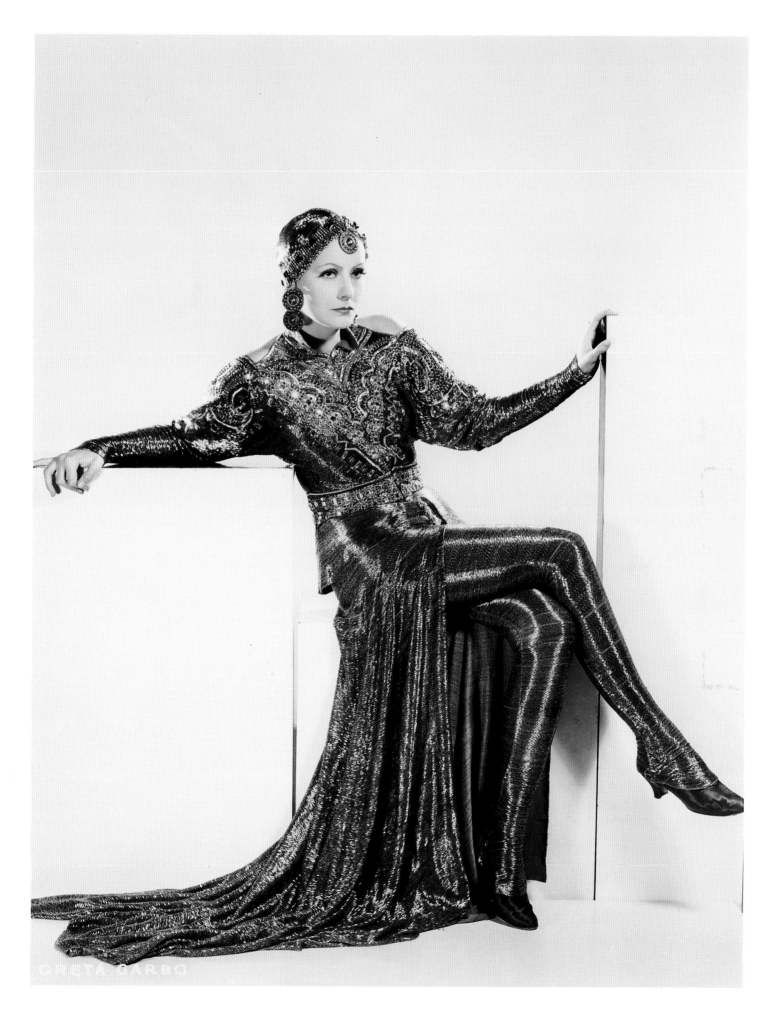

GRETA GARBO

look beyond it and see her mentally on the screen. It takes all the imagination I possess to visualize the glamorous finished costume on this bedraggled woman. At times, watching her standing in the robes of a queen or wearing a devastating evening gown, with hop sneakers on and her hair unwashed, I have wondered how we would make it.

We try one hat after another on her. She shrieks with laughter. She puts a hat on backward. We like it. It becomes fantastic. I beg her to wear it that way. She pulls it in a more ridiculous fashion. We fit it like that. We laugh 'til we cry. We decide it must be worn like that. Slowly it begins to be taken more seriously. The ridiculous has become sublime. Her disheveled hair is forgotten. She for one fleeting moment crystallizes into something very beautiful and remote. I have learned from experience that on the day of shooting, when she finally washes her hair, puts on her film makeup, and steps into high-heeled shoes, she will once more look like M-G-M's Garbo.

If the best friendships are made at work, Adrian could boast of talented and congenial friends: the writers Aldous Huxley, Christopher Isherwood, and Clemence Dane; choreographer Agnes de Mille; photographer Cecil Beaton; director George Cukor; designer Elsie de Wolfe (aka Lady Mendl); and actor Cary Grant. Garbo socialized with most of these celebrities singly but rarely in a group. She preferred the company of rich, cultured dilettantes like Mercedes de Acosta and Salka Viertel, for whom she secured writing contracts at M-G-M. Because Garbo had developed an extreme distaste for studio executives, she forced the company to hire "writers," who ultimately wrote nothing for the screen but were solely brought in to act as go-betweens. It was a weird arrangement but, as Adrian grew to realize, it was Garbo's way.

"The Garbo world was not only lopsided but also one of the most complicated and exasperating I would ever know," recalled Adrian. "Garbo was incapable of directness. I could never go straight

to any point with her or use a direct route. I had to zigzag. She was also capable of a guilelessness that was ensnaring."

When you were with Garbo, you were sure you had never seen anyone so enchanting in your life. When she radiated that magical glow, you were sure that you alone had the key to her friendship. But if you were so rash as to mention that you had seen a mutual friend the day before, Garbo would become a frowning, petulant abstraction. She would turn on you in anger and ask you why you were always bringing up this person's name.

A friendship with Garbo brought you into a world of secrecy. It did not take long for her to school you in the rules. You were not to discuss her with your friends, and certainly not with mutual friends. You were not to disclose that you had seen her. If you were walking with her on the street, you should avoid greeting a friend; if possible, you would dart down a side street to avoid him.

You were never to make a definite date with Garbo, but if she wished to see you, you were expected to break any date you had. Upon her arrival at your house, she would immediately rush into the kitchen to look into the pots on the stove and charm the cook. You were invited to call but you never expected to be asked for dinner, lunch, or tea. Occasionally you were offered a carrot from her lunch box, but it was Garbo etiquette for you to graciously refuse. You could give her a gift, but you were not to expect a thank you in any form. Certainly you were never to know if she derived a moment's enjoyment from it.

After years of jumping through hoops, some of Garbo's friends gave up. Whatever they had seen in her did not justify this silly rock and roll. However, there were some who could not forget the enchantment of her screen performances. In person, too, she was extraordinarily, magnificently beautiful. To enjoy this beauty, these friends were willing to endure her demands.

In spite of her apparent seclusion, Garbo was not unaware

Following pages: Greta Garbo in a man-tailored velvet tunic and pants as the Queen of Sweden in *Queen Christina*, 1933, and in contrasting court attire. The silk velvet gown, encrusted with hand-embroidered panels, was one of the most expensive costumes Adrian ever created.

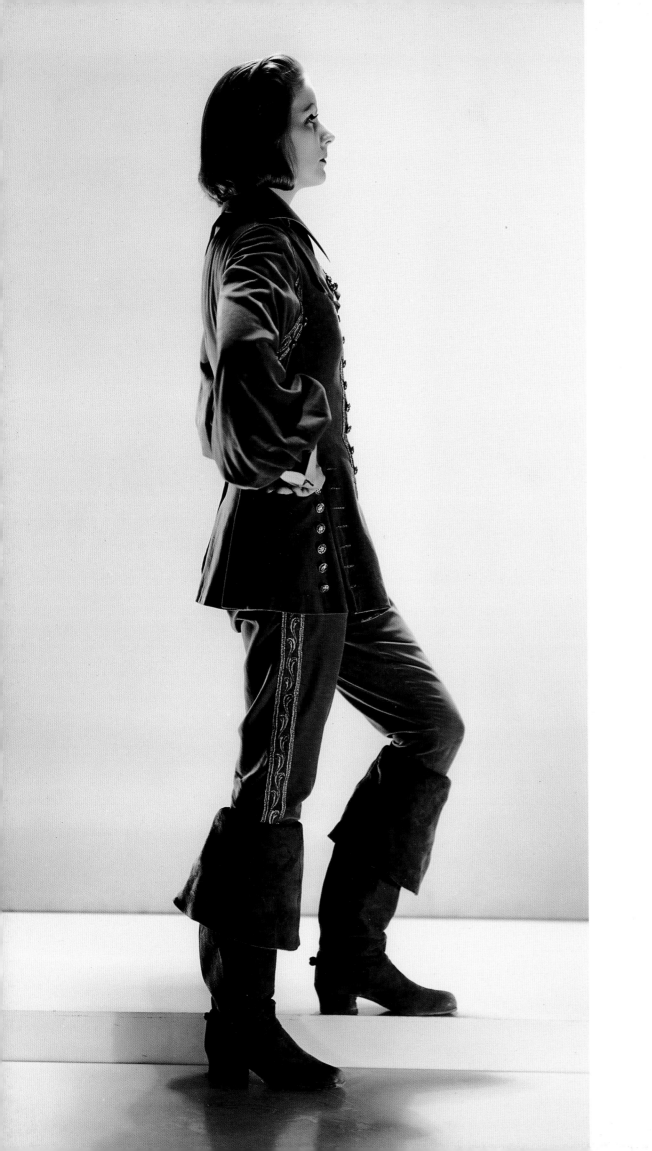

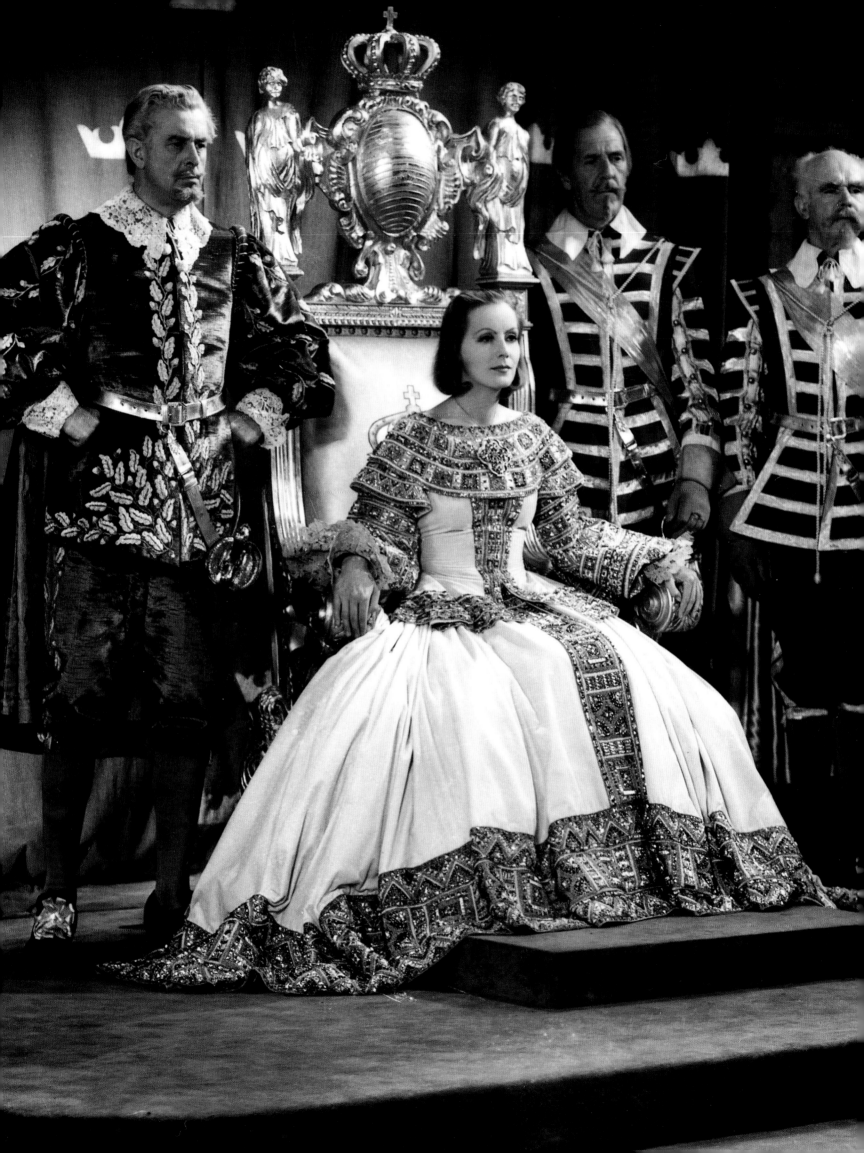

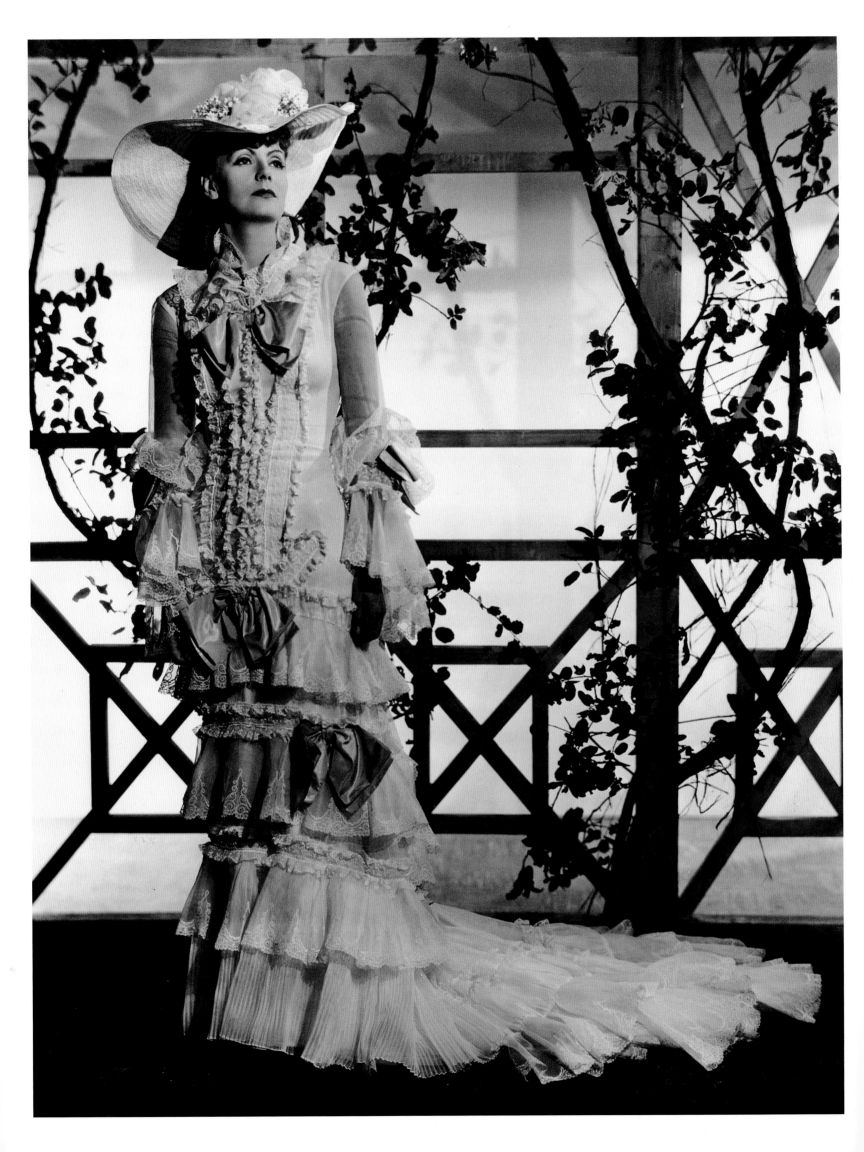

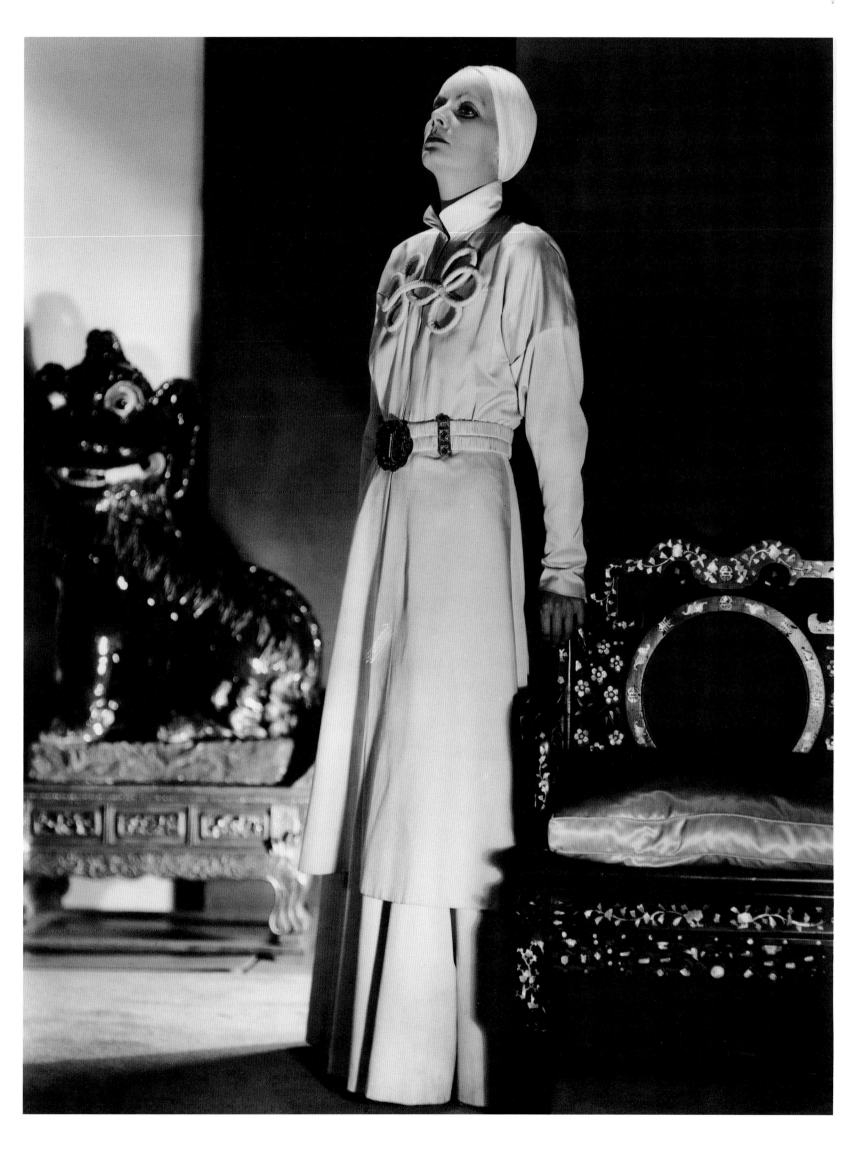

of romance. She left a long trail of heartbroken swains, although in truth they were not too heartbroken. Garbo did not bring out a sense of gallantry in a man. She made the rules. She tried to force him into her way of living, and too soon. No man was allowed to remain himself. He became a dog on a leash and the tugging did not lead to a pleasant walk. Photographs of them walking with her showed them invariably six or eight feet behind her as she rushed ahead, acting as though she did not know they were there.

Many of them were men of talent and offered much to her. She never hesitated to take what they offered, but she did so with the selfishness of a spoiled child and then turned away from them. Fortunately most of the men were more mature than she was, and they were patient with her rudeness and thoughtlessness until their good natures were eventually tried beyond repair.

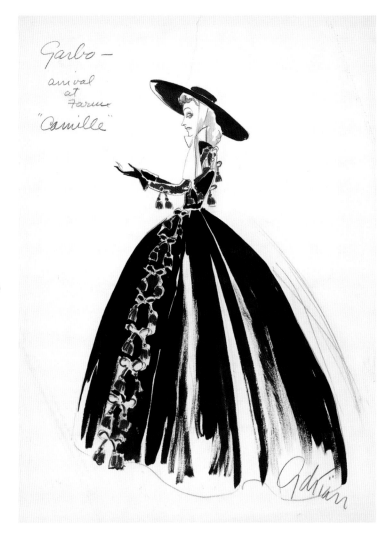

History is populated with women who were so beautiful that they fired the imaginations of men, but so tyrannical that they ended up alone, steeped in their own frustrations. Garbo was one of these sirens. Somewhere in early life, something very terrible must have happened to her, something very hurtful, for her to live in such a state of mistrust.

If Garbo can offer so much beauty to the world, what does it matter if she is difficult? It does not matter, unless you want to become her friend. Then you must not expect anything

Previous pages: Greta Garbo in costume for the film *Anna Karenina*, 1935 (left) and *The Painted Veil*, 1934 (right).

Above: Original costume sketch for Greta Garbo in *Camille*, 1936.

Opposite: White organdy gown and straw hat for Greta Garbo in *Camille*.

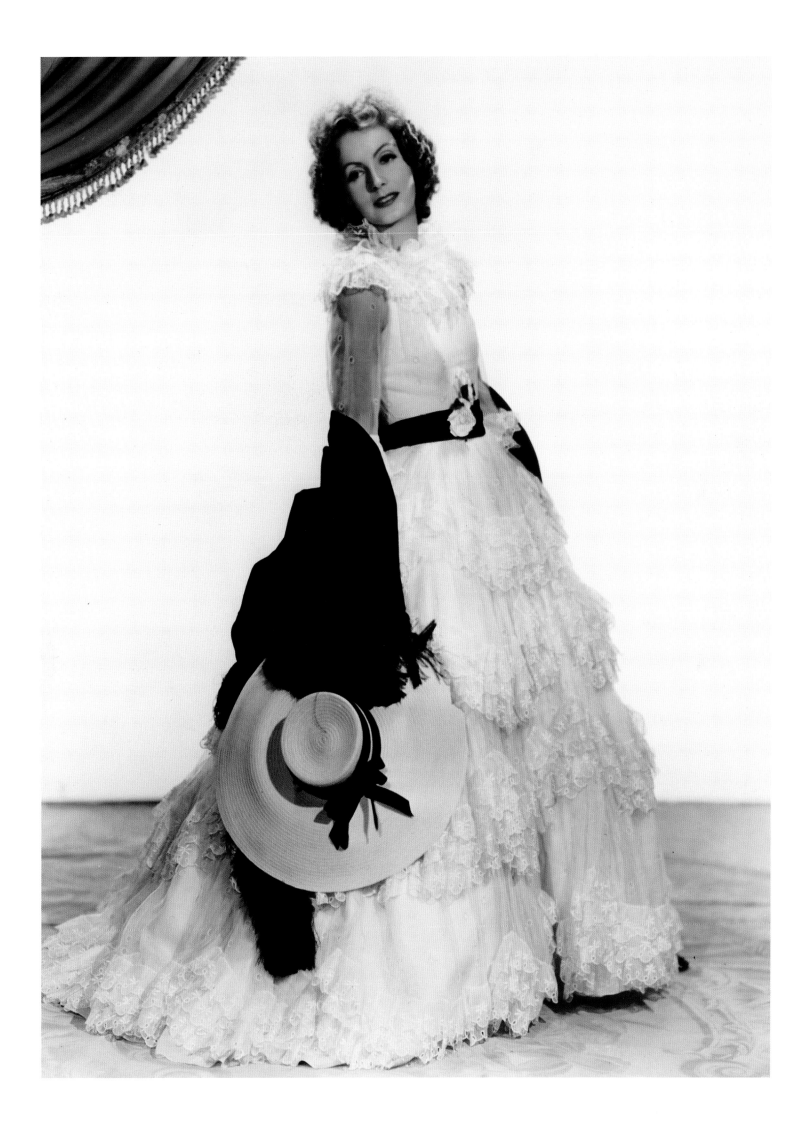

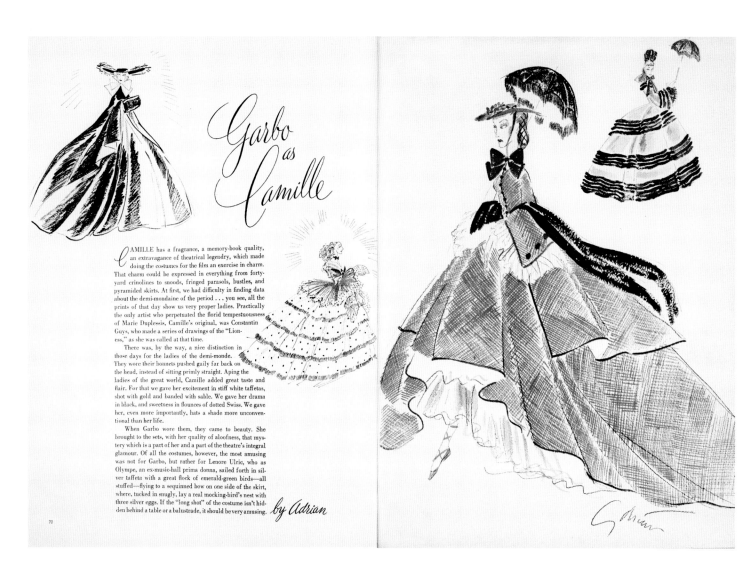

Garbo as Camille

CAMILLE has a fragrance, a memory-book quality, an extravagance of theatrical legendry, which made doing the costumes for the film an exercise in charm. That charm could be expressed in everything from forty-yard crinolines to snoods, fringed parasols, bustles, and pyramided skirts. At first, we had difficulty in finding data about the demi-mondaine of the period . . . you see, all the prints of that day show us very proper ladies. Practically the only artist who perpetuated the florid tempestuousness of Marie Duplessis, Camille's original, was Constantin Guys, who made a series of drawings of the "Lioness," as she was called at that time.

There was, by the way, a nice distinction in those days for the ladies of the demi-monde. They wore their bonnets pushed gaily far back on the head, instead of sitting primly straight. Aping the ladies of the great world, Camille added great taste and flair. For that we gave her excitement in stiff white taffetas, shot with gold and banded with sable. We gave her drama in black, and sweetness in flounces of dotted Swiss. We gave her, even more importantly, hats a shade more unconventional than her life.

When Garbo wore them, they came to beauty. She brought to the sets, with her quality of aloofness, that mystery which is a part of her and a part of the theatre's integral glamour. Of all the costumes, however, the most amusing was not for Garbo, but rather for Lenore Ulric, who as Olympe, an ex-music-hall prima donna, sailed forth in silver taffeta with a great flock of emerald-green birds—all stuffed—flying to a sequinned bow on one side of the skirt, where, tucked in snugly, lay a real mocking-bird's nest with three silver eggs. If the "long shot" of the costume isn't hidden behind a table or a balustrade, it should be very amusing.

by Adrian

70

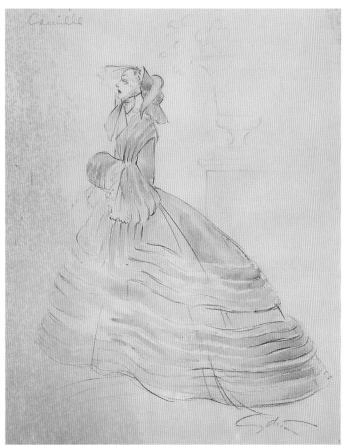

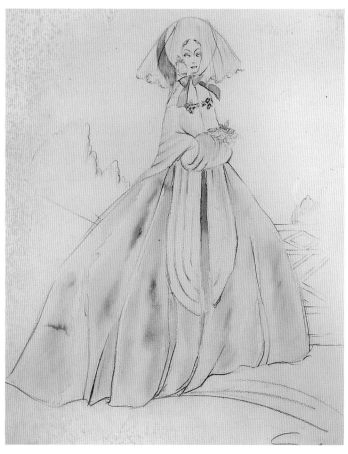

Various Adrian original costume sketches for Greta Garbo in *Camille*.

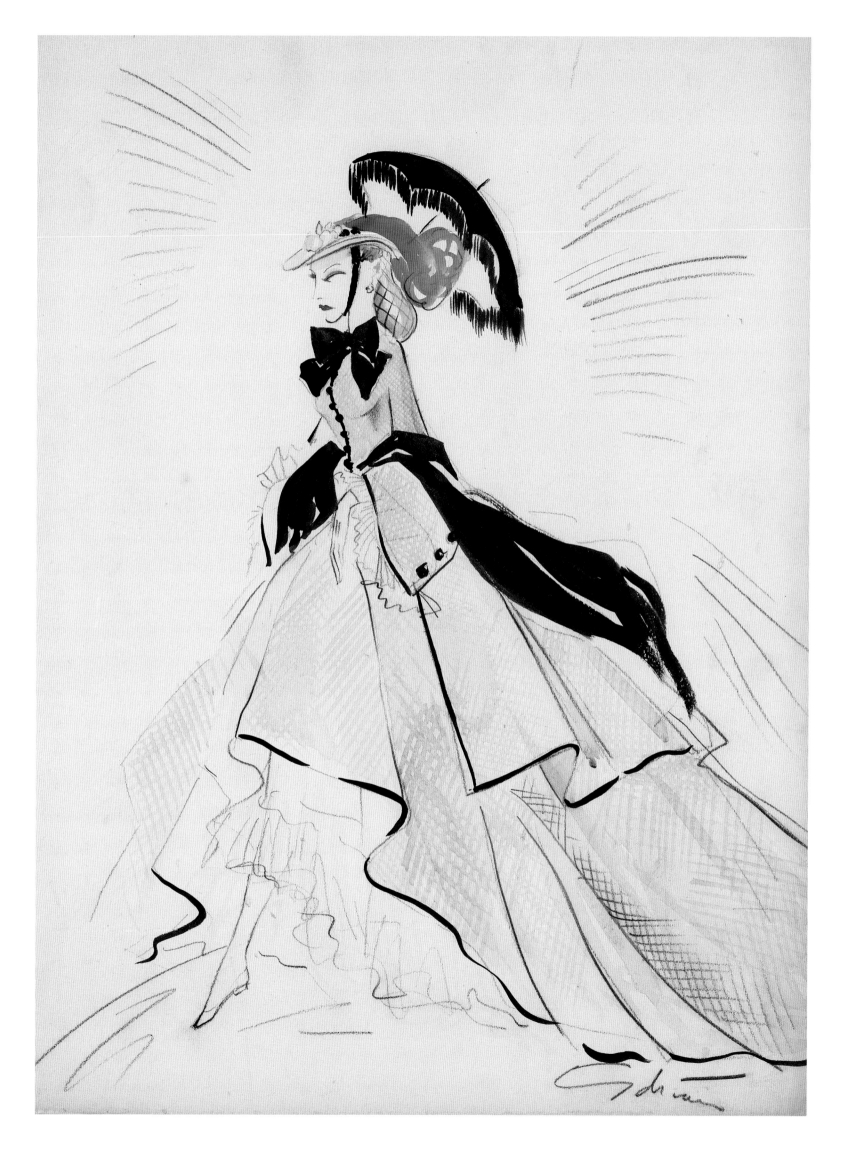

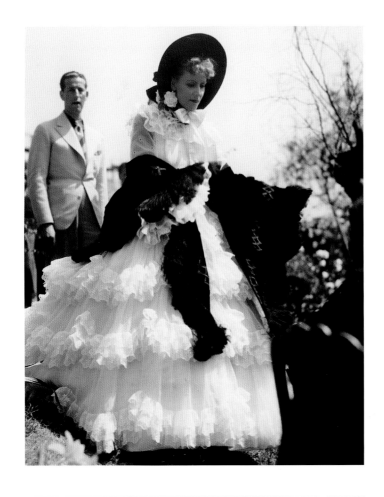

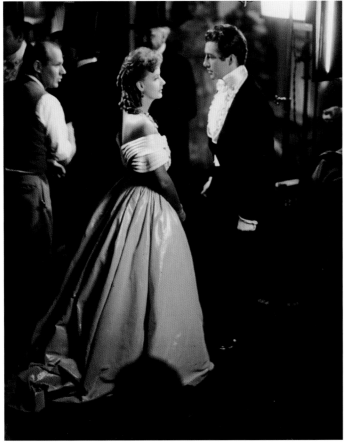

This page: Greta Garbo in three candid photographs on the set of *Camille*, one of which shows Adrian in the background. The other two photographs are of Garbo with co-star Robert Taylor.

Opposite: Adrian's silk velvet and fur-trimmed ensemble for Greta Garbo in *Camille*, 1936.

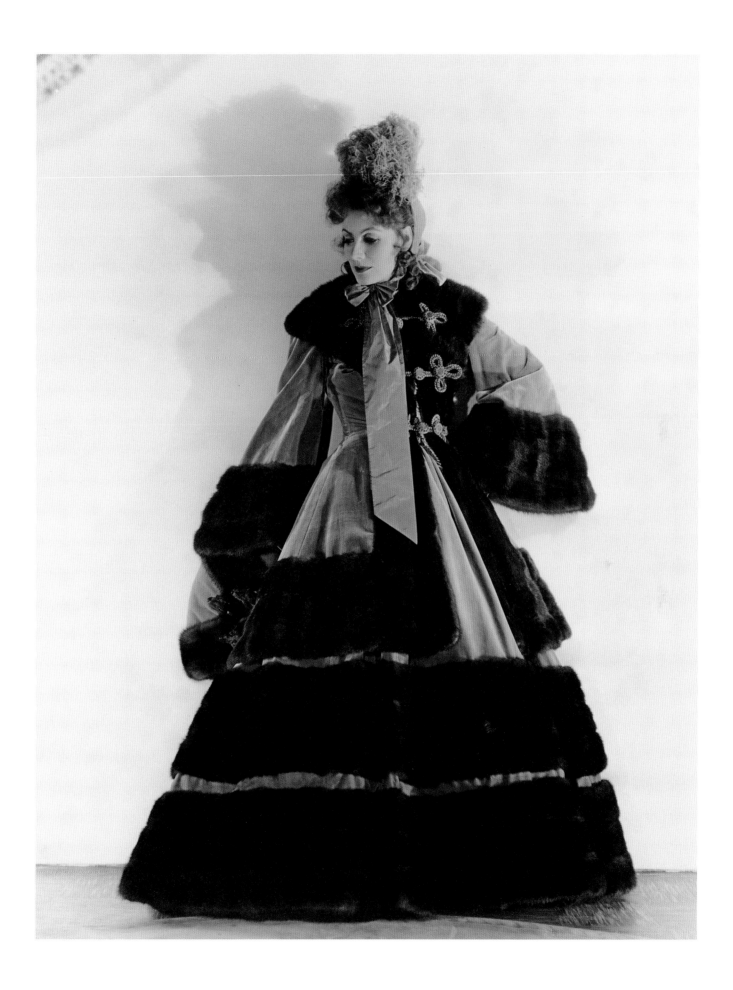

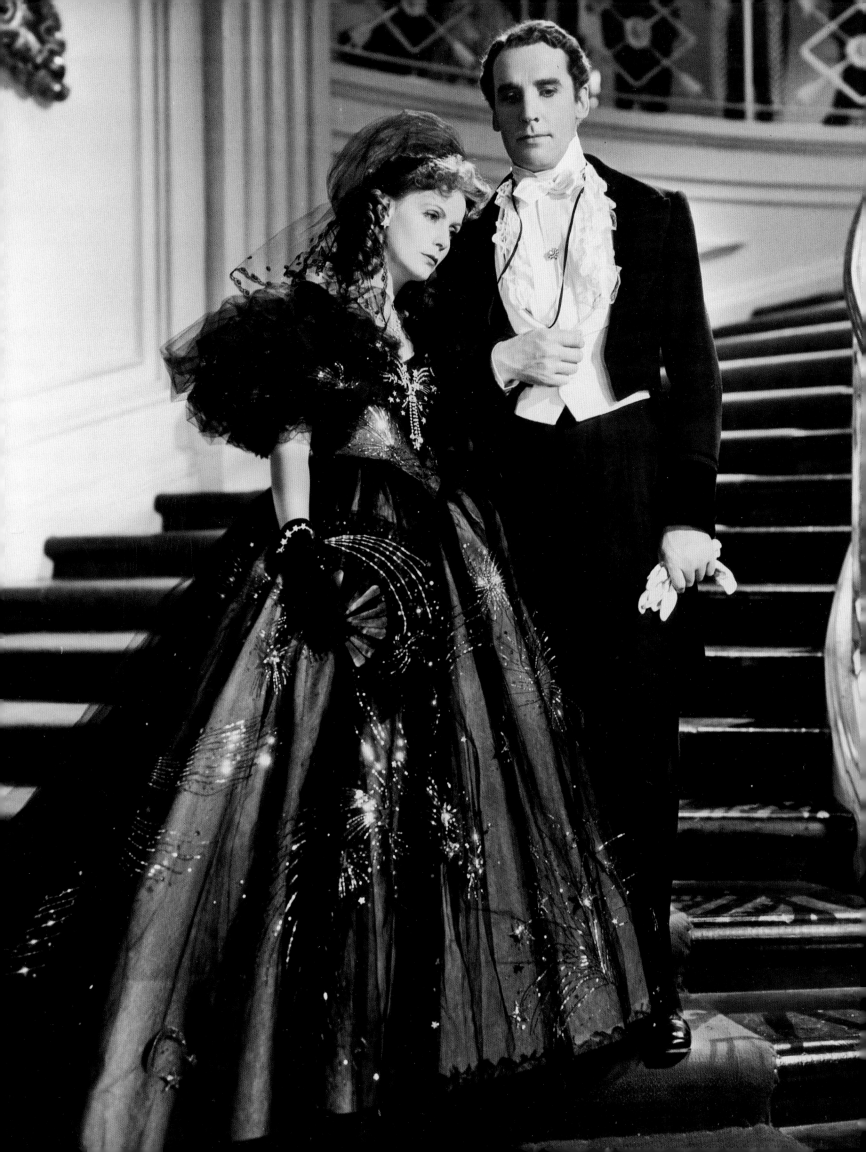

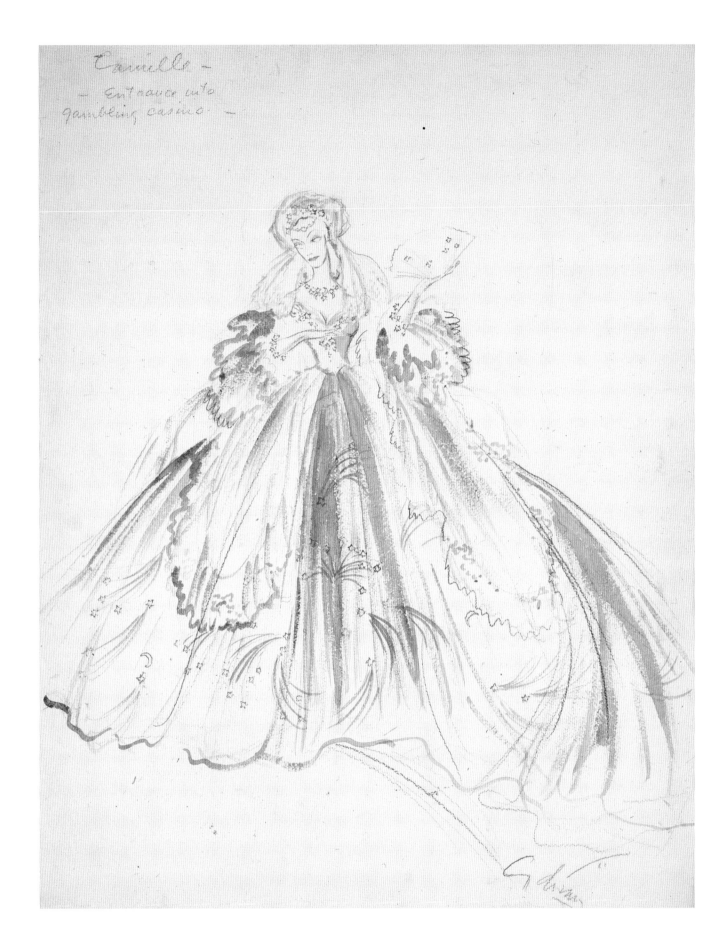

Camille –
– Entrance into
gambling casino. –

Opposite: Greta Garbo on the
staircase with actor Henry Daniell
wearing the "Shooting Stars"
embellished tulle gown in *Camille*,
1936.

Above: Adrian's original sketch of
the "Shooting Stars" gown.

remotely like friendship. The experience has evaded Garbo. Her chameleon-like nature seems to defeat it. In the years I knew her, Garbo had a tendency to use a queen's approach to life. I often felt like crowning her, but not with a tiara.

Adrian and Garbo scored a success in 1939 with Ernst Lubitsch's *Ninotchka*, because it was her first comedy, and she sparkled in it. Why not do another, asked M-G-M. Adrian sensed danger. "When the glamour ends for Garbo," he said, "it also ends for me. She has created a type. If you destroy that illusion, you destroy her." The studio insisted on doing exactly what Adrian had warned against, casting her against type. *Two-Faced Woman* was a curious remake of *Her Sister from Paris*, the film for which Adrian had gotten his first on-screen credit. Gottfried Reinhardt was the producer, some years after his impresario father, Max Reinhardt, had brought him to Hollywood. Gottfried was young and self-impressed. "We want no more of the old Garbo," he snapped at Adrian. "We want a new Garbo, more like the typical American girl."

"It can't be," Adrian shot back at him. "Garbo is not a typical American girl. You have plenty of those already. Garbo is a special person. She must be treated—*presented*—in a special way. It will never be a success."

Adrian began the task grudgingly but soon became excited, designing fourteen dazzling costumes. Director George Cukor, undertaking the project against his better judgment, was told to scrap these designs and use existing costumes, which were altered to fit Garbo. Adrian was incensed. Before the film started shooting, he went to Garbo's dressing room to say that he was terminating his contract with M-G-M.

"I will never forgot her last words," wrote Adrian.

"Goodbye," she said to him. "I am sorry you are going, but I must say I never did like very much the clothes you made me wear in my pictures."

Adrian's original sketch for the last dress he designed for Greta Garbo in *Two-Faced Woman*, 1941. The dress was completed but never worn in the film.

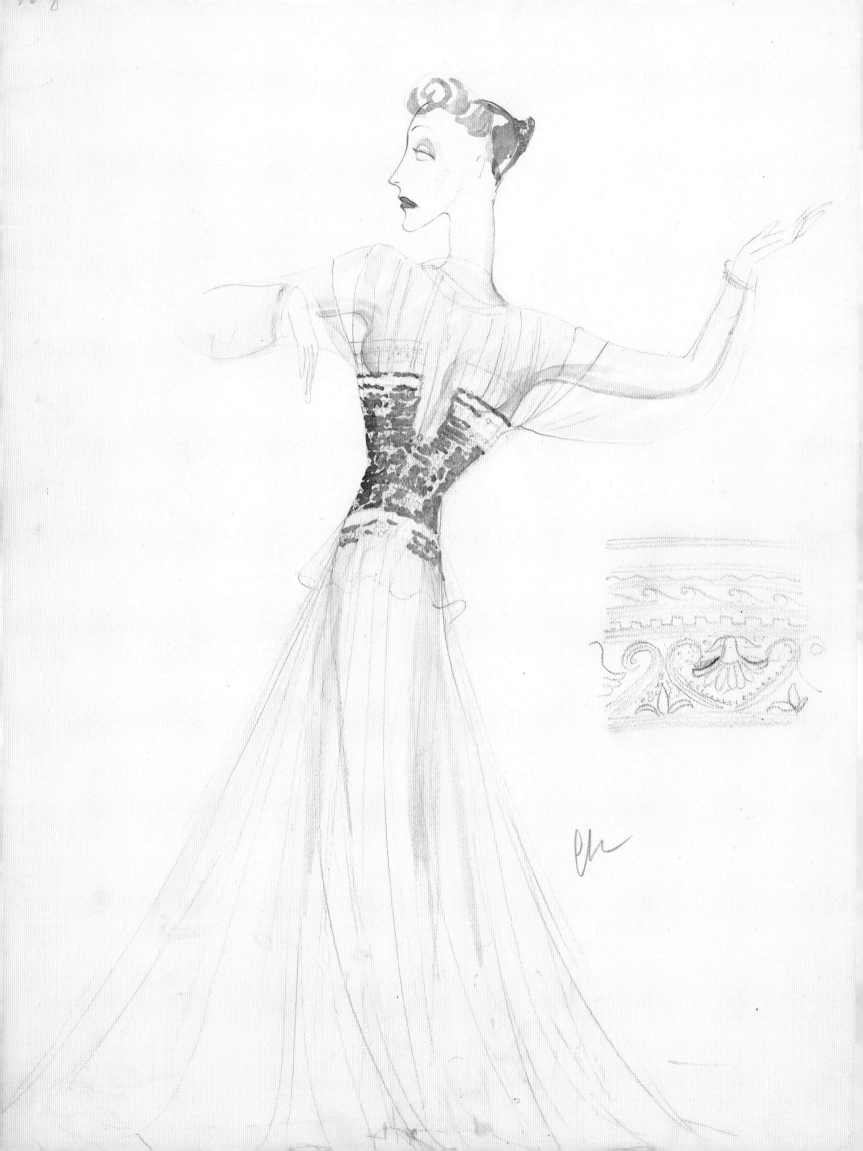

JANET GAYNOR

Adrian met Janet Gaynor in 1931, and under odd circumstances. She was one of the top ten stars at the Fox Film Corporation. Gaynor had been the first winner of the Academy Award for Best Actress in 1928. After falling ill with appendicitis, she was told by her studio's designer that she had lost her figure and was impossible to dress. Gaynor bypassed her bosses and asked Louis B. Mayer if he would allow Adrian to design the gowns for her upcoming film *Daddy Long Legs*.

"I found Janet a bit nervous and eager," wrote Adrian. "During her fittings I had much work to do on other pictures but would look up occasionally from my sketching. Janet later told me, 'You were very charming, but certainly impersonal.' She sent me a warm note of thanks, which I still have. As they say in the movies, 'Years passed,' and in 1938 I was still at Metro. I was invited to a dinner party. At this party, I again met Janet, and we sat in a corner and talked for a long time. That little arrow which people talk about must have hit me that night. I could not get her out of my mind after that."

Gaynor had recently emerged from a short career slump with a powerful performance in William Wellman's *A Star Is Born,* and she was in demand. Adrian persuaded a mutual friend to host quiet dinner parties, and he got to know Janet. Visiting her beach house with the same friend, Adrian contrived to spend an hour alone with her. "When I got home that night," wrote Adrian, "I really had it. I was so in love that I had pains and tossed about in bed. I couldn't sleep, couldn't read, wanted to telephone Janet but felt it was too late. I had a wonderful, miserable time. I didn't go to my office the next day because I couldn't concentrate."

That night Janet came to dinner at Adrian's home in Toluca Lake. They sat in his garden under a large pepper tree. The moon shone

Previous page: A beautiful photograph of Janet Gaynor by John Engstead, 1944.

Above: A drawing of Janet Gaynor by renowned *Vogue* fashion illustrator René Bouché. The Leonard Stanley Collection.

Opposite: Cecil Beaton's portrait of Janet Gaynor circa 1945. Janet said, "Cecil Beaton captured me better than any other artist." The Leonard Stanley Collection.

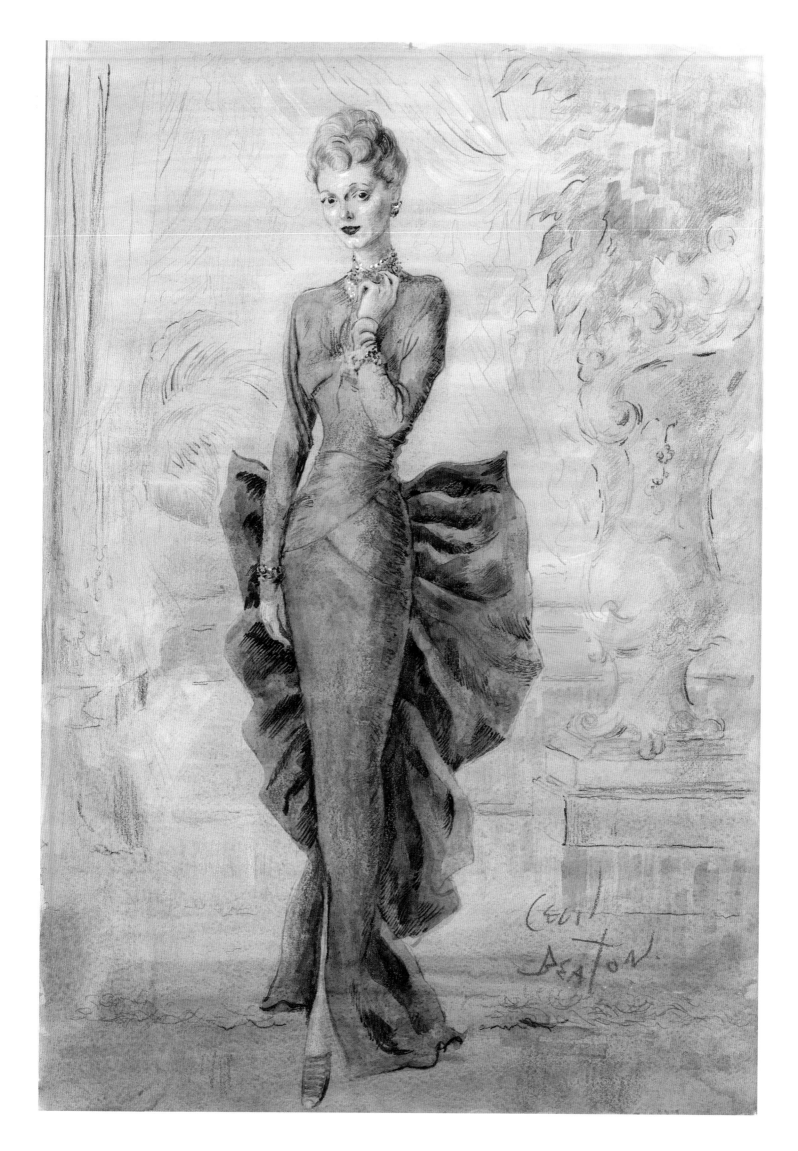

through its feathery leaves, lighting her as prettily as a movie close-up. But the true light came from within. "Anyone who has ever met Janet knows what illumination emanates from her," said Adrian. "I found that illumination to be a happy thing in my lonely life. She was in direct contact with a gay and spiritual current, and to be with her was a joyous experience." A Hollywood romance began that night.

"As I observed Janet's many-faceted nature," wrote Adrian, "I was overcome by her honesty. She was tiny in size, yet she had true

Adrian and Janet boarding the train for their honeymoon trip to Mexico City in 1939.

stature. Her spirit was infinite and uncontainable. Her thinking—direct, never devious—was a joy. You always knew where you stood with her. She never broke her word, and her understanding was almost cosmic. In all the years of her career she never had an agent. All her business contacts were direct, because she would stand up for what she felt was correct, like a squirrel to a tiger. And yet she was always reasonable."

When Gaynor was loaned by David O. Selznick to M-G-M, Adrian saw her during work hours, but a hairdresser said to her on the set, "Gee, Mr. Adrian must have a crush on you. He never stays around here this long." Janet showed no reaction to the comment. A short while later, Adrian entered her dressing room and asked her to dismiss her maid. Janet was concerned because the usually imperturbable Adrian was wild-eyed and nervous.

"Janet, will you marry me?"

"Let's take a bit more time," she responded.

The actress had never allowed herself to have a private life. "I had been working steadily for seventeen years," she said later. "Making movies was all I knew of life. I wanted to have time to know other things. I wanted to fall in love. I wanted to get married. I wanted a child. And I knew that in order to have these things, I had to make time for them."

Adrian and Janet were married on August 14, 1939.

"Suddenly, I was in a whole new world," recalled Janet. "I was married to a man whose whole life was about glamour, art, and high fashion. So I simply stopped making movies. Then, as if by a miracle, everything I wanted happened." On July 6, 1940, their son, Robin Gaynor Adrian was born. Janet retired from films to raise their son, and, after Adrian left Hollywood, she was an active participant in all his business ventures. "We both liked wide open spaces more than cities," wrote Adrian, "and we liked the same people, and we wanted to explore life with the same curiosity."

ADRIAN, LTD.

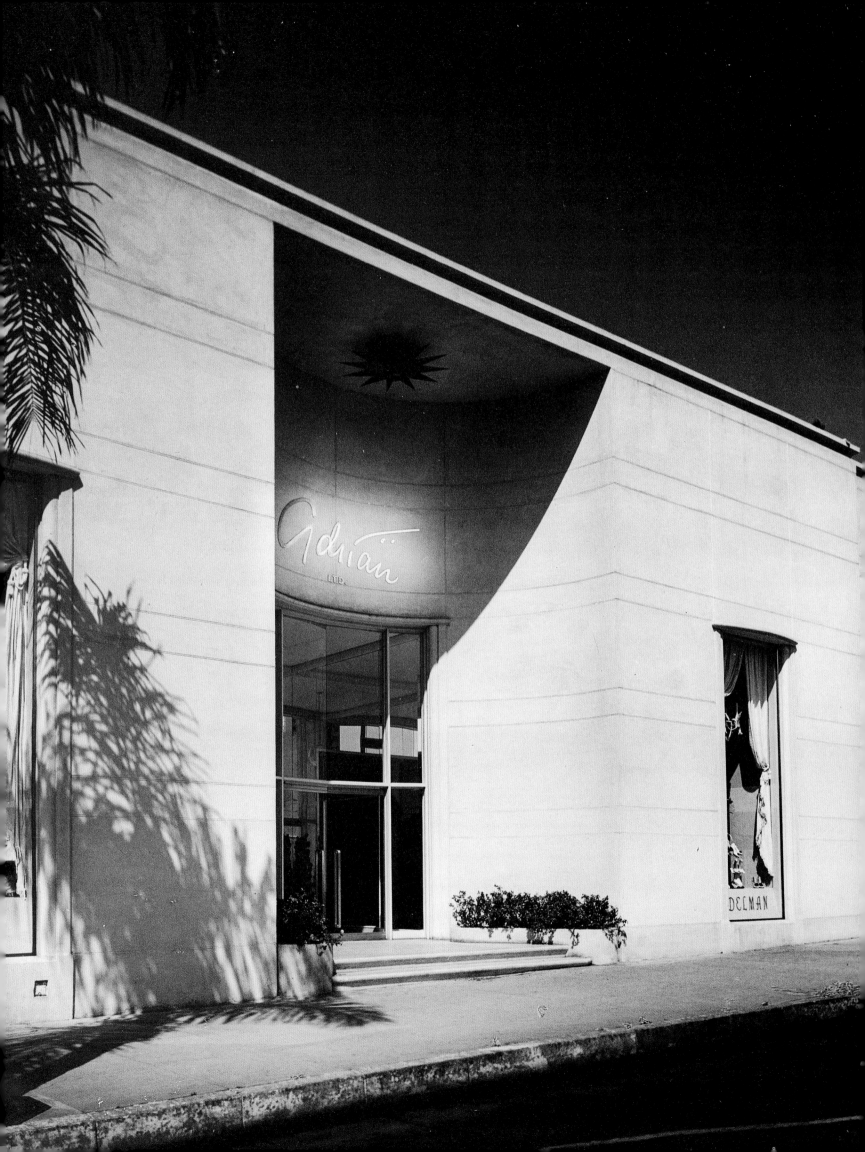

n 1939, Adrian had done superlative work for his favored subjects—Norma, Joan, and Greta—in three hits, *Idiot's Delight, The Women,* and *Ninotchka.* Even then, 1939 was being touted as "Hollywood's Greatest Year." Great films were everywhere. Still, Adrian reached a pinnacle with *The Wizard of Oz.* Drawing on his childhood enchantment with the books of L. Frank Baum, he designed costumes —not just gowns—that assured the film's greatness.

After this profusion of classics, 1940 was a letdown. Europe was denied American films, and M-G-M was relying on formula.

The world was choosing sides in a global conflict, and Hollywood, tense with anticipation, was caught up with change. Adrian was, too. In 1939, Adrian married movie star Janet Gaynor, and they lived in his Toluca Lake house.

"Everything seemed to be changing," wrote Adrian, "myself most of all. When the studio decided to turn Garbo into a sweater girl, I decided it was time to make my own change. Janet was understanding, and she was eager for me to do what I felt best. When I told Mr. Mayer, he could not believe I was serious. I said that our association had been a happy one, too nice to ruin, and so I wanted to leave. Mr. Mayer was extremely complimentary about what my work meant to him and the studio. Nevertheless, the only thing for me to do was find a new pattern for my life." After an association of over thirteen years, Adrian formally left M-G-M in September 1941.

The war had interrupted Paris's domination of the fashion world, and American women were turning to American designers. Adrian's plan was to open his own salon, offering custom designs as well as "fashions for immediate wear." He reasoned that his name would be

G d r i a n

PRESENTS HIS FIRST COLLECTION
FOR THE FALL AND WINTER
OF 1942

⋅:⋅

Previous page: Interior of the main room in Adrian's Beverly Hills salon, 1942. Photograph by Maynard L. Parker.

Opposite: Main entrance of the Beverly Hills salon, 1942. Photograph by Maynard L. Parker.

Above: Program cover for Adrian's first Fall and Winter collection of 1942. There were approximately 125 pieces per collection.

enough to sell his designs through department stores nationwide. The Victor Hugo restaurant had just closed, leaving a spacious structure in Beverly Hills. To buy this Wilshire-adjacent property, remodel it, create a fashion line, hire a staff, and publicize an opening would require partners. Adrian asked for help from Woody Feurt, a fashion and merchandising expert whom he had known since 1929 when Feurt presided over the opening of the French Room in Bullock's Wilshire and, more recently, with Henri Bendel in New York.

Architect Claud Beelman remodeled the building and Eleanor Le Maire designed the interiors. The new company would be called Adrian, Ltd.

"As the building progressed," recalled Adrian, "Janet and I wandered through it and the two salons looked larger each time we entered them. The ceilings were twenty-five feet high. The made-to-order room had a stage, with a lighting system that could serve a theater." Le Maire's palette of creamy ivory, powder pink, and pale blue-green was a color combination that Adrian dubbed "glamorose."

When Japan attacked Pearl Harbor, the United States was pulled into World War II. Adrian geared up, hoping to stage his first show in mid-January, before wartime rationing restricted access to building supplies and fabrics. The restrictions arrived earlier than expected: in mid-December, Adrian was ordered to surrender his building to the War Office. It was time to strategize. The collection would debut not in Beverly Hills but at Villa Encanto, Adrian's Toluca Lake residence.

The premiere showing of Adrian, Ltd. took place in early 1942. "Buyers from all over America drove out to our country estate for the gala occasion," wrote Adrian. "We also welcomed writers and editors from *Town and Country*, *Vogue*, and *Harper's Bazaar*. Our living room was large and high-ceilinged, and Woody created dramatic lighting effects. I had carefully chosen music, and we seated seventy-five buyers from the most important stores in America—Bonwit Teller, Marshall Field's, and Neiman Marcus. We were hosting a cross-section of the country."

Main salon interior. Trophée on column designed by Tony Duquette.

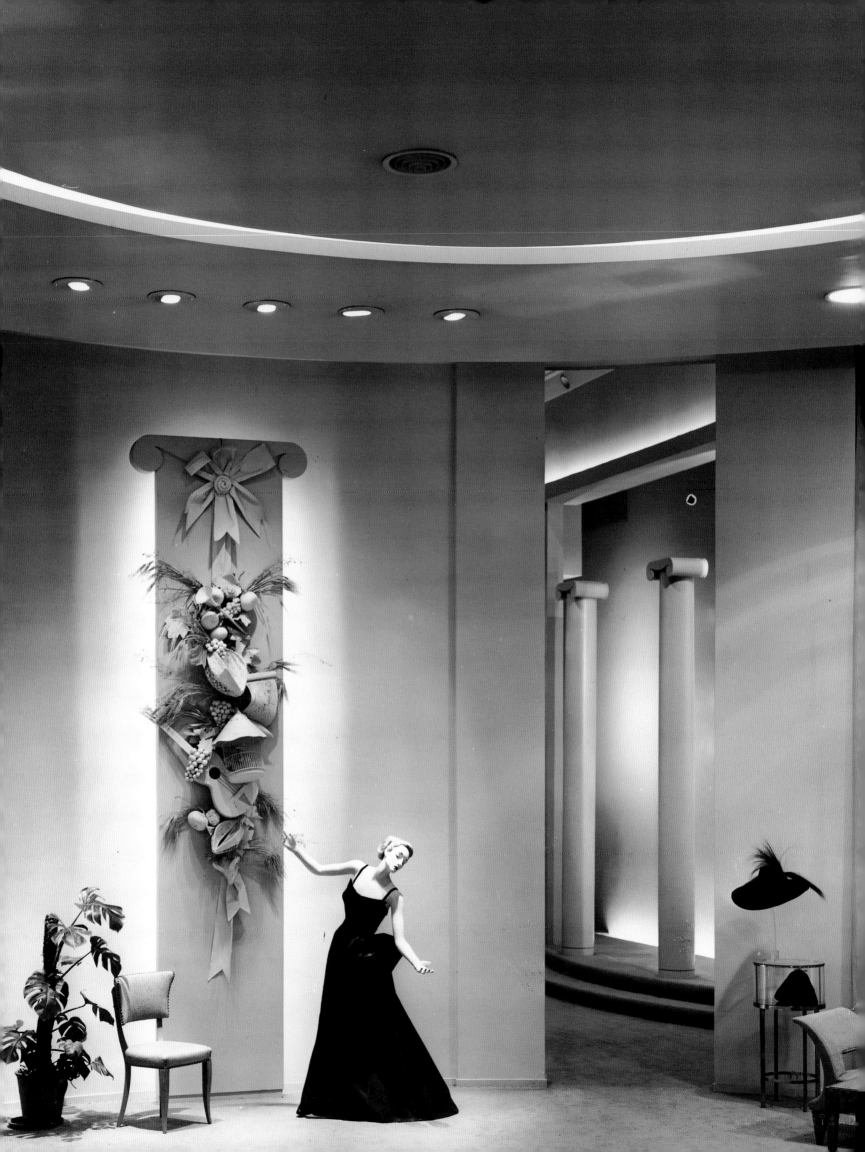

As the models paraded, Janet and I watched the buyers as eagerly as we watched the mannequins. Buyers are famous for their poker faces. Theirs is a competitive business. They avoid enthusiasm for fear that a competitor may take their cue and buy the same models. But these buyers were not behaving traditionally. The showing seemed to delight them. When they applauded, we thought we were not hearing correctly. Was it wishful thinking? The applause continued, loud and constant, and we were off to a glorious start.

On February 19, 1942, a second presentation was held, this time at a rented space in Beverly Hills. The show was an invitation-only event for Hollywood wives and leading ladies. Joan Fontaine, Greer Garson, Carole Landis, and Margaret Sullavan were among the guests. After the show, Jeanette MacDonald told Adrian that she would have modeled the gowns for free just for the opportunity to wear them.

In its March 15, 1942 issue, *Vogue* magazine wrote: "Adrian understands the role of his off-screen heroine, and the clothes to fit that role. They now fit the setting of real life, and they are made to give performances 365 days a year. They represent quiet distinction, wonderful fabrics, and excellent workmanship."

Fine-quality fabric was crucial to Adrian's work. He collaborated with fabric houses in both America and Europe, and he worked for hours with Pola Stout, a Polish weaver known for her fine woolens, to achieve fabrics with detail and lightness. Adrian also worked with Bianchini-Férier, a French silk house that had a New York factory as well.

Another boost came in mid-March, when the War Office informed Beelman and Adrian that their Beverly Hills facility was unsuitable for war work. But war was still raging. Would Americans want his designs? Adrian met with the owner of the building.

"Perhaps because of the uncertainty of these times," said Adrian, "it might be best to stay in our temporary quarters for a while and not continue with the building."

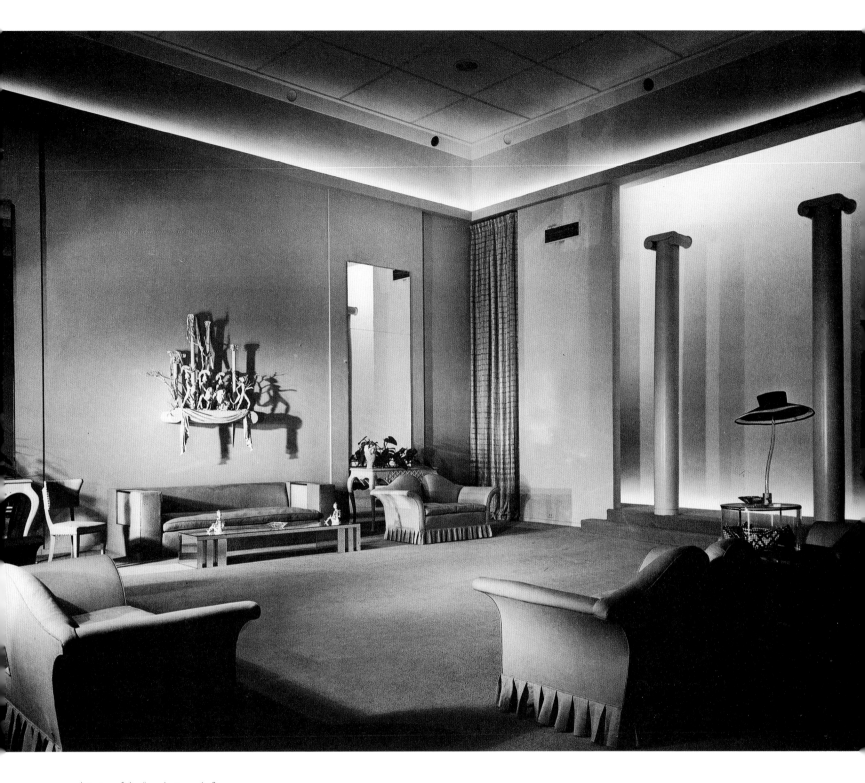

Interior of the "made-to-order" room with a stage and Ionic columns.

The landlord looked at him and smiled. "Did you ever hear the story of the two frogs? Adrian had not heard the story and the landlord continued, there were once two little frogs sitting on the edge of a butter churn. By accident they both fell in. After trying to keep afloat, one cried, I can't go on. I can't keep swimming! He gave up and drowned. The other frog kept paddling away and, before long, he churned a pad of butter under himself and had a place to rest. He was

saved. Now, which of these frogs do you want to be?"

"Well," Adrian said, "naturally, I think I'll swim." Adrian put Beelman and Le Maire back to work and then headed to New York for business. When he returned, there was more worrisome news.

"The buyers had not bought enough," wrote Adrian. "We were pouring money into the business at a frightening rate, and our auditor said that it would not be wise to open the new building, no matter how glamorous the prospect might appear. It would be suicide. Now the Adrians were in a real-life drama.

"The opening night in our new setting was like a movie," Adrian recalled, "only we were living it. We had spent a fortune on this venture. Would we succeed? One night would tell us."

As the sun set, limousines rolled up for the first time to the porte cochere of Adrian, Ltd.

"I had designed six scenes which were carried out by the designer Tony Duquette in his typically personal and spectacular manner. The lighting system, with a bank of dimmers for fifteen spotlights, was keyed to achieve every dramatic effect."

The music started. The first scene had a snowy Grandma Moses setting. As a sleigh with a cardboard horse galloped across the stage, mannequins modeled topcoats.

Then there was a Persian garden where models wore exotically styled housecoats and evening gowns. When they changed to suits, each girl led a life-size lamb on wheels. The crowd laughed when a wooly black sheep peeked out from behind them.

"For the finale, I needed to present a group of organdy evening gowns that were picturesque, romantic, and important to the collection. For a setting I decided on a hot summer night in New Orleans. I had secured authentic recordings of birds and frogs, and an engineer had mixed these sounds onto a single soundtrack. No music on this recording, just bird songs and frog calls."

"The salon lights were dimmed. In the darkness, the eerie sounds of a summer night took hold. The dimmer slowly brought up an ellipsoidal spotlight of pale blue. It shone like moonlight on a lacy white

Opposite: Interior of Adrian's Beverly Hills salon office.

Following pages: Adrian Ltd. display props designed by the talented Tony Duquette.

A NEW HAND IN THE AMERICAN COUTURE

Adrian

THAT fine creative hand of Adrian's, shown above, is now designing clothes for a new leading lady—the American woman. Half the leading ladies on the screen—Katharine Hepburn, Greta Garbo, Norma Shearer, Joan Crawford, and many others—have worn his clothes. Now, for the first time, he is focusing his talents on an off-screen heroine—the American woman.

And for this new star in private life, Adrian is producing a fashion Double Feature. For the woman who lives or visits in California, he is designing custom-made clothes. And for others, he is designing immediate-wear clothes, which will be shown in all the large cities, from Memphis to Minneapolis, from New York to Dallas, from Salt Lake City to Pittsburgh.

The curtain went up on this new production of Adrian's late in January. Before the official opening, there was a sneak preview...to which representatives of shops from all over America came by 'plane and train. The new building that will house Adrian clothes was not yet finished, and Adrian and his wife, Janet Gaynor, opened their private house to the preview...a house in lovely shades of green.

In this first collection of Adrian's, there are all the drama, the photogenic lines, the feeling for contrast that have made his film clothes such "good pictures." But more than drama is sewn into each seam. Adrian understands the rôle of his new off-screen heroine, and the clothes fit that rôle. They fit into the setting of real life: they're made to give three hundred and sixty-five performances a year; they have quiet distinction, an excellence of fabric and workmanship.

The day suits are excellent. Never melodramatic, never dull, they often have firm, rounded shoulders, deep armholes, slim skirts, jackets that fasten all the way up to the throat. Sometimes jacket contrasts with skirt, as in the black-and-rust suit opposite. Coats are loose and enveloping, or snugly belted. And one of the newest has a flaring skirt with a hem-line dipping low in back. You see it on page 64—in a clear bright yellow. Co-starring with coats, capes, and suits are flat little berets swathed with jersey snoods that frequently twist into chignons in back.

ONE of the hits of his evening collection is a new shirtwaist dress—the kind of a dinner-dress that plays such an important part in American wardrobes. Its blouse is white...a sort of glorified shirtwaist blouse ...its skirt is black and slim and slit and draped with great subtlety.

Another hit of his evening collection is cotton. Under Adrian's direction, gingham and calico turn in some clever performances. For one dinner-dress, nine different colours and sizes of checked gingham collaborate in a new way. Above a pair of green house pyjamas, Adrian puts a brown-and-white checked gingham coolie coat...sewing onto each check a shimmering green sequin. For a house-coat, he chooses black-and-white calico, adding, for a touch of good theatre, *moyen-âge* sleeves that touch the floor.

PHOTOGENIC LINES (OPPOSITE)

From Adrian's first collection of real-life clothes, a suit that makes a perfect picture, whether there's a camera around or not. Black jacket, rust skirt—both of Botany Perennial wool designed by Pola Stout. Costume custom-made for you at Adrian's new shop in Beverly Hills. Leather bag: Mark Cross ➡

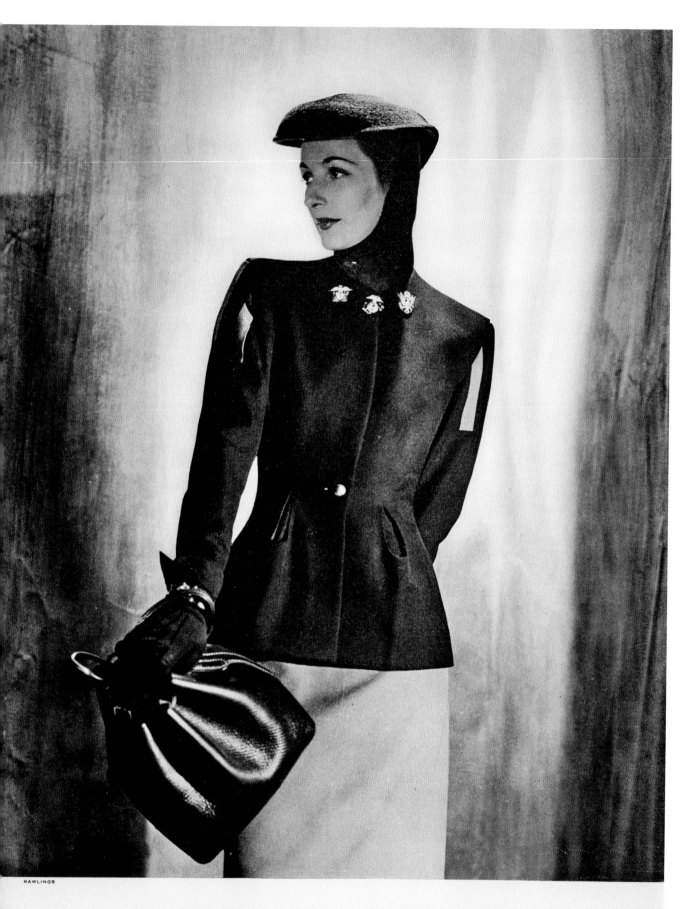

RAWLINGS

PHOTOGENIC LINES IN A SPRING SUIT

tree. The nimbus of light gradually expanded, including two enormous frogs made of emerald green lace. In the background, birds and frogs sang almost in harmony, their calls rising in a melodic chorus. One by one, our models glided into view, displaying the lovely gowns as blue and yellow light outlined their contours."

The buyers rose, and they applauded for two solid minutes.

Adrian's fashion shows became theatrical performances. He had managed to give the fashion world something that they had never before experienced.

When the evening was over, Janet and Adrian were relieved, and Woody [Feurt] was beaming. "The wild applause was followed by enthusiastic purchases," recalled Adrian. "After this our business was thriving. Orders poured in, and more importantly, reorders followed."

There was recognition from the industry that Adrian had belatedly joined. In 1943, he received the Neiman Marcus Award for Distinguished Service in the Field of Fashion. In 1945, he received the American Fashion Critics' Award (the Coty Award) from Mayor LaGuardia in New York.

Where Adrian had at one time created gowns to convey a personality, he was now helping American women to express their own personalities. "A purely American look was born," wrote Adrian. "Going hand in hand with a new informal way of living, it was a slim, clean-cut daytime look and an easy-to-wear evening look. American designers were given a chance to show what they were made of. They stepped forward to meet the challenge of the wartime limitations. Domestic factories began to weave fine materials. 'Designed in America' and 'Made in America' were proud slogans."

The war ended and, before long, Paris regained its dominance in the world of fashion. When Christian Dior's full-profiled designs were popularized as the "New Look" in 1947, and American women embraced the look, editors like Carmel Snow dismissed Adrian as a passé designer resisting the superiority of Paris. Adrian did not take these attacks lying down. He continued to design as he saw fit,

Previous pages: 1942 *Vogue* article describing Adrian's first collection for Adrian, Ltd.

Opposite: Adrian designed this coat using gingham, one of his favorite fabrics. The coat is quilted and embellished with scattered black sequins.

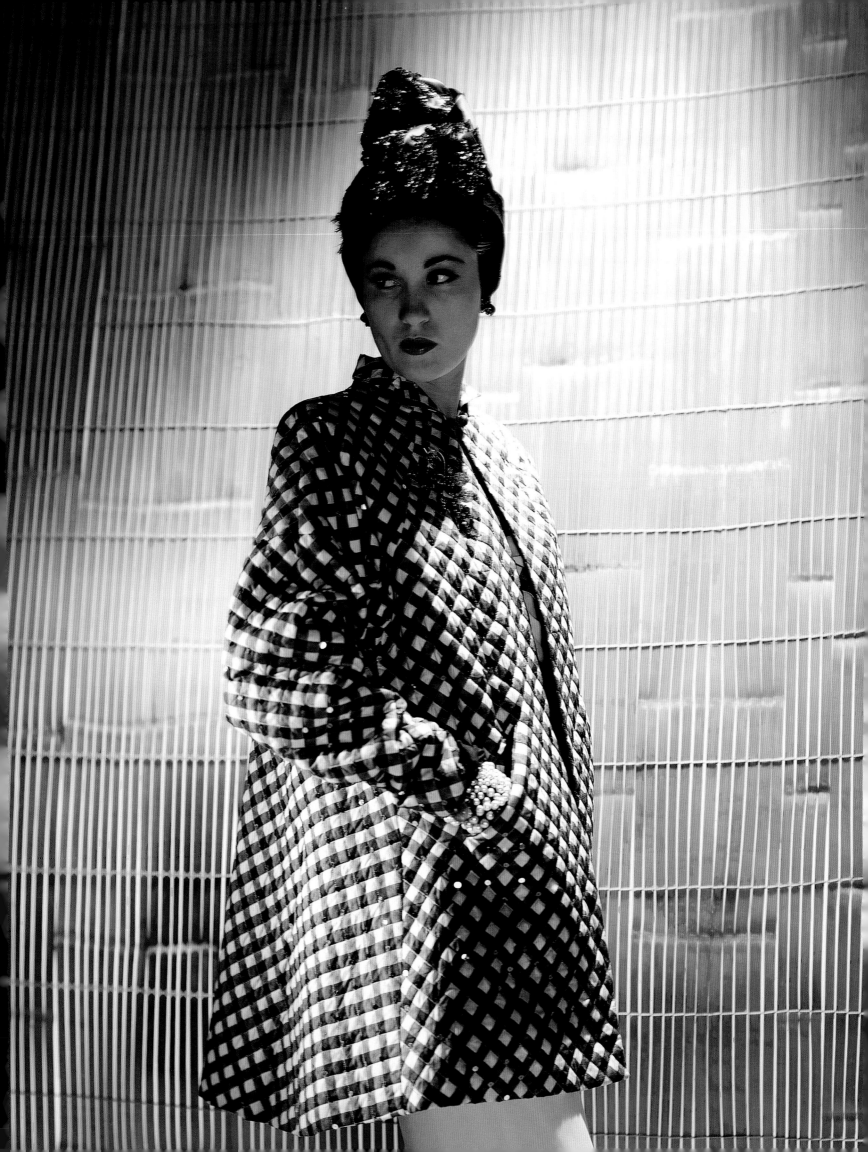

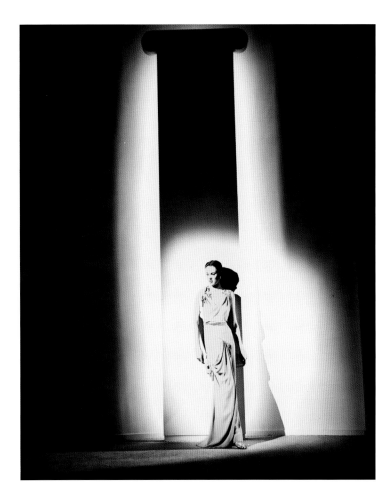

decrying the unnatural lines and shapes being foisted on women. The conflict escalated to the point of public debates and social confrontations.

Eventually, the stress took its toll. Although Janet prevailed upon Adrian to take vacations, to enjoy their new horse ranch in Bull Canyon, and to express himself in oil painting, Adrian persisted with his schedule. He was committed to his work and defending his territory. While sketching designs for his Fall 1952 collection, he suffered a major heart attack. His doctors allowed him to supervise the show from a wheelchair. Once the collection had been presented, he was forced to close Adrian, Ltd.

At the last showing, Janet told a salon full of buyers the news. The buyers grew somber and tearful. Adrian was an artist of the highest integrity, and the closing of Adrian Ltd. marked the end of an era. Adrian could take pride in ten years of outstanding success of Adrian Ltd. His fashion work had brought as much acclaim as his film work—a unique and enviable achievement.

This page: A full-length dinner dress from Adrian's 1942 collection.

Opposite: Adrian's glamorous silk-column evening gown. The bodice is adorned with an array of oversized, brightly colored silk flowers. A floor-length black tulle wrap completes this alluring look. Photograph by John Rawlings.

Following pages, from left: A two-toned full-length dinner dress from Adrian's 1942 collection; a two-piece evening ensemble with a tangerine-colored jacket trimmed in gold embroidery.

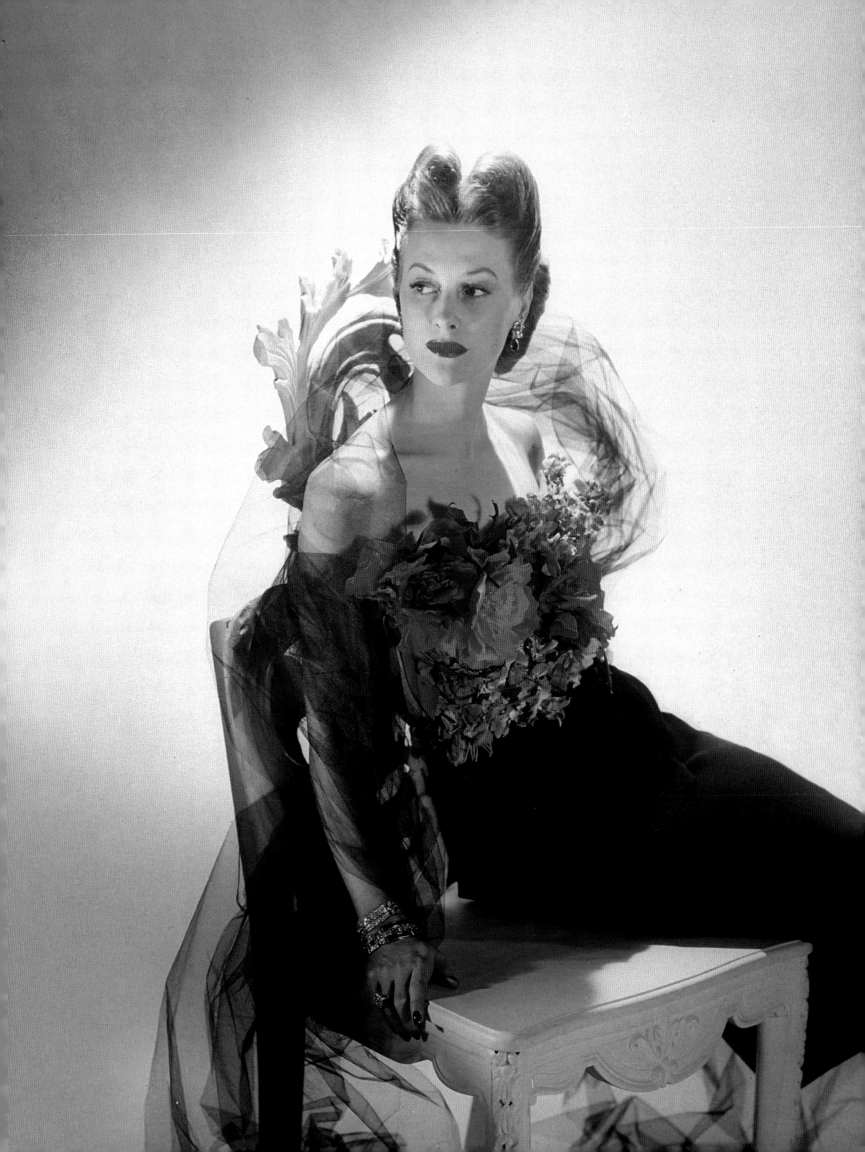

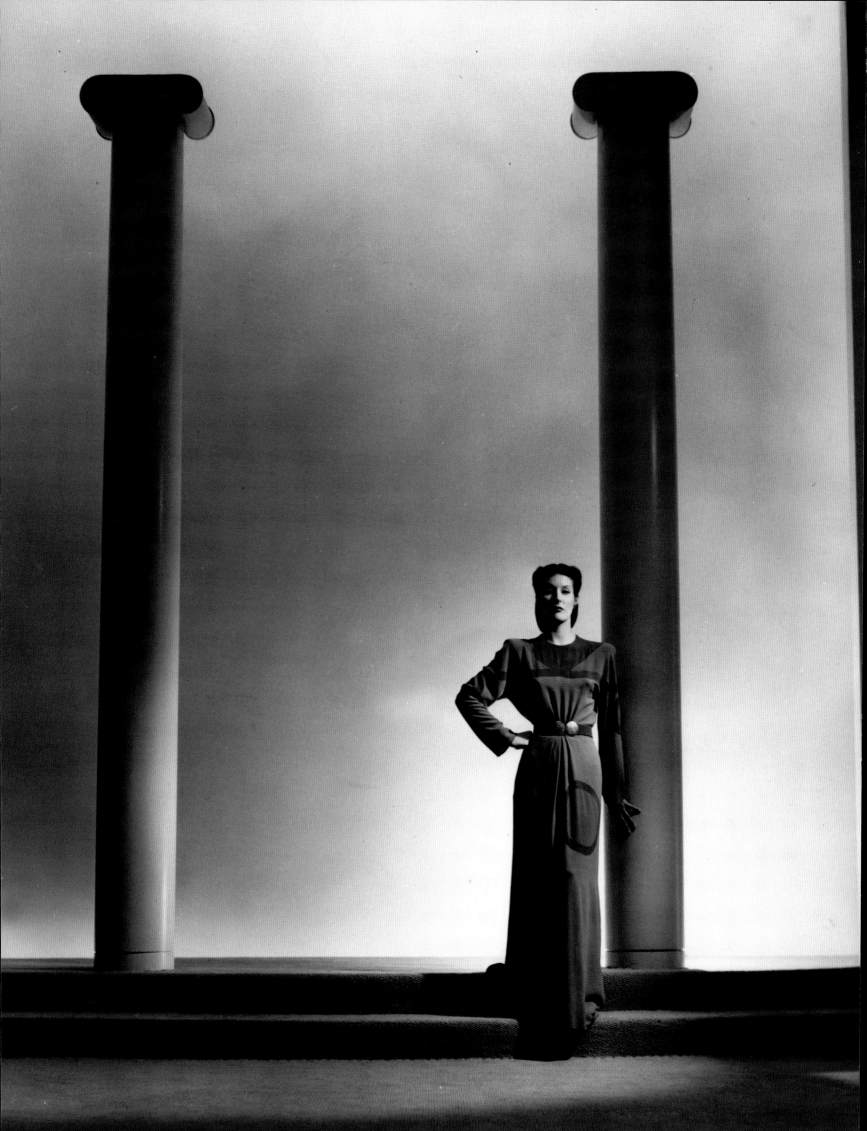

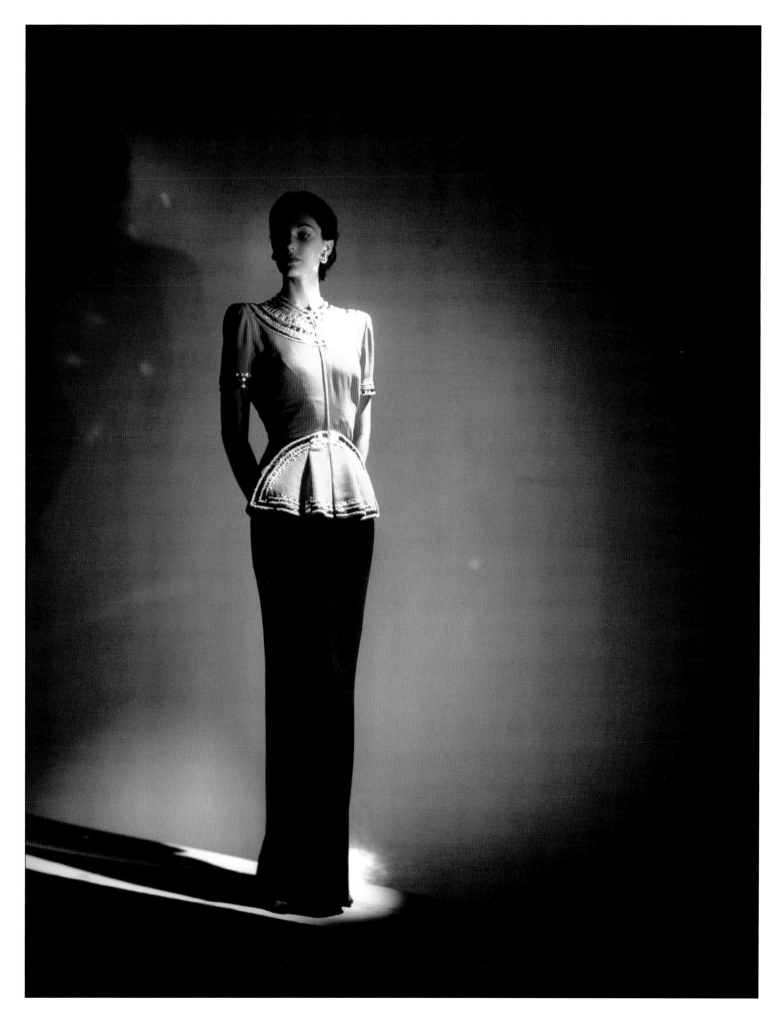

1944

ADRIAN'S SALON VISIT

The first time that I went to Adrian's salon was in the spring of 1944 during the Second World War. My mother, my sister, and I were in Los Angeles for the day, and I begged Mother into going to Adrian's beautiful salon at the corner of Beverly Drive and Wilshire Boulevard in Beverly Hills. I was just fourteen years old, and I was already collecting everything I could find on Adrian.

We were in the large room in the back with the two ionic columns and a stage and, all of a sudden, there was Norma Shearer being fitted for a suit. She was breathtakingly beautiful with white, white, flawless porcelain skin and flaming red hair wearing a bright fuchsia pink wool suit . . . dazzling!

In those days, nobody would put bright red hair and fuchsia pink together, but Norma did, and it was sensational.

LEONARD STANLEY

Joan Crawford wearing a striking dinner gown by Adrian, in the drawing room of her Brentwood estate. Photograph by George Hurrell.

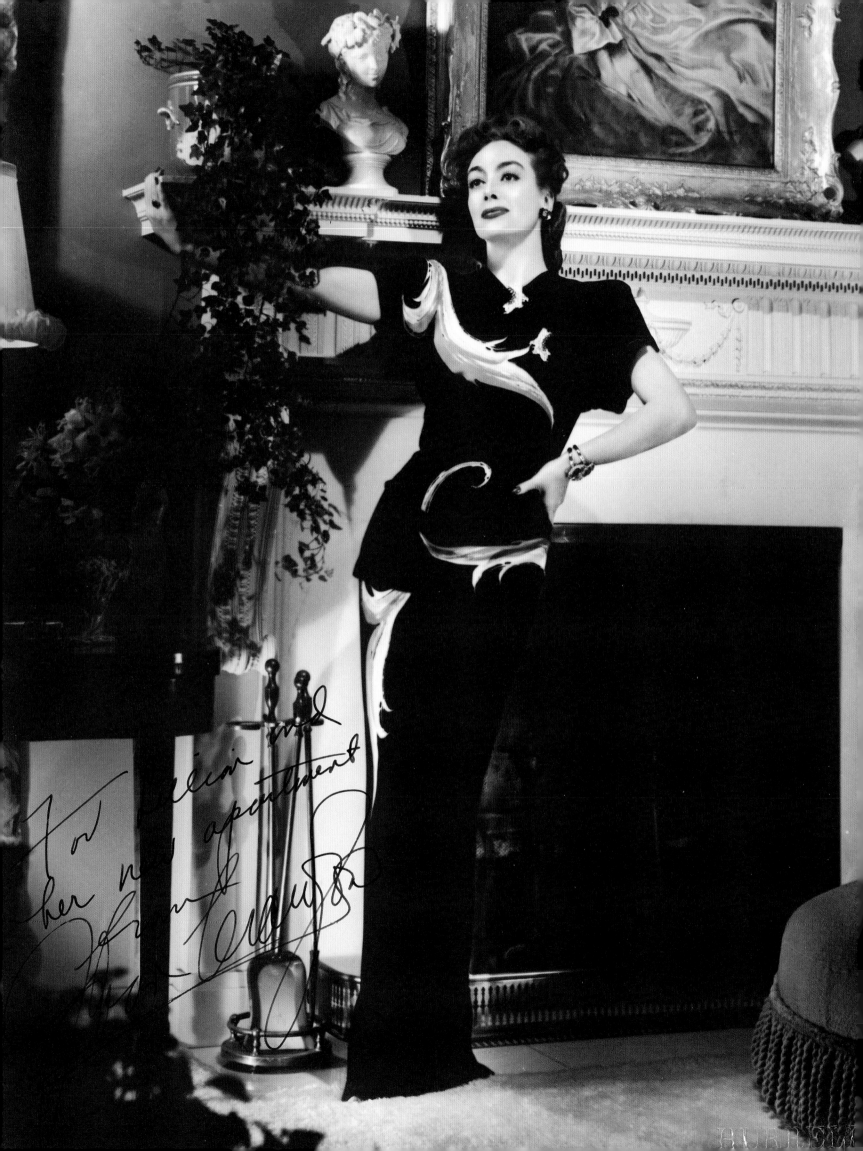

For Alicia and
her new apartment
from
Joan Crawford

NIGHT WOOLS
BY ADRIAN

THESE ADRIAN CLOTHES ARE
IN DOROTHY LIEBES FABRICS

Dear Carmel: I hope you like the things we chose from the Adrian showing. The materials and the use of them seemed to me so excitingly new, and the colors are really beautiful. . . The great topcoat on Lauren Bacall (**1**) is woven of ribbon, silver thread, green and fuchsia pink wool all in a wonderful, elegant profusion. Adrian made a misty silver dress to go under it, but I like it over black. The dress Lauren wore (**2**) is wool—a clear orange top over a black skirt. The suit I wore (**3**) is of soft white wool —it might almost be heavy raw silk—with shining gold woven into the plaid of the jacket, and a brilliant green skirt.

—*Slim Hawks*
(Mrs. Howard Hawks)

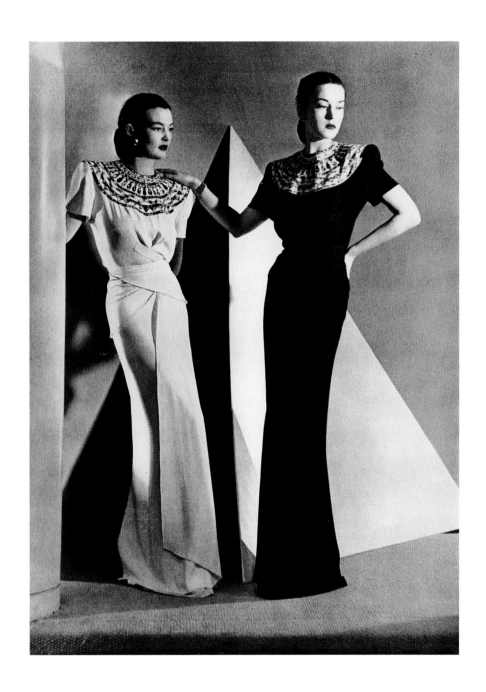

Opposite: "Slim" (Mrs. Howard Hawks) describing Adrian's 1944 collection. A young Lauren Bacall modeling two of his designs.

Above: Two floor-length dinner dresses with Egyptian-inspired white cotton collars appliquéd in gingham designs.

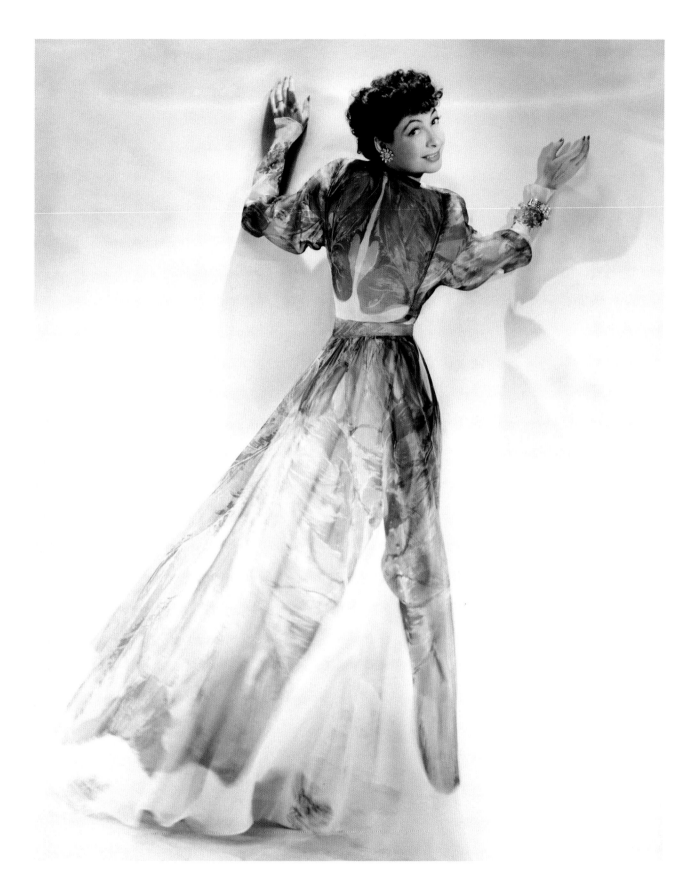

Opposite: Two drawings by
famed fashion illustrator Carl
"Eric" Erickson for Marshall Field
& Company advertisements. The
Leonard Stanley Collection.

Above: Actress and writer Ilka
Chase, daughter of longtime
Vogue editor-in-chief Edna
Woolman Chase, wearing an
Adrian silk-print evening gown.

Above: New York City Mayor
Fiorello La Guardia presents the
American Fashion Critics' highest
award, the Coty, to Adrian for his
outstanding contribution to fashion
for the year 1945. The luncheon
ceremony was held at the Waldorf
Astoria in New York City.

Opposite: Adrian's striking
dinner dress. Both black and
white versions have long, narrow
sleeves, a wrapped bodice, and
shoulder strap attached to the skirt,
reminiscent of holding up a train.
Worn by Adrian's two favorite
models, Kitty and Bess. Photograph
by John Engstead.

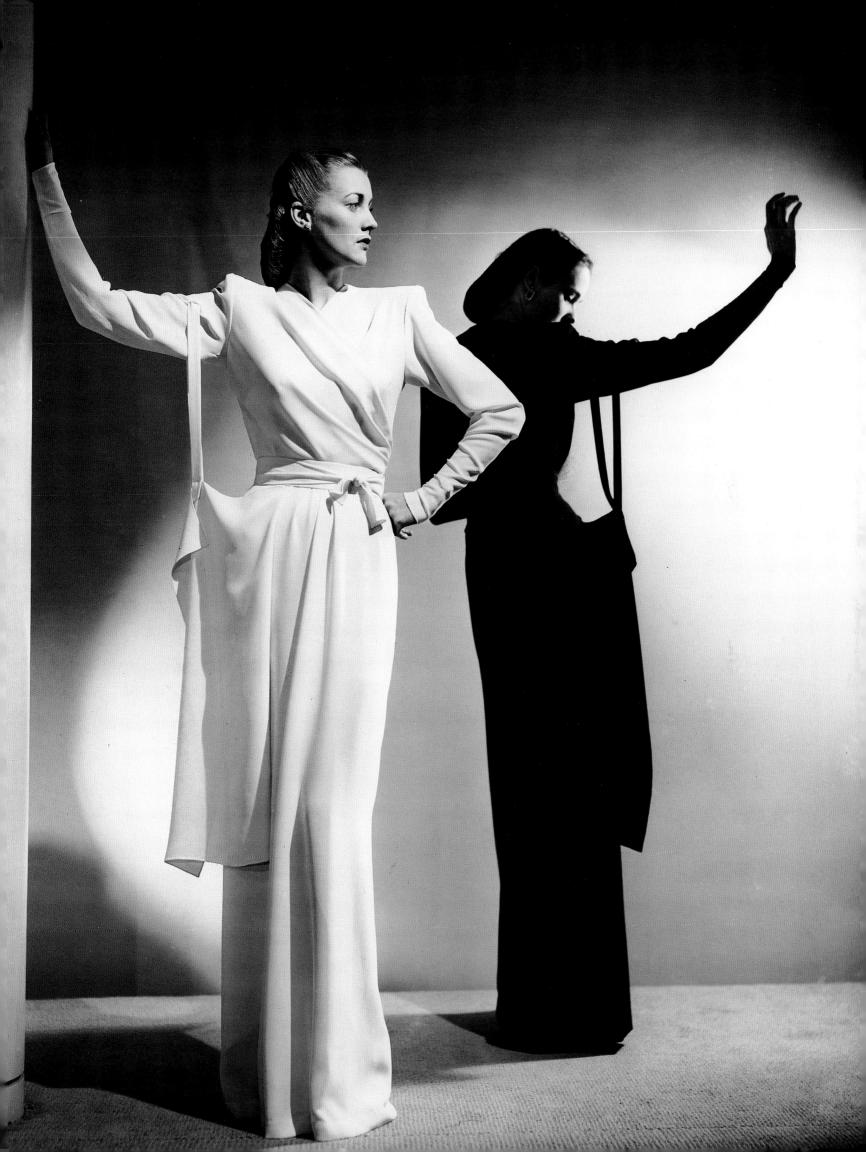

Adrian dresses the little woman

Too many tabus often thwart the tiny woman when she chooses her clothes... thinks Adrian, who designs everything for his doll-size wife, Janet Gaynor. If you're well-proportioned—and your clothes are well-proportioned—you needn't heed such old admonitions as: don't wear horizontal stripes, avoid flares; steer away from tunics and two-colour suits. You can wear almost anything—except the too-cute and the too-cautious.

Flared coats? Miss Gaynor wears them frequently. This one is of raisin gabardine ... an illusion of height is achieved by that upstanding collar, that steep crowned taupe velour hat.

Three-quarters coats? They won't cut you in two if you wear a very narrow skirt that suggests more leg length . . . here's proof.

...his 5-foot wife, Janet Gaynor

Horizontal stripes on a size 10? Stay slim, watch proportions, and don't hesitate. Janet Gaynor wears them admirably in this pink-vermillion-and-green striped dress. But see the fine sense of proportion: the high neck, long sleeves, slim skirt, just-right-length tunic, the perfect fit. Unbreakable rule for the small scale woman is insistence upon perfect fit.

Hats. Banned only are droopy or overpowering hats. High crowns and pill-boxes are tall-making—note the "show-case window" in the one above—for showing off a jewel. Big brims are possible, too, but go for brims that tilt UPWARD.

UP hair—like Miss Gaynor's upbrushed curls—is another height encourager. So are stoles. And capes. Accessories must stay in scale—but no dinky jewels for the diminutive. Miss Gaynor likes antique ones— gold chain chokers, huge rings, those two antique onyx bars worn on her beige men's wear suit sketched at the right.

A *Vogue* magazine article featuring drawings of Janet Gaynor by Cecil Beaton.

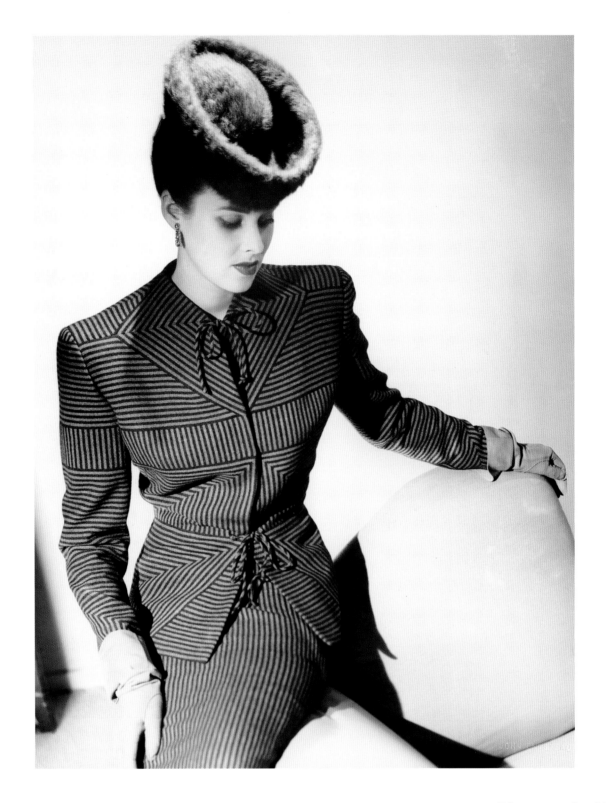

Above: An Adrian signature silhouette suit that showcases his extraordinary mitering and tailoring.

Opposite: A dramatically cut and tailored suit of dark wool.

Following pages, from left: Mrs. Howard Hawks ("Slim") wearing one of Adrian's iconic dresses "Roan Stallion." A dramatic vermilion and white horse is printed across the bodice and long skirt. Adrian donated this model to the Metropolitan Museum of Art Costume Institute. Photograph by John Engstead; a Trojan helmet decorates the bodice of the dark, dolman-sleeved long dinner dress. Photograph by John Engstead.

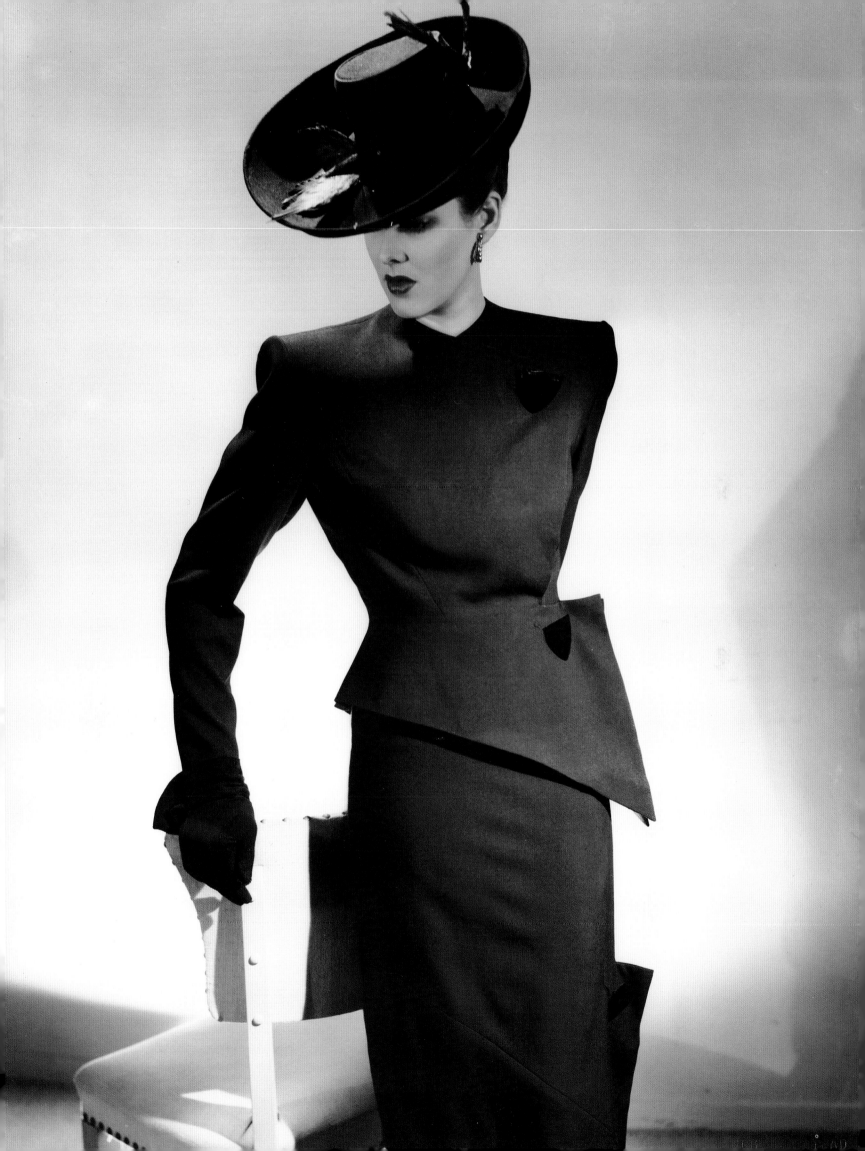

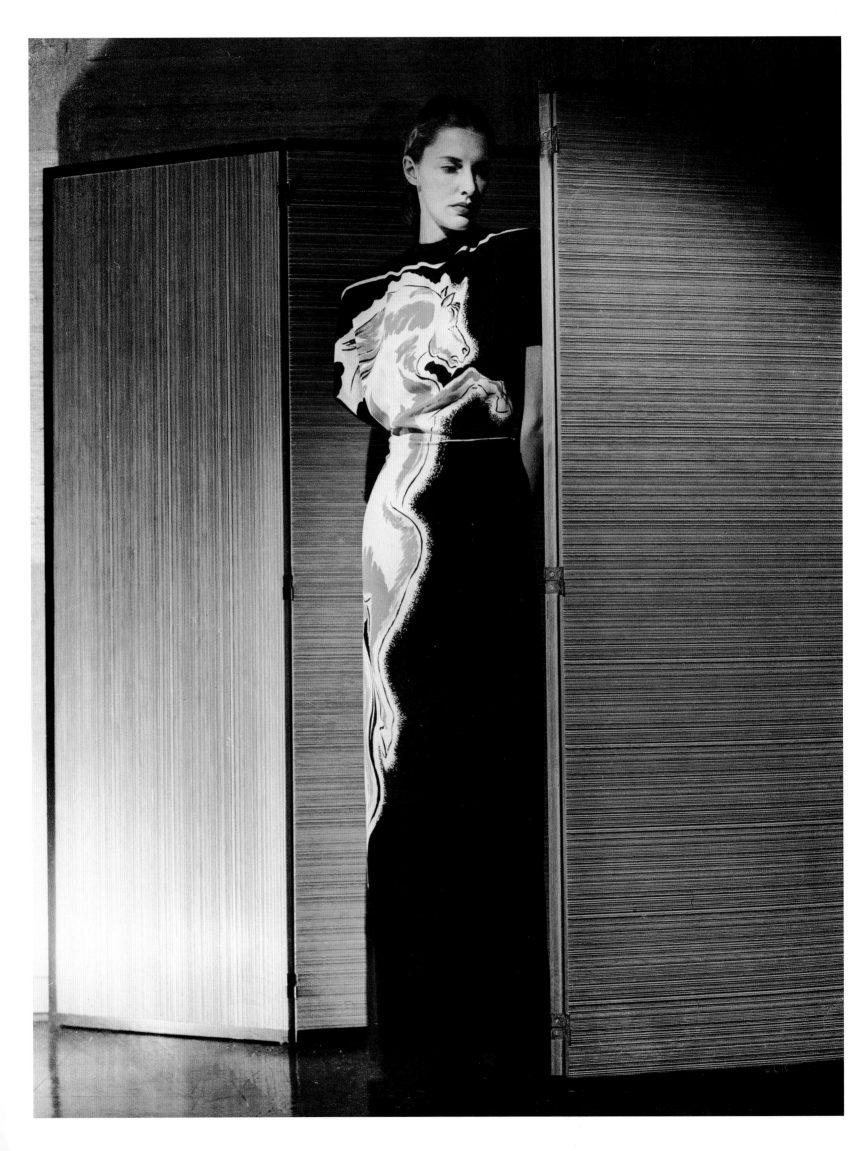

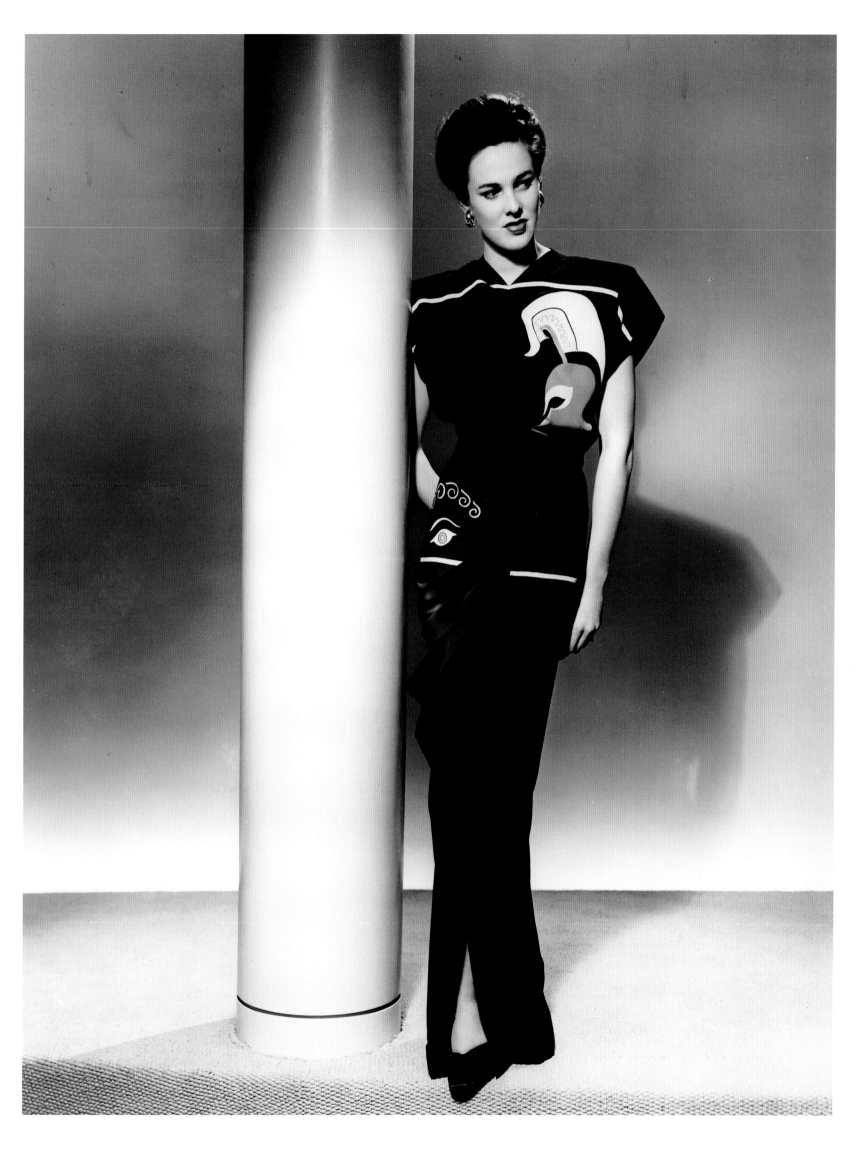

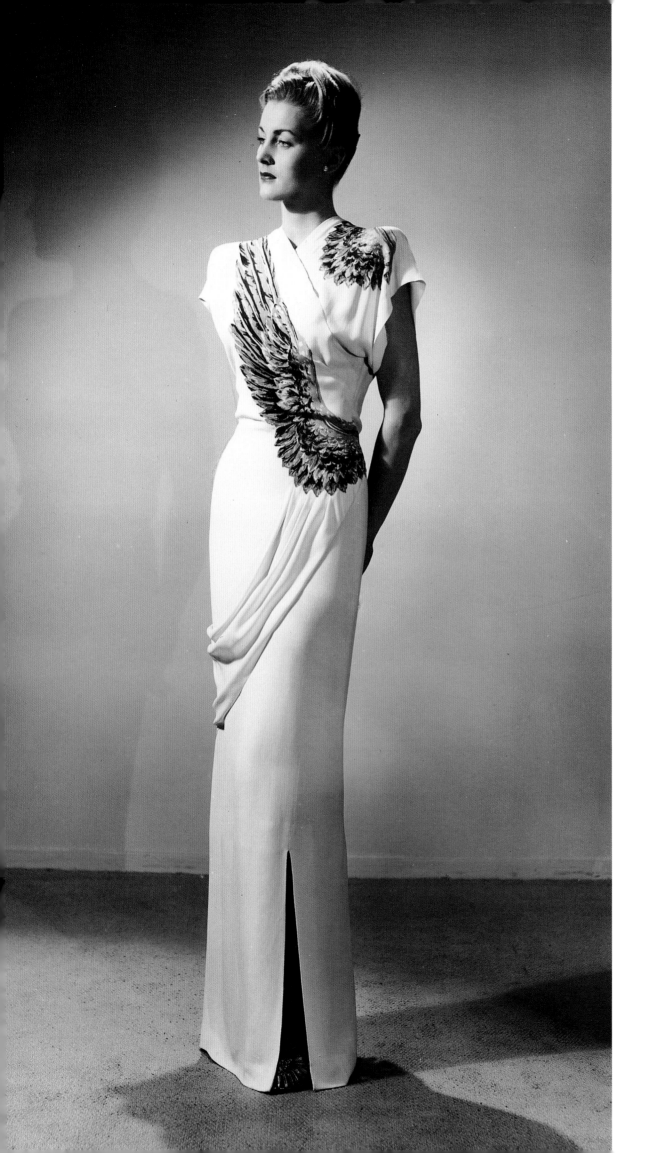

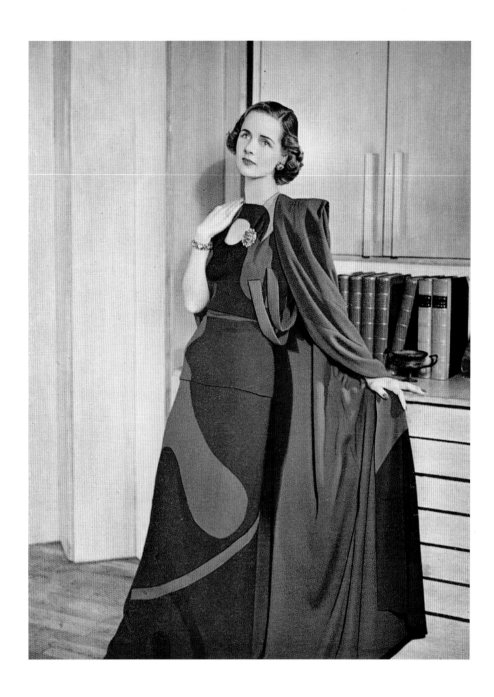

Opposite: Adrian called this
long, white silk crepe dinner dress
"Winged Victory." It was also
available in black.

Above: Intricate as a puzzle and
modern as a Picasso, this crepe
dress and cape is done in Adrian's
most finished manner.

Following pages, from left: Long-
sleeved black crepe dinner gown
named "Dark Fire" by Adrian;
heavily beaded, dramatic white
tunic and long bias-cut silk crepe
embroidered skirt. Adrian named
this ensemble the "Columnar
Gown."

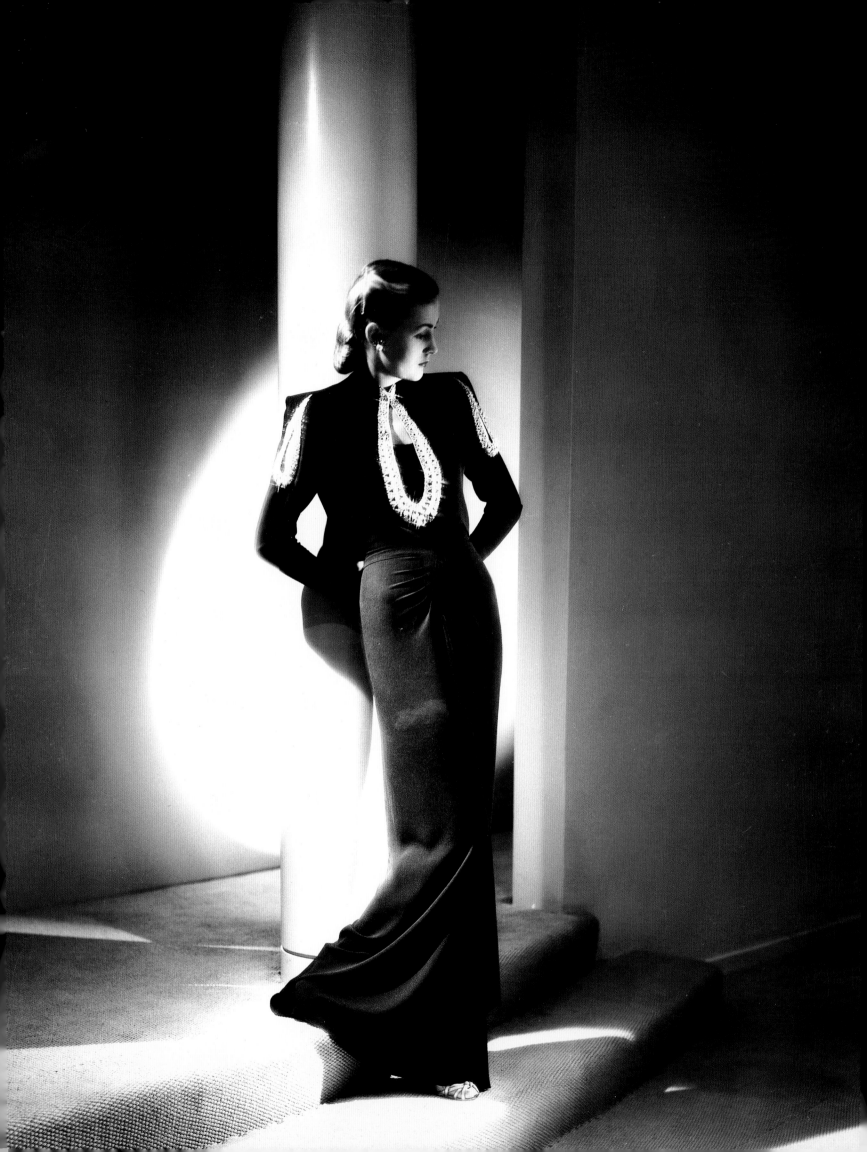

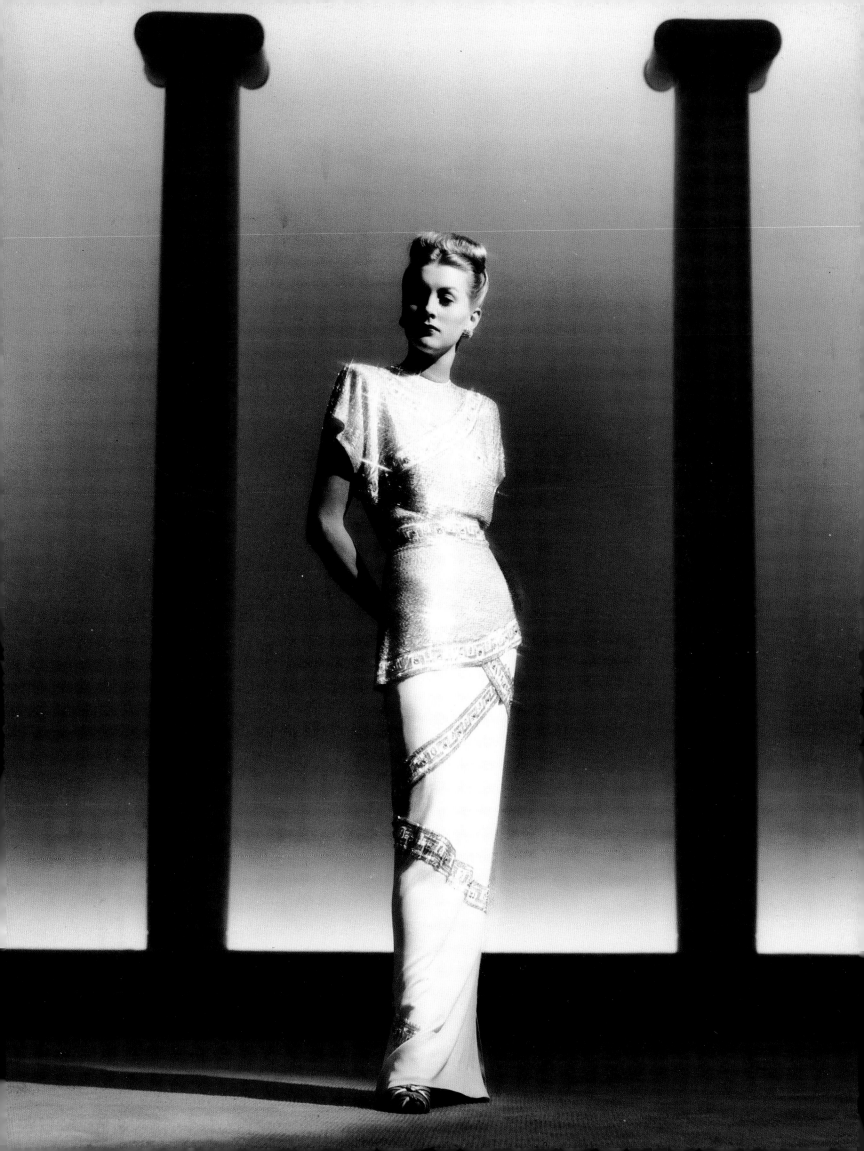

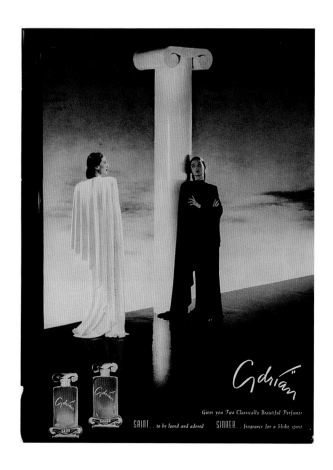

This page: Two advertisements from Adrian's perfume line. In addition to the ready-to-wear and custom-made clothing, Adrian also created two fragrances: "Saint" and "Sinner." The perfume line proved to be very successful.

Opposite: 1946 sketch by Carl "Eric" Erickson of a dramatic black silk gown in taffeta.

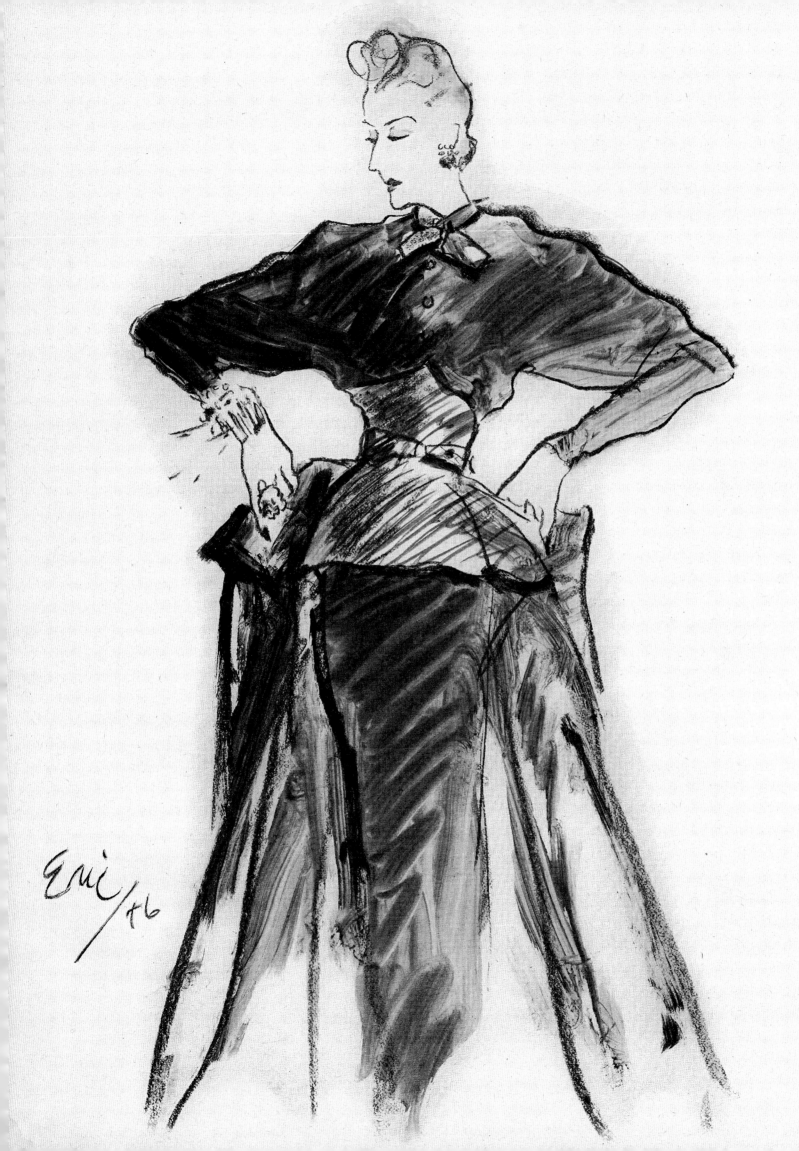

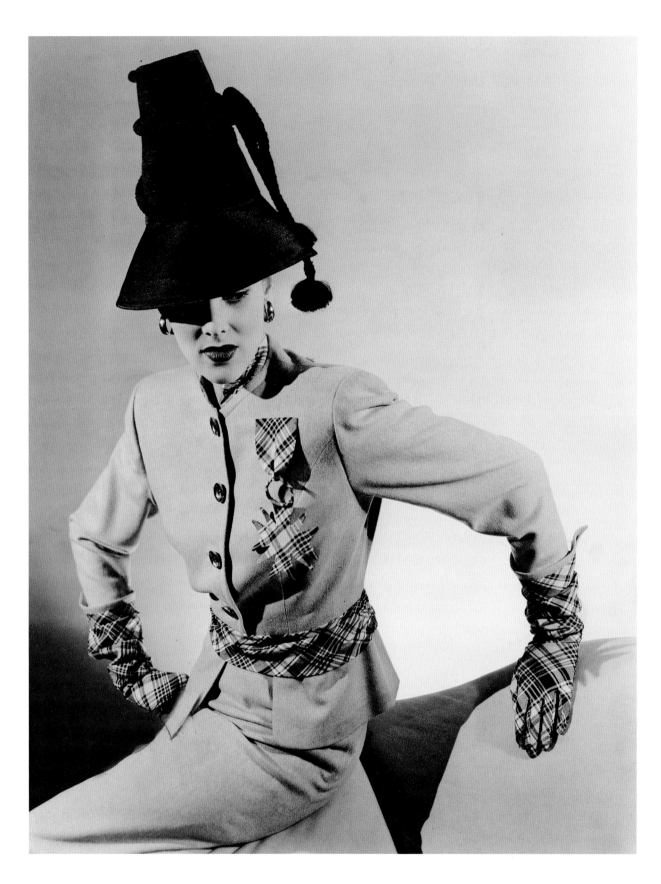

Above: A two-piece wool suit with
bias-cut gloves, matching plaid
sash, and medallion embellishment.

Opposite: A beautifully tailored
Adrian signature silhouette suit in
dark wool.

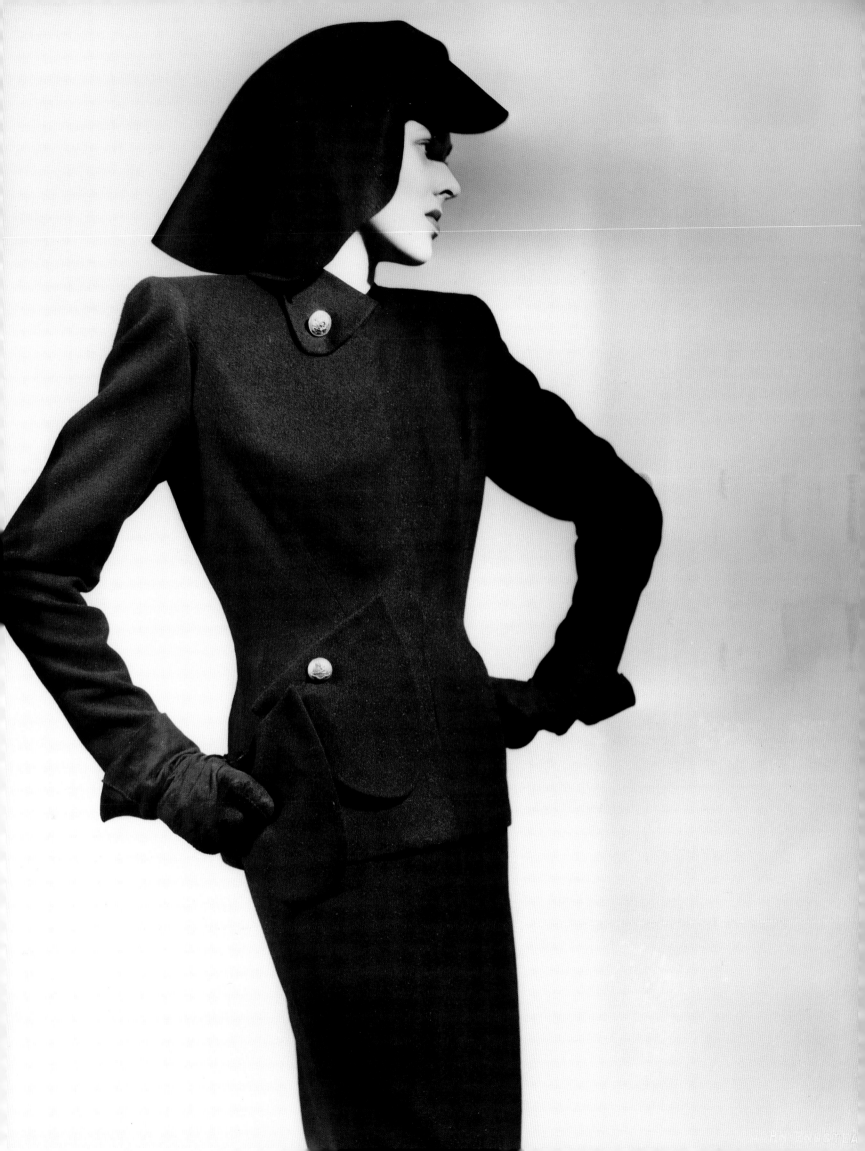

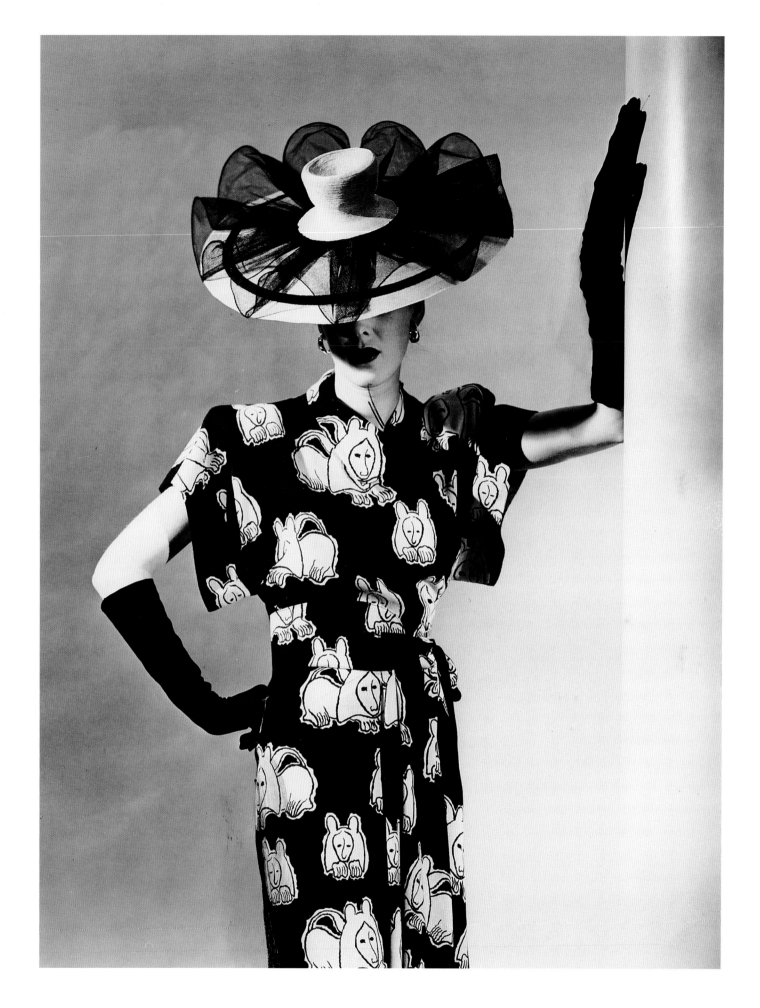

Adrian used Wesley Simpson's
Cowardly Lion print on cobble-
spun woven fabric for this
afternoon dress. The hat was also
designed by Adrian.

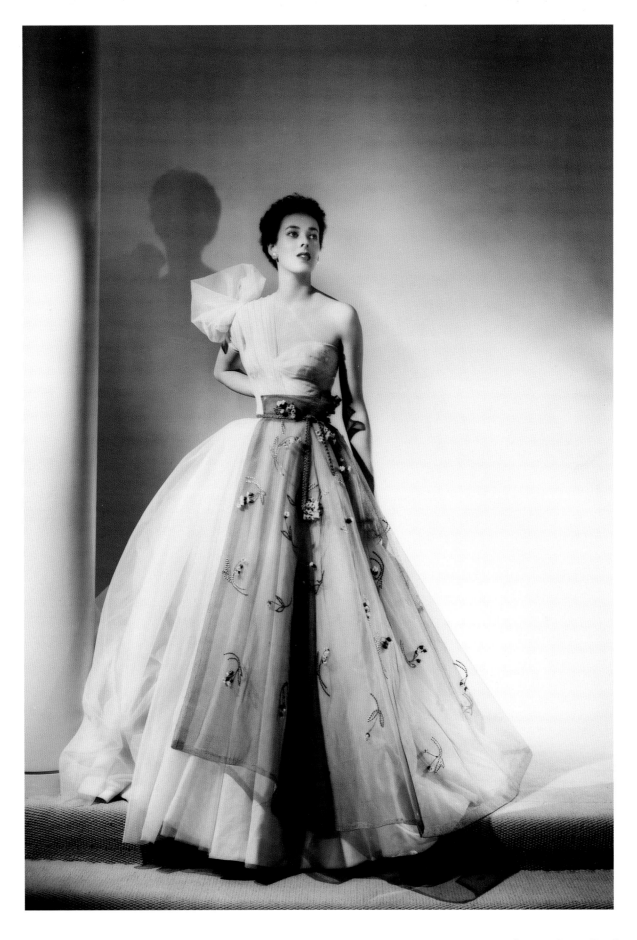

Above: Dramatic one-shoulder
evening gown with silk-tulle
embroidered overskirt modeled by
Bess Dawson.

Opposite: Lauren Bacall models
one of Adrian's romantic evening
gowns. Strategically placed pink
roses appear to be cascading atop
gathered layers of black silk tulle.
Photographed by John Engstead
on the terrace of Mr. and Mrs.
James Pendleton's Beverly Hills
residence.

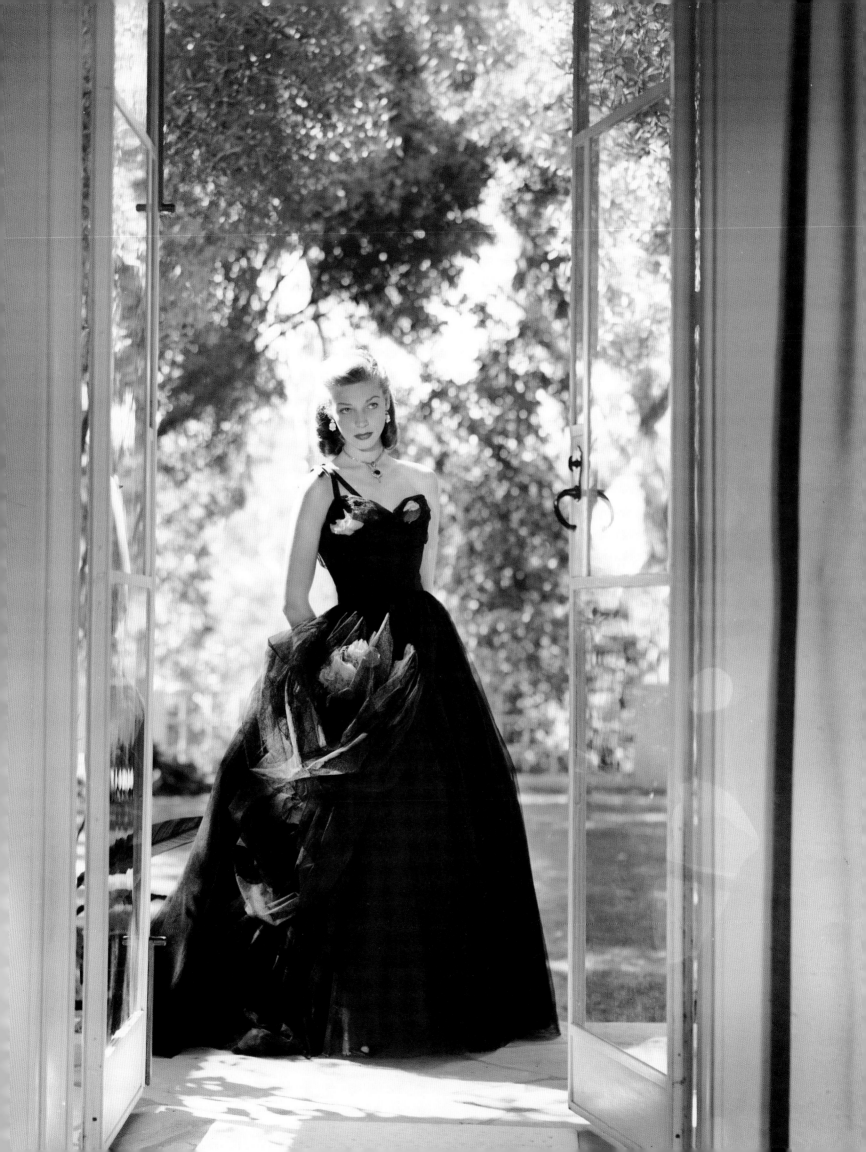

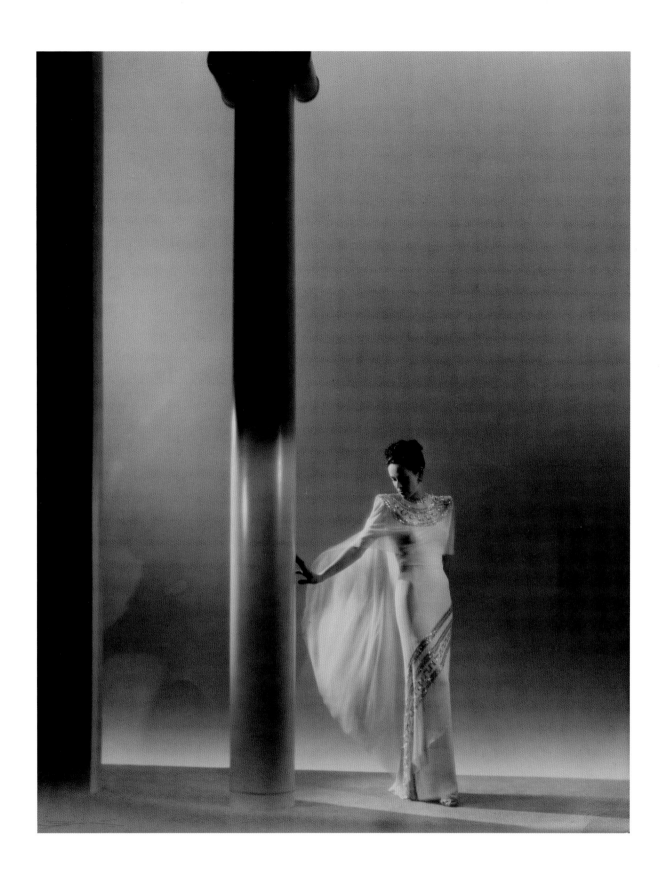

Above: Full-length image of Adrian's "Patrician" gown. Photograph by John Engstead.

Opposite: Marlene Dietrich wearing one of the loveliest dresses Adrian ever designed. This sheer white beauty was called "Patrician." The gown, detailed with silver and crystal embellishment, was ordered by Marlene Dietrich and also by the actress Greer Garson. Photograph by A. L. "Whitey" Schafer.

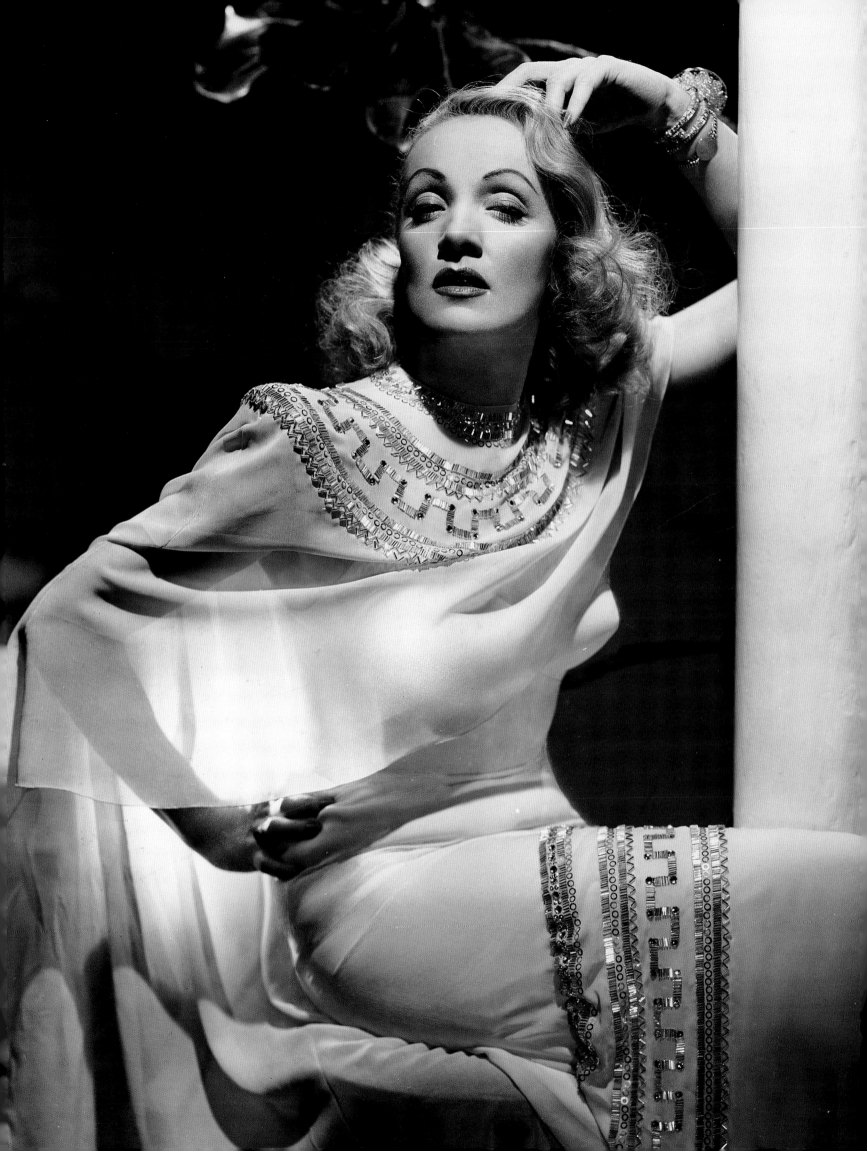

Adrian

presents his

SPRING and SUMMER

COLLECTION for

1947

Above: The cover of Adrian's Spring and Summer collection program for 1947.

Opposite: Adrian's long-sleeve black evening dress with emerald-green and fuchsia accents enhanced with gold-embroidered trim.

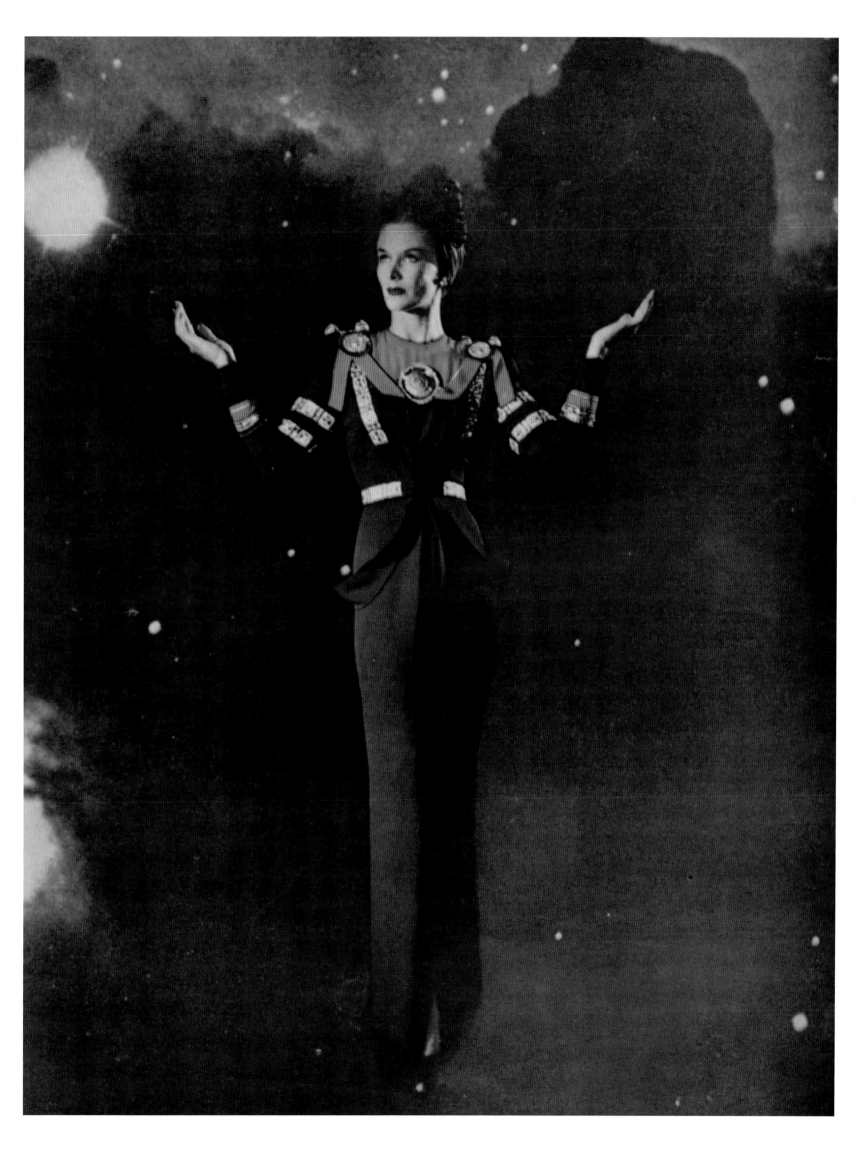

Costume print

Circular coat

Tubular suit

The Adrian look for 1947

IF a woman were to be dressed by Adrian this year her clothes might be made-to-order or ready-to-wear, since Adrian's collections include both. The shoulders of her suit would be square-cut, defined, for Adrian continues to cut and shape—but not to exaggerate—these shoulders which are characteristic of him. Her day silhouette could be spare— for Adrian continues the slim silhouette, but uses material freedom when he feels that it gives grace and meaning to a dress. And if such a woman, in wearing Adrian clothes, came to have a feeling of being streamlined, it would be exactly as the designer intended.

"I feel very much the need," he says, "of doing clothes that will fit into the wonderful new architecture and new rooms that we hope will be created this year. Contemporary clothes for a fast-moving century, clothes that are part of the life that women lead today."

The costume print. Coral and white shells on black rayon crêpe— not at all the "little print dress," but the important costume that happens, this year, to be in print. Bonwit Teller; The Dayton Co.

The circular coat. Cut in a complete circle below a flat, smooth yoke, Adrian's milk-blue fleece coat with deep armholes—citing his occasional use of more-material-again. Bonwit Teller.

The tubular suit cut high at the throat, long at the hips, narrow all the way down. Shoulders, structurally Adrian. Of grey rayon and wool faille. Bonwit Teller; Filene's.

Opposite: *You wear it casually for summer dining, but there's no casual design about this shirtwaist and skirt: it is a polished, complete plan. Silk print blouse, black raw silk skirt. Bonwit Teller; Marshall Field; Nan Duskin...Adrian's "Saint" lipstick.*

Above: *Vogue* article called "The Adrian Look for 1947."

Opposite: Adrian's two-piece silk shantung suit highlighted with gingham appliqués and matching gingham gauntlet gloves. Adrian named this suit "Pennsylvania Dutch." Photograph by John Engstead.

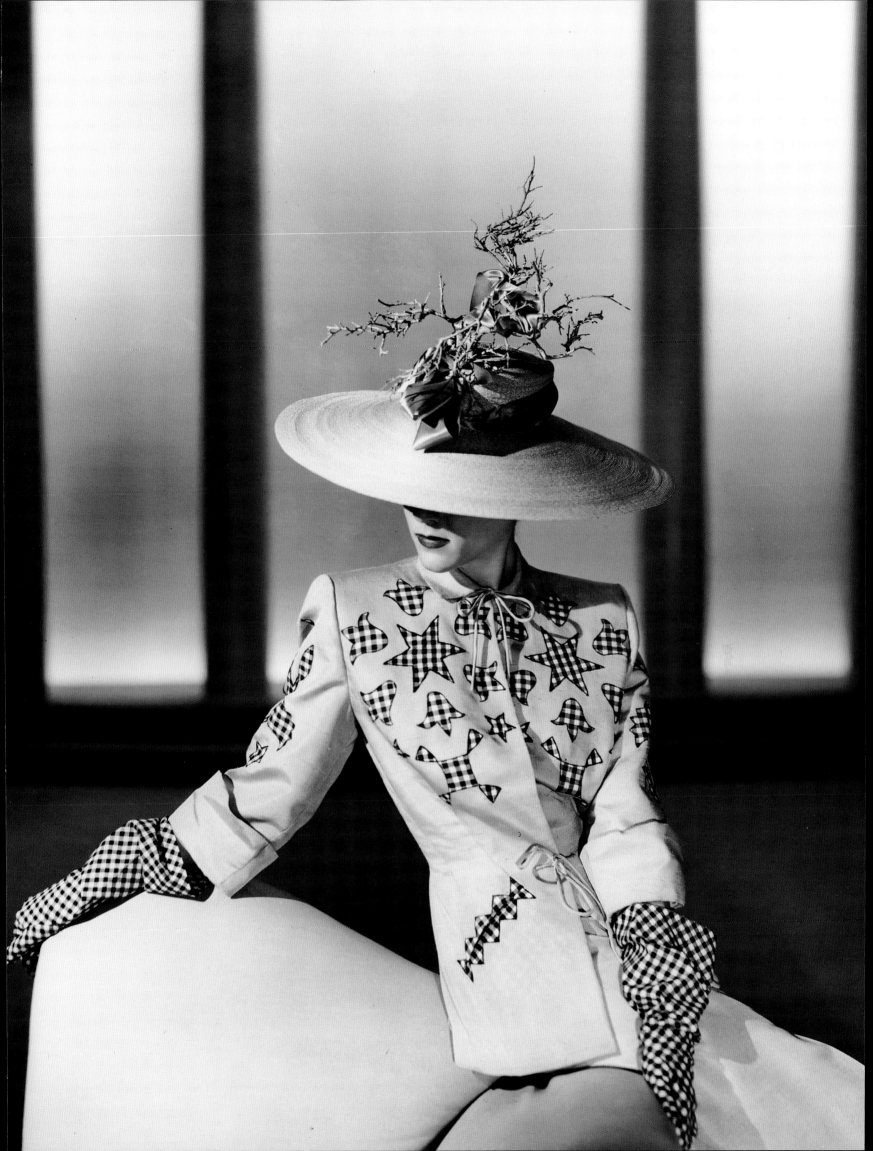

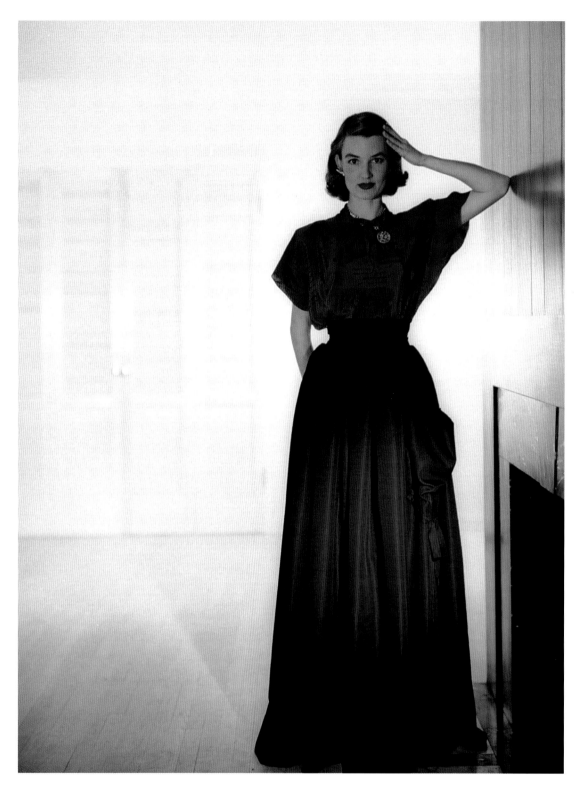

Above: A shirtwaist "Alice in Wonderland" print blouse and black raw silk full-length skirt for summer dining.

Opposite: Slim Hawks wears Adrian's casual summer dinner dress accentuated by gingham appliqués. The cap-sleeve bodice with garlanded vines, leaves, and birds is completed with a contrasting floor-length, full skirt adorned in stars scattered above a dog at the hemline.

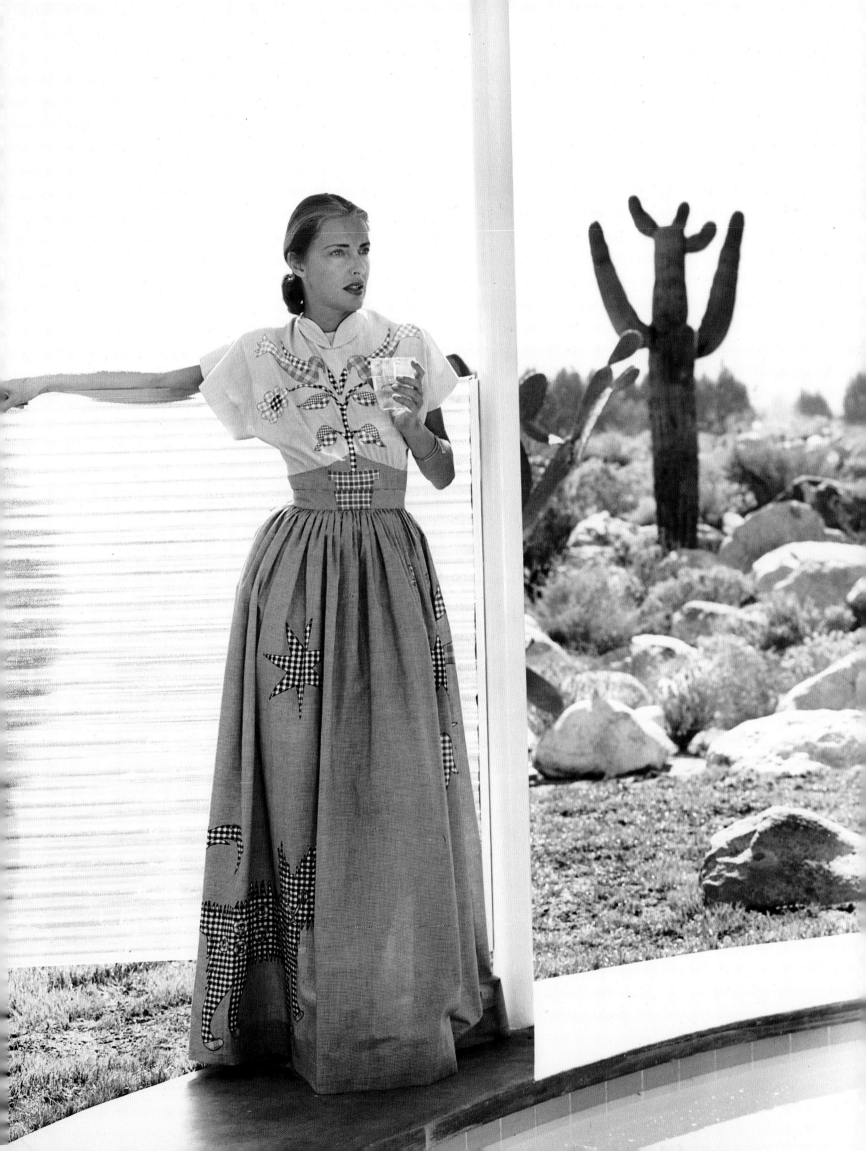

Above: A detail of the chicken-printed fabric Adrian used for the dress seen opposite.

Opposite: A perfect example of Adrian's amusing humor when designing his collection. A chicken coop is displayed across the bodice of this dress, called "The Egg and I." The fabric print of the floor-length full skirt is covered in broods of chickens.

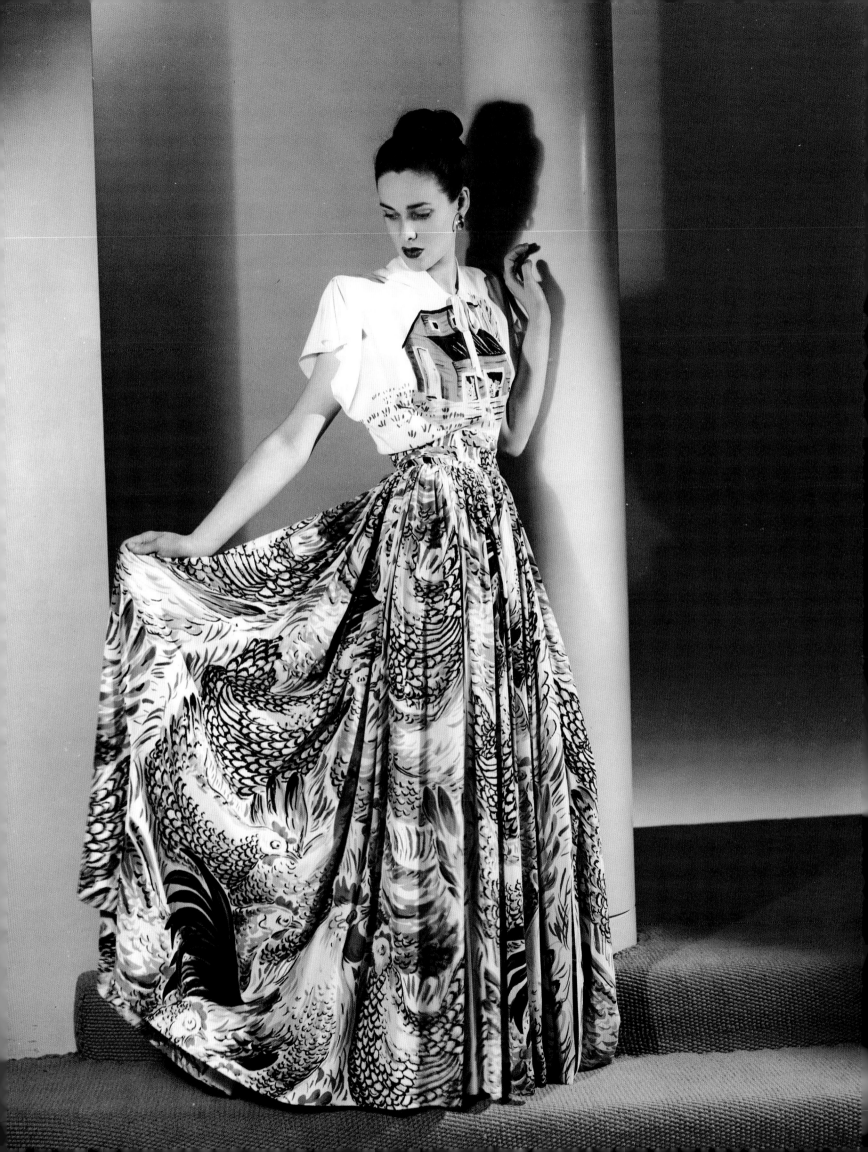

Above: A sample of the printed fabric that Adrian used for the dress he called "Gambol on the Green."

Opposite: Floating clouds and birds in flight cover the scalloped-sleeve blouse and top section of this long, full skirt, greeted by flocks of lambs gamboling on the green above the scalloped hemline.

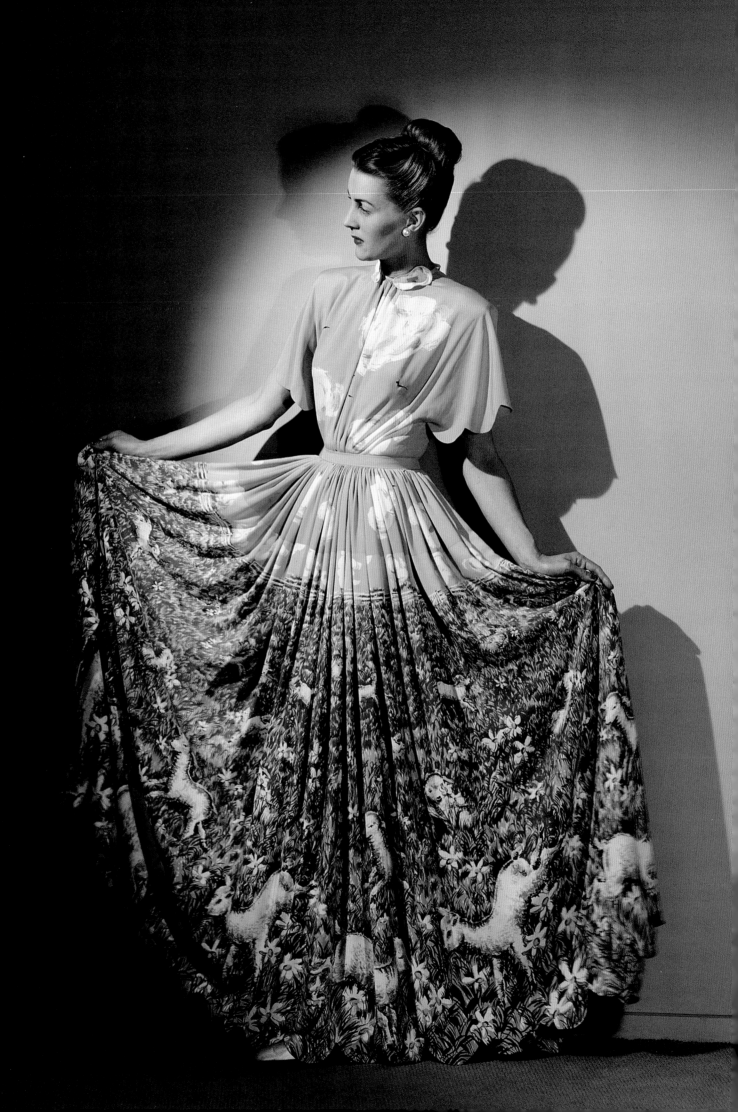

MILLICENT ROGERS

BY GILBERT ADRIAN

Millicent Rogers had the handicap of too much publicity. Her wealth was a legend to the world and often, Millicent said, to herself as well. Because, although she inherited a great fortune, she was extravagance itself, and often spent beyond her yearly income. She said, "Sometimes, I believed I was as rich as the newspapers said I was."

Millicent came to California and was intrigued by Clark Gable. We met her at a dinner party and became friends. We lived in the San Fernando Valley at that time, not a great distance from Mr. Gable. Millicent would spend weekends with us analyzing him, wondering why he was so difficult with her about their friendship. She had enormous taste and style in houses, jewels, furniture, pictures, and clothes. She had been on the list of the ten best-dressed women for years. Her emotions were apt to lead her into difficult channels, but her flair of love and beauty fed her when she was so often disappointed in love.

Janet and I were leaving for Santa Fe to stay for a few weeks at Alan Clark's beautiful house. Millicent said she thought she would like to go along with us, and although we were pleased, we were also slightly worried. We knew her reactions were very definite, and she could just not like it at all, and become a real problem and responsibility. We did know she had always loved the "wide open spaces."

Fortunately, she did love it, and when Mabel Luhan invited us all to dinner, Millicent became intrigued by Taos as well. The Indian country does have a certain magic, at least for Janet and me. During dinner Mabel said, "Adrian, you and Janet ought to buy a ranch near here that is the last of the really beautiful properties for sale."

Janet and I react to land rather like trout to flies, and we said, "Let's go and look at it after dinner."

The light was almost gone when we arrived at the ranch, and we could barely tell about its beauty.

Fashion icon Millicent Rogers wearing Adrian's black silk-velvet gown called "In the Grand Manor" with butterfly-winged sleeves. The jewelry worn by Miss Rogers is from her personal collection, 1947. Photograph John Engstead.

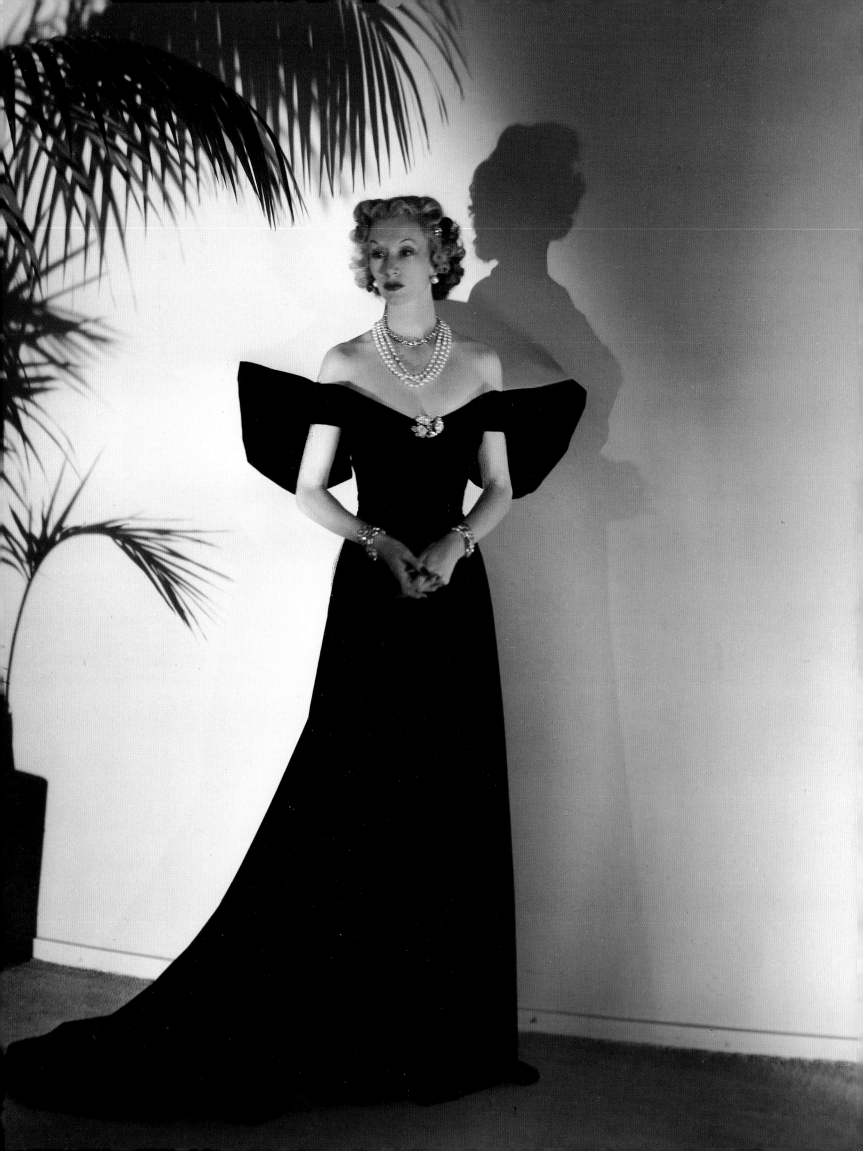

When we returned to Mabel's house, Millicent went with Janet to powder their noses. Janet said Millicent whispered in her ear, "Janet, if you and Adrian don't buy that ranch, I will. I feel it, I love it."

Janet said, "But Millicent, you couldn't see it any better than we could, it was too dark."

Millicent said, "I know, but I feel it, and I want it." These phrases have been such a typical part of Millicent's entire life that we felt she meant it.

The next morning we were leaving to return to California and, before we went to bed, we said to Millicent, "We're going to leave at seven to see the ranch, and then be on our way. Do you really want to come along so early?"

Millicent said, "Of course."

Knowing that she did not get up early, we didn't count on her joining us, but at quarter to seven, she knocked on our door and said, "I'm ready, are you?"

That was it. We saw the ranch, loved it, but didn't want it.

Millicent stayed on, bought it, and never left it again.

She was like the last of a rare species of bird, a striking individualist in a world fast becoming mass-produced.

Opposite: Millicent Rogers modeling Adrian's spectacular ball gown of black silk tulle. Coque feathers cover the bodice and front of the floor-length full skirt cascading down the back of the dress to the top of the hemline. The dress was custom made-to-order. Photograph by George Platt Lynes.

Following pages, from left: Anita Colby in an exquisite black-wool jacket encrusted in heavily embroidered gold thread paired with a long, slim front-slit skirt. The "attendant" in the background holding an umbrella was designed by Tony Duquette. Photograph by John Engstead; Adrian's white crepe full-length evening coat with an elephant trunk holding a small bouquet of violets printed on the back. Plaster elephant and attendant designed by Tony Duquette.

Pages 214–215: An article from a 1947 *Vogue* magazine discussing the Adrian look.

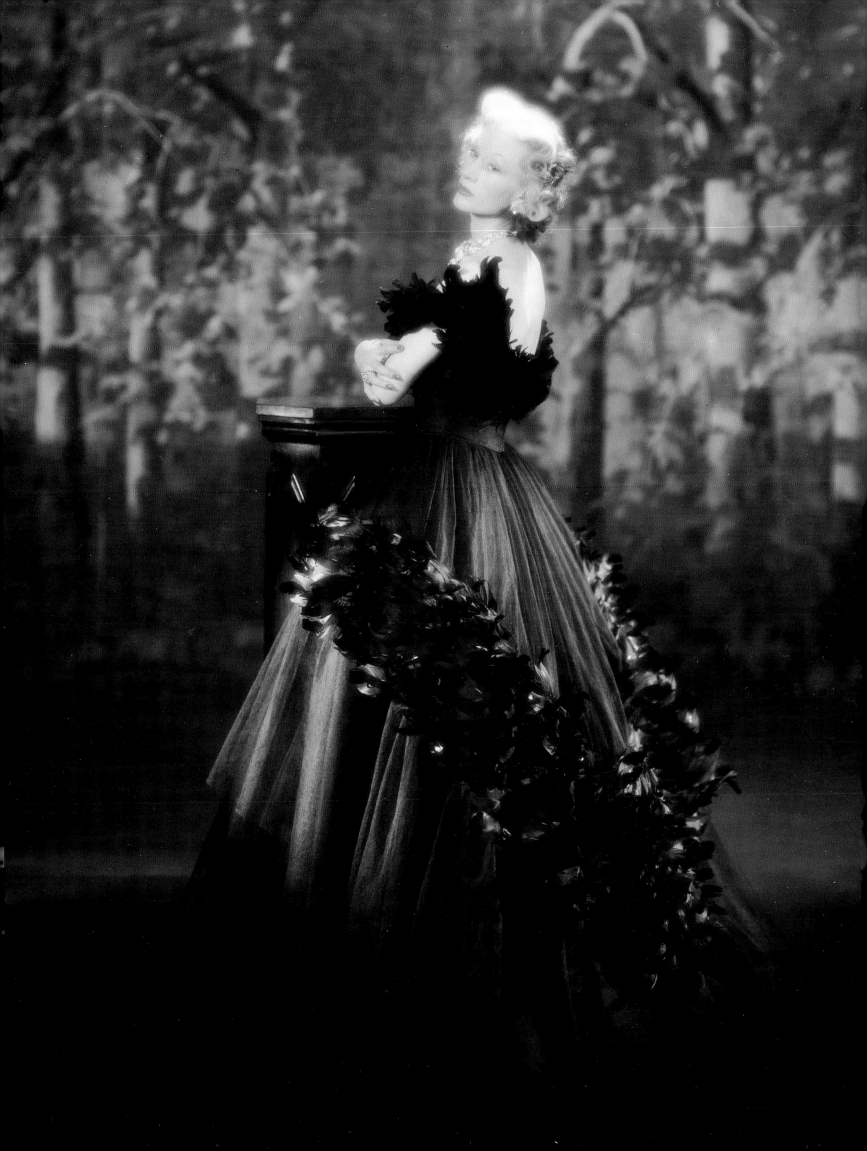

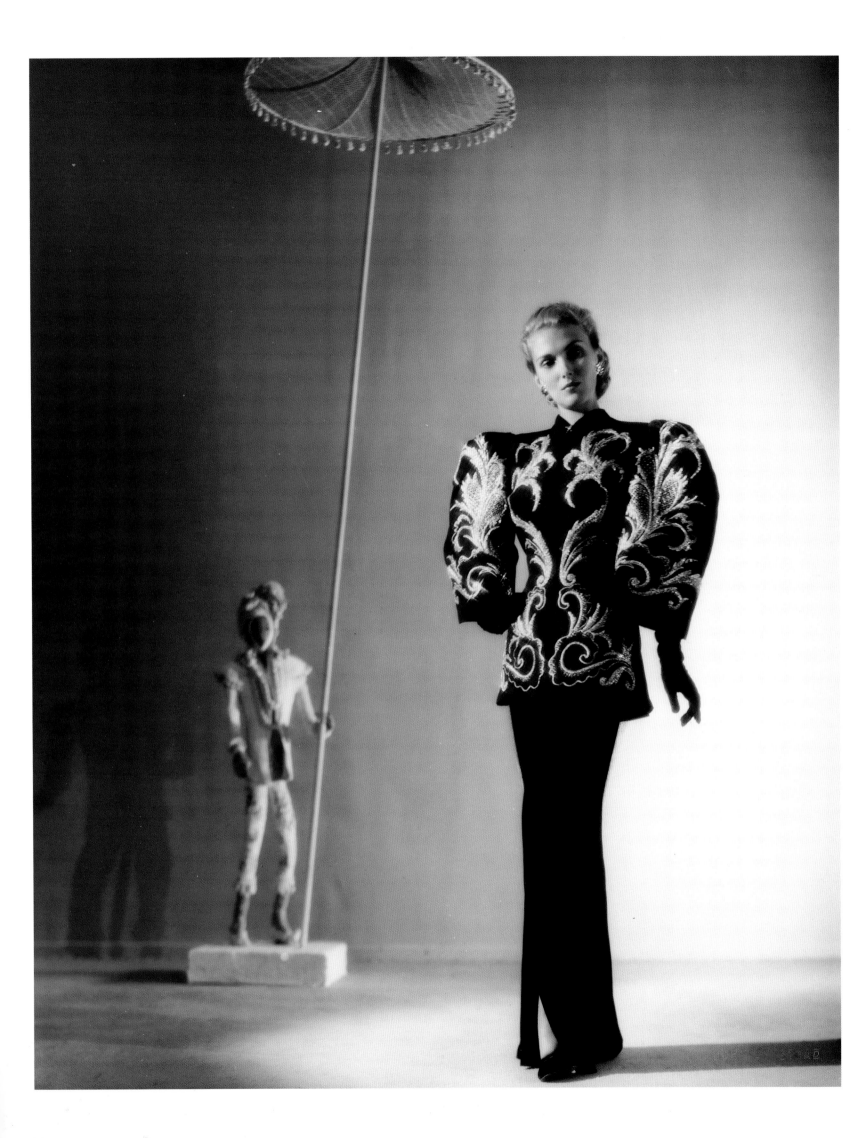

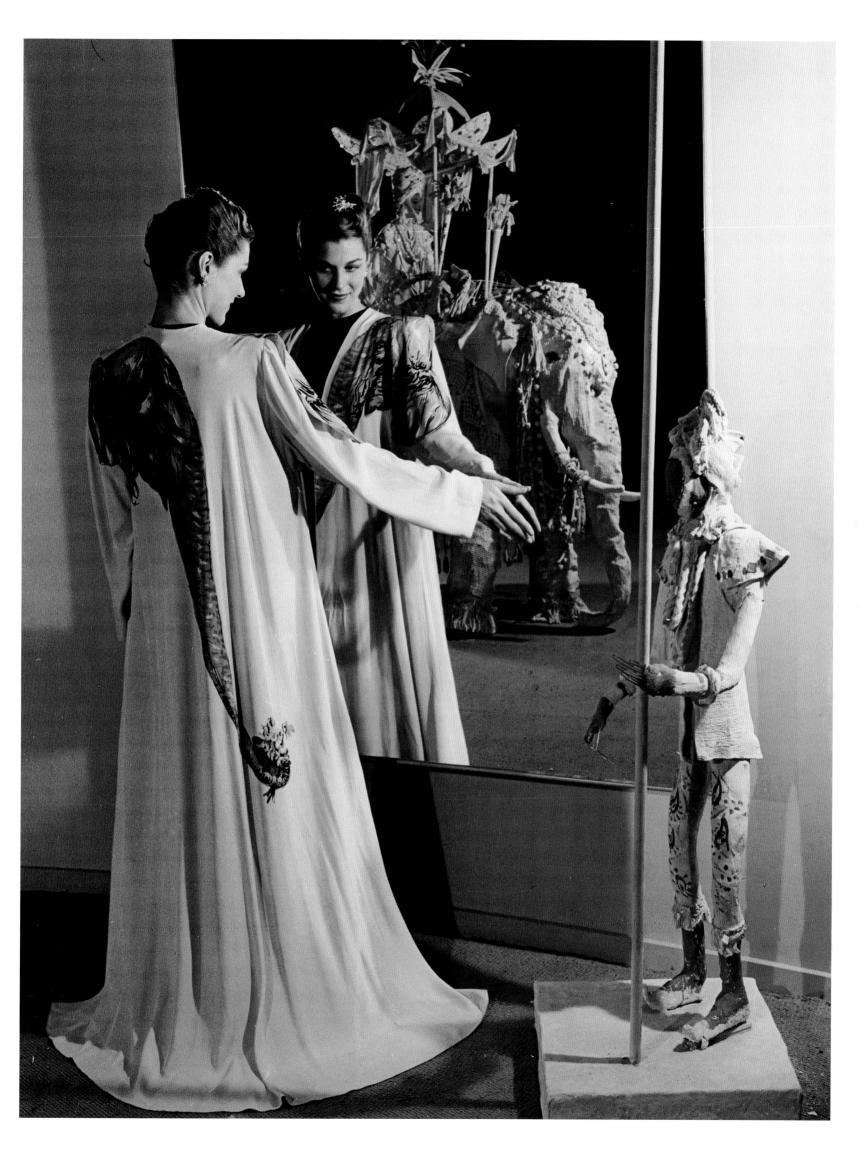

The Adrian look *(continued)*

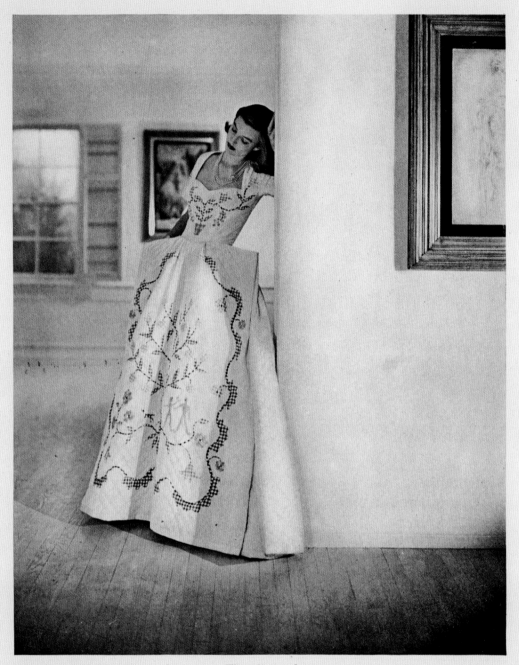

The picture dress

Finding no nostalgia in our latest past, Adrian draws upon lines from the Greeks for the evening dress on the opposite page. And Adrian says he "designed purely for prettiness, for the big romantic moments" the picture dress which is photographed above; one of the young dresses which he feels is not significant of trend, but never out of fashion.

Above: *Quilted, stiffened white taffeta patterned in gingham. Made-to-order.* Opposite: *One dress with two aspects —the usefulness of two. With cape and side-drapery flung back, the black rayon crêpe dinner dress shows a blaze of colour. Bonwit Teller; Frost Bros.; Garfinckel's. Jewels: Brock & Co.*

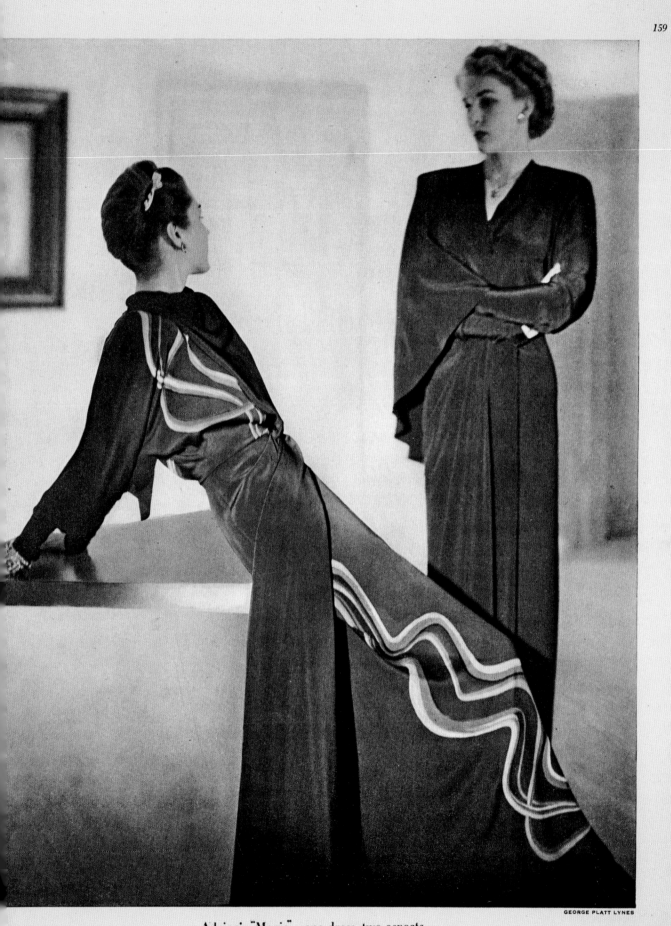

GEORGE PLATT LYNES

Adrian's "Magic"... one dress, two aspects.

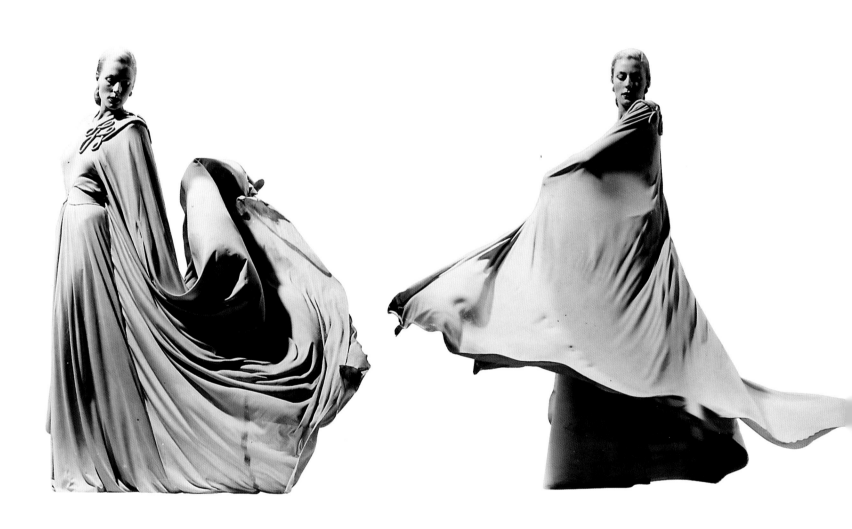

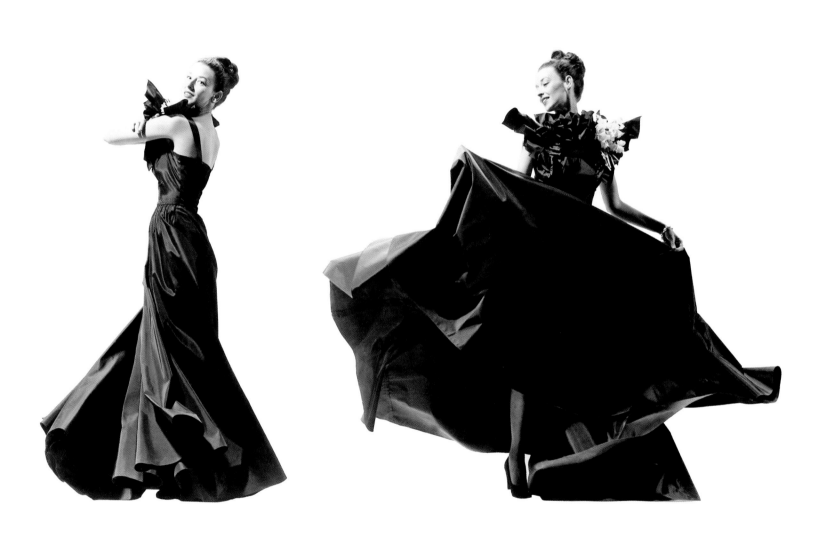

ADRIAN
COLLECTION

FALL WINTER

Previous pages, from left: Silk jersey full-length hostess gown; ravishing black silk taffeta long, full-circle dance dress with a floral statement on the left shoulder.

Above: Program cover for Adrian's Fall/Winter 1948 collection. Opposite: Erwin Blumenfeld photographing Adrian's dramatic black evening dress named "Streamlined and Winged."

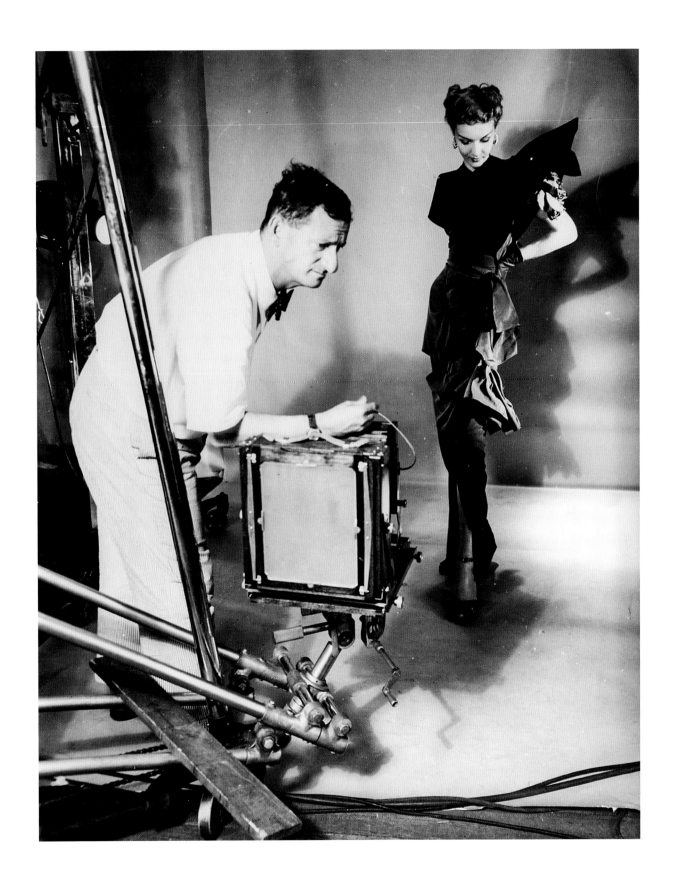

n 1947, when I was nominated for an Academy Award, I went to Adrian's Salon in Beverly Hills and told him I needed a very special dress for a very special occasion. Adrian asked which evening gown from the Collection did I want to order. I said, "Oh, no! I want a dress designed just for me, and surely like all designers you must have a cache of some of your special fabrics hidden somewhere." Adrian laughed and said he did, and he then brought out a beautiful emerald green Bianchini silk taffeta. Now green was not one of my favorite colors, but Adrian said that it is what he wanted to make the dress out of, and I don't argue with brilliant designers. I must add it has since become one of my favorite colors.

The dress had an enormously full skirt with masses of pink and red silk flowers cascading down one side of the skirt. Long opera gloves were made of the same green silk taffeta and a very short ruffled cape to match. It was beautiful.

That evening there should have been two Oscars, one for me and one for Adrian's dress.

LORETTA YOUNG

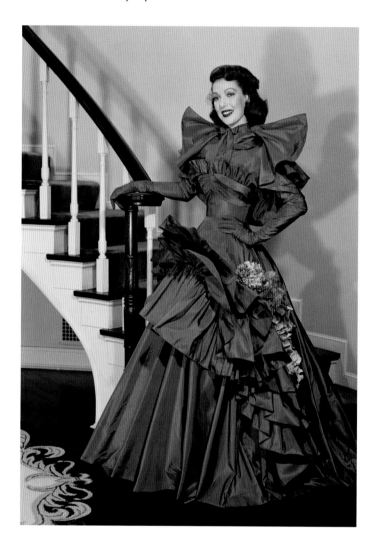

Above: Actress Loretta Young wearing her Adrian custom dress, jacket, and long opera-length gloves in emerald-green Bianchini-Férier silk taffeta.

Opposite: Loretta Young holding her Oscar after winning the Academy Award for Best Actress in 1947.

Following pages, from left: Silk jersey dinner gown embellished with metallic trim named "India Inspires." Photograph by John Engstead; halter evening gown in ombré shades of blue-silk lamé. Photograph by John Engstead.

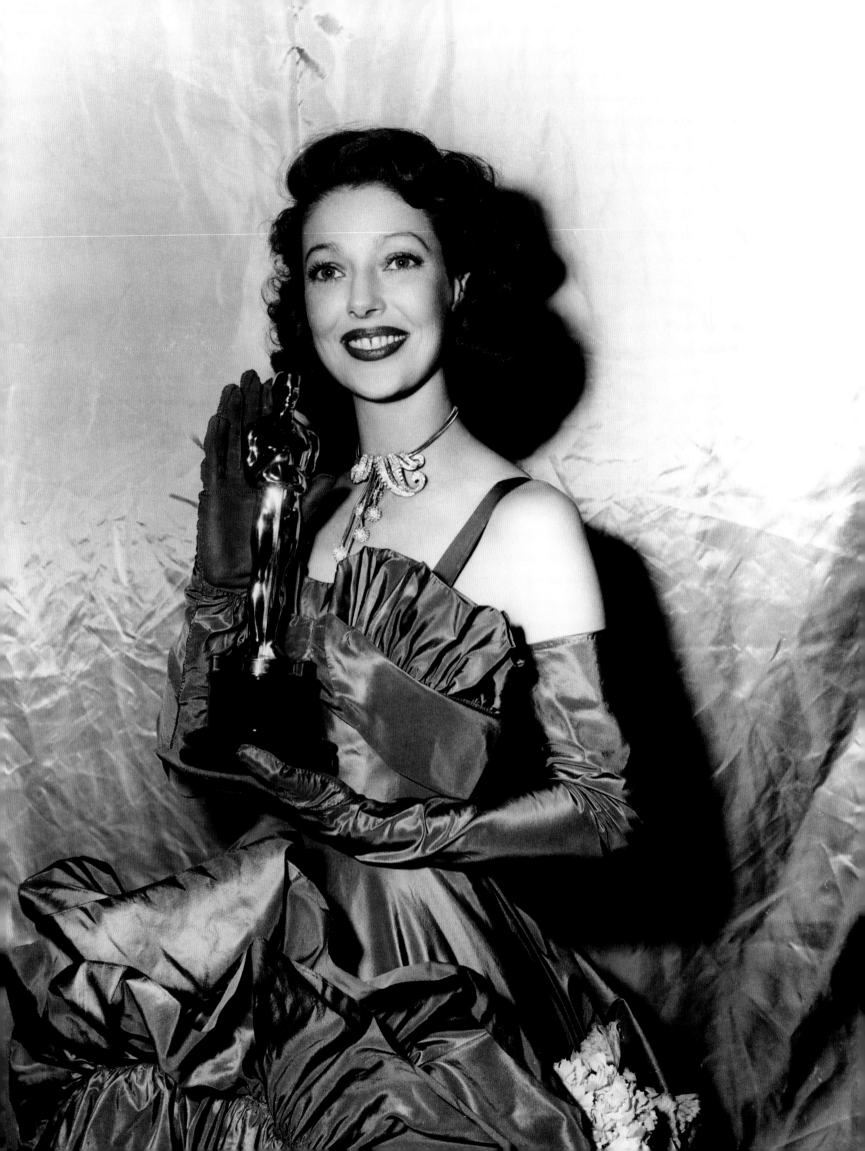

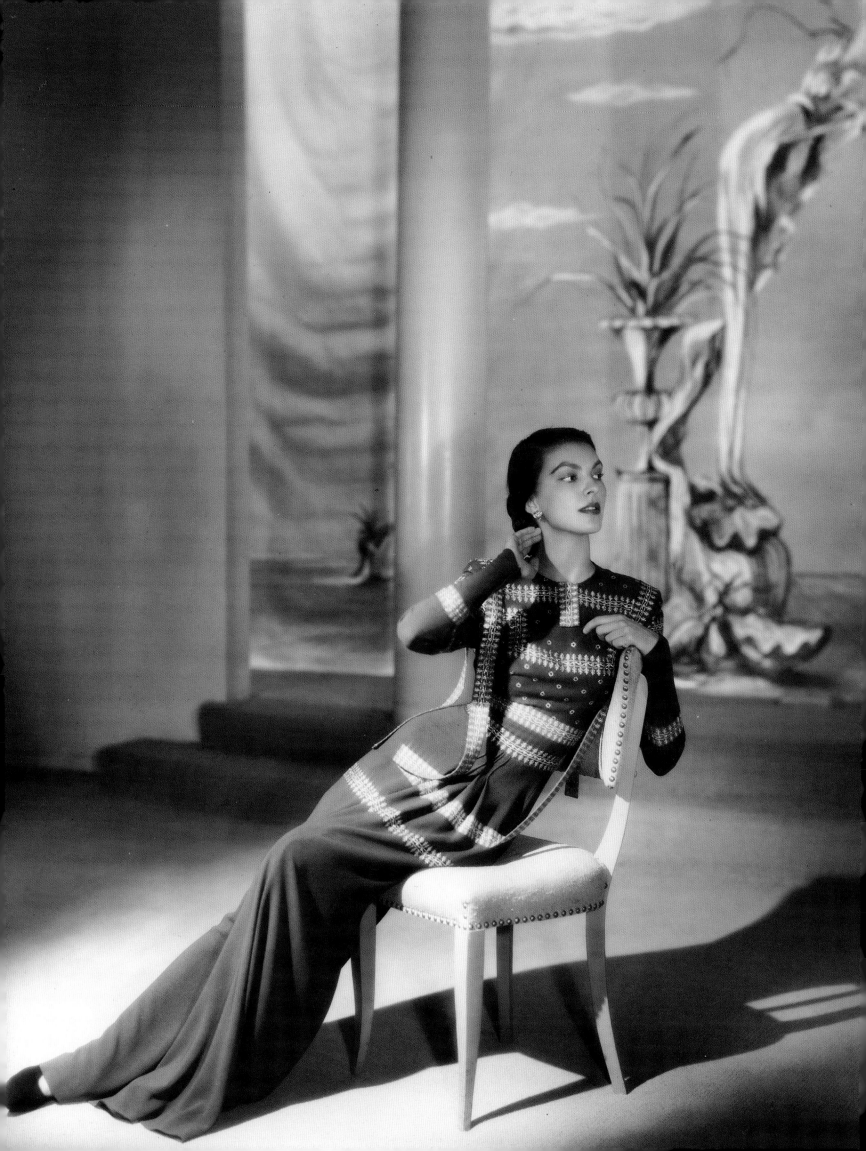

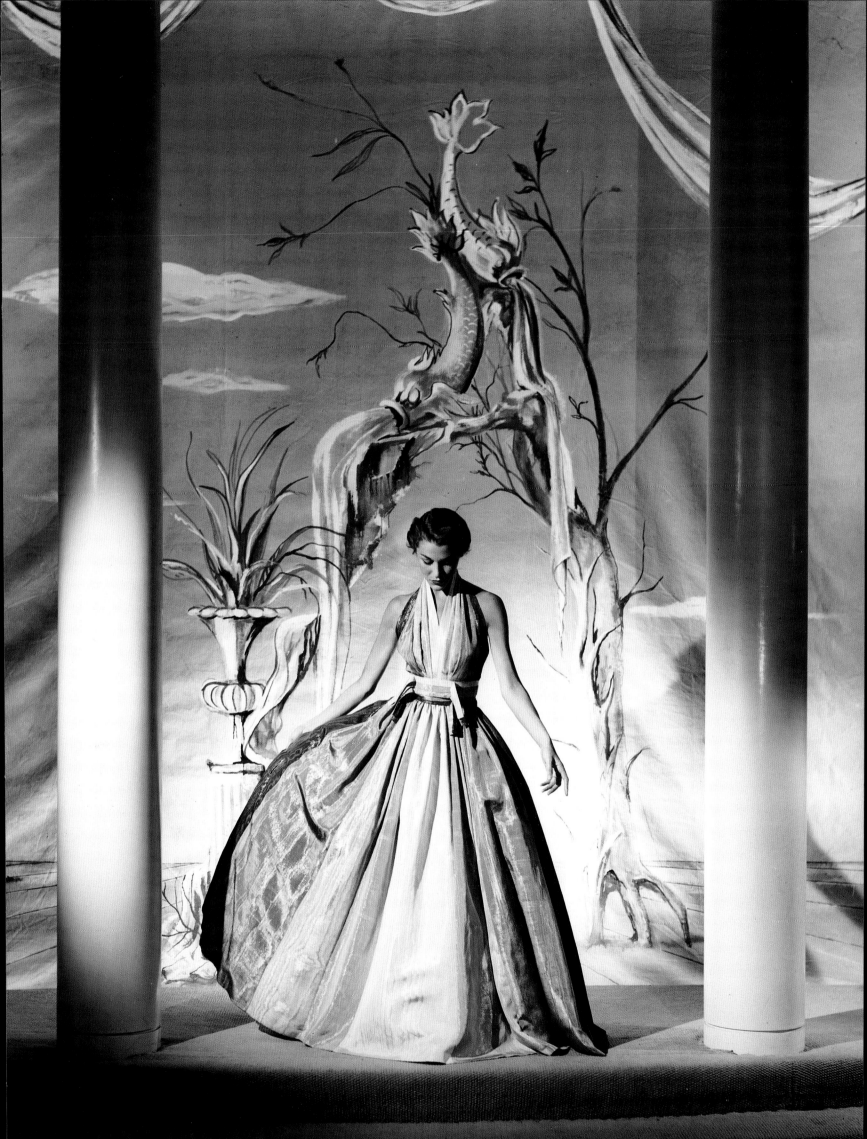

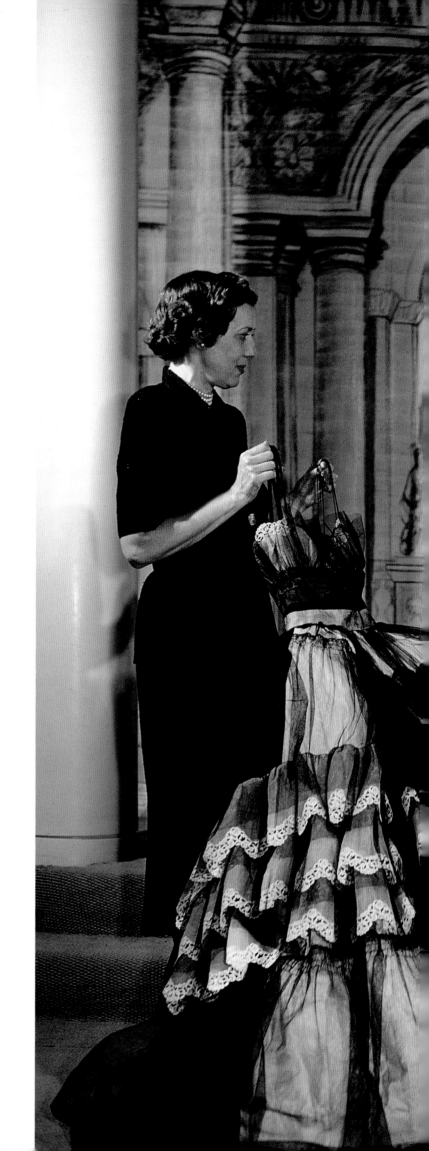

Loretta Young modeling an elegant red-silk chiffon evening gown that Adrian named "The Flame That Went Out Dancing." Architectural backdrop designed by Tony Duquette.

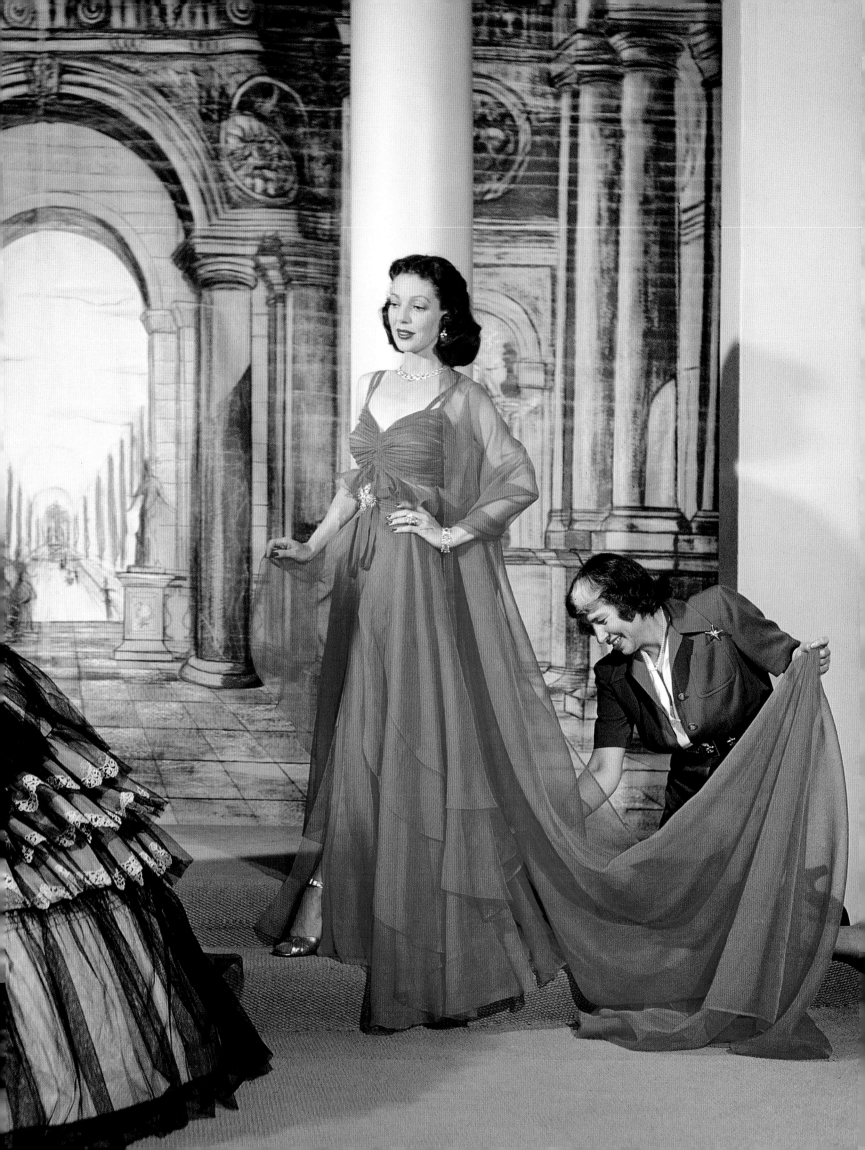

1949 COLLECTION FOR FALL AND WINTER

J. W. ROBINSON CO. BEVERLY HILLS

Above: Program cover for Adrian's 1949 Fall/Winter collection.

Opposite: Wesley Simpson's contrasting polka-dot and striped fabrics that Adrian used for a one-shoulder dress and stole ensemble.

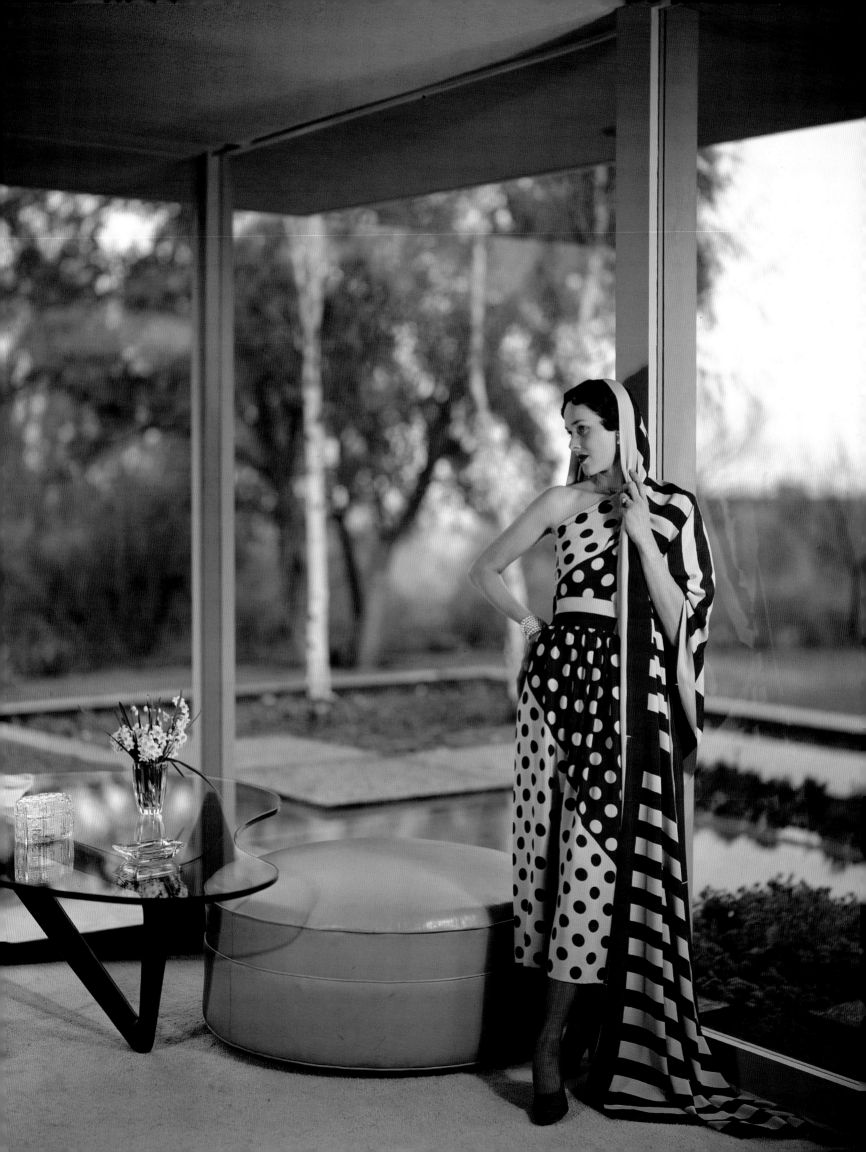

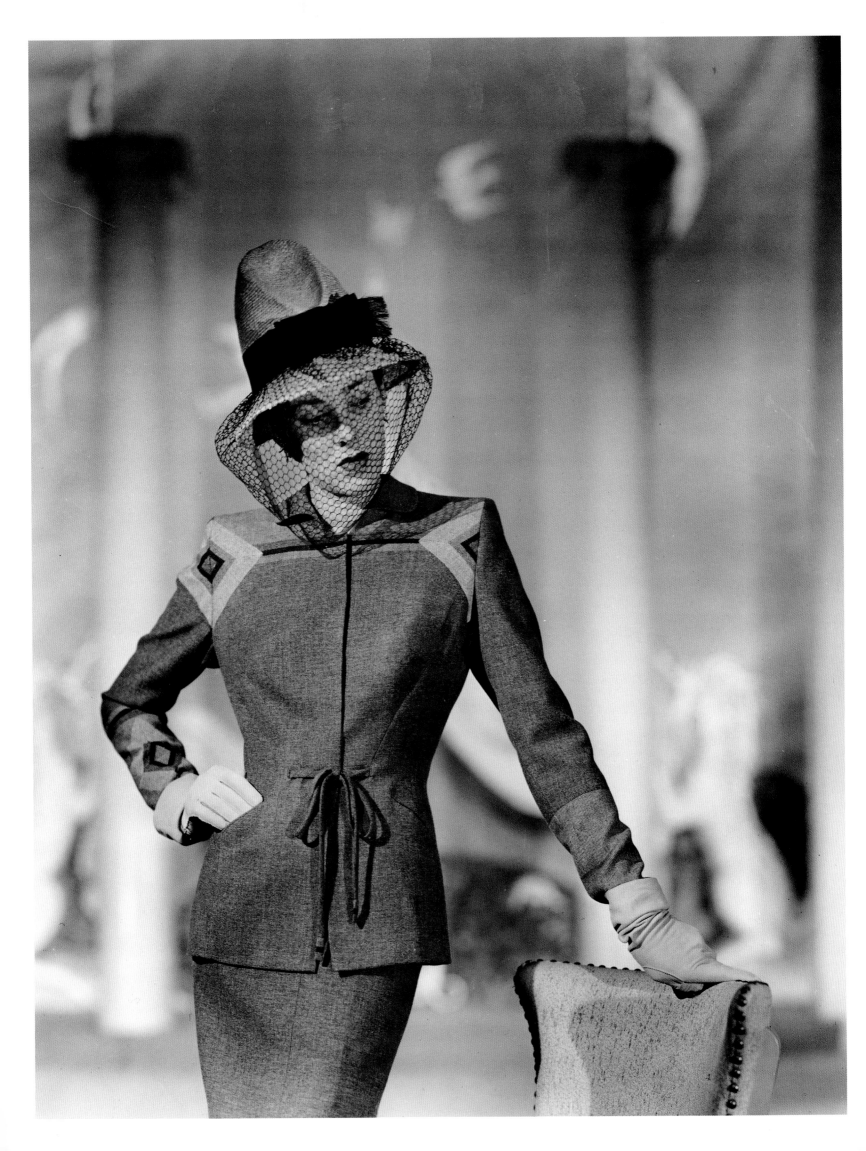

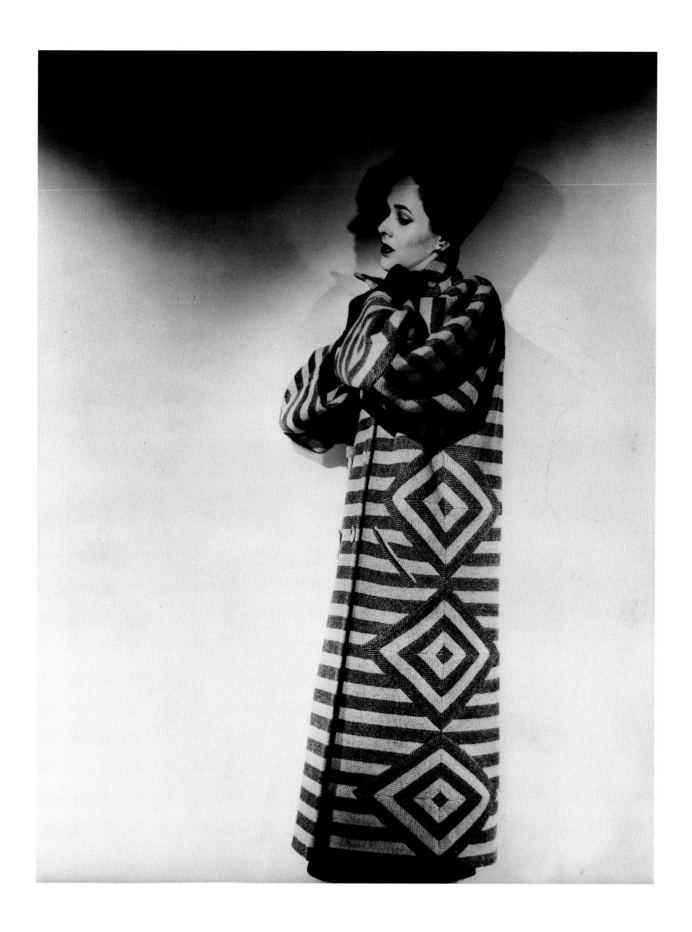

Opposite: "Variety," a classic
Adrian silhouette suit—mitered and
tailored to perfection. Photograph
by John Engstead.

Above: Adrian's intricately mitered
striped wool coat.

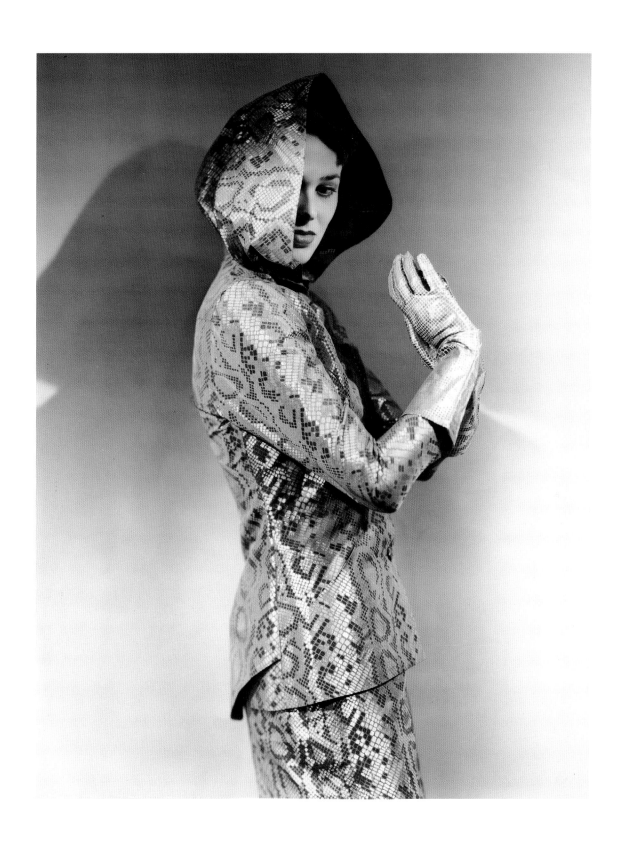

Opposite: Adrian-designed
metallic snakeskin fabric.

Above: Adrian's "King Cobra"
hooded suit. Photograph by John
Engstead.

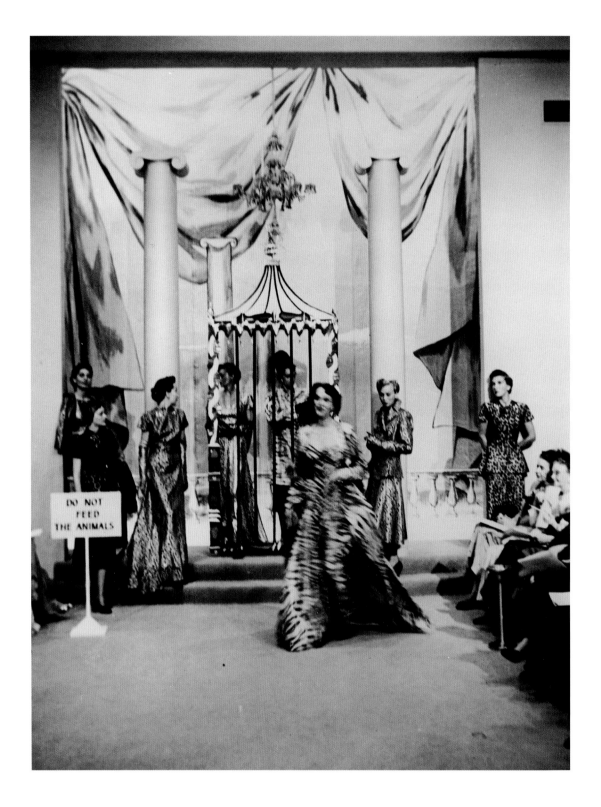

Above: Adrian's playful sense of
humor is displayed by his sign,
"Do Not Feed the Animals."
Photograph by John Engstead.

Opposite: Adrian's gold-lamé
leopard-print gown with dramatic
back draping, full skirt, and opera-
length gloves. Adrian designed all
the animal-themed fabrics for this
collection.

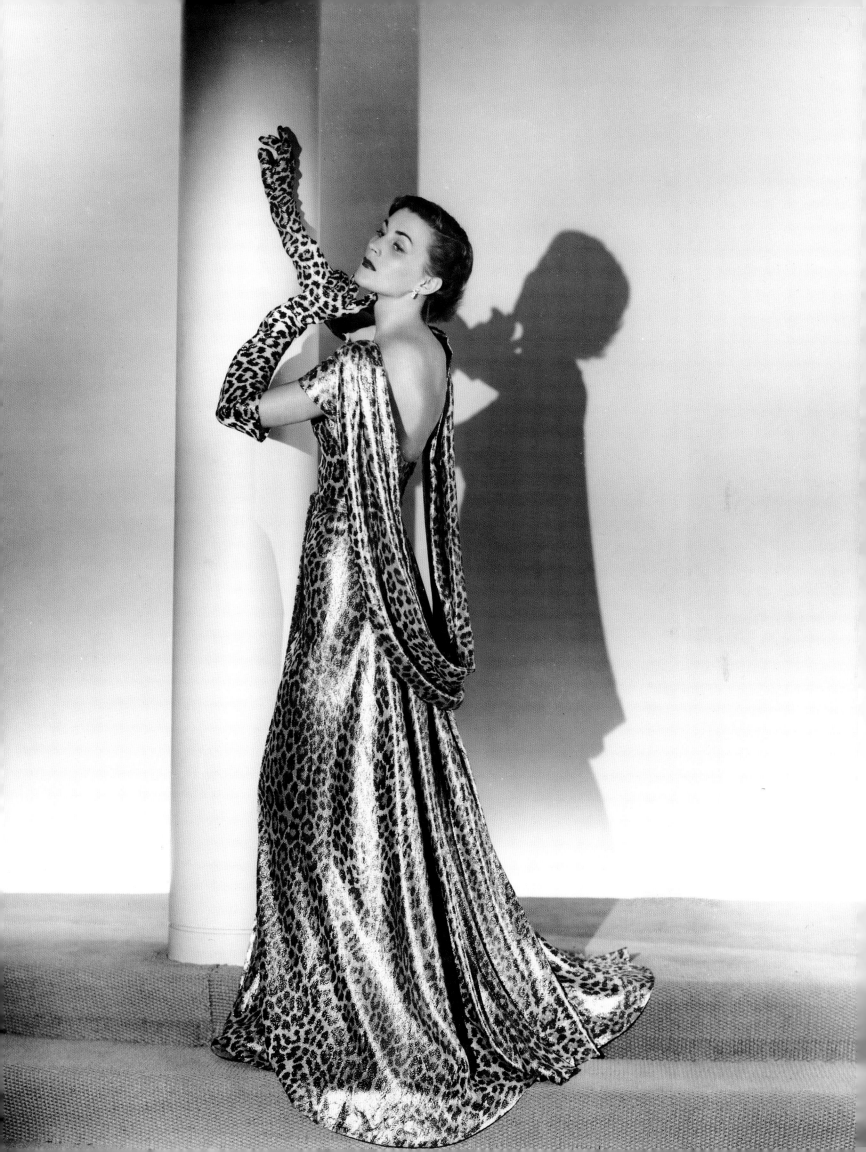

Above: Adrian and Janet in a
final fitting with his head fitter,
Hannah Lindfors, who was with
Adrian throughout his M-G-M and
Adrian, Ltd. years. Janet is wearing
Bianchini-Férier spun-gold lamé
on pure silk taffeta. Photograph by
John Engstead.

Opposite: Loretta Young wearing
a print of black lace on white
organza. The apron and stole are
in pure silk black lace. The stole
is trimmed in organza ruffles.
Photographed on her terrace by
John Engstead.

Above: A strapless evening gown
with an embroidered bodice and
long, slim skirt. African warrior
prop designed by Tony Duquette.
Photograph by John Engstead.

Opposite: Two enchanting
embroidered white organdy
evening gowns. Unicorn tented
backdrop by Tony Duquette.
Photograph by John Engstead.

COLLECTION
FOR SPRING OF 1950

Above: Program cover for Adrian's 1950 Spring collection.

Opposite: *Vogue* illustrator René Bouët-Willaumez's drawing of Adrian's cerise taffeta evening gown and open-weave crocheted black stole from his Spanish collection. Drawing, the Leonard Stanley Collection.

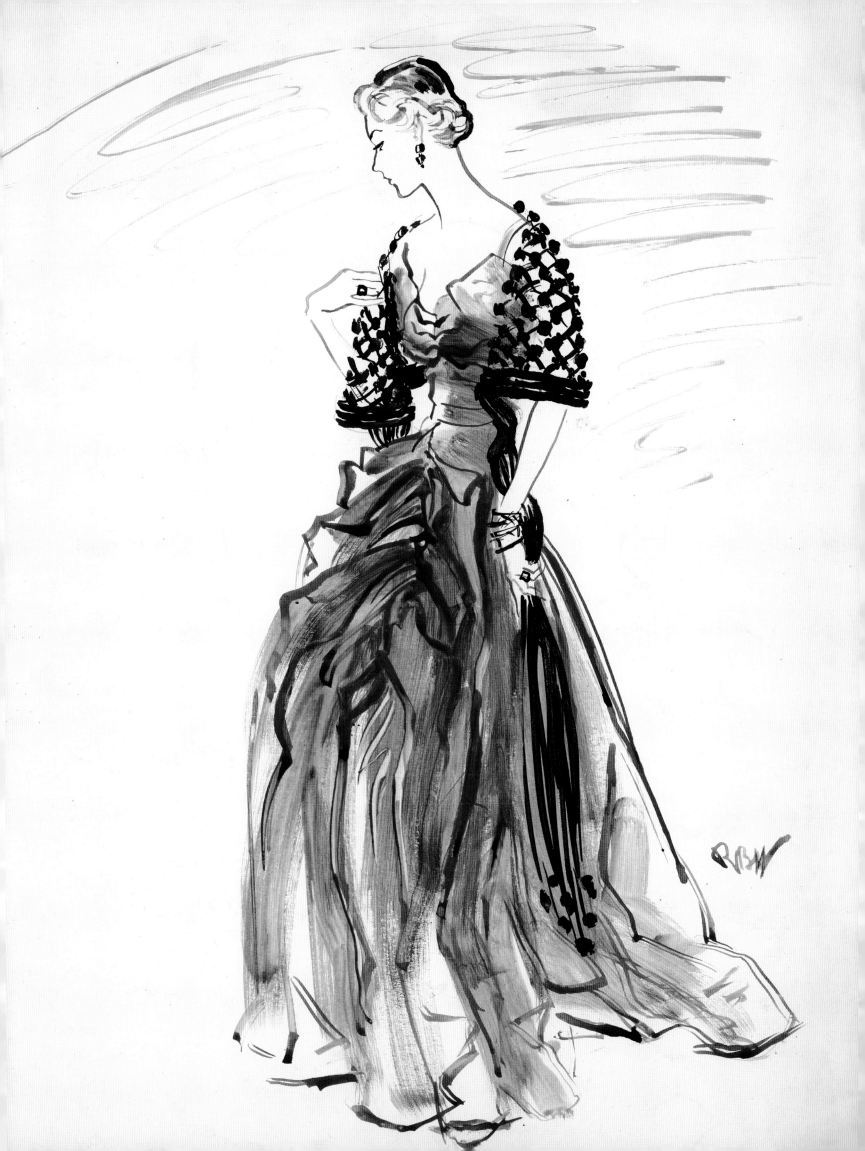

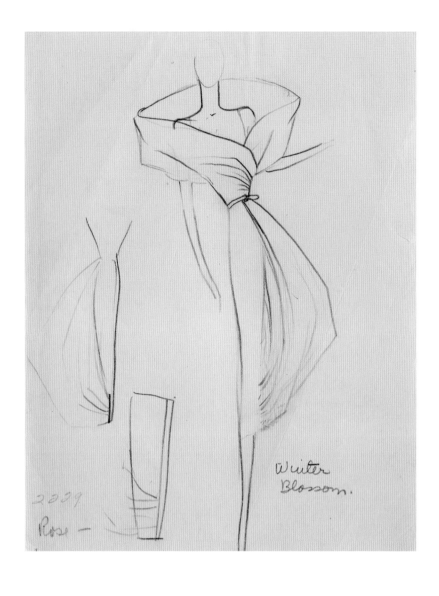

Left: Adrian's original sketch of his cocktail dress called "Winter Blossom" and, below, a photograph of a model wearing the finished dress.

Opposite: Interior of John Engstead's photography studio showing him photographing Georgiana Montálban, Loretta Young's half-sister and wife of Ricardo Montálban, modeling a gown from Adrian's Spanish collection.

Following pages, from left: Adrian's model, Nadi, showing the back view of "Spanish Drama." A red-wool matador jacket with circles of intricate jet-beaded embroidery is paired with a dramatic silk taffeta skirt; René Bouët-Willaumez's illustration of Adrian's "Spanish Drama."

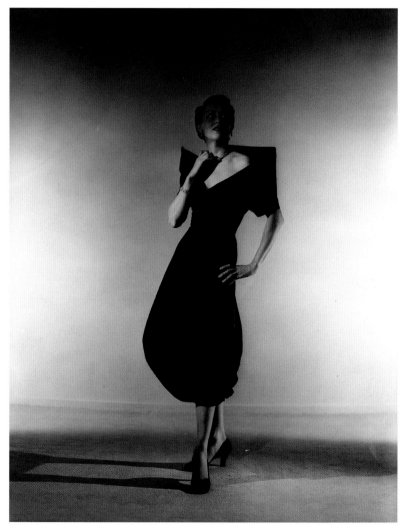

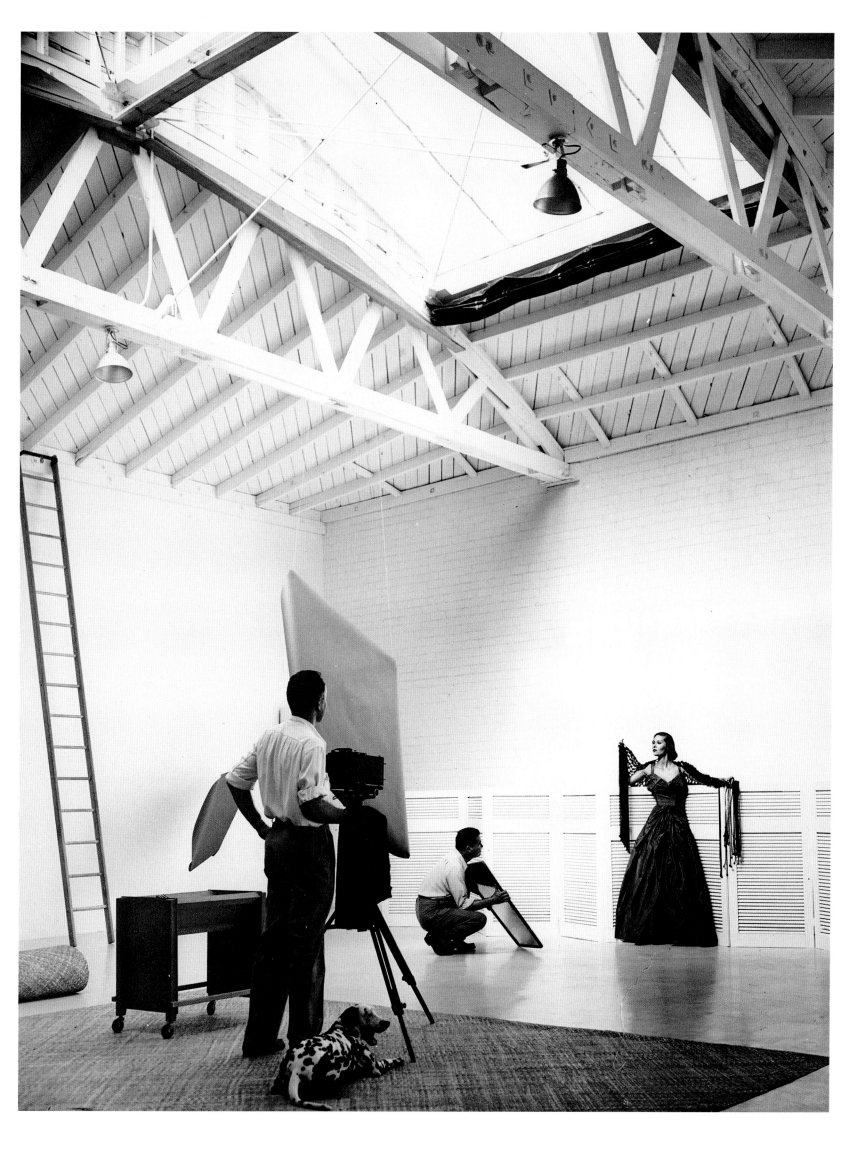

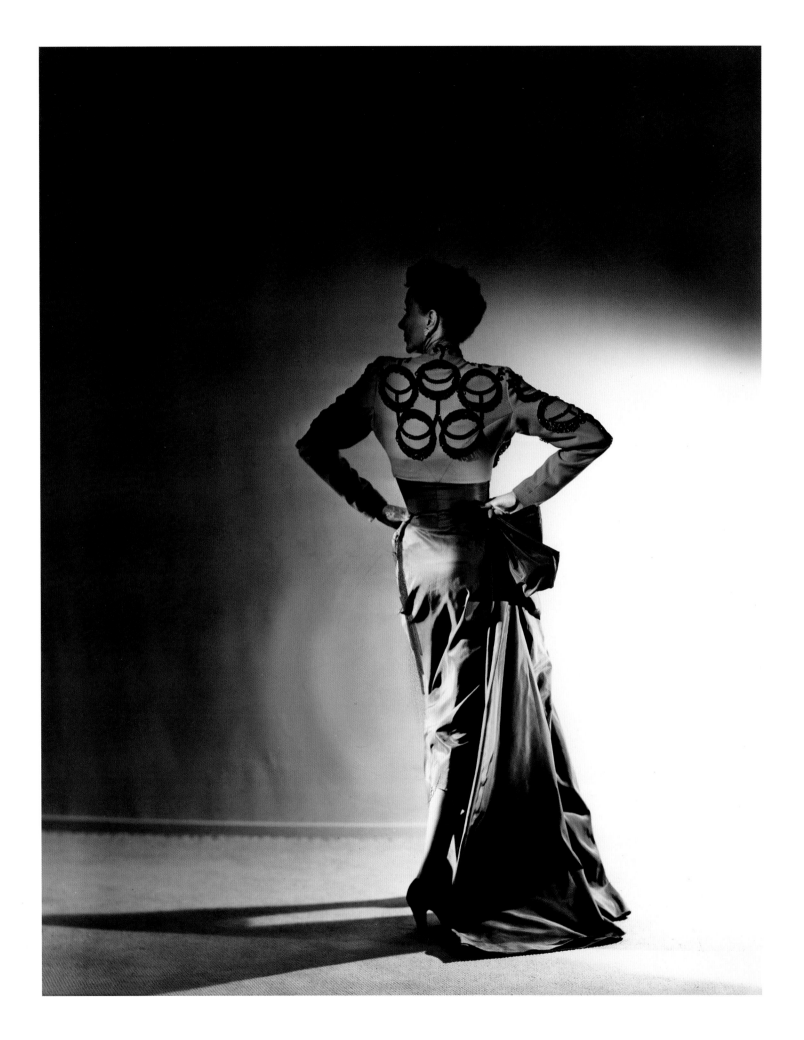

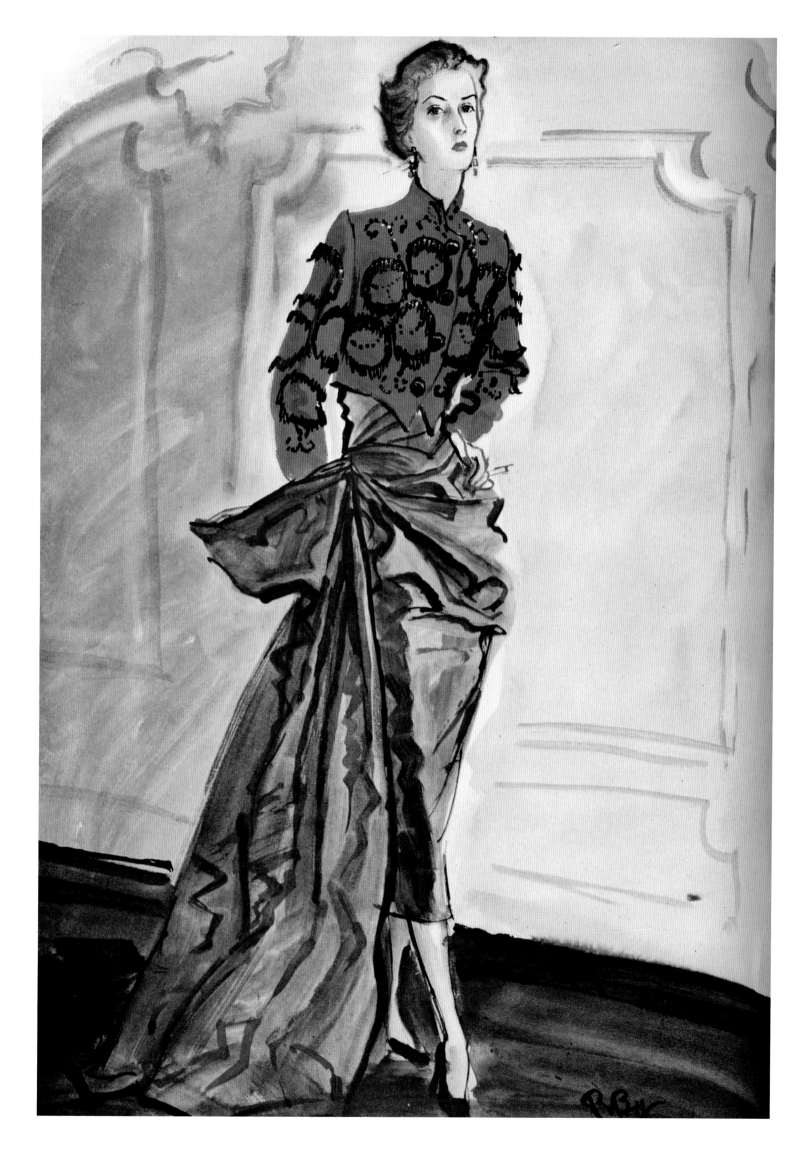

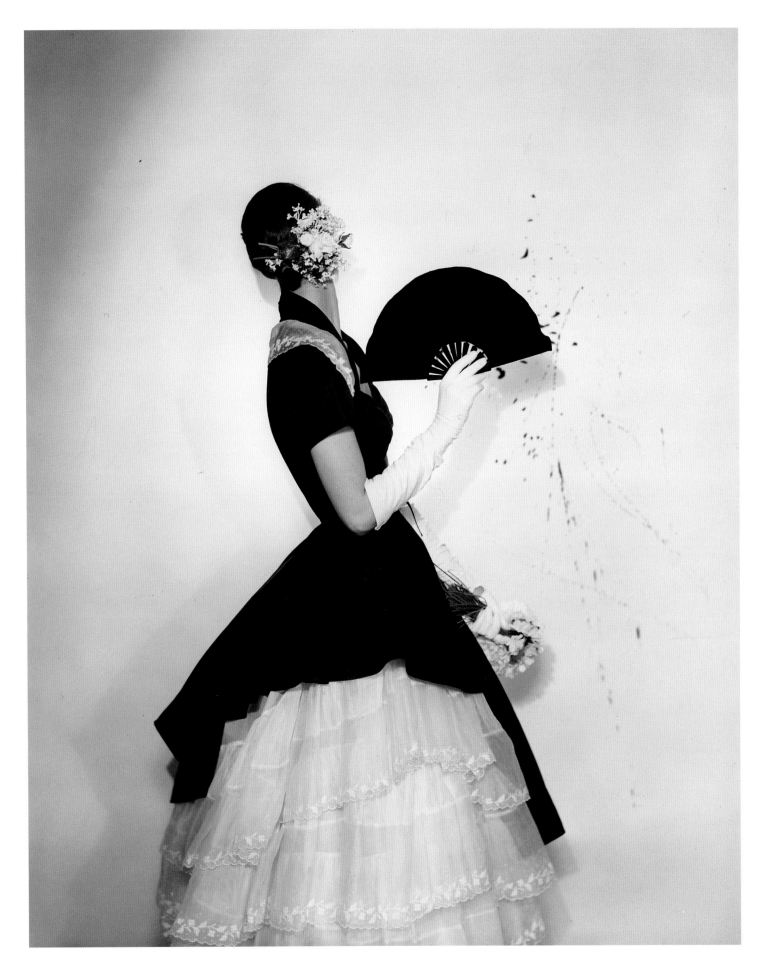

Above: Adrian loved the
combination of white-embroidered
organdy and contrasting black silk
taffeta as worn by the model in this
photograph by Cecil Beaton.

Opposite: "A Spring Story," another
example of Adrian's combination
of white-embroidered organdy and
black taffeta. Photograph by John
Engstead.

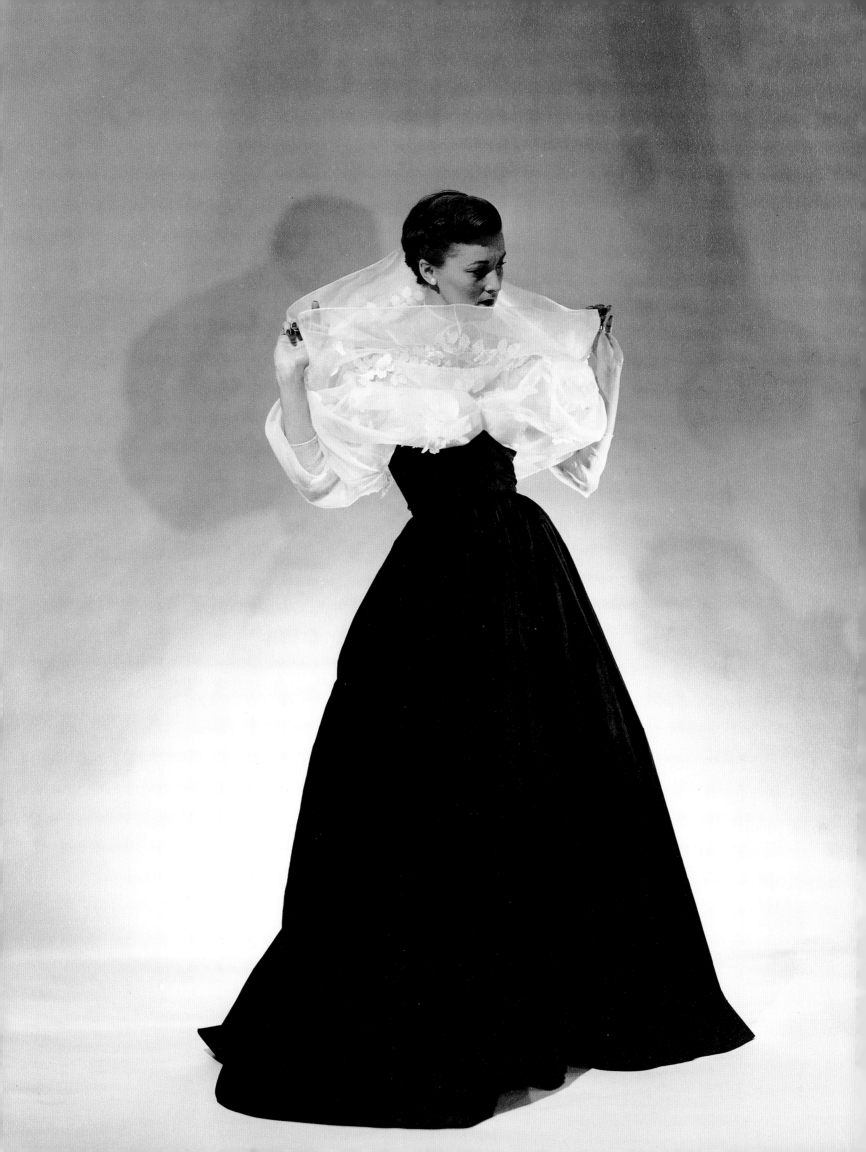

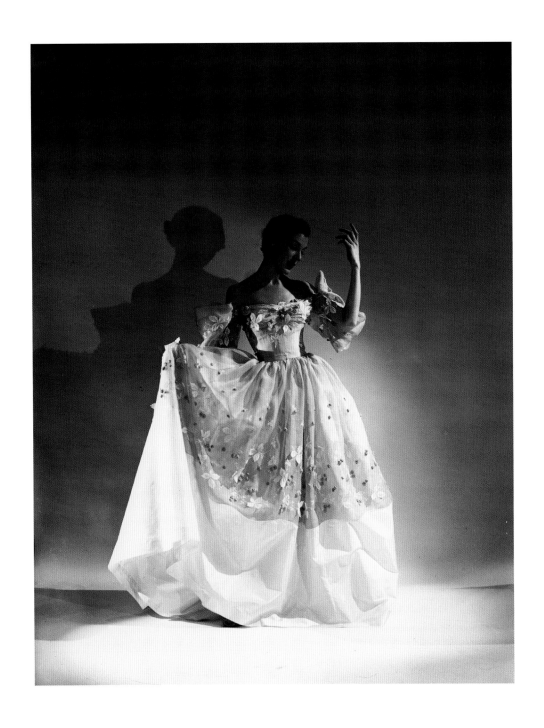

Above: Adrian's white "St. Gall Swiss," an embroidered organdy ball gown. Photograph by John Engstead.

Opposite: Loretta Young on the terrace of her Beverly Hills home modeling Adrian's magnificent ball gown of striped sheer silk gauze with yards of horizontally draped swags below a floor-length overskirt. Photograph by John Engstead.

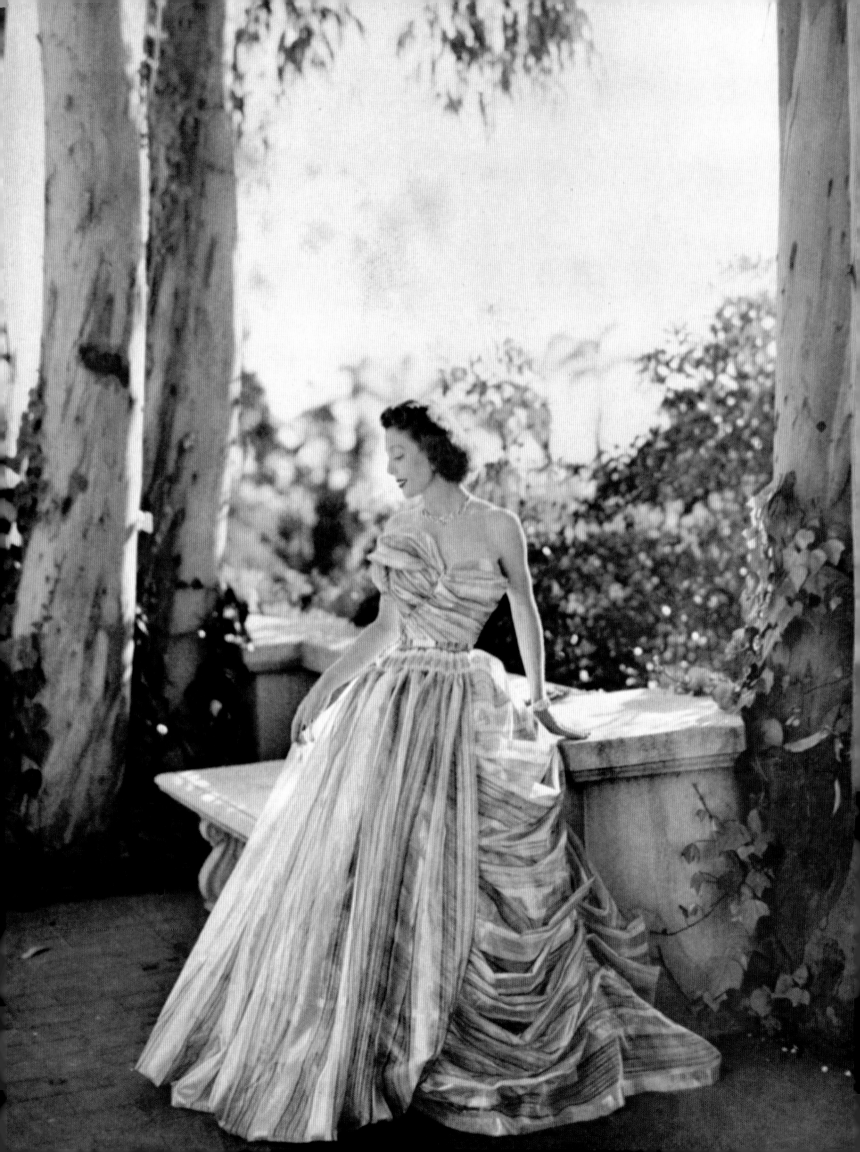

Above: Program cover for Adrian's
Spring/Summer 1951 collection.

Opposite: Suit with dramatic
full cape. Photograph and crop
markings by John Engstead.

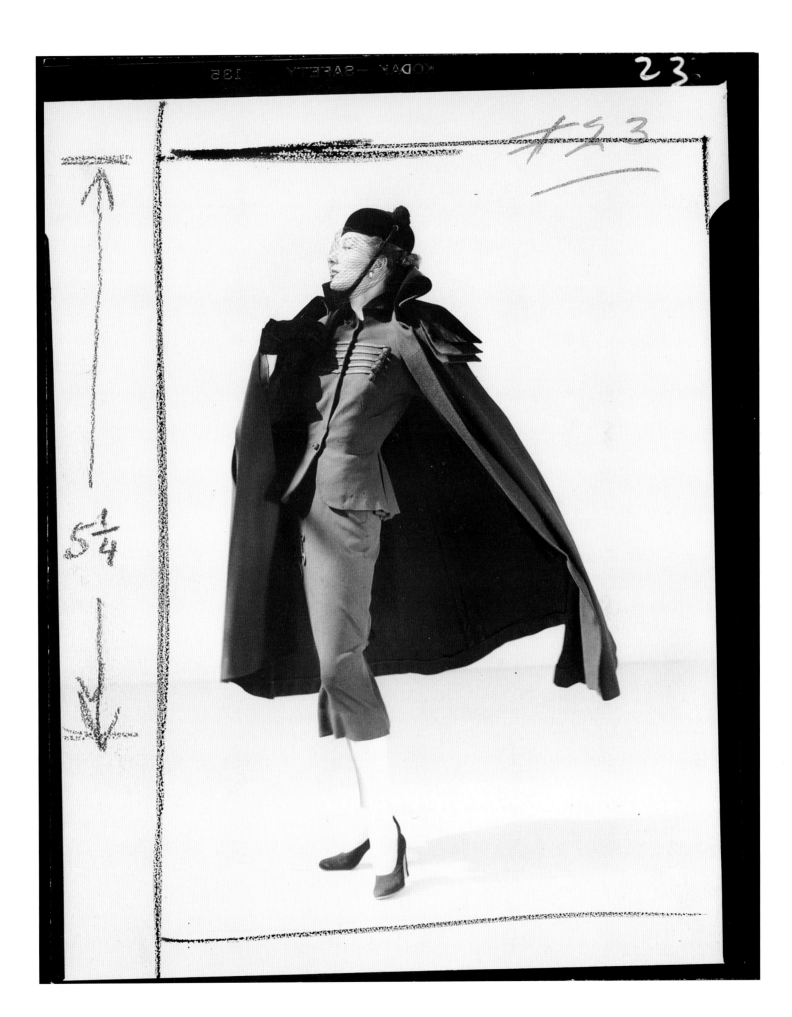

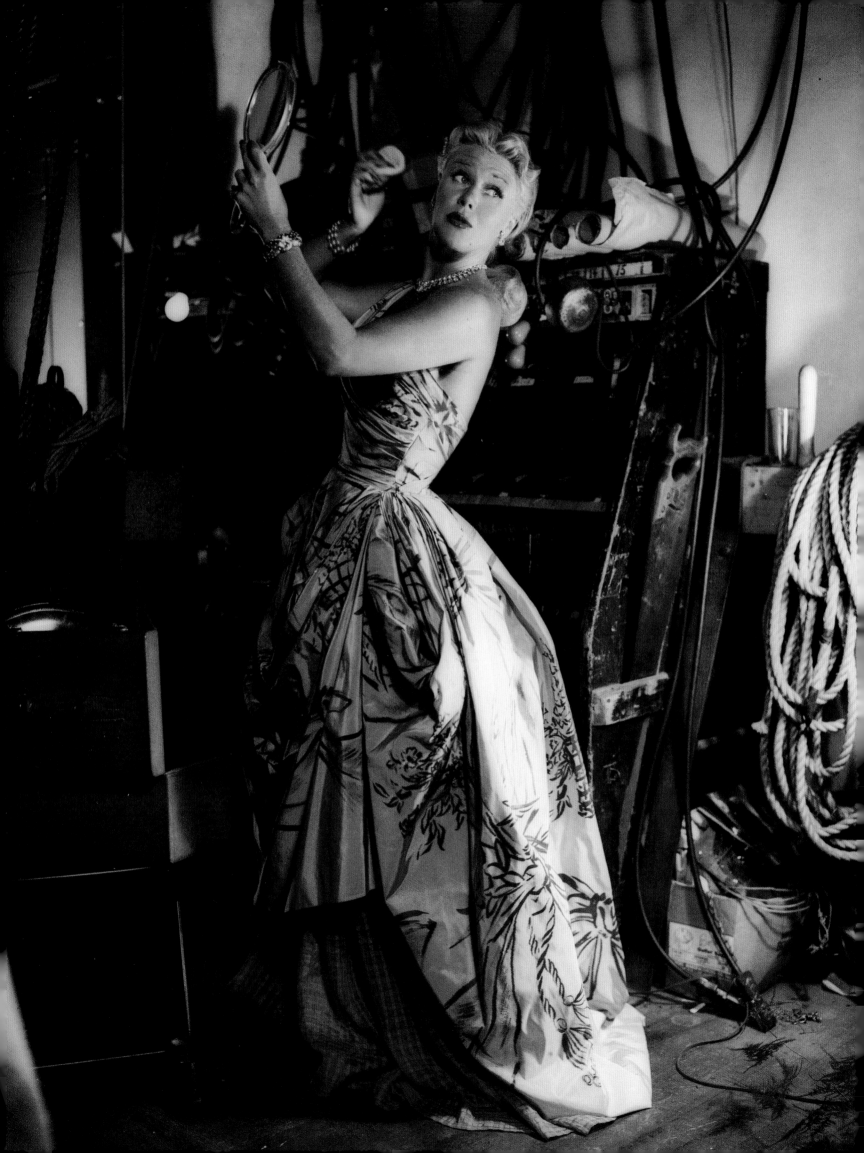

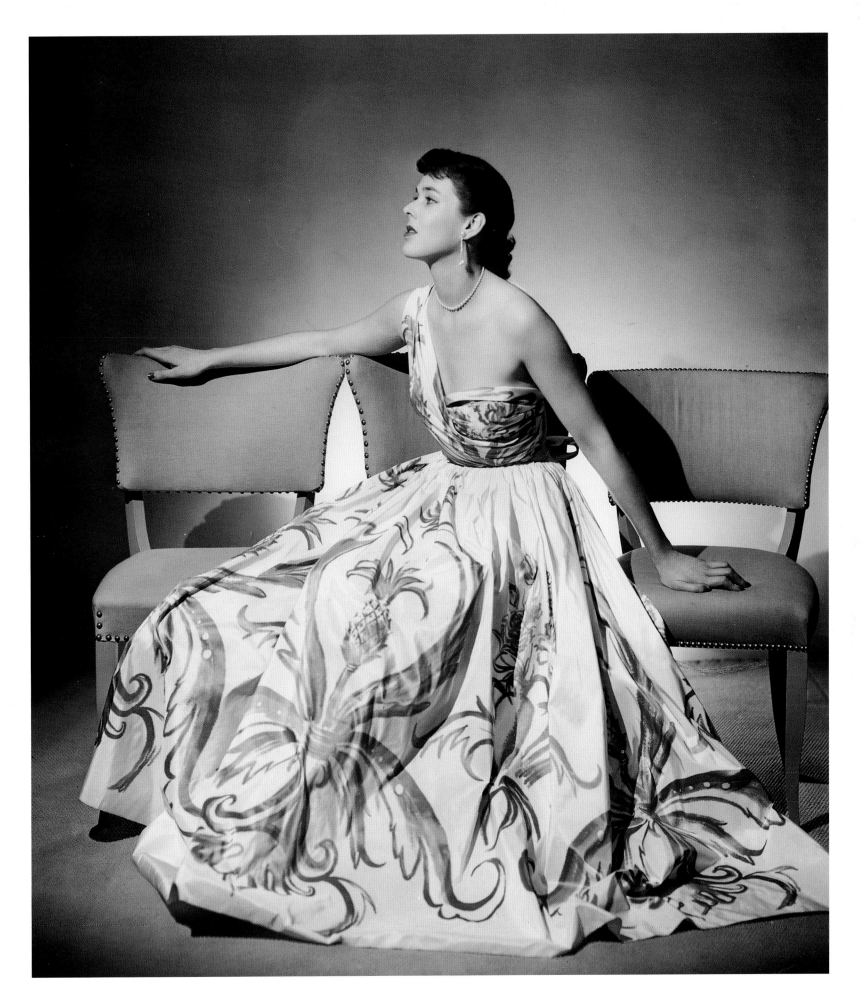

Opposite: Adrian used a silk-warp taffeta print for this sumptuous gown modeled by Ginger Rogers.

Above: Adrian designed the oversized pineapple motif on the Bianchini silk taffeta for this gown worn by model Bess Dawson. Photograph by John Engstead.

Above: A black-tie evening at Adrian, Ltd. Pictured from left: Janet Gaynor, Tom Lewis, Loretta Young, and Claudette Colbert.

Opposite: Reginald Gardner, Clifton Webb, and Janet. Adrian had black-tie evening showings of his collections. His fashion shows turned into theatrical events with special lighting, creative props, and original music. A dinner catered by Mike Romanoff would follow.

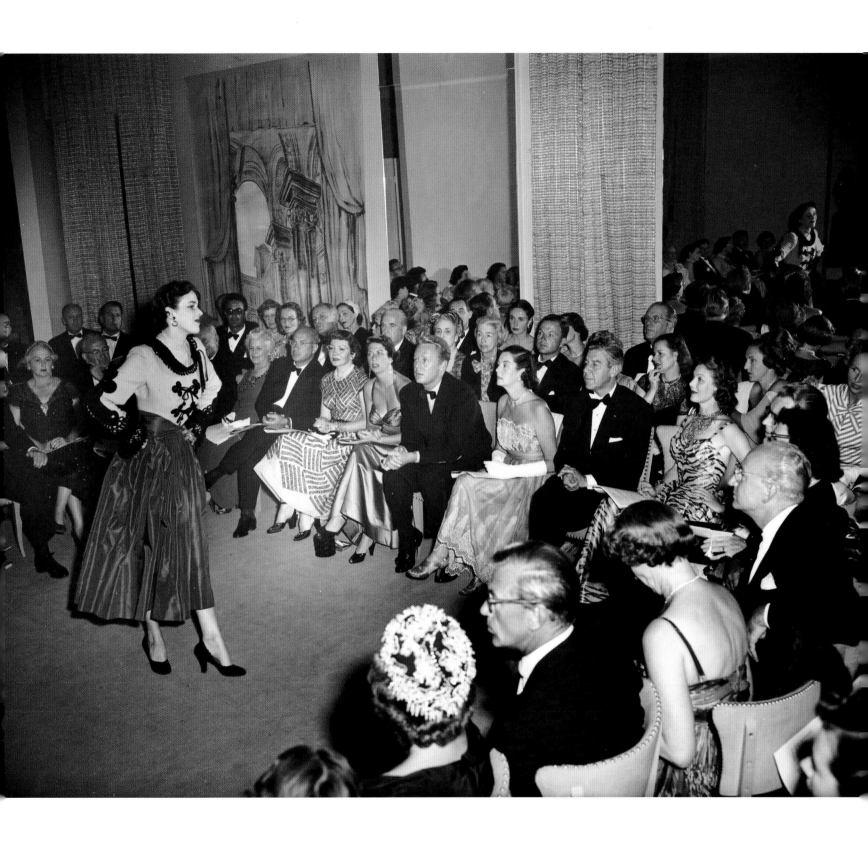

Seated in the fashion show
audience are Rocky and Gary
Cooper, in the foreground; Mr. and
Mrs. James Pendleton; Loretta
Young and husband, Tom Lewis;
Van Johnson and wife, Evie;
Claudette Colbert and husband;
behind model Bess Dawson, Dr.
Jules Stein and wife Doris.

Clockwise from top: Collection of Adrian's suits in Pola Stout woolens; Mr. and Mrs. Clark Gable join Adrian at a table; Mike Romanoff with Virginia Zanuck (wife of Darryl F. Zanuck, head of 20th Century Fox) and Adrian.

Opposite, from top: Mr. and Mrs. Gary Cooper with Adrian; fashion show finale.

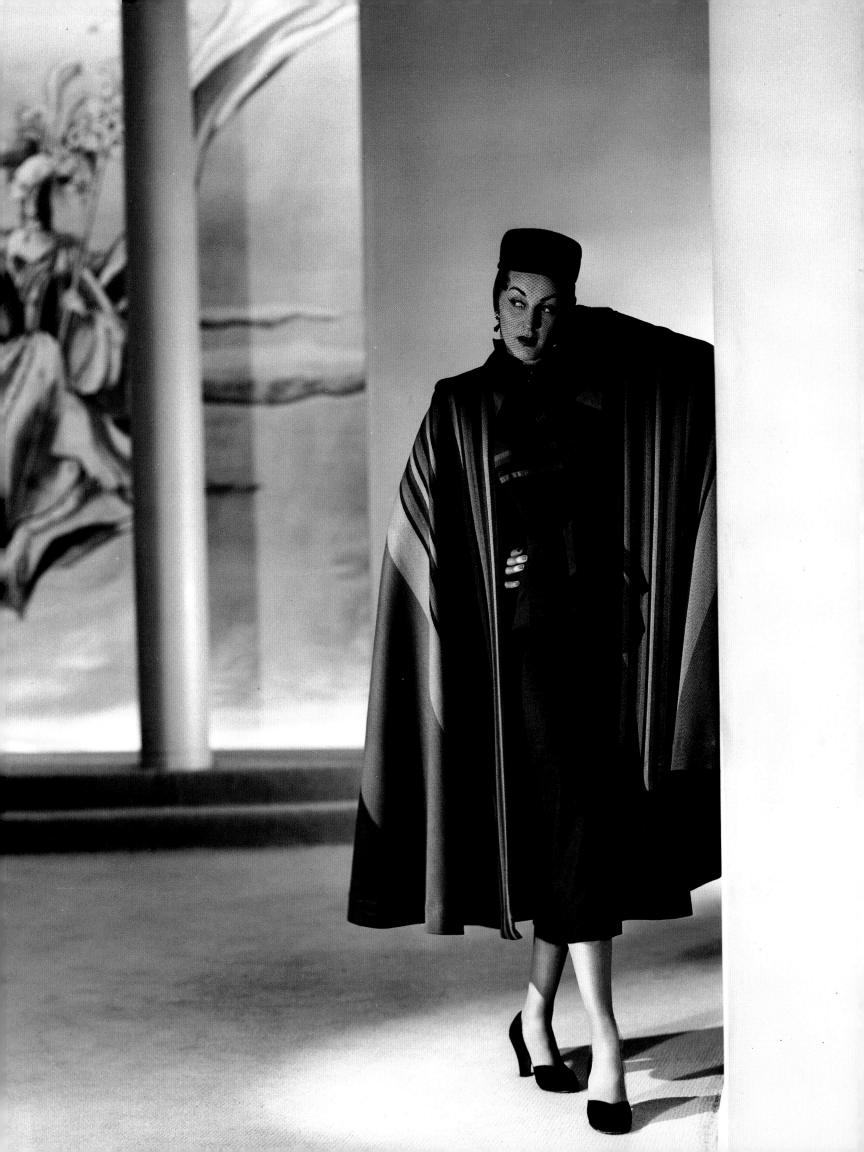

I've always felt it is easier and wiser for a woman to trust her mirror than friends compliments or advice about clothes.

If you don't look well in it, — don't wear it — regardless.

I've always designed clothes I believed in — I remain true to a few truths I've found have not let me, or women, down.

Whatever I have done for this collection is done for purely rational reasons — to make a woman's reflection in her mirror reflect beauty and make her body look its best.

There are certain beautiful fashion truths which never change. For instance — pearls. Pearls have never been replaced — they still are the gracious jewels that give distinction and beauty and women never tire of them.

Fashions in jewels come and go — but the strings of pearls weather every storm.

I feel about daytime clothes, today, the way women feel about pearls. I feel that a woman's life is so limited by the speed and hectic activity that there is a certain trim look that is as enduring as the pearl; that suits are the pearls of fashion's necklace and that the right suits go on forever — they are not this Season's suits — they are forever — I like to design suits with that in mind.

It's as simple as that — the clothes this Season are not designed to change fashion as much as they are to enhance women.

I think fashion has crystallized for our era — I don't think it will vary much for the next fifty years. I think for our way of living, we have reached the peak of variety — for years it will be "news of detail" — but the general silhouette is formed — and here it is, yours — for a long time — but, exciting because it is timeless. Of course, we'll make news each season and say "this year women will look "Egyptian" or "this Season ladies be Venetian ladies" — but, we know that only a handful of ladies will look Venetian and the majority of fashionable women will look in their mirrors and shrug their trim, square shoulders and turn the page — and remain themselves . . . the women of 1950 — who have, at last, found out what suits them for years to come . . .

Adrian

Opposite: Adrian suit and dramatic cape of Pola Stout striped-wool fabric.

Above: A letter written by Adrian discussing his philosophy on fashion.

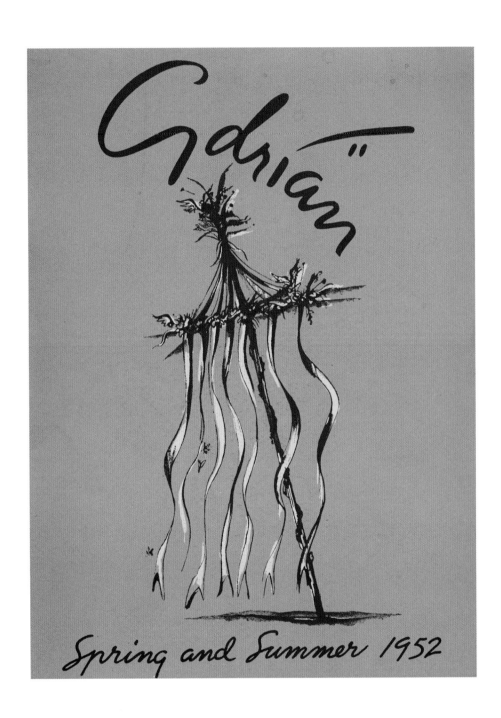

Spring and Summer 1952

Above: Adrian's program cover for his Spring/Summer 1952 collection.

Opposite: Fashion show finale featuring ball gowns of Bianchini-Férier silk taffeta. Photograph by John Engstead.

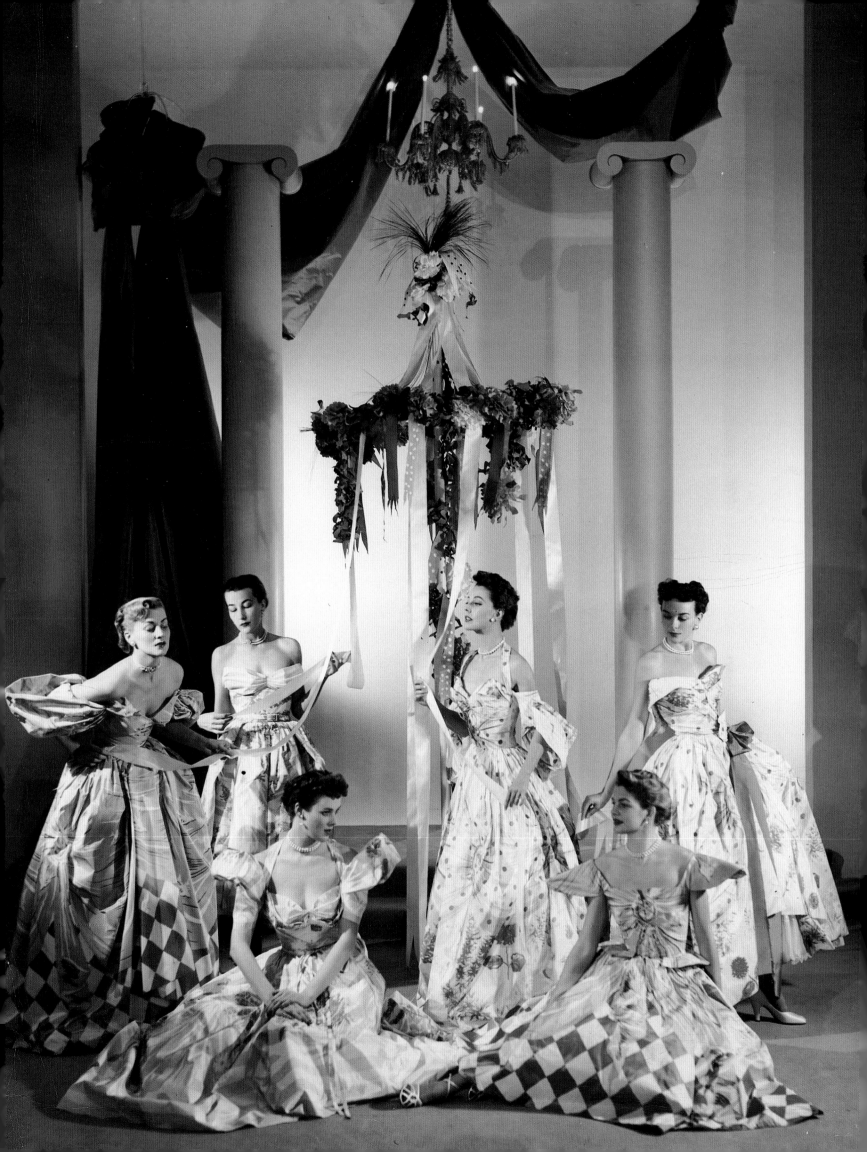

n the summer of 1951, I took the bus from U.C.L.A. (where I was living in the S.A.E Fraternity House) to Beverly Hills to Adrian's salon on Beverly Drive. I hoped that I would be able to attend the opening fashion show scheduled for that day. It was by "Invitation Only," and all my pleading had absolutely no effect on the woman in charge—there was a definite "No." I was so disappointed, I kind of teared-up on the way back to U.C.L.A., but I got my revenge.

Just six months later, while working for Tony Duquette, I had fabricated a Maypole prop for Adrian's next fashion show and was sitting with Janet, Adrian, Tony and Beegle Duquette, Woody Feurt and his wife, Caroline—just the seven of us at the dress rehearsal of Adrian's last great collection.

LEONARD STANLEY

Left: Detail of a Bianchini-Férier silk taffeta used for the "Snow Rose" ball gown.

Opposite: The "Snow Rose" ball gown in white silk taffeta printed with clusters of roses, closely shaped bodice, wing-draped sleeves falling below the shoulders, and a full-length gathered skirt. Photograph by John Engstead.

Following pages: A young Audrey Hepburn modeling a ball gown of Bianchini-Férier flowered silk taffeta designed by Adrian. Richard Rutledge photographed Miss Hepburn for the March 1952 issue of Vogue.

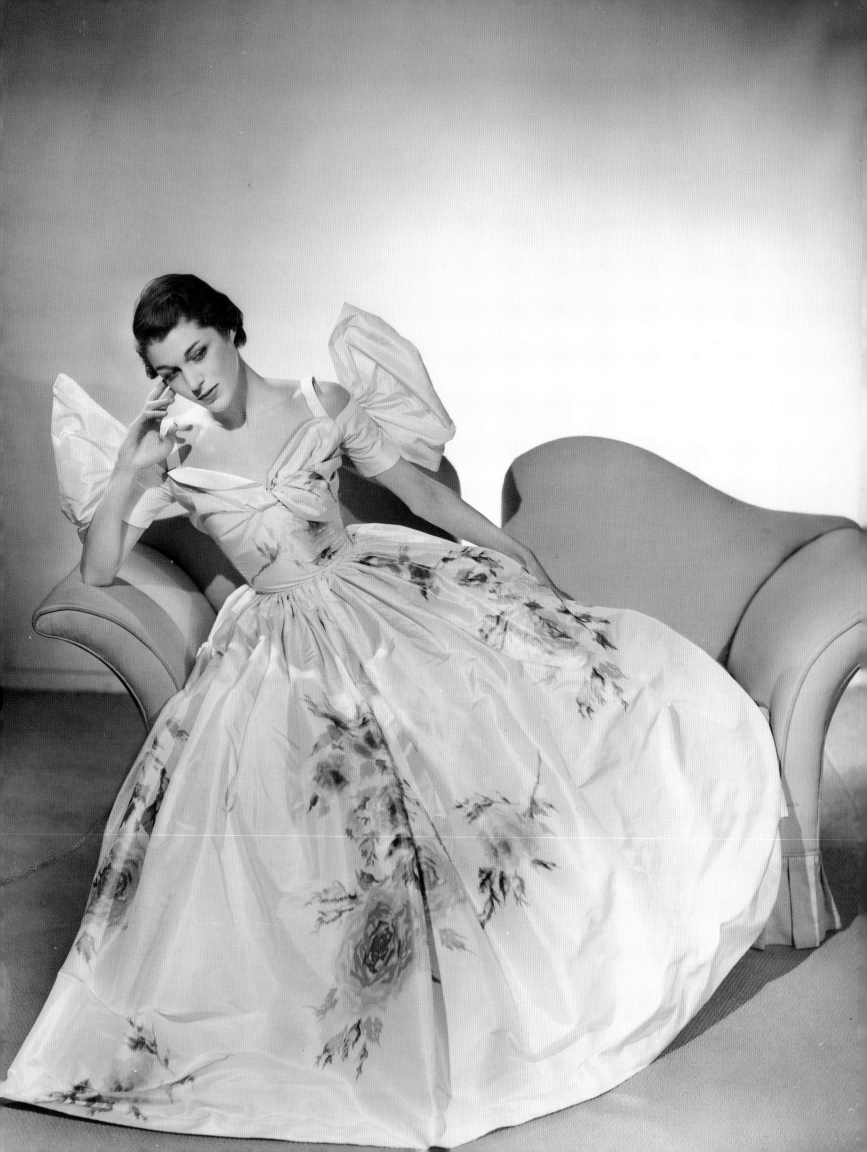

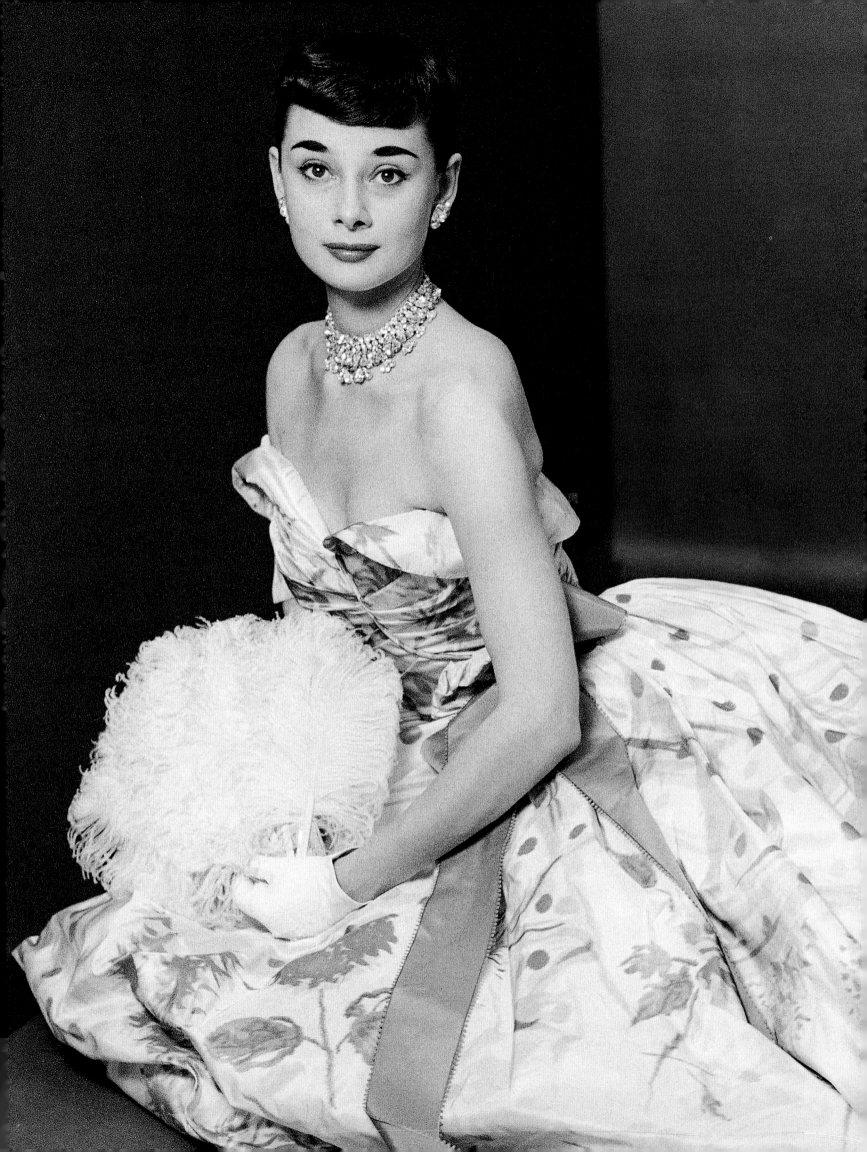

ADRIAN: LIFE AT HOME

Previous pages: Adrian's high-ceilinged living room at Villa Vallombrosa.

This page: Outdoor staircase at Villa Vallombrosa.

Opposite: Adrian's living room.

VILLA VALLOMBROSA

Adrian first rented a house on Franklin Place to be near the Valentinos. But, after Rudolph Valentino died and Adrian went to work for Cecil B. DeMille, he rented a charming place in what was called the French Village in Hollywood.

In 1928, Adrian was living in the Tower House. The French Village was a group of unique French architectural houses in a park-like setting.

After leaving the French Village, Adrian rented another house in Whitley Heights called "Villa Vallombrosa."

In 1931, Adrian had a small dinner party with Greta Garbo and Mercedes de Acosta during which he showed them his sketches for the film *Mata Hari*, and they all discussed Garbo's wardrobe.

Adrian had also opened a shop on Olvera Street in downtown Los Angeles.

LEONARD STANLEY

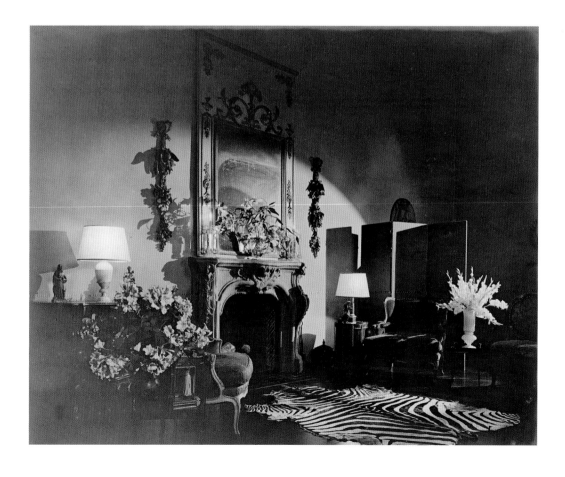

Cecil Beaton drew a charming sketch of the shop for *Vogue* magazine, June 15, 1931, which included an article about the interior.

"Mr. Adrian, premiere designer of Metro-Goldwyn-Mayer, is prized and guarded as one of the most important treasures, and rightly so, for he possesses astonishing talents in many directions; his paintings are extraordinary, and the costumes that he designs have the merits of being utterly photogenic, possessing the heightened smartness and exaggeration necessary for photoplays."

"There are certain stores in Hollywood, which have sprung up during the last year and which tell a story for themselves. In Los Angeles's old Mexican Olvera Street, there is the oasis of Mr. Adrian's shop, a revelation of amazing and fantastic taste. There are wildly imaginative frescoes and wall panels of the jungle by Adrian himself; there are lamps, urns, glass ornaments—and you never knew that lamps, urns, and glass ornaments could be so beautiful."

CECIL BEATON

Opposite: Cecil Beaton's sketch of Adrian's Olvera Street shop, featured in *Vogue,* June 15, 1931. Later in the 1930s, Adrian moved his antique and design shop to the glamorous new Sunset Strip area between Hollywoood and Beverly Hills, next door to the popular restaurant and nightclub "The Trocadero. "

Within the image: ANTIQUES MEXICAN GLASS GIFTS—

Adrian

VILLA ENCANTO (ENCHANTED HOUSE)

Adrian's next residence was his large house in Toluca Lake called "Villa Encanto." Adrian had many big Easter lunches and Christmas parties in the Toluca Lake residence because he loved Easter and Christmas so very much.

Adrian married Janet Gaynor in 1939. They made "Villa Encanto" their home along with their monkeys, talking parrots, two mynah birds, and eight goats.

According to an article in the *New York Times Magazine*, Adrian was quoted as saying, "Milking is very relaxing, particularly goats with whom I had an immediate success."

Janet and Adrian also loved entertaining friends and having intimate dinner parties. Paul Flato, the famous jewelry designer, remembers, "One night, Adrian and Janet invited Irene Castle and me for dinner. When we arrived at their house, it was like a small castle all candlelit, as Adrian always did something different. After a delicious dinner, Janet and Adrian took Irene and me to the nursery and showed us the most beautiful cradle and child furniture Adrian had designed for their baby who was to arrive shortly."

Then, in July 1940, their son Robin was born.

LEONARD STANLEY

Above: Adrian and his pet monkey, Omen, out for a stroll.

Opposite: Adrian and Janet pictured on their beautiful ivy-covered staircase.

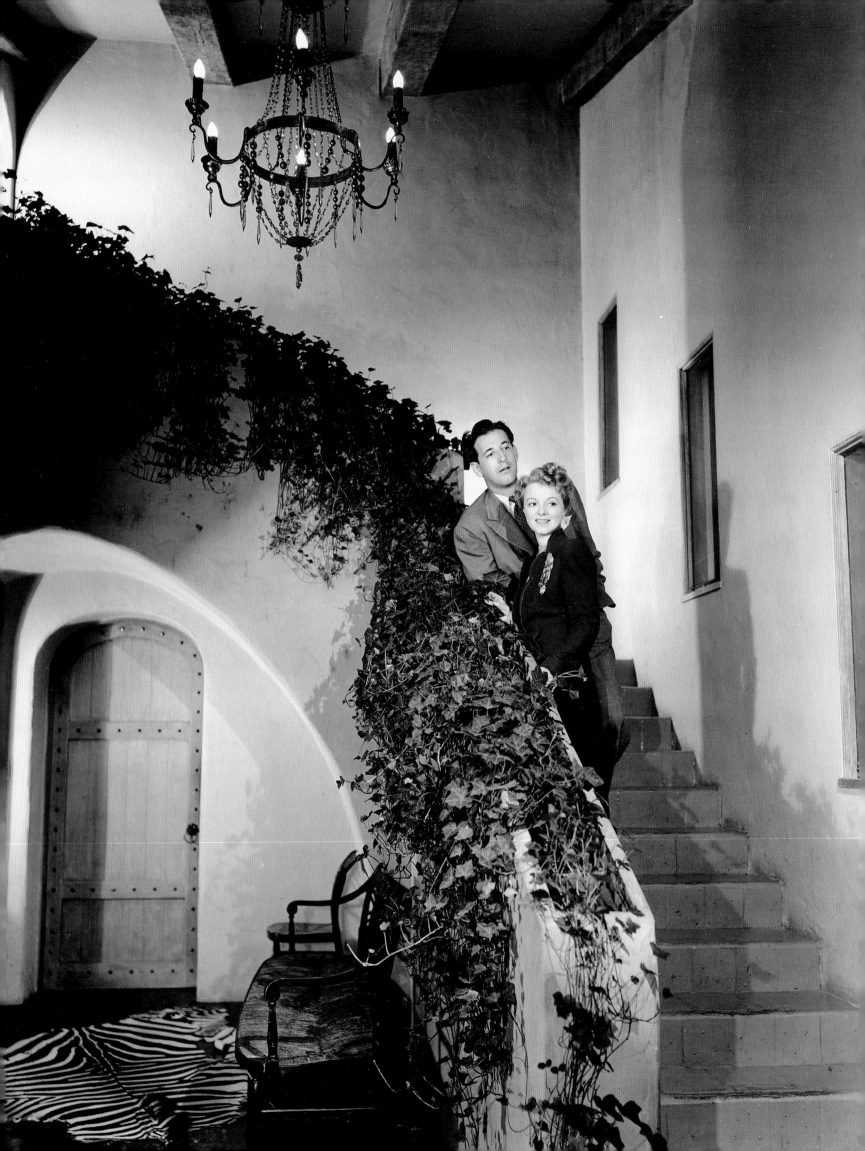

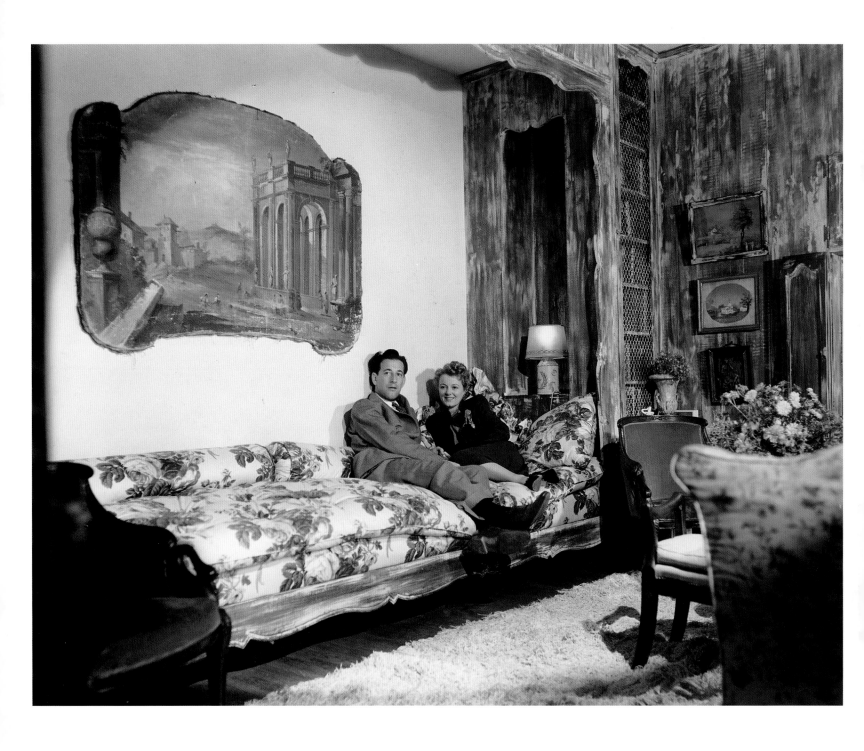

Above: The couple relaxing at Villa Vallombrosa.

Opposite: Adrian-designed four-poster bed with a pineapple-motif headboard.

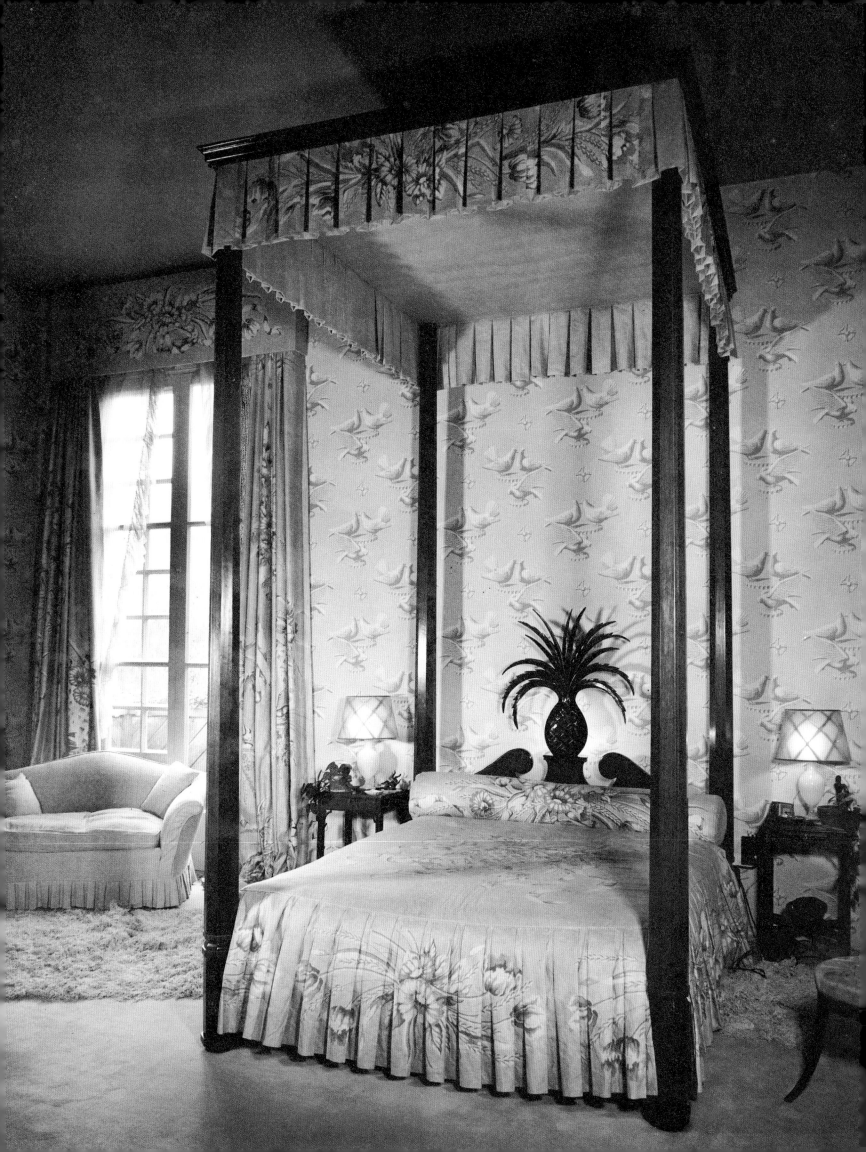

39

Design by Adrian

ADRIAN WRITES OF HIS CONNECTICUT HOUSE ON A CALIFORNIA HILL

Adrian, one of America's great couturiers, and his wife, Janet Gaynor, love California with a convert's zeal. Here is his formula for a house that is dramatic as California sunshine, photogenic as a movie star. A New England farmhouse on the outside, its spirited interior reflects the tastes, collections, travels of its talented owners.

■ Probably because Janet and I were both born in the east—she in Philadelphia and I in Connecticut—we get a great kick out of living in a very eastern house on a western hill—with no snowed-in moments. The most bromidic phrase a Californian hears from a newly-arrived easterner is "I like it out here but I must say that I yearn for a change of season. Too much sunshine for me!"

Possibly true at first, but after you've lived in California you can *never* get too much sunshine, and you *do* sense a change of seasons. You can even find a few shrubs and trees turning russet and yellow in the fall, if you know where to look!

March is the green month—bursting with fruit blossoms and tulips. All this Rotarian praise for California seems far removed from trying to tell about our house, or why Janet and I love it. It is probably because it behaves so well in the sun.

The living room gives the illusion of much sun pouring in because of the windows which are enormous bays at each side of the *(Continued on page 80)*

◄ Our living room—I waited over ten years to own the Grinling Gibbons woodcarving over the mantel. Now it mellows on our wall. The cupids on either side of the fireplace I picked up in Venice. They were evidently in a fire and are charcoal-black. I had the table made many years ago. It's now upholstered in rough silk. Nested in it is a fine white Bristol glass birdcage, planted round about with primulas and ivy and candles. CONTINUED ON THE NEXT PAGE ►

Above: *House & Garden* magazine article from 1945 in which Adrian writes about the design of his living room, which is seen opposite.

Following pages and pages 278–279: More from the 1945 *House & Garden* article featuring Adrian and Janet's New England–style farmhouse in California.

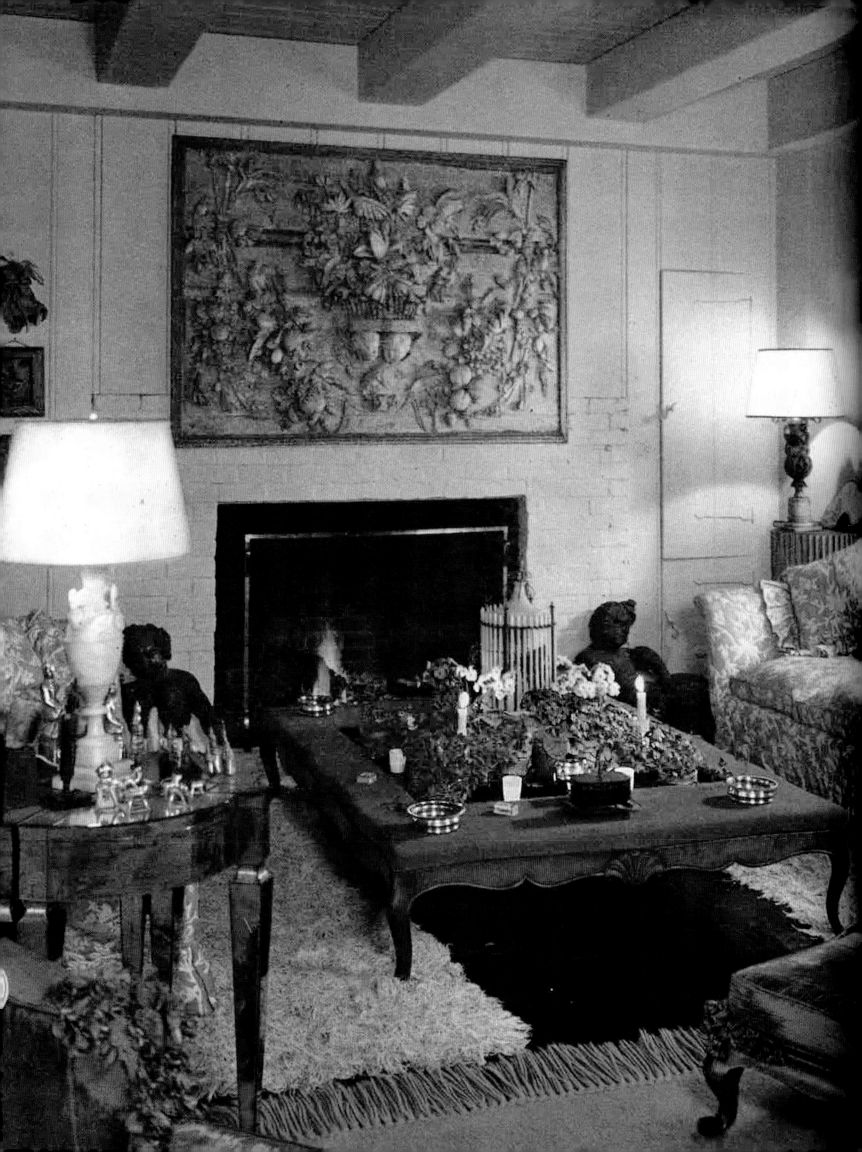

A HOUSE WITH A HAPPY FACULTY FOR MIXING ITS PERIODS

This is what we see from our porch: our barn; beyond, a neighbor's race horses.

Under our living room stairs there is a conversation-group; two gossip chairs and a sofa covered in handpainted gray linen.

In the living room bay, linen shades painted with Pillement trees filter our sunlight as they once did Italian sun. Lemon-yellow sofas are backed by Viennese wooden greens containers. The Venetian pink and blue glass chandelier, picked out with white, swings over a black Regency table.

In our East Indian Room we have blue organdy curtains stenciled, lace-like, in white. Under them there is a screen of white curtains printed with a fragile green pattern.

Our gray and white porcelain stove is as plump as an Austrian baumkuchen. It warms the eye and also our little East Indian room.

Our East Indian Room just off the living room was a bar. We didn't particularly want a bar, so we changed it into a gay room for lunch or dinner when we are alone or have a couple of guests. It's as lively as a Roman candle; the chairs are glossy white with flare-ups of coral, blue-green, pale blue, and lemon yellow; jewel-like Indian paintings on the turquoise walls line up the door deftly.

CONTINUED ON THE NEXT PAGE ▶

Design by Adrian continued

Our dining room is pink—pink walls, pink carpet, coral-pink gingham curtains. Even the old architectural wallpapers are banded in checker-bold gingham. On the green-marbleized table top there is an architectural group by Tony Duquette. The chairs are leopard-cushioned.

Our large bedroom is full of roses. Handpainted roses bloom in the center of the green and white gingham bed to match the wallpaper garden. By the fireplace is my collection of handpainted boxes and a chair quilted with an old Persian shawl.

The storage wall of our bedroom is an antique Provençal armoire, reminiscent of a Breton *dot*. In it we can fold the bedspread and keep extra blankets. The chairs have a Gallic kinship with it, but the lamp is pure Yankee.

THE UPSTAIRS IS PERENNIALLY GAY, PERMANENTLY SUNNY.

Our guest room. The walls are soft blue-green. Over-doors of gray and white wallpaper hang on either side of the bed. The organdy curtains and the chair have the same toile design in a lush mulberry. The sand-colored, quilted cotton bed matches the carpet quietly.

DESIGN BY ADRIAN

Continued from page 39

room. And yet, the sun never gets in too much. One sees it outside with lots of reflected light, so that we are constantly aware of it without being submerged in it.

The sun comes into our bedroom early and leaves early for other parts of the house. It comes into the little East Indian room for lunch and departs, politely, immediately afterward, leaving it cool all afternoon and the most comfortable spot for dinner.

It has been most surprising to our friends to find how easily Venetian, French and Austrian pieces fit into an American house. The Austrian stove, which may have warmed some of Marie-Antoinette's friends, certainly looks snug and right in the little room where it now stands; the baroque rose-festooned containers filled with lemon leaves, which stand on either side of the bay windows in the living room, seem to be made for the place; and the little Venetian chandelier swings as happily in California as it ever did in Venice.

I watched the Grinling Gibbons carving (now over the living room mantel) for ten years before I ever owned it. I remember first seeing a photograph of it in an English magazine which told about its arrival in America. Then, one day when I was in New York I came upon it quite by chance in an antique shop. Each year, I made a pilgrimage to see it—never dreaming that I would own it. After ten years of ogling it, Janet insisted that I buy it. Today its tawny, dusty wood mellows beautifully against the robin's-egg blue of our living room walls.

The dining room gets the afternoon sun. It is pink, with pink gingham curtains of larger checks which have under curtains of smaller checked gingham. The Regency table and chairs are black and gold. The table top is emerald green marbleized wood. The antique wallpaper panels are framed in gingham which plays against the classic formality of the architectural subjects. The chandelier is from Ireland and is very sympathetic to its English and Italian companions.

Our guest room is the sunniest room in the house. We made it turquoise blue for coolness, with mulberry and white organdy curtains for air.

One must admit that there are plenty of chilling nights during the rainy season. Let us break down and say that. June is a very dreary month in California because it brings so much fog, and one feels that it will rain until noon practically every day. "What is so rare as a day in June" in California should certainly be, "What is so raw as a day in June." But June only lasts thirty days. Then we have sun.

And so again we say that it is all a matter of choice or taste—and it is so wonderful that all tastes are different. And the most wonderful of all is the ardent way we all love that part of the country in which we live.

Top: Adrian's favorite possession was his large, seventeenth-century Grinling Gibbons wood-carved panel.

Left: Conclusion of the *House & Garden* article.

Opposite: Janet posing below the Grinling Gibbons wood carving in the living room of their Pepper Hill Farm residence. Photograph by George Platt Lynes.

Above: Janet modeling a slim
Adrian-designed dinner gown
with the Guan Yin collection in
the background. Photograph by
George Platt Lynes.

Following pages: An article
written by Adrian about his valley
residence, from *Vogue*, 1945.

Opposite: Jean Howard
photograph of Adrian's
extraordinary collection of antique
Guan Yin statues.

Terrace on which Adrian the designer and his wife, Janet Gaynor, serve lunch

Magic in the Valley

Memories of fun and friends of the
designer and his wife, Janet Gaynor

By Adrian

I SUPPOSE that every place that one loves holds some magic, and we definitely feel that there is magic for us in our valley. We live in the San Fernando Valley in California, about thirty miles from Beverly Hills. It sprawls between high hills, and the air is so clear it has the fresh just-after-the-rain smell. At night when we dine on our terrace, the stars hang low.

Janet and I, and our son, Robin, have just moved to another house in the valley, and who knows what the future will bring. But I like to think back on the many magic moments that we have had in the past. There was magic around when we entertained outdoors under low-hanging stars. There was magic in our friends, in their humour, their serious talk; there was magic in Nancy, our cook, who turned ration points into miraculous meals. Then there was my own magic, the rabbit-out-of-a-hat kind.

My magic depends more on the successful workings of ingenious mechanics than on any skill I might have. Therefore, the secret catch sometimes does not work, I find my thumb caught in the wrong place, and the water, instead of disappearing into thin air, disappears down a guest's neck. But that generally makes

ADRIAN'S TERRACE where he and his wife, Janet Gaynor, have entertained their many friends. Shaded by an enormous pepper-tree, it is furnished as an outdoor living-room, the rattan chairs upholstered in vivid printed cottons, brought back from Jamaica. Here, the long wooden table is set for lunch with turquoise casseroles put on pewter plates, and red-flowered mats. Eight primula plants flank a bird-cage of Bristol glass.

the guest feel superior to the whole thing, so she's pleased despite nearly drowning.

Janet—in the rôle of an extremely patient and slightly worried wife—waits eagerly, and at times victoriously smiles when the right thing happens at the right time.

I'll never forget Ilka Chase one night. At the end of a nerve-wracking evening of burning cigarettes being passed through her dress (leaving no marks)—and cotton snakes sailing out of jars—a door suddenly slammed, and Ilka just sat down and cried. I felt dreadfully about the whole thing and decided to give up magic forever —until another wave of it hit me.

We have a screen in the living-room behind which my magic sits. Janet prides herself in never having looked behind it. I'm not sure whether that is from self-control or a desire to forget the entire thing.

Into this valley, too, comes the magic of friends. When I am not putting them through the paces of my magic, they put us under the spell of theirs. Dali, by sign language and a form of ballet, took us into his magic land of Freud and art. (Because he speaks no English, our contact is wide-eyed French pantomime.) Clare Luce learned to dance the Varsovienne in our living-room one night—just as it is danced in New Mexico (the cow punchers call it the "Little Foot"). We've heard the magic of Katharine Hepburn's descriptions of her family. And Hedy Lamarr has explained to us some of the machine parts she has invented (quite a jolt to those admirers expecting only the heavenly body).

Dr. Lin Yutang and his wife have brought China very close with word pictures. Chris Kantz Scanavy, one of Europe's expert skiers, has

shown us new ways to ski down the mighty Alps on the living-room carpet; and Jimmy Pendleton, his flair for pantomime as clever as his flair for decorating, has given us a five-minute performance of the musical "One Touch of Venus." Last year, its star, Mary Martin, told us of her dream—to leave the movies and return to the stage. We are delighted we had a part in encouraging her to make the jump.

There were the evenings when Artur Rubinstein and Ludwig Bemelmans kept us in hysterics with Rabelaisian tales of their experiences; when Elsie Mendl, at the drop of a hat, practically turned a somersault and stood on her head for long minutes.

There was the night that George Antheil played us some of the first dreams of his new symphony. No rabbits here, the real thing. And Stokowski told us he would give this symphony its first performance in New York. Then there was the Sunday morning we heard his great orchestra playing it over the radio.

Nancy has her own magic about food. They are all her own secrets and I would no more try to find out how she does her tricks with the stove than I would tell her how I do mine with the rabbits. But Janet has pried out of her the three recipes on page 136. She says that either the egg dish or the chicken make a very easy luncheon because they have all the things in one dish and only need a green salad and hot biscuits and a bottle of white wine to complete the meal. With my sweet tooth we always have a dessert. The peaches and custard is such a simple dish and yet all our friends enjoy it and never seem to get it at home. The custard and peaches should be served ice cold.

SINGING TREES RANCH

Talk about finding a needle in a haystack—good luck to anyone trying to find Adrian's Desert Hot Springs Ranch for the first time. It is in the middle of nowhere. Nearest neighbor, miles and miles away, but once you arrive and drive through the wooden gates you realize it was all worth it. The place has a magical charm and the tamarisk trees really do "sing." Also, there is a fragrance in the air that is unique and haunting.

Adrian bought the property in the 1930s. It was not much more than a chicken coop. But, over time, it morphed into a comfortable home with great simplicity and privacy, a real oasis in the dessert.

LEONARD STANLEY

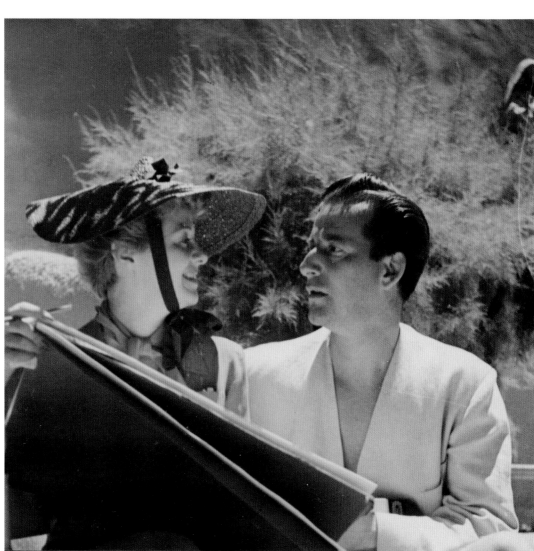

Top: Entrance gates to Singing Trees Ranch, Desert Hot Springs, California.

Right: A charming photograph of Janet and Adrian at their ranch.

Opposite: Drawing by Van Day Truex of the observation tower at Singing Trees Ranch, and a photograph of the actual tower (opposite, below right).

Opposite, below left: Janet and Adrian relaxing on an oversized sofa/daybed designed by Adrian.

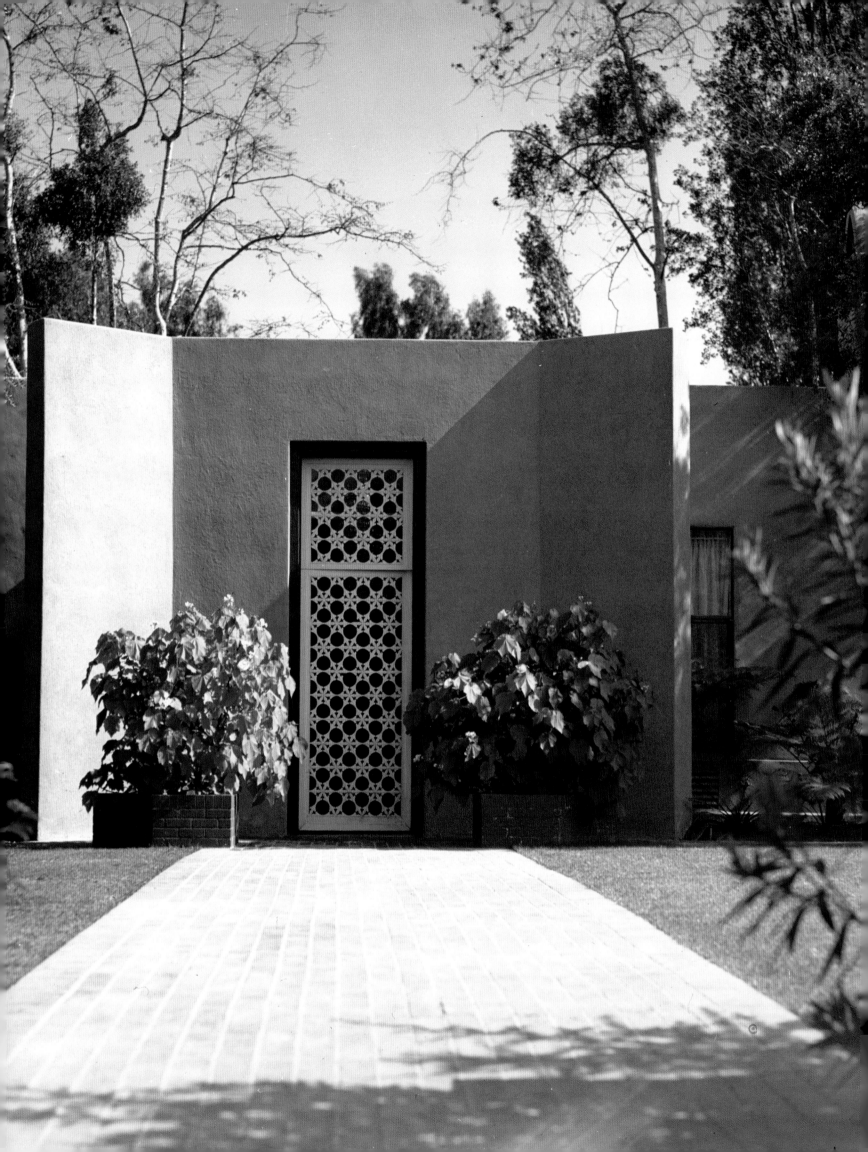

Opposite: Dramatic modern entrance to Adrian's Bel-Air, California, residence, incorporating an antique carved wood door from India.

Above. Entryway planter of Adrian's Guan Yins and greenery.

Right: View of the garden showing the swimming pool and a large bronze Buddha head.

Following pages and pages 292–293: *House & Garden* article from October 1952 about Adrian's Bel-Air residence.

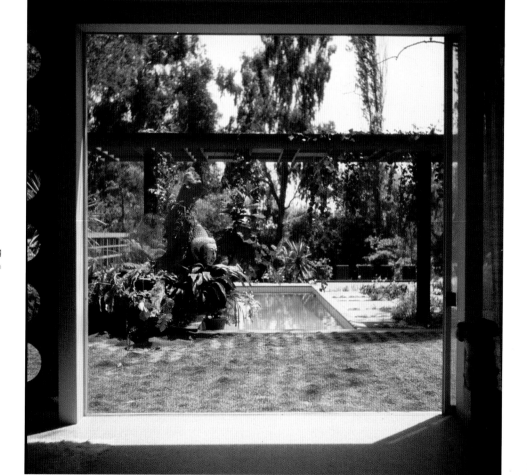

The carved wood front door from India lets filtered light into the entrance hall. Light from chandelier inside shines through door at night.

Romantic mood for modern living

The story behind this house is partially the story of Mr. and Mrs. Gilbert Adrian's fascination with Africa which started Adrian painting imaginary African landscapes several years ago and finally resulted in a trip which Mrs. Adrian (Janet Gaynor) described in HOUSE & GARDEN in October, 1949. The Adrians' new house in Bel Air, California, designed by architect Burton A. Schutt, represents the latest flowering of this semi-public love affair: it is modern, romantic, and decidedly North African in flavor. We show it to you for many reasons, but primarily because it is an excellent example of how meaningful mementos can be used to give individuality to a modern house. Also, because it demonstrates how warmth and livability can be achieved by skillfully mixing modern and period furnishings. Lastly, because it is a house designed for and by people who knew what they wanted and got it. Although it is modern in essence, it has none of the rigid earmarks of a "school," and although it serves the Adrians efficiently, it exhibits none of the clichés of "functionalism." Three features which the Adrians find particularly successful are: (1) the manner in which the rooms flow into each other and out to the pool and terrace; (2) the many skylights which supply pools of light inside the house during the day; (3) the doors and sliding walls, cut out in patterns of Oriental derivation, (Continued on next page)

FRED LYON

Forthright architectural lines of the living room are an excellent foil for a broad assortment of furniture, art objects, mementos. On the rear wall behind the table of African sculpture are Mr. Adrian's paintings of imaginary African landscapes. Over the fireplace hangs a treasured possession, a Grinling Gibbons wood carving. The walls are painted robin's-egg blue.

DECORATION IN TRANSIT *continued*

which filter the sunlight as though it were falling through a forest. This is a 24-hour-a-day house, a place where the owners, having surrounded themselves with the things they love, like to spend as much time as possible. It serves as a setting for relaxation, work, and entertaining. It is a family center, containing besides Mr. and Mrs. Adrian and their young son, Robin, a monkey, a parrot, a myna bird, and an assortment of dogs. The Adrians like to entertain with parties of all kinds, except cocktails. Their favored number of guests for dinner is six to eight. They dine in a green and blue dining room (their favorite color combination), lit by a crystal chandelier and candelabra. A typical menu includes for the first course: hollowed cucumber filled with gelatin and ice-cold cherries; for the second: butterfly steaks, corn soufflé, asparagus, sweet and sour red cabbage; next a green salad; then lemon tart with meringue. Mrs. Adrian, who frequently wears East Indian house clothes, arranges flowers herself in informal groupings.

The blue and green dining room has emerald green walls, royal blue taffeta curtains held by a gilt Empire bow. The chandelier is from Ireland, the table and chairs, Directoire and Regency.

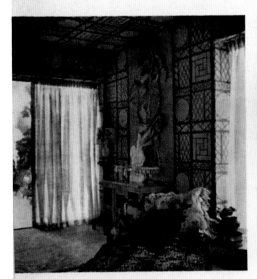

Bamboo-like wallpaper in bedroom gives summerhouse effect. Carved panel on wall once hung in a French theater.

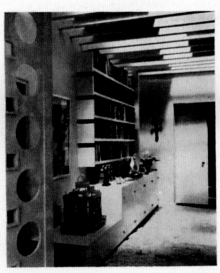

Books and paintings line one wall of this hallway leading to a small inner garden. Lemon yellow walls are lit by skylight above beams.

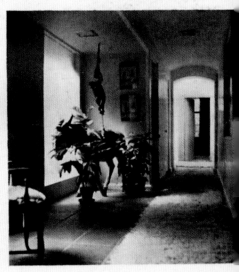

A porcelain monkey from Vienna hangs over an Italian donkey, unearthed at the Chicago World's Fair, in hall leading to bedrooms.

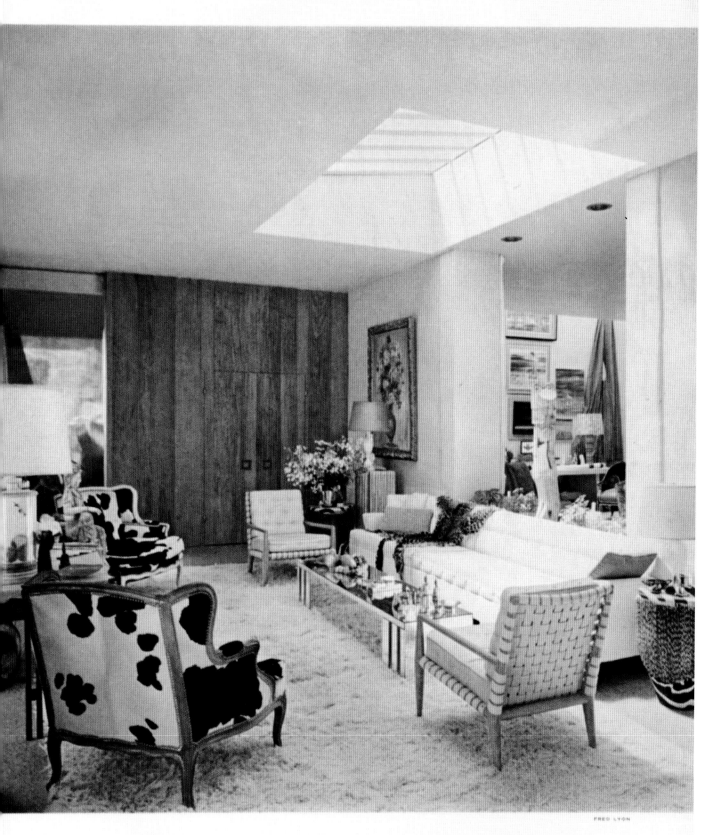

FRED LYON

African accents mix well with contemporary furniture

Against a striking architectural background, dramatized by California sunlight through the skylights, Mr. and Mrs. Gilbert Adrian have created a livable, personal house. Their formula: an adroit mixing of modern furniture and mementoes collected on their trip to the Belgian Congo (see HOUSE & GARDEN, October, 1949). Notice the African drums used as end tables, the chairs upholstered in cowhide, and the Oriental sculpture.

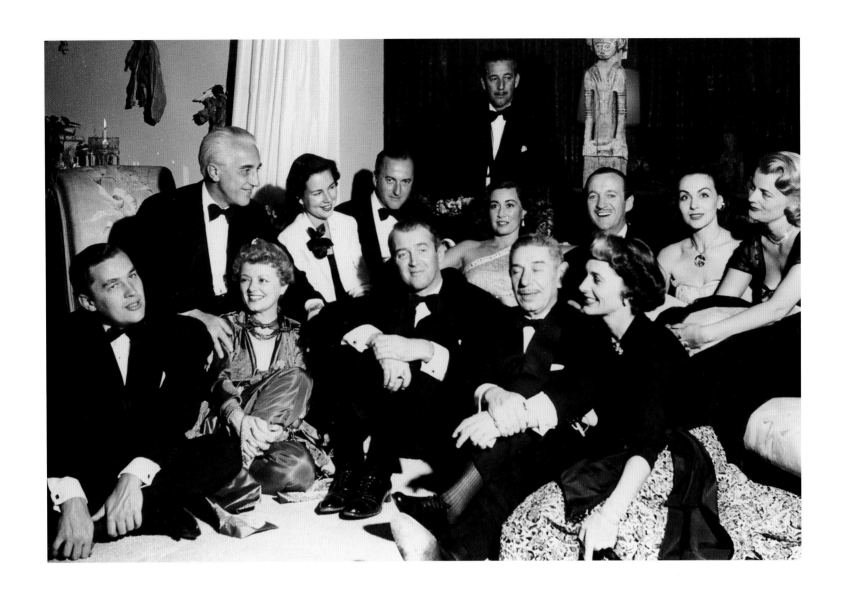

Above: A glamorous evening at Adrian's Bel-Air residence. Seated, from left to right: Mr. Charles Amory, Janet, Jimmy Stewart, Mike Romanoff, Gloria (Mrs. Jimmy Stewart). Seated behind Janet: Iva S. V. Patcevitch, Gloria (Mrs. Mike Romanoff), J. Watson Webb, Jeanne (Mrs. Alfred Gwynne Vanderbilt), Mr. and Mrs. David Niven, and Mrs. Charles Amory. Adrian standing in the background. Photograph by Jean Howard.

Top: James Pendleton leans on the arm of the sofa in conversation with two seated men and composer Cole Porter standing behind.

Bottom: Janet and Adrian hosting Rex Harrison at an elegant dinner party at their Bel-Air home. Janet is wearing a gold lamé East Indian–inspired ensemble designed by Adrian.

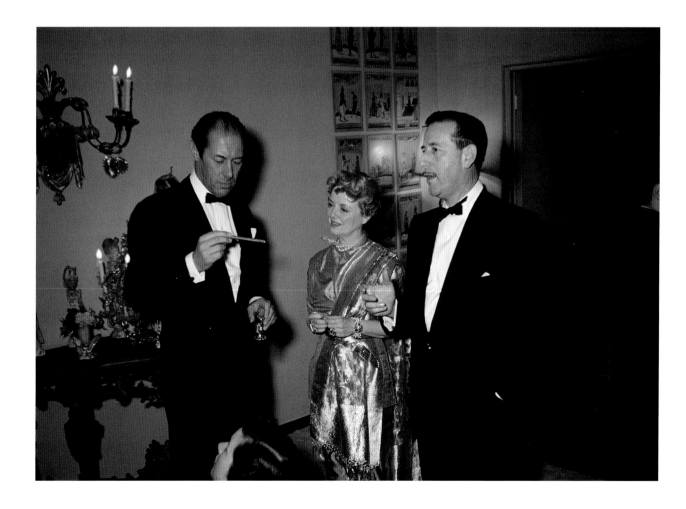

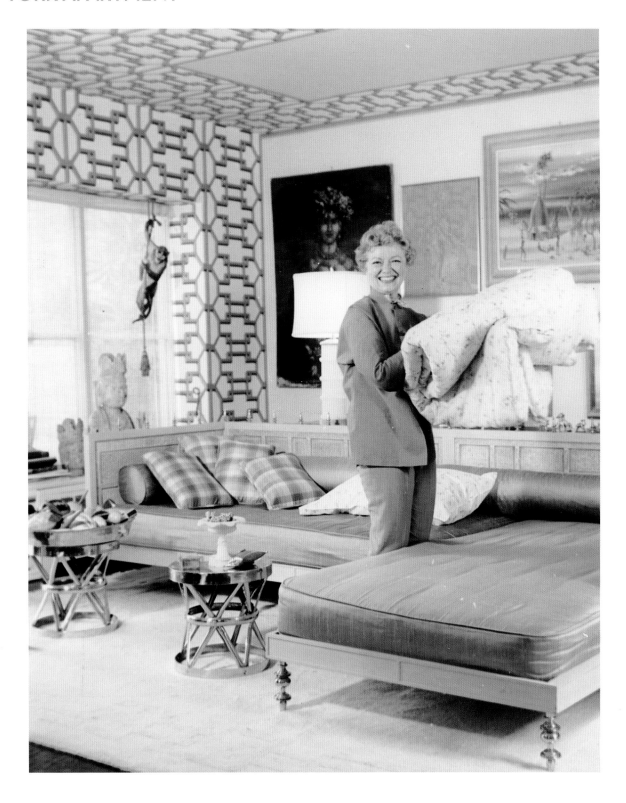

Spending part of the year in Brazil, part of the year in Los Angeles, and part of the year in New York, the Adrians rented a tiny but charming pied-à-terre with a small terrace at 12 East 72nd Street between Madison and Fifth Avenues. Great location. It was all they needed when visiting the city.

Two photographs of the Adrians in their New York apartment.

LEONARD STANLEY

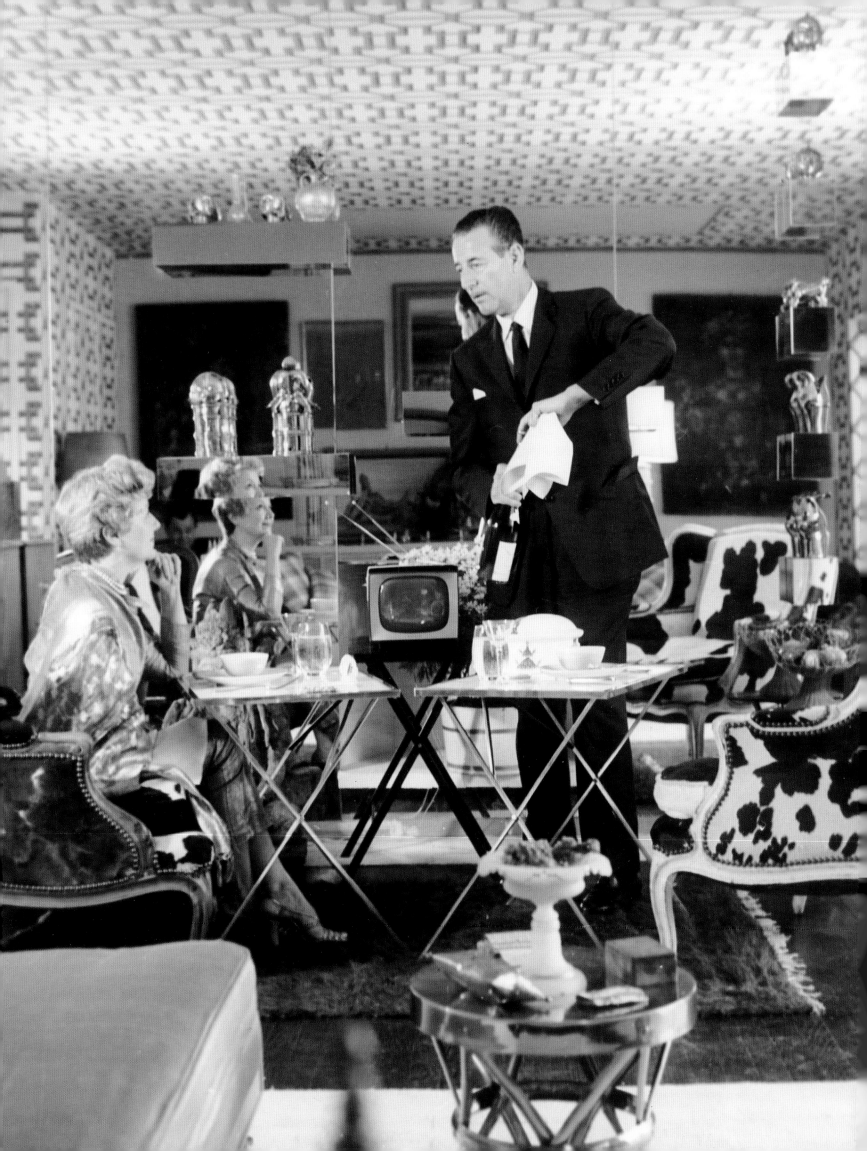

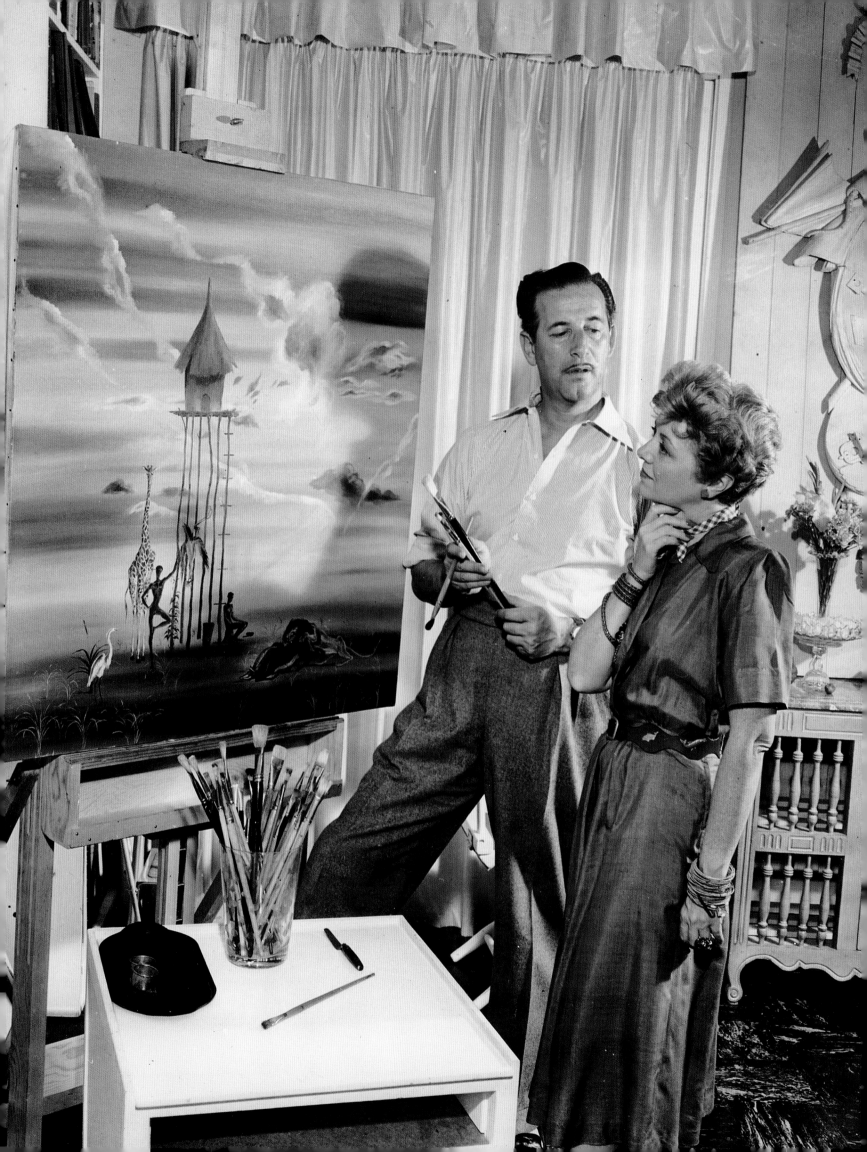

PAINTINGS:
AFRICA AND BRAZIL

A drian had long been aware of E. Coe Kerr and the New York gallery, M. Knoedler & Company. "I had secretly hoped Knoedler's would like my work," wrote Adrian. "I had not dared to think they would give me an exhibition. Knoedler is a conservative gallery, not interested in experimentation. When Mr. Kerr said he would like to show my paintings, I was almost overcome. He asked me how long it would take to do about twelve more. I had about ten, so I said six months."

Adrian's premiere exhibition opened in 1949, and his subject matter was African wildlife. "The next day," wrote Adrian, "Janet and I left for Africa, to see if it was anything like my paintings. How foolish we were to go into the center of Africa without a gun of any sort. But Africa was good to us. Not once was it anything less than its magnificent self. It did everything it could to live up to the dream of my paintings. Janet would say, over and over, 'There's your painting!' Yet these enchanting scenes were far more fantastic than anything I'd dreamed."

The Adrians and their guides spent two months traversing several thousand miles of interior. There were encounters with a wandering hippopotamus, a charging rhinoceros, and a pride of lions, who were minding their own business in the moonlight when Adrian aimed a flashlight at them. "We caught the yellow reflection of seven pairs of eyes in the low bush a hundred yards away," wrote Adrian. "Those eyes just glared at us." The guide went to his car to flash his headlights at them. "While I waited, I stood there with my flashlight, feeling rather like a Christian in the Roman Colosseum. The guide flashed the headlights. One by one, the lions rose and walked off, slowly switching their tails to express their irritation with us."

Traveling down the Nile River to Juba, a city in the Anglo-Egyptian Sudan, he saw human beings to whom fashion was irrelevant. "We passed tribes of savage-looking Dinka, Nuer, and Shilluk," wrote

Previous page: Adrian and Janet discussing one of his African paintings.

Opposite: Program for Adrian's first gallery showing at M. Knoedler & Company Inc., March 1949.

Paintings of Africa

BY

GILBERT ADRIAN

MARCH 1st - MARCH 12, 1949

M. KNOEDLER & COMPANY, INC.
14 EAST 57th STREET • NEW YORK

GILBERT ADRIAN

Born in Connecticut in 1903—started drawing at three. When I was fifteen or sixteen, I wanted to be an animal painter. My interest in Africa started when I saw "Paul J. Rainey's African Hunt" when I was about twelve. Read every book on animals and Africa for the next twenty-five years.

Because I always had a wild imagination—my family thought some form of the theatre would be an outlet for it.

Studied art in New York at "Parsons" or "New York School of Fine and Applied Art". Then went to Paris to study at their branch but was interrupted and brought back to America to design for Irving Berlin's "Music Box Revue".

Valentino's wife brought me to California, and I found myself designing clothes for the movies. I did not stop drawing Africa, however, and continued drawing over the years.

Africa still holds my greatest interest—I have made a study of the tribes, vegetation, birds and animals.

I have tried to keep the true knowledge of Africa and mix it with my own dream of what I think it must be like. The animals are all authentic. The tribes I have used are the Shilluc, Nuer, Dinka and Watusi because of their elongated bodies. I have let my fancy direct me in the grouping and occasional exaggeration of architecture, although all of it is authentic.

It is really a lifetime thwarted trip to the Belgian Congo—and Sudan—which I seem to get farther and farther away from actually, although I do get nearer and nearer mentally.

It seems strange that I return to painting the animals I wanted to thirty years ago, when I was fifteen—however, that's probably as it should be.

Catalogue

1. THE ANIMAL MARKET

2. SUDAN

3. DEATH OF A MONARCH

4. PRAYER FOR RAIN

5. THE FOG

6. I THINK IT HAS STOPPED RAINING

7. THE RAIN POOL

8. THE BIG WIND

9. FEEDING THE GIRAFFES

10. AFRICAN AFTERGLOW

11. BIRTH UNDER THE TRAVELERS TREE

12. THE DESERTED VILLAGE

13. STRANGE AFRICA

14. DANGERS OF AN AFRICAN NIGHT

15. A LETTER HOME

16. SETTLING FOR THE NIGHT

Adrian. "These men were absolutely nude, except for a fine string of blue beads about their stomachs and fantastic headdresses atop their heads. They were utterly nonchalant about their nudity and walked with such pride and dignity that we felt almost self-conscious wearing clothes."

Sailing down the Nile, Adrian was confronted with such intense heat in his cabin that he dragged a mattress to sleep on deck. He was then awakened by a rain so powerful that he was nearly swept off the deck and into the mouths of waiting crocodiles. "I have always enjoyed the softest chairs, indulged myself with beauty, and insisted upon perfection as a background," wrote Adrian. "And yet Janet and I have found our happiest moments on the edge of a canyon, or in some little room hung with mosquito nets, not with chintzes and taffetas. We have found a place of beauty on an iron bed in the Congo, our sleep interrupted by the foghorn cries of hippopotami."

His first fashion show after the African trip, in August 1949, featured fabrics inspired by animals—pale gold lamé woven with cobra markings, taffeta printed with leopard spots, and a gold lamé fabric patterned with tiger stripes.

After Adrian's severe heart attack, he was forced to close Adrian, Ltd. in the fall of 1952. Upon his recovery, Janet encouraged Adrian to take short vacations. Depression often follows a heart attack, and if unattended, can lead to another attack. Janet did her best to bolster Adrian's spirits, suggesting a motor trip to the Canyon de Chelly in the Four Corners region of northeastern Arizona. Their son, Robin, who had turned twelve, accompanied them. "The canyon sits in Navajo country like a deeply carved piece of chocolate cake," wrote Adrian. "Peach orchards stand below the red sides of the deep, deep cliffs. We stayed at the little trading post, and each night we would go to the edge of the cliff as the sun set. In the canyon bed below, Indian children were herding flocks of sheep and goats to bed. We could hear the goat bells as the tiny hogans sent smoke into the twilight."

Adrian was recovering his strength, but not quickly enough. He had decided that painting in oils would be his new career. "I'd had

Adrian's jungle scene. The Leonard Stanley Collection.

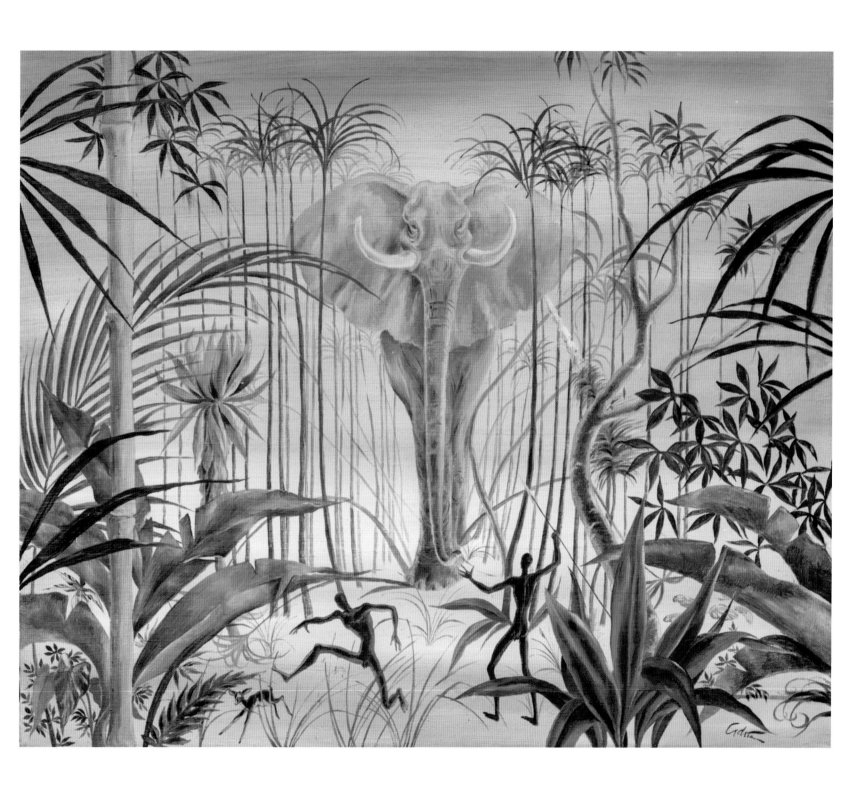

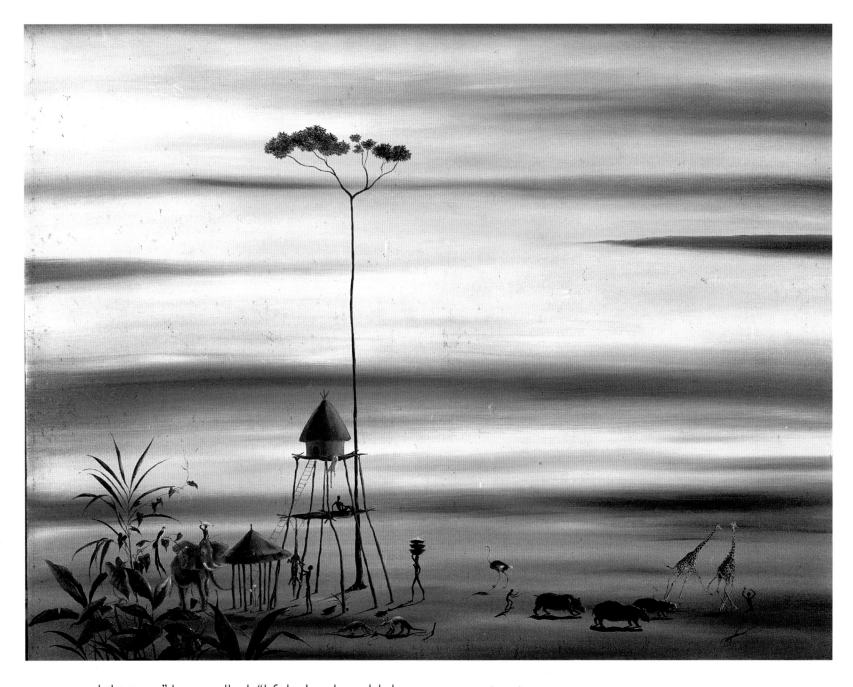

exhibitions," he recalled, "I felt that I could devote my entire time to the work I loved. I could still design men's shirts and ties, which had been an offshoot of my business, but painting was to get the greater portion of my time." Adrian set up his easel near the canyon and did fourteen paintings of the Navajo environment. "I should not have tried. I was not strong enough. One should never paint unless one is equal to it. I later destroyed all but three paintings because I was so disillusioned. I almost wrecked my painting career. I stopped for a year. I'm glad I did. It taught me not to paint unless I could not help it."

By March 1954 Adrian had recovered sufficiently to visit Brazil for its first international film festival, appearing with stars such as

Above: Adrian titled this painting *Sudan*.

Opposite: This painting, *Birth Under the Travelers Tree*, was one of Janet's favorites.

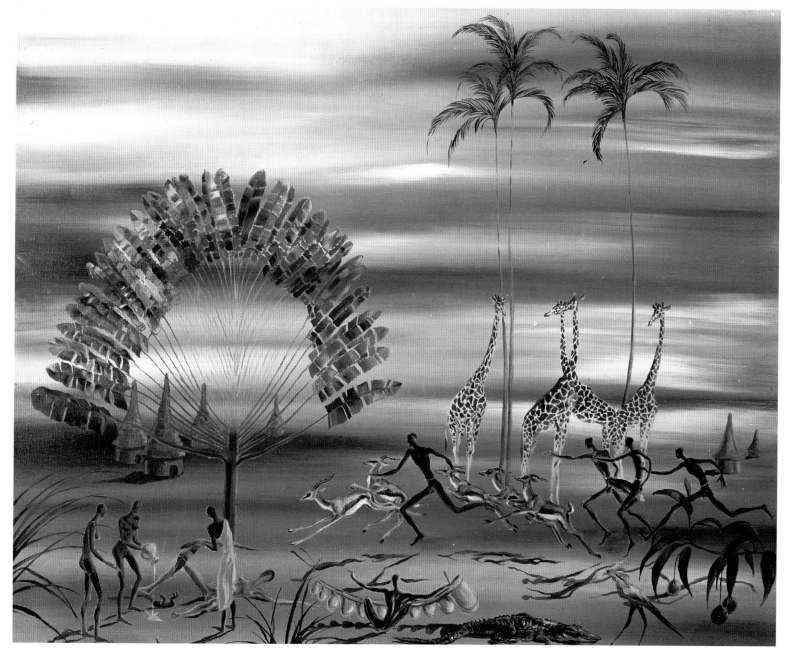

Fred MacMurray, Jeanette MacDonald, and Edward G. Robinson. After the festivities honoring the fourth centennial of São Paulo, the Adrians accepted an invitation to visit Anápolis, a municipality of the State of Goiás. More adventures ensued. "As we went out about fifteen miles from the town," recalled Adrian, "Janet and I climbed over a slight ridge and there lay the Amazon valley, with the green we had been expecting, so green it looked as though emeralds had been bled for color."

"We know that land not far from us is full of precious minerals. One of the largest diamonds in Brazil was found in the State of Goiás. Crystal fields are very near, and in the nearby state of Minas Gerais a prize aquamarine had recently been discovered, larger than any yet

found in Brazil. Gold is also here. Jaguars tread over fields of amethyst and tourmaline."

Pasture lands had grass high over the backs of cattle, and forests rose from soil so rich I can almost see the buds rising. Here was a land for farmers to dream about." There was a farm in the valley, a *fazenda* of two hundred acres that included a coffee plantation of eight thousand trees as well as sugar and bananas. The Adrians bought the fazenda, built a house, and for three years they lived there and worked the land.

"During this period we both went through a very deep and enriching time," recalled Adrian. "Janet felt she had discovered many facets of her life that she had never known to exist. I found that seemingly insurmountable things had been conquered. We found that our son was growing into an assured young man. As we sat on our terrace after a day of supervising the crops, we became aware of the privilege of breathing air that had not been polluted by man."

Their peaceful existence was interrupted by illness. First Janet needed an unspecified surgery. No sooner had she recovered than Adrian was hit with a virus that developed into pneumonia. His condition worsened to the point that Adrian was feeling pain each time he breathed and was using up oxygen tanks. Janet took charge and worked with their friend Richard Halliday to arrange for a military plane to transport Adrian to a hospital in São Paulo. By this time he had deteriorated to the point where the local doctor contemplated removing a lung. Janet called Dr. Samuel Alter in Los Angeles, and then, in desperation, she reached out to an unlikely person.

Janet had read Dr. Ernest Holmes's books on the "Science of Mind." She sent a wire to Dr. Holmes saying, "My husband. Desperately ill. Will you please help?" At midnight in São Paulo, a call came from Dr. Alter. Janet was afraid that she might get emotional so she had Robin tell Dr. Alter about the proposed operation. At that moment an orderly delivered a wire from Ernest Holmes: "Work in progress." Robin heard Dr. Alter stop speaking. Then he said, "Robin, tell your mother to bring your father home. He can be given oxygen

and morphine, but bring him home." When Dr. Alter came to see us at the hospital in Los Angeles, he said he had put the receiver down and wondered what made him stop and make such a decision.

Adrian had improved sufficiently to fly home but was not out of danger. Tests, X-rays, and antibiotics continued. Then he received an unexpected call from Dr. Holmes, who told him not to worry about the bad reports. "We know the truth about these things," said Dr. Holmes. "When they take the next X-rays they will find nothing but improvement."

Adrian was weak and tired, but these words helped him. "Here was a man with much more faith than I had. I was able to relax without fear or worry. In a couple of days the respiratory specialists told me that they'd found an extraordinary improvement but were hesitant to encourage me without further tests." Adrian's continued recovery astonished the doctors. "I think you're a hoax," said Dr. Alter, "to scare us like this and then improve so remarkably." After Adrian was released, he asked Dr. Alter what he thought of the episode. "I've seen other so-called 'miracles,'" said Dr. Alter. "There are occurrences that science cannot explain. I'm sure that constructive thinking—and faith—can cause chemical changes. It's possible that these can affect cures. We know so little about these things."

Adrian had rented his Bel-Air home to Orson Welles, so he accepted an invitation to recuperate in a guest house at Pickfair, the estate of Mary Pickford and Buddy Rogers. In 1933 Adrian had designed costumes for her last film *Secrets*. "You made me beautiful," said Pickford. "This is a tiny way of showing my appreciation." Adrian regained his strength to the point where he was able to see his ranch in Brazil again, accompanied by Janet and Robin, and to finally relax. "We spent a peaceful summer, painting, farming, reading, and watching the kapok flowers fall like rose-colored snow."

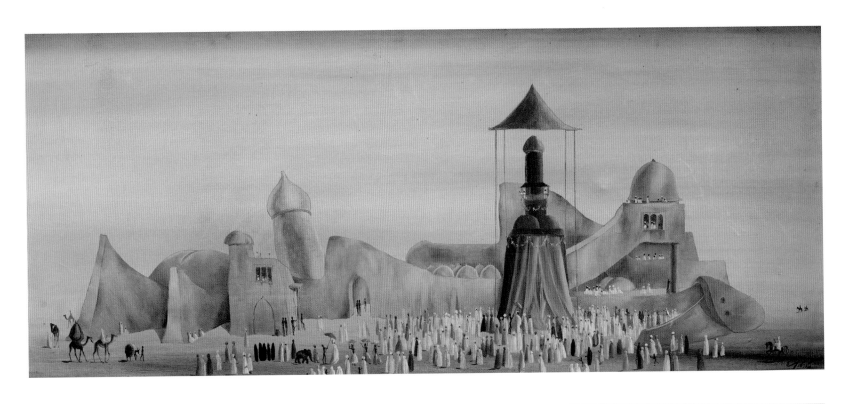

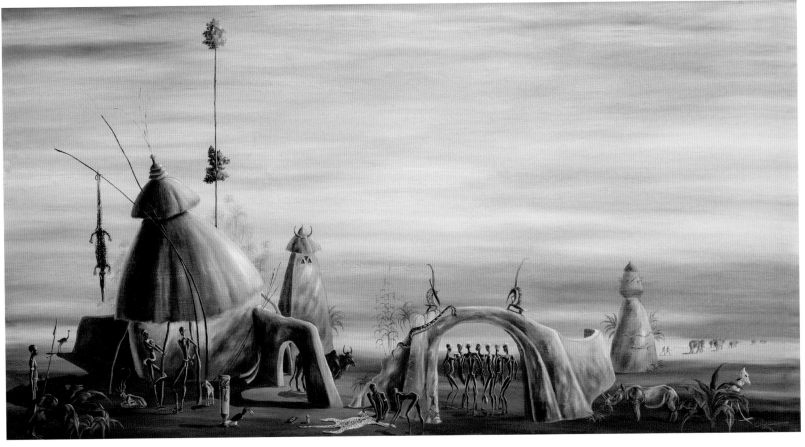

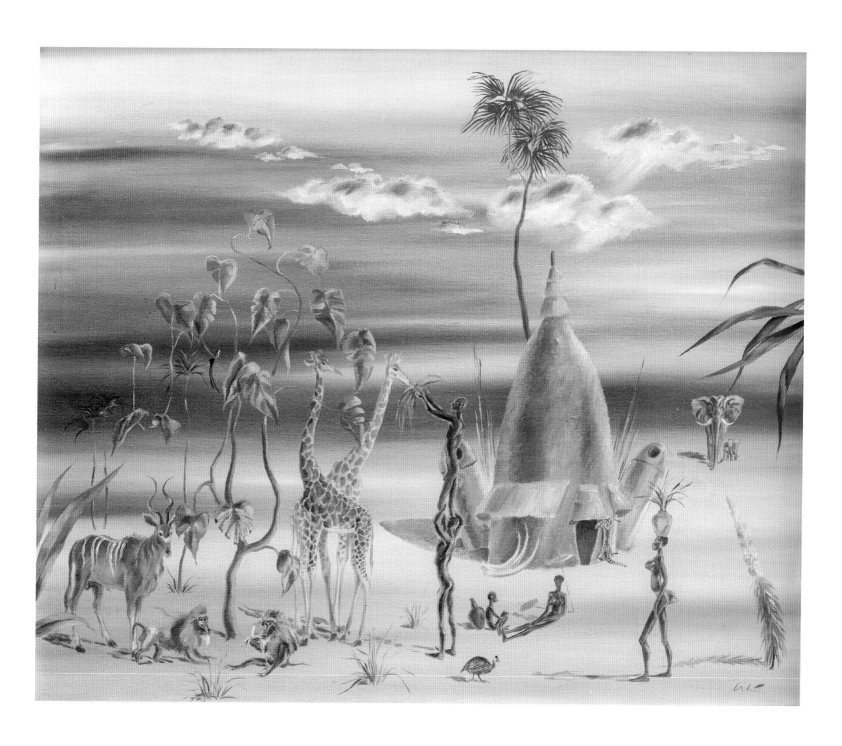

Opposite, from top: *Imaginary African Village; Drying the Alligator*, one of the largest paintings that Adrian ever created, measuring four feet by seven and a half feet. Both the Leonard Stanley Collection.

Above: *Feeding the Giraffes*. This was one of Adrian's favorite paintings. The Leonard Stanley Collection.

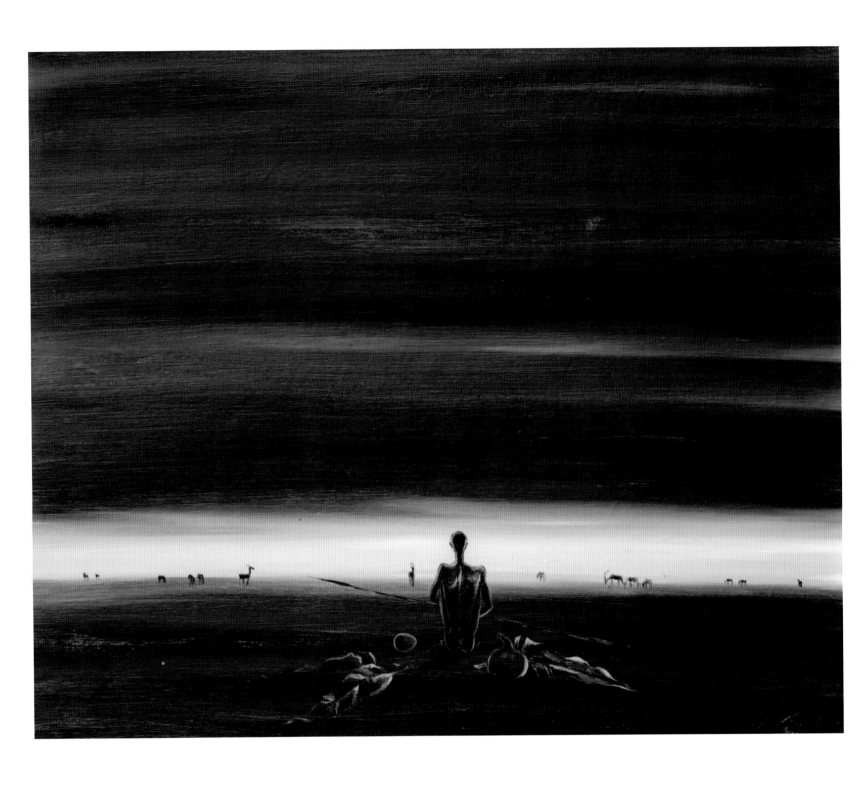

Two dark, dramatic African sunset scenes painted by Adrian. Painting above, The Leonard Stanley Collection.

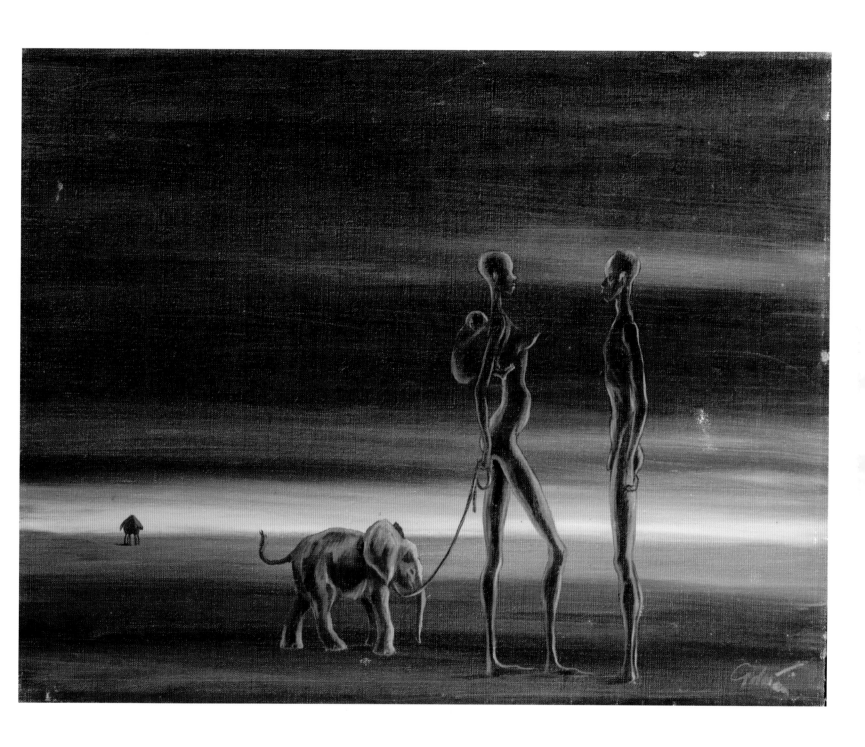

Following pages, from left:
Imaginary figure drawing.
Imaginary African native figure
drawing. Both from The Leonard
Stanley Collection.

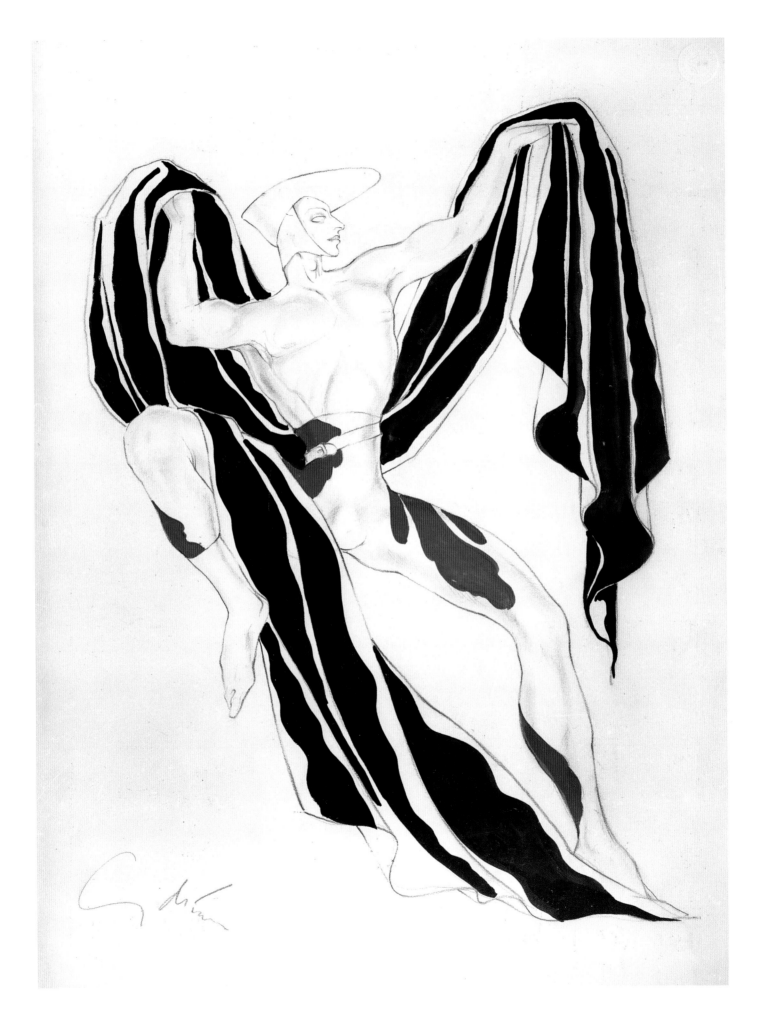

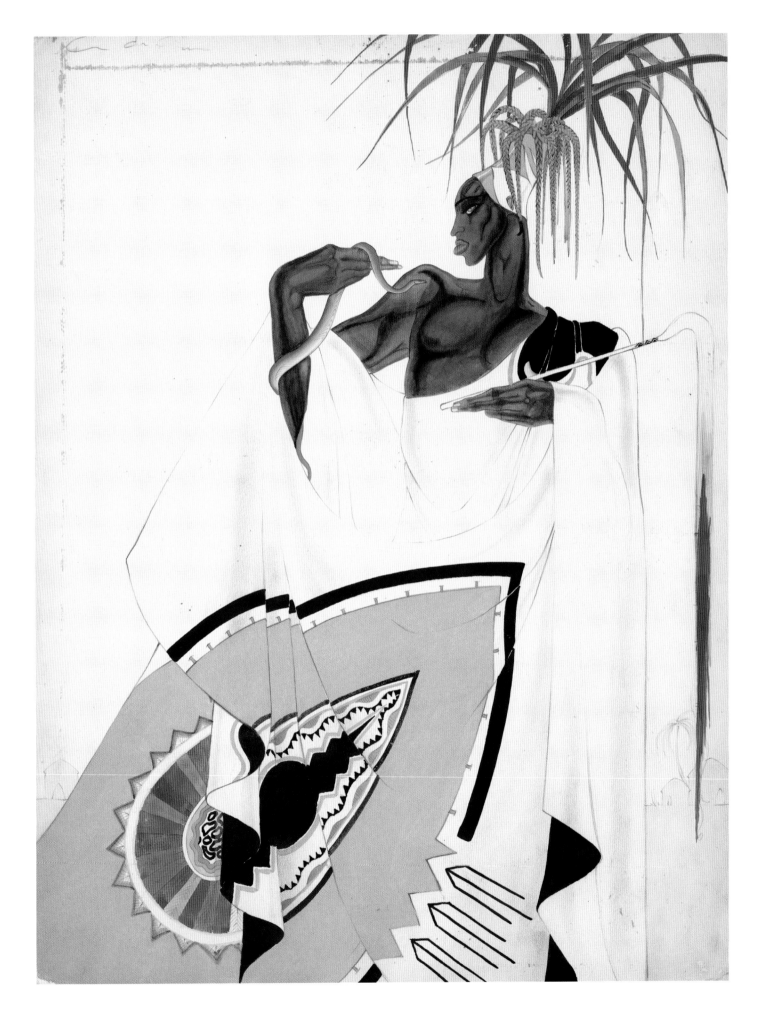

313

Above: Three photographs of Adrian and Janet in Africa.

Opposite: Photograph of Janet and Adrian in front of one of his African paintings. Photograph by John Rawlings.

Following pages: An article from *Vogue* magazine about the Adrians preparing for their first trip to Africa in 1949.

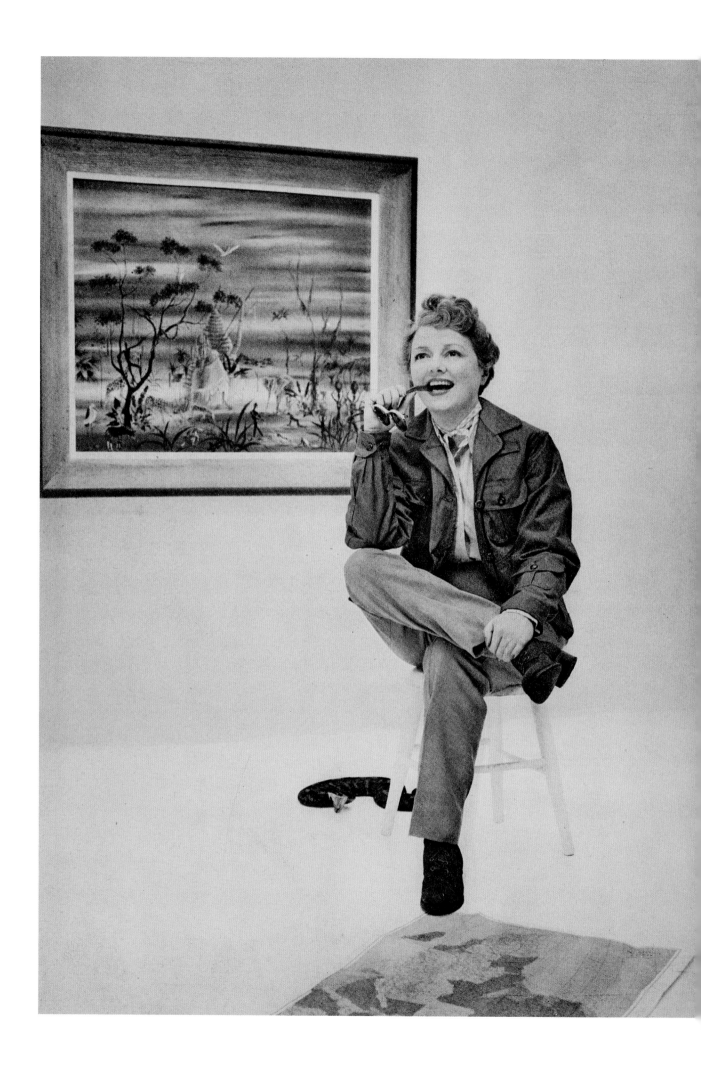

"FROM THE NILE ON, A SHANTUNG
SUIT. THE EXTRA SKIRT IS SLACKS"

ONE OF ADRIAN'S PAINTINGS OF
AFRICA; EXPLORER'S SYMBOLS

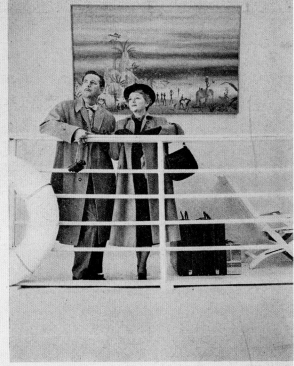

THE ADRIANS; THEIR LUGGAGE—SIXTY POUNDS APIECE

AFRICA TO THE ADRIANS

Early in March, Knoedler's had a show of twenty canvases by a brand-new painter, Gilbert Adrian—who, as Adrian, is not exactly unheard-of in the designing world. All of his remarkably documented paintings (a few of them are shown here) are concerned with the Belgian Congo and the Sudan. Two days after the show opened, Adrian and his wife, Janet Gaynor, went for the first time to Africa, to look at the land that had fascinated Adrian all of his life, and which he had previewed in his paintings.

Apart from several happy forays into Abercrombie and Fitch's Dr. Livingstone department, neither of the Adrians had had any experience as explorers. Their plans, not to shoot but, rather, to admire the animals ("an enormous love of animals is our principal mo-

OPPOSITE: MRS. GILBERT ADRIAN (JANET GAYNOR) IN JUNGLE KIT. THE PAINTING, HER HUSBAND'S PRE-VIEW OF AFRICA

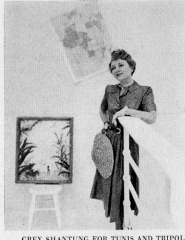

GREY SHANTUNG FOR TUNIS AND TRIPOLI

tive"), modified the equipment-situation somewhat. Still, each had been allowed a maximum of sixty pounds of luggage, which had to include clothes for stops en route. There would be one spring day in Madrid (for this, a navy-blue wool suit for Mrs. Adrian). There would be stops in Tunis, in Tripoli (a grey Shantung dress). There would be a few days in Nairobi, coming and going, where dinner dress would be needed. There would be seven days on the Nile, where "we'll need pith helmets, although we plan to try out the theory that if you (Continued on page 118)

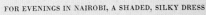

NUCLEUS: MRS. ADRIAN'S SHOES.
HER JEWELLERY PLAN: SCARFS,
GOLD, SUNGLASSES, A KNIFE...

FOR EVENINGS IN NAIROBI, A SHADED, SILKY DRESS

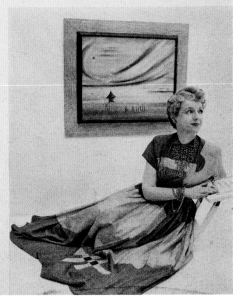

RAWLINGS

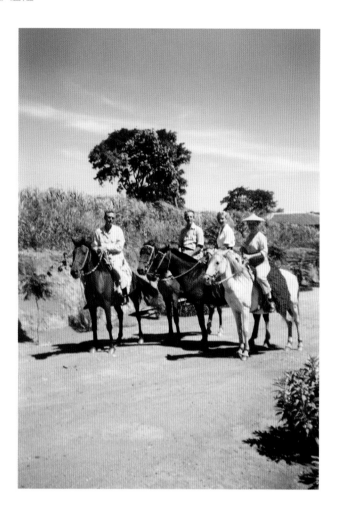

Clockwise from top left: Photograph of Adrian and Janet with friends in Brazil. Adrian holding Baby, his pet macaw, and Adrian's painting of Baby. The Leonard Stanley Collection.

Opposite: Adrian's painting of the house, with a view of the guest room. The Leonard Stanley Collection.

Opposite: Two of Adrian's paintings. His dog, Senior, and a water trough he designed for the animals. Both The Leonard Stanley Collection.

Above: Painting by Adrian. Eyes of a black panther peering through the jungle stalking his prey. The Leonard Stanley Collection.

Adrian's painting of the main
house he designed for his Brazilian
fazenda. The Leonard Stanley
Collection.

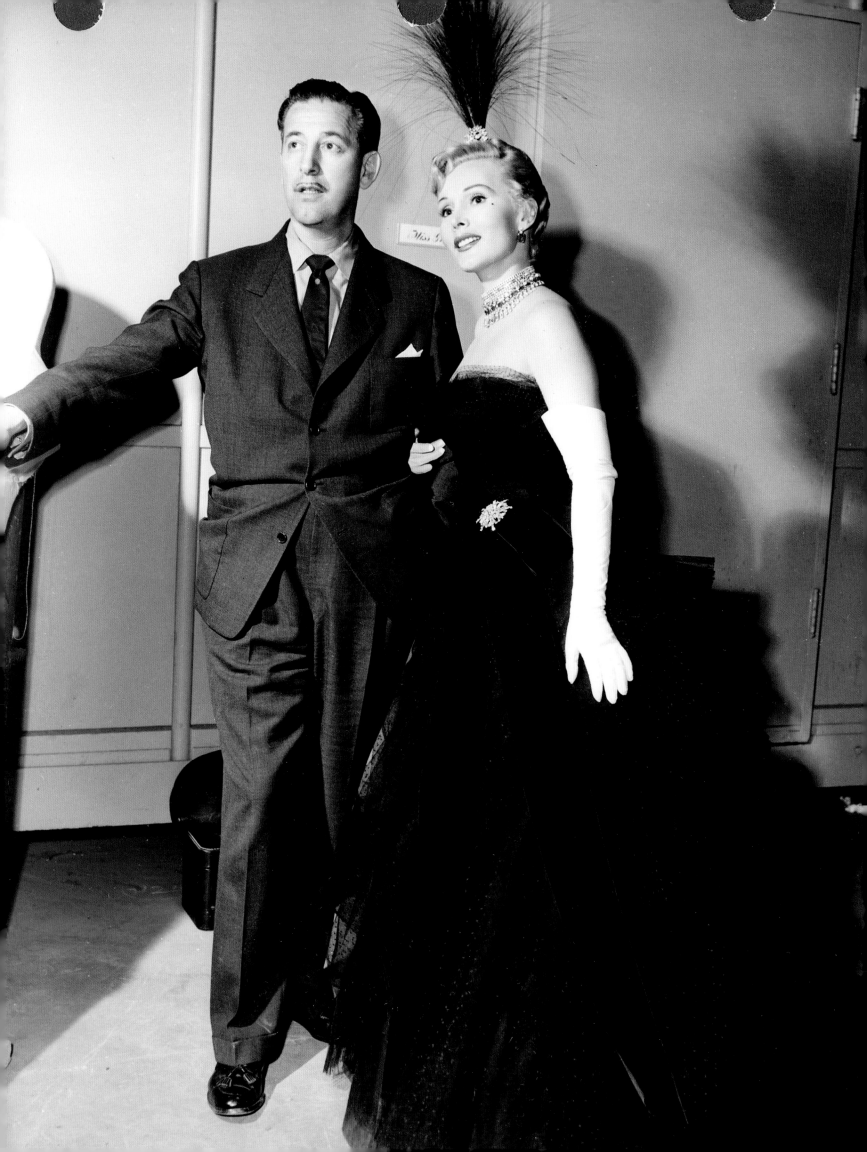

LOVELY TO LOOK AT

n 1951, Adrian was approached by M-G-M to design costumes for the new movie, *Lovely to Look At*, which was to be a remake of Jerome Kern's *Roberta* from the 1930s. The film would be directed by Mervyn LeRoy, but the fashion show sequence at the end would be directed by Vincente Minnelli.

Ten years had passed since Adrian left the studio, and he was delighted with this new challenge. The gowns he designed were very dramatic and beautiful.

The film starred Kathryn Grayson and Howard Keel along with Ann Miller, Red Skelton and Marge and Gower Champion.

The movie was released in 1952.

LEONARD STANLEY

Previous page: Adrian and actress Zsa Zsa Gabor on the set of *Lovely to Look At*. Zsa Zsa is pictured wearing a black tulle ball gown from the fashion show finale in the film.

Below: A publicity still of comedian Red Skelton with four models from the movie's fashion show finale sequence. Rosemarie Bowe (far left) is modeling Adrian's tiger-print bathing suit and is seated on a matching tiger-appliqué beach towel.

Opposite: An assortment of glamorous and dramatic gowns that Adrian designed for the fashion show finale.

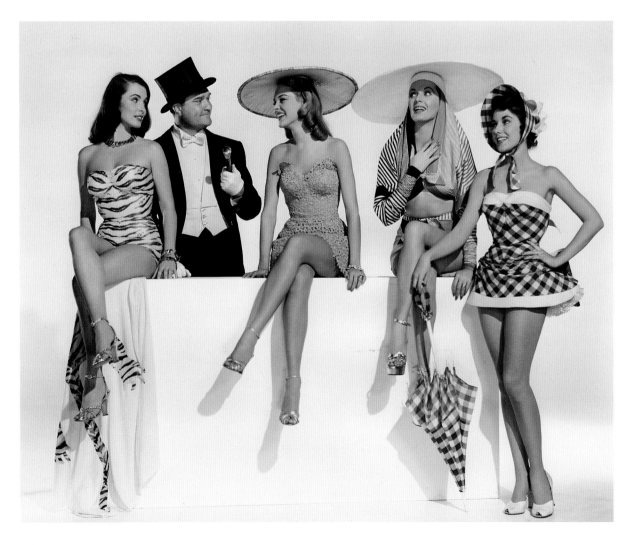

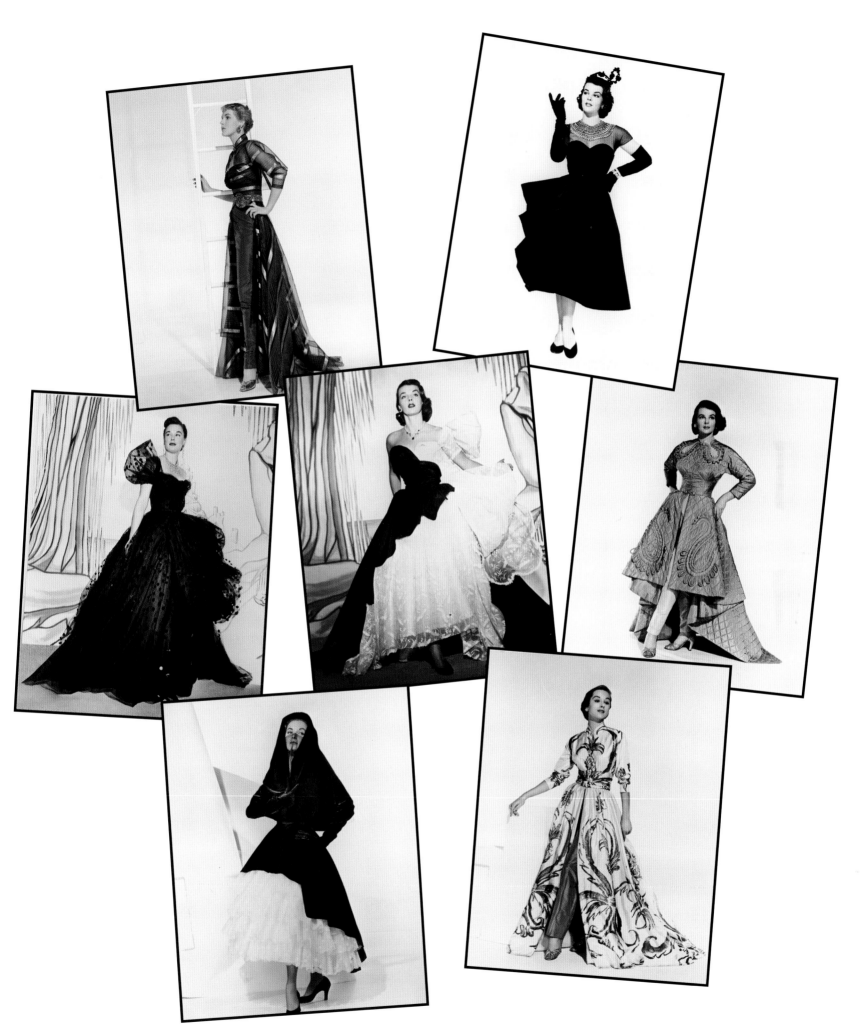

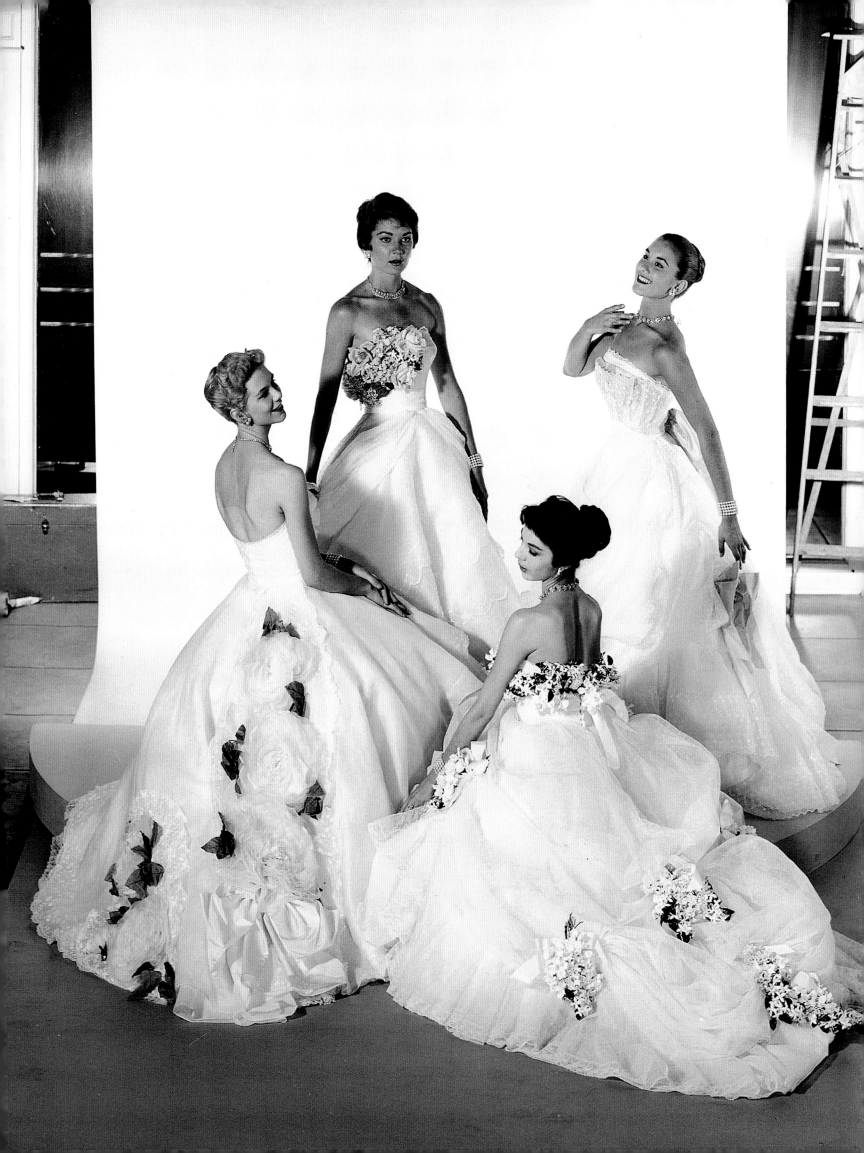

RETURN TO
THE THEATRE

A drian had written essays during his illness, and in 1957, he began writing his memoirs. "How long it takes us to reach any sort of maturity," he began. "As our thoughts crystallize, they inspire actions, and these become images on a canvas, a painting of our lives. After some years, we step back from it. We study it. Has it been worthy of the time we have spent on it? Have our thoughts led us to progress, or to destruction?" He completed a first draft, and was in discussions with Bennett Cerf of Random House about a prospective autobiography.

Both Adrian and Janet were receiving offers of work, and they finally had the confidence to accept them. Janet appeared on the screen for the first time in twenty years, playing a mother in *Bernardine* for Twentieth Century-Fox, her old studio. In 1958, Adrian designed costumes for the Los Angeles Civic Light Opera production *At the Grand*, a musical update of the 1932 *Grand Hotel,* starring Paul Muni and Joan Diener. To design costumes for the same story twenty-six years later was not strange for Adrian, even after years in American fashion. "It was like being out of a cage," he told the *Los Angeles Times*. "You're not designing something to sell or something that women will buy. What you want is something to knock the audience's eyes out."

Adrian had the costumes fabricated at Western Costume Company next door to Paramount Studios. The company's reputation for workmanship was the best in the industry.

Since his first design work had been for Irving Berlin's *Music Box Revue*, this would be a curious return to the theatre. Janet was preparing for a play. *Midnight Sun* would open in New Haven in the fall.

Judging from Adrian's memoir notes, he was contemplating the turns his life had taken.

Since I had that unpleasant sickness, when I thought it might be the end, I found myself thinking a great deal more about where

Previous page: Four romantic white silk organdy and taffeta floral-detailed ball gowns that Adrian designed for *At the Grand*, 1958.

Opposite: Adrian's costume sketch of a ball gown he designed for the production *At the Grand*. The gown was made of Scalamandré ivory-colored silk gauze with marbleized blue-and-green veining.

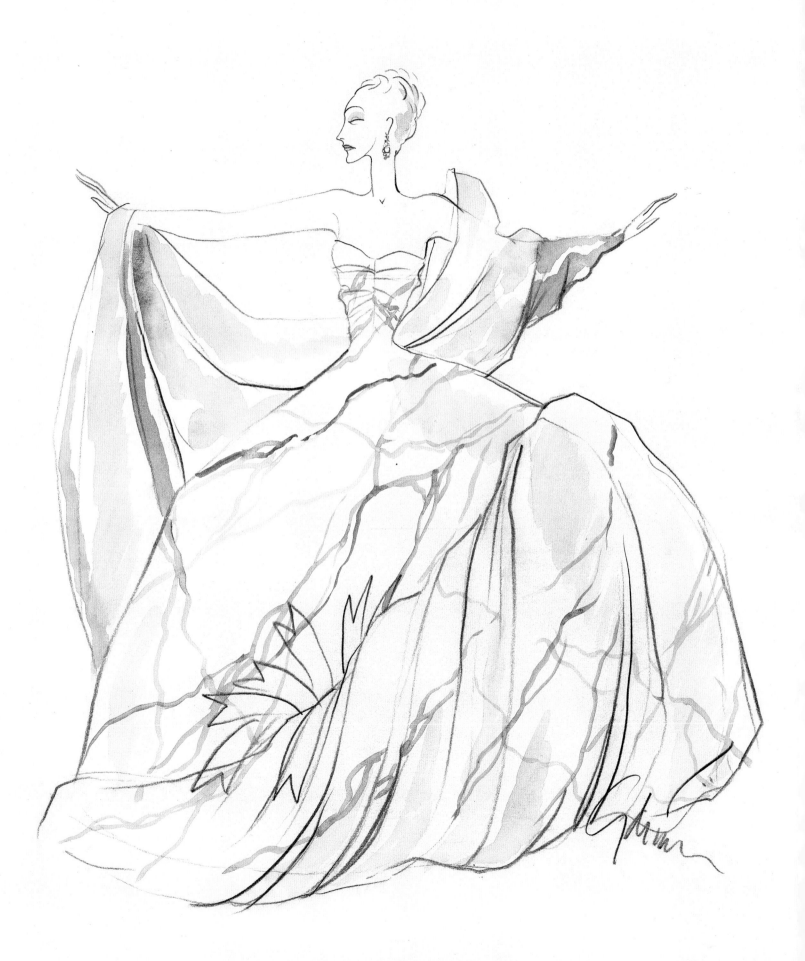

I stand spiritually. After we pass fifty, we begin to examine the higher qualities in man. We admit that death is around the corner, and we try to attract the attention of the unknown, just to let it know we have an eye out for spiritual advancement. If I was created by God, then I must be part of God. I try to understand God. When I look at beauty in nature, I think I understand. Yet I understand that decay can also be growth, as in a jungle with young plants coming out of decay.

In my work I have touched moments of ecstasy, when talent has flowed freely and directly from its source. I have had moments of peace and gratitude. When I think of the good fortune I have been blessed with, I can only feel that good outbalances evil in my life, yet I have battled with evil, and many times have lost, but not so often that I cannot recognize good as the ultimate victor.

But I have had thoughts that were not on a high plane. I was aware of their destructive potential, snarling like beasts in a mental cage. Like an animal trainer, I lashed them away. It frightened me to think that these thoughts could become real, and I wondered why God allows the human being to create anything other than beauty. I look at a magnificent sunset and I forget that at that moment, somewhere else, there is illness, pestilence, murder, war, and endless forms of horror.

Perhaps the wonder of God is that there has never been an answer to these contradictions and, yet, it may be that evil exists solely to prove that good is the most powerful influence. It's rather sad that I have these questions when there is so much beauty around me and so many laws of nature fulfilling themselves. Why can't I be simple, like a flower? But as I say this, a hand with a scissors clips off the flower's head. Oh, if I could see only good. Perhaps the hand places the scissors on a table, and picks up a prayer book. What is the answer?

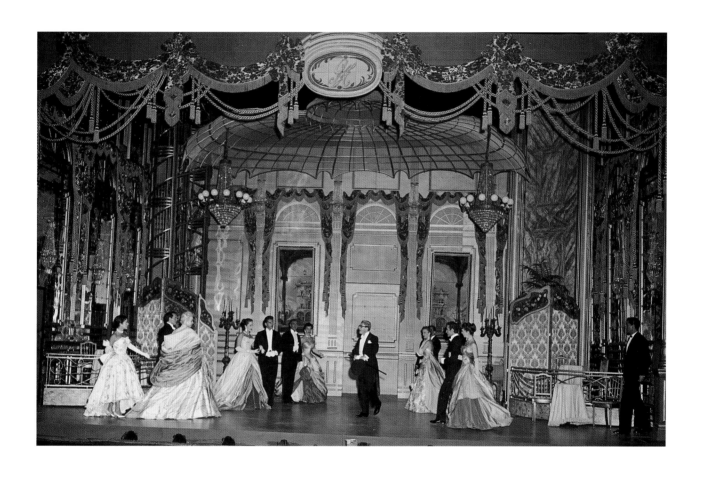

A production image from
At the Grand.

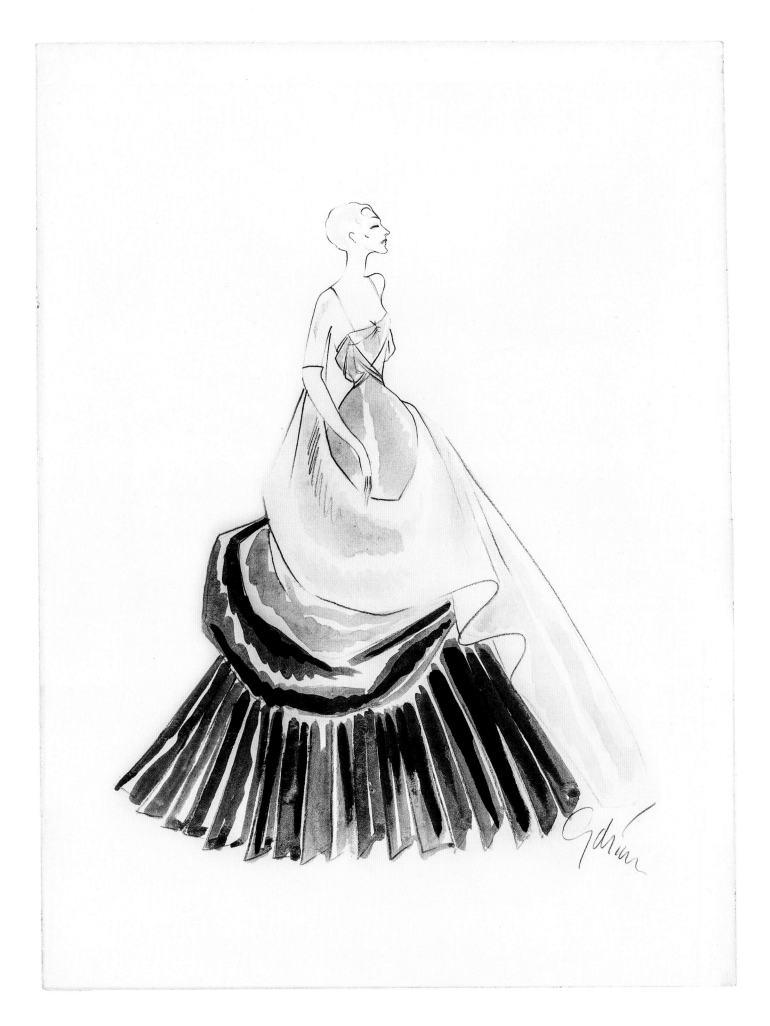

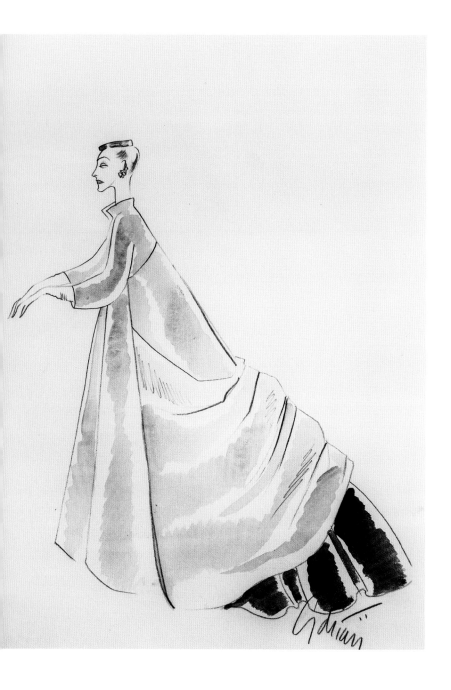

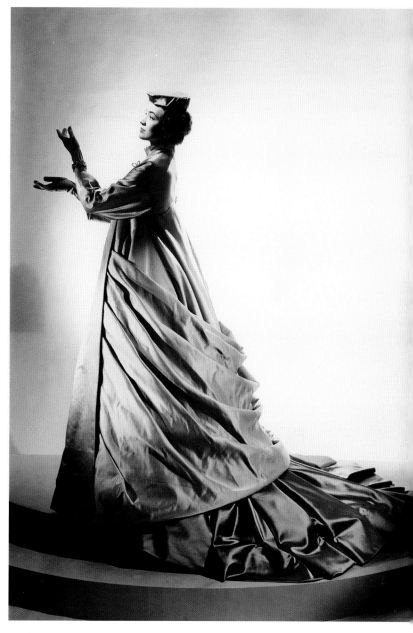

Opposite: Adrian's costume
sketch of a lavish ball gown for the
production.

Above and right: Adrian's costume
sketch of an evening gown and
coat and a photograph of the
finished design.

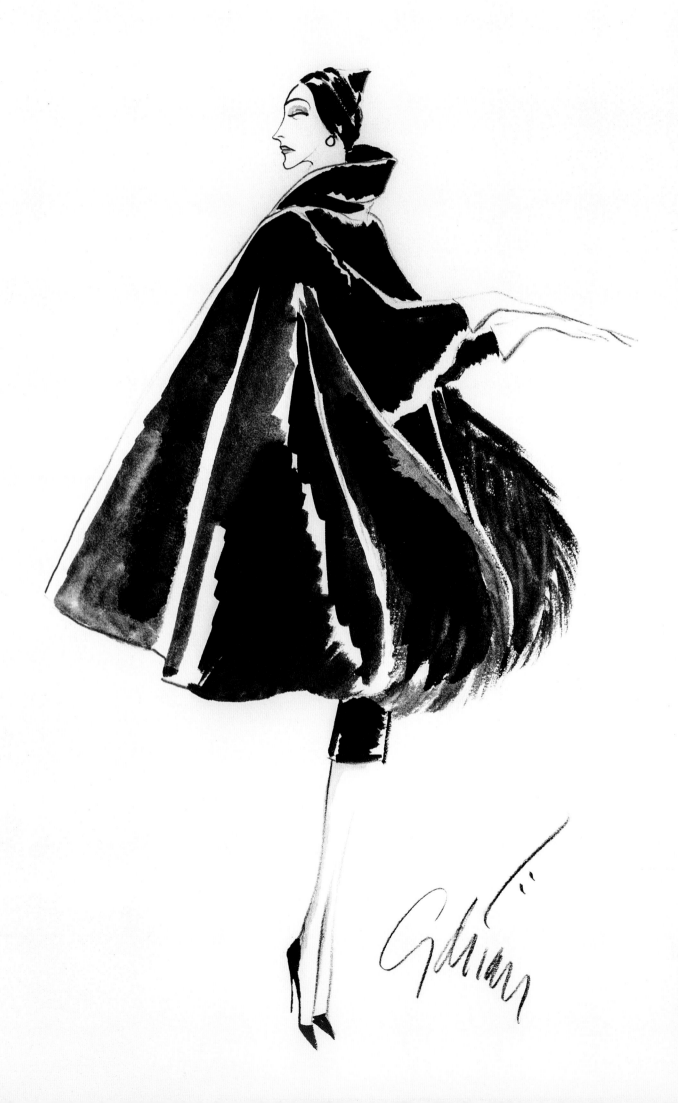

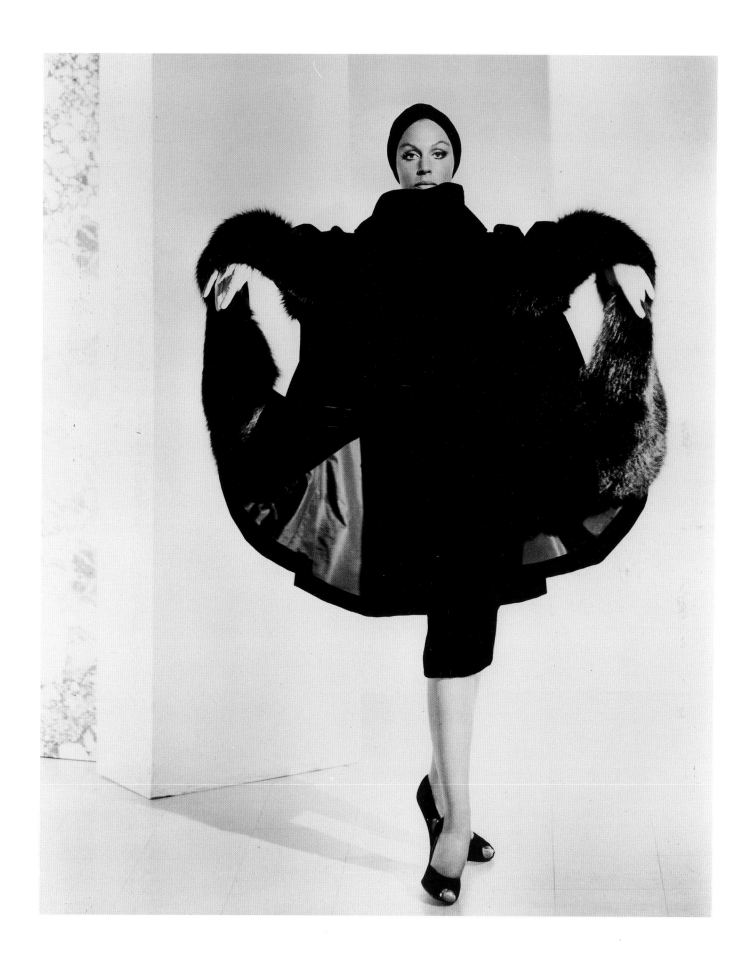

Adrian's sketch of a dramatic fur-
trimmed cape designed for Joan
Diener and the actress wearing the
finished ensemble.

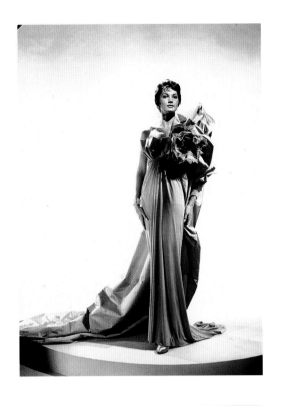
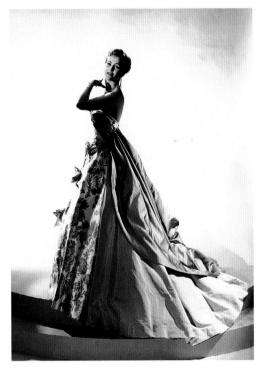
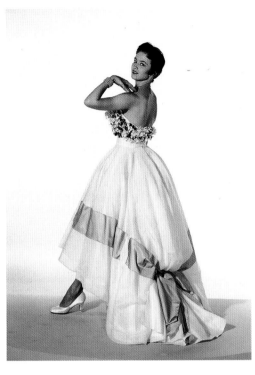
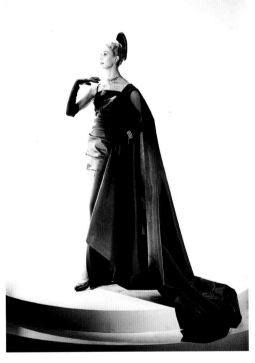
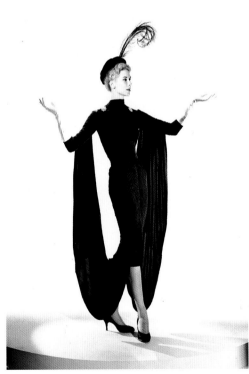
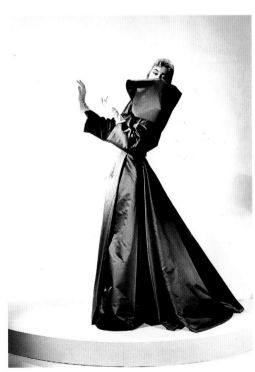

Twelve theatrical costumes
designed by Adrian for
At the Grand.

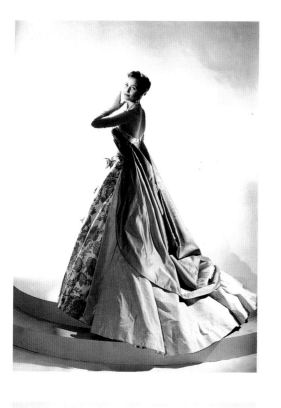
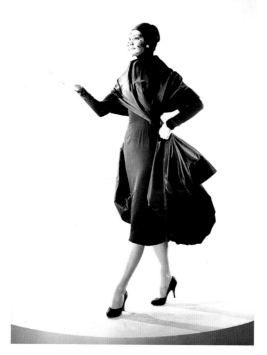
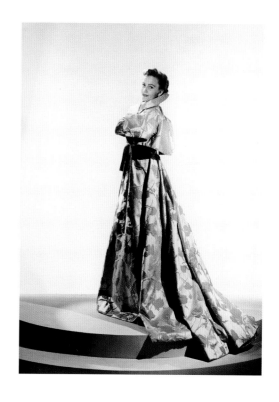
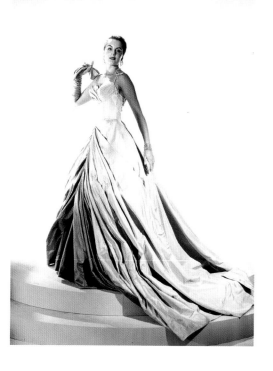
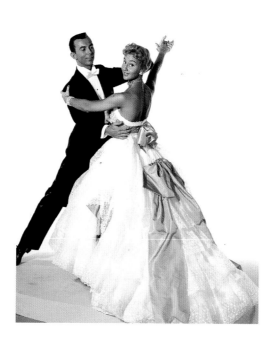
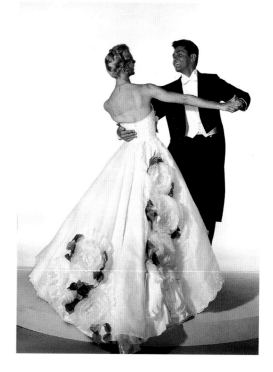

n 1959, Adrian was asked to design the costumes for Alan Jay Lerner's and Frederick Loewe's new musical production *Camelot*, to be directed by Moss Hart. The stars would be Richard Burton as King Arthur and Julie Andrews as Queen Guinevere.

Adrian accepted, and he designed some of the most beautiful costume sketches he ever created. Adrian was finishing his designs just before he died. These were the last drawings he ever made.

After Adrian died, Tony Duquette was asked to take over the project, which he accepted.

At the Tony Awards Ceremony in 1961, both Adrian and Tony Duquette received the Best Costume Design Award for 1960.

LEONARD STANLEY

Opposite: A sketch for Julie Andrews as Queen Guinevere.

Following pages and pages 344–347: Costume sketches for Richard Burton as King Arthur and for Julie Andrews as Queen Guinevere, and twenty-four imaginative costumes designed and sketched by Adrian for the production of *Camelot*. These beautiful sketches were the last drawings that Adrian created.

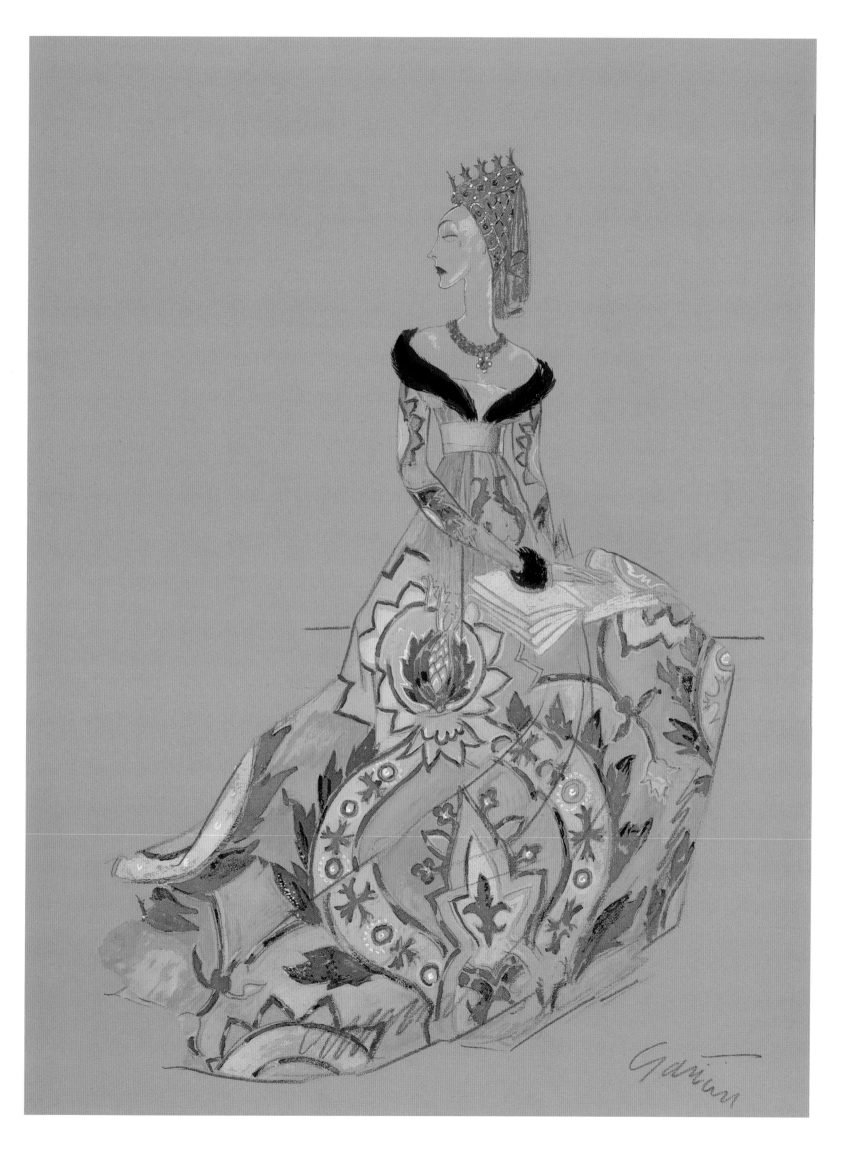

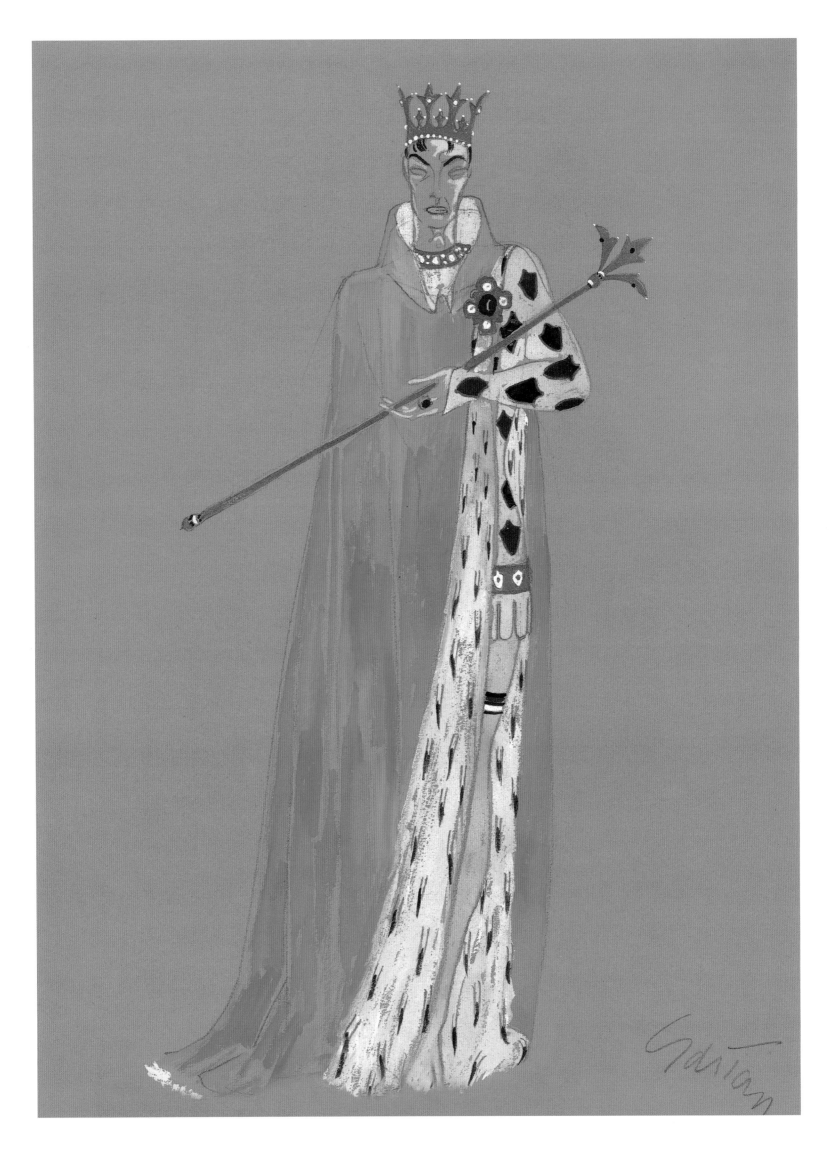

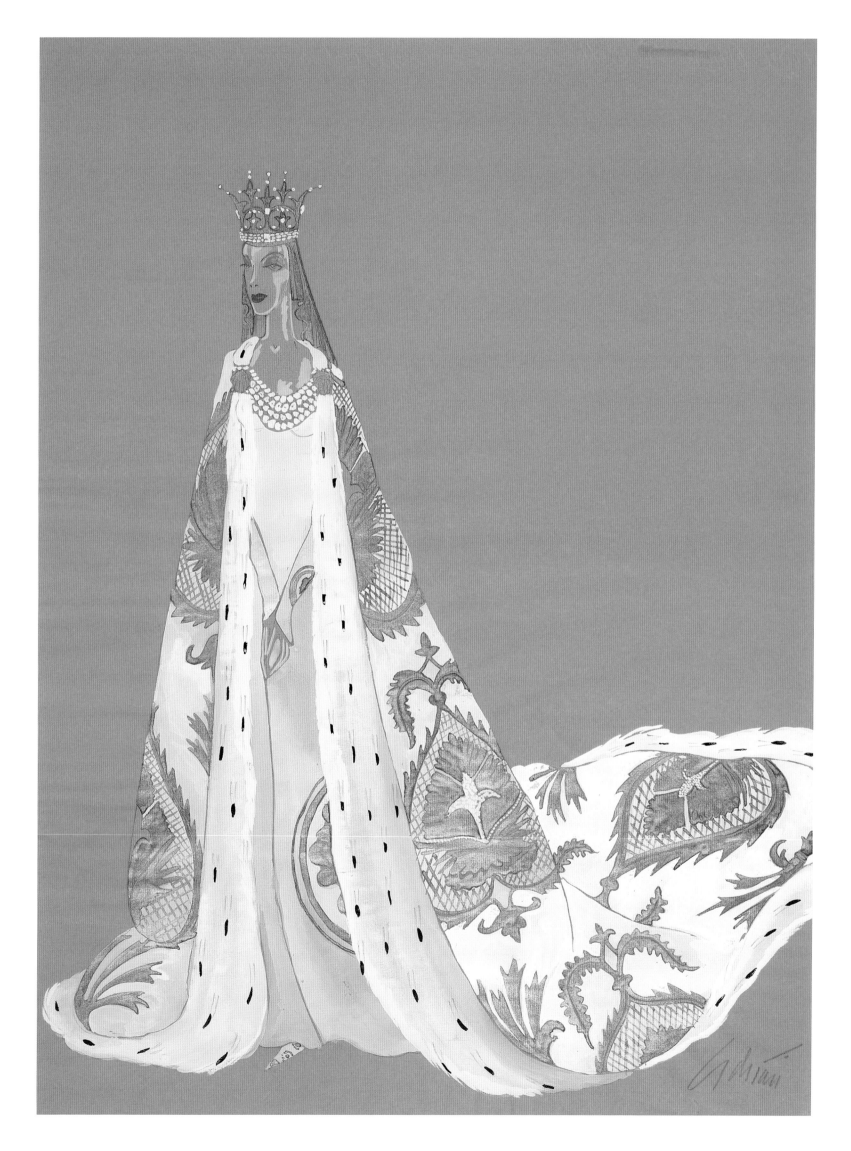

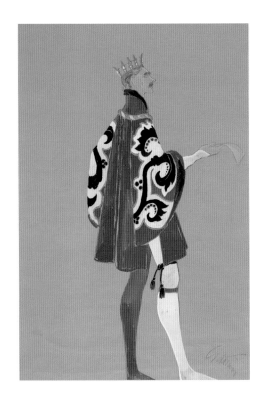

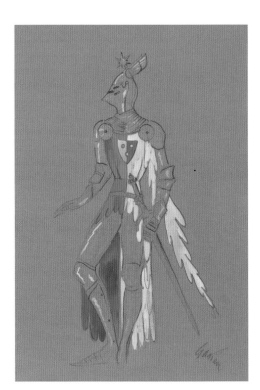

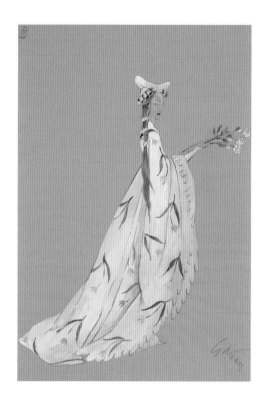
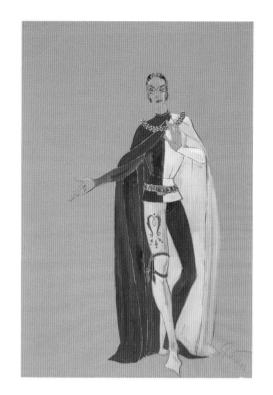
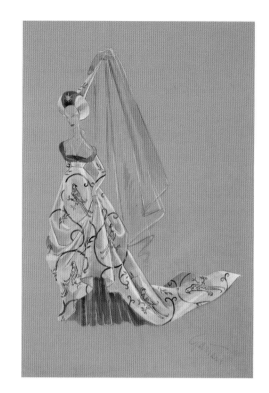

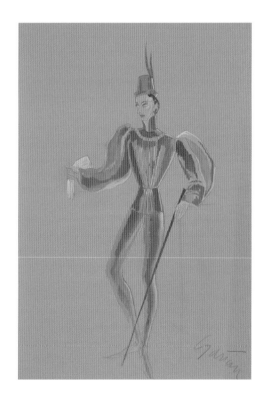

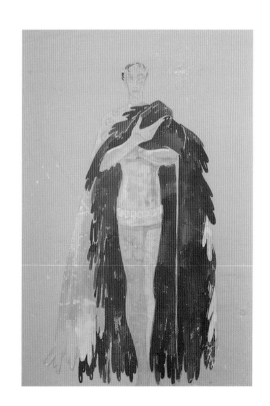

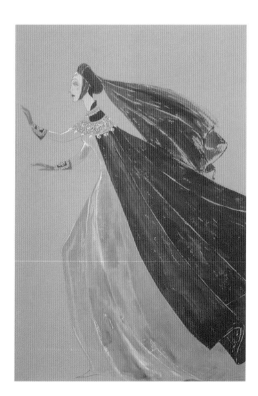

EPILOGUE

BY LEONARD STANLEY

Adrian died of a cerebral hemorrhage on September 13, 1959. I was having lunch at the counter of Armstrong-Schroeder's Restaurant in Beverly Hills. When I picked up the *Los Angeles Times* I was shocked to read of Adrian's untimely death. He was only fifty-six years old.

I remember going with Tony Duquette to see Janet at the Adrians' pied-à-terre on Melrose Place in Los Angeles. She and Adrian had been married for twenty years. They had enjoyed a close, wonderful marriage and had been absolutely inseparable. It was very hard on her after he died. I recall one thing in particular that Janet said to Tony and me: "Every time I open the closet doors, I burst into tears at all of the memories associated with Adrian's clothes." She finally had to give everything away to friends.

During Adrian's brief lifetime, he had managed to give the film, fashion, and design world memorable images that would live on to this day.

Janet once told me, "Adrian had 'boundless vision.'" I think that says it all.

Adrian at the height of his success in the mid-1940s. Photograph by John Engstead.

349

PHOTOGRAPHY CREDITS

Adrian: A Lifetime of Movie Glamour, Art and High Fashion

First published in the United States of America in 2019 by
Rizzoli International Publications, Inc.
300 Park Avenue South
New York, NY 10010
www.rizzoliusa.com

Copyright © 2019 Leonard Stanley

Foreword: Robin Adrian
Text: Mark A. Vieira

Publisher: Charles Miers
Editors: Joe Davidson, Victorine Lamothe
Production Manager: Colin Hough Trapp
Design Coordinator: Olivia Russin
Managing Editor: Lynn Scrabis

ISBN: 978-0-8478-6011-1
Library of Congress Control Number: 2019943688
2020 2021 2022 2023 / 10 9 8 7 6 5 4 3 2
Printed in China

Visit us online: Facebook.com/RizzoliNewYork
Twitter: @Rizzoli_Books
Instagram.com/RizzoliBooks
Pinterest.com/RizzoliBooks
Youtube.com/user/RizzoliNY
Issuu.com/Rizzoli

Endpapers: Image of the original ribbon used for Adrian's "Custom Made" label.

Page 2: Adrian in his Beverly Hills salon office. Photograph by John Engstead.

Page 4: Robin with Adrian's pet macaw, Baby, photographed at their Brazilian fazenda in 1956.

Page 6: Adrian photographed by Laszlo Willinger.

Page 8: Adrian photographed for *Life* magazine circa mid-1940s.